WOMEN in the WORLD

Annotated History Resources for the Secondary Student

Compiled and edited by
Lyn Reese
and
Jean Wilkinson

The Scarecrow Press, Inc.
Metuchen, N.J., & London
1987

This activity which is the subject of this report was supported by the Department of Education, under the auspices of the Women's Educational Equity Act. However, the opinions expressed herein do not necessarily reflect the position or policy of the Department of Education, and no official endorsement by the Department should be inferred.

Library of Congress Cataloging in Publication Data

Reese, Lyn, 1938-
 Women in the world.

 Includes indexes.
 1. Women—History—Bibliography. 2. Feminism—Bibliography.
3. Women—Study and teaching (Secondary)—Bibliography.
I. Wilkinson, Jean, 1914-
II. Title.
Z7961.R44 1987 [HQ1121] 016.3054 87-16436
ISBN 0-8108-2050-1

Illustration Credits

1 These illustrations are from the following books published by the International Women's Tribune Centre, Anne S. Walker, artist: *feminist logo's, A Clip-Art Book* and *Rural Women in Action;* both public domain materials; *Women Organizing*, permission of Anne Walker, artist

2 *Fem-Imaging: Women's Clip-Art,* Gail Horton and Carolyn Grossberg, Left-Hand Lighthouse Press

3 *MacAtlas,* Micro Maps

4 All the illustrations designated by #4 are in the public domain and may be found in the following books:

 Traditional Designs from India, Pradumna & Rosalba Tana, Dover Books, 1980
 Geometric Patterns & Borders (African Patterns), David Wade, Dover, 1982
 Design Motifs of Ancient Mexico, Jorge Enciso, Dover, 1953
 Japanese Borders & Designs, T. Meuten, Dover Books, 1975
 Compendium of Frames and Borders, Harold Hart, Hart Publication, 1983
 Women: A Pictorial Archive from 19th Century Sources, Jim Harper, 1982
 Banners, Ribbons & Scrolls, Carol Belanger Grafton, Dover, 1983
 Pattern Design (Middle East jar, Mycean jar, Italian and Islamic design), Archibald
 Christie, Dover, 1969

5 *The Remarkable Women of Ancient Egypt,* Barbara Lesko, BC Scribe Publications

6 *In Search of Our Past,* Susan Groves, Education Development Center

7 *Two Voices from Nigeria,* Lyn Reese, Stanford Program for Cross-Cultural Education

8 *Unwinding Threads: Writing by Women in Africa,* Charlotte Bruner, Heinemann Books, N.H. Wolff, illustrator

9 *Women in Africa,* Vol. II, Gross & Bingham, Glenhurst Publications

10 *Aramco World Magazine,* permission granted in magazine

11 *NAJDA Newsletter,* Women Concerned about the Middle East

12 Marcia Freedman, *Noga-Venus; A Feminist Quarterly*

13 *Women's Roots: Status and Achievements in Western Civilization,* June Stephenson, Diemer, Smith Publishing Co., Inc.

14 *Her Space, Her Place,* Mazey & Lee, Association of American Geographers, (from the field notes of D.R. Lee)

15 *Listen Real Loud: News of Women's Liberation Worldwide,* American Friends Service Committee, logo

16 *Listen to Women for a Change,* Women's International League for Peace & Freedom

17 *The Global Pages,* Immaculate Heart College Center, Vols. 3 & 4, Laurien Alexandre, editor and illustrator

Illustration Credits

18 *Women in China,* Vols. I & II., Gross and Bingham, Glenhurst Publications

19 *Report from a Chinese Village,* Jan Myrdal, translated by Maurice Michael, illustrated by Gun Kessle, Pantheon Books, a Division of Random House, Inc.

20 *Li Ch'ing-chao, Complete Poems,* Rexroth & Ling Chung. Reproduced with permission of *New Direction*

21 *Sources of Strength: Women and Culture,* Lisa Hunter, ed., Education Development Center

22 *Chiliying: Life in a Rural Commune in China,* Beers & Parramore, North Carolina State University

23 *Sourcebook on Philippine Women in Struggle,* Floro & Luz, Philippine Resource Center, Logo: Gabriela (Philippine Women's Organization)

24 *Women in Ancient Greece and Rome,* Gross & Bingham, Glenhurst Publications, Nancy Wright, artist

25 *Eminent Victorian Women,* Elizabeth Longford, Pantheon Books, a Division of Random House, Inc.

26 *Third World/Second Sex: Women's Struggles and National Liberation,* compiled by Miranda Davies, Zed Books, Ltd.

27 *Woman Composers,* Carol Plantamura, drawings by Nancy Conkle and Bellerophon Staff, Bellerophon Publications

28 *liberazione della donna, feminism in Italy,* copyright 1986 by Lucia Birnbaum, illustrations from posters for the Movement for the Liberation of Women, le donne al muro

29 *The Underside of History,* Elise Boulding, Westview Press, Inc.

30 *On Top of the World: Five Women Explorers in Tibet,* L. Miller, The Mountaineers

31 *The Women Troubadours,* Meg Bogin, W.W. Norton

32 *Victorian Women: A Documentary Account of Women's Lives in 19th Century England, France, & the United States,* Hellerstein, Hume & Offen, Stanford University Press

33 *Women in Latin America,* Vol I, Bingham and Gross, Glenhurst Publications, illustration courtesy of the Bancroft Library, University of California, Berkeley

34 *The Neglected Resource: Women in the Developing World,* Kristin Helmore, International Women's Tribune Centre

The symbol used in the *Women in the World* logo on the cover and title page is from *feminist logo's, A Clip-Art Book,* published by the International Women's Tribune Centre

Acknowledgements

From the beginning of this project we have been given encouragement and practical and emotional support by friends and colleagues who share with us the commitment to women's history. Along the way we were also inspired by the women who researched and wrote the books we read. We felt supported by the increasing number of feminist scholars who furnish the historical evidence with which to legitimize the teaching of women's history in secondary schools.

We are grateful for the friendship and professional cooperation of Marjorie Bingham and Susan Gross, Women in World Area Studies, whom we consulted first about resources for this bibliography. We are fortunate to have Audrey Shabbas as a Berkeley neighbor and colleague. Her advice plus that of Marcia Freedman guaranteed the enrichment of our section on Middle Eastern resources. Our thanks to Renée Wilson and the staff at the Education Development Center for their willingness to answer our questions and give us good advice on the production of our bibliography.

We thank Mary Agnes Dougherty, Ellen Oicles, Audrey Shabbas, and Sonya Blackman, who brought their classroom experience and literary judgment to the job of reading and annotating in the areas of Japan, India, the Middle East and Latin America.

The following friends performed an invaluable service by reading and annotating books: Frieda Agron, Laurien Alexandre, Adya Bryant, Yvonne Gitelson, Janie Kail, Jeri Lyster, Eve Mintz, Dorothy Neville, Julie Sanderson and Margy Wilkinson.

Among the many librarians who gave us time and assistance in our ERIC search and perusal of Young Adult resources, those we must especially thank are Betty Bacon, Virginia Pratt, and Ursula Sherman from the University of California School of Library Studies and Information Services, and Linda Perkins, Jane Scantlebury, and Martha Shogren from the Berkeley Public Library.

We thank the personnel in those Area Studies Teacher Outreach and Sex Equity Centers who responded to our letters and calls requesting information on available resources. Special appreciation goes to those who personally assisted us in our research at the World Affairs Council Outreach Center in San Francisco, the Social Studies Resource Center in Culver City, the Immaculate Heart College Center in Los Angeles, and The Third World Resource Center in Oakland. Mary Heffron and Tom Fenton of Third World Resources kept us in good humor and abreast of the latest books on Third World countries.

Acknowledgements

We acknowledge the staff of A Woman's Place, Black Oak Books, Cody's and Old Wives Tales, all Bay Area bookstores where we spent numerous hours browsing and buying.

Our two editors, Mary Heffron and Martha Winnacker, earned our appreciation for their thorough editing and helpful comments.

Our deepest gratitude belongs to our colleague, Charles Reese, who from the beginning saw this bibliography as an on-going project. To this end he provided us with a data base design that will allow for the updating of resources. The project fully utilized the unique power of Apple's Macintosh™ computer and LaserWriter™ printer, and a comprehensive array of excellent software available. This book is visually attractive and easy to read because of Charles Reese's skill and creative use of those Desktop Publishing tools.

Table of Contents

Table of Contents

INTRODUCTION

This project is the culmination of our work during the last fourteen years in uncovering and using women's history materials in the K-12 classroom. In addition to our classroom teaching, we developed a Junior and Senior High School World History curriculum on women and a cross-cultural anthology on the female adolescent experience. As consultants, we have worked with teachers bringing new materials to their attention and demonstrating strategies for classroom use.

In the last few years the number of good quality student World History resources about women has increased; yet it has become obvious to us that this exciting new scholarship is not reaching the teacher. Although bibliographies are available for American History courses, no comparable list exists for Junior and Senior High World History and Area Studies. For this reason, we applied for and received a Women's Educational Equity Act Grant from the U.S. Department of Education. This allowed us to do the research for this book which pulls together a wide variety of materials to stimulate both teacher and student interest in women's place in history.

Women's stories are central to the story of humankind. Women's activities have been essential in the creation of community, culture, and civilization as the resources in this bibliography will affirm. Today, new statistics and studies reveal women's crucial role in global issues. In any study of problems relating to refugees, global assembly lines, development, health, and education, women are in the forefront, helping to resolve the issues that directly affect them.

Third World women in particular have emerged as active participants in defining problems and working for their solution. In addition to struggling against the patriarchy inherent in their own cultures, they are also struggling against the legacy of colonialism and the cultural and economic oppression by foreign systems. Yet their voices have been largely ignored in educational texts, media, and literature for the classroom, and their contributions and strengths have remained an untold story. Instead, negative stereotypes of passive and mistreated women stand unchallenged. This leaves the impression that Third World women are complicit in their oppression. We need to hear from the women themselves in order to learn about their day-to-day lives, how they deal with their concerns and how they create bases of power - not only today but throughout time.

Even where western civilization is emphasized, scant attention is paid to the important and diverse roles of women. The resources listed here will help rectify this omission by providing information regarding European women's participation in general and the lives of notable women in particular.

INTRODUCTION

Our highest priority has been to select materials that will make visible the lives of women, that provide authenticity, and that tell an interesting story. Of these materials, only those that have the best chance to attract the adolescent reader were included. Our aim is to allow teachers to:

- place women's history at the center with men's history
- allow a wide diversity of women to speak for themselves
- challenge the stereotype of women in Third World countries as "exotic"
- make visible women's important contributions to their economies and culture
- identify special issues affecting women
- examine periods when women held political, economic and social power and eras when there was a significant change in women's status
- help in the construction of a more realistic history inclusive of race, gender and class

We see this bibliography as a beginning effort. We have uncovered a wealth of materials in the last year, yet we are aware that many good resources may have been overlooked. We are eager to hear from educators about other resources and about the usefulness of this bibliography. Please send your comments to: *Women in the World: Curriculum Resource Project*, 1030 Spruce Street, Berkeley, CA 94707.

How to Use the Bibliography

Section Divisions:

We have divided the material into sections representing the following geopolitical areas of the world. We have not covered the whole world. In our limited research time, we directed our attention to those geopolitical groupings most emphasized in secondary course outlines and texts; therefore, resources from such countries as Canada, Australia, New Zealand have not been included in this edition.

AFRICA: The selections from the pre-Islamic period represent cultures from the whole continent. We have chosen to place post-Islamic North African pieces in the Middle East/ North Africa section in conformance with most bibliographies we reviewed. We urge the reader to look in this latter section for modern resources on North Africa.

ASIA: Asia includes East Asia, South Asia and Southeast Asia.

CROSS-CULTURAL: This section offers resources from more than one of our major geopolitical regions. Here you will find anthologies that offer information on neglected regions, such as Indonesia, Iraq, Pakistan, Bulgaria. Using these materials will allow interesting comparisons between diverse societies. Be sure to check this section for information on any country. For example, if you are teaching India, selections in the cross-cultural section may include information on this country.

EUROPE: This section includes pieces from the Soviet Union.

LATIN AMERICA: This region encompasses South America, Central America, Mexico and the Caribbean Basin.

MIDDLE EAST/NORTH AFRICA: Selections found here are from Afghanistan, Turkey, Iran, Lebanon, Israel, Syria, Jordan, Iraq, The Persian Gulf states, Saudi Arabia, Oman, North and South Yemen, and Mediterranean Africa.

Categories within Sections:

Materials within each chapter are grouped under the following categories:

> **Background/Reference**
> **Anthology**
> **Autobiography/Biography**
> **First Person Accounts**
> **Fiction**
> **Curriculum**

We have reviewed some audio-visual materials. Generally, these are with annotations of curriculum, particularly when they are part of a curriculum package.

Annotations:

Each annotation contains information on the following:

Title, author, publishing house, date of publication, and **number of pages.** In each category, the selections are listed alphabetically by title. All the resources listed are in print and are available, unless otherwise noted. The address of each publisher is listed in the Appendix. To facilitate ordering resources, we have used, with a few exceptions, only resources that are distributed in the United States.

How to Use the Bibliography

Reading Level: We have indicated three reading levels - **Easy, Average** and **Advanced** for both **Jr. High** and **Sr. High.** Under **Description** (described below) we also let teachers know when a selection should be used only with mature students. Some pieces will hold the interest of readers from **Jr. High** through **Sr. High** and that is shown as **Easy - Advanced** at both grade levels.

Illustrations: If illustrations are a significant factor in the resource's content, we indicate this in the **Description.**

Time Period: Every annotation notes the time covered by the material. Since they are not listed chronologically, check for the dates you are interested in. If you are looking for resources on ancient civilizations, you will find them according to their geographical location. (See **Place**) Every historical period is not represented as we did not find resources for every historical era.

Place: Generally we list all the countries represented in the resource. When there are numerous references, we use a broader category such as Africa, Asia, Europe, Middle East /North Africa, Latin America or World.

Themes: This category offers information on general topics, concepts, historical events and personalities, thereby providing clues to help teachers decide how this selection could fit into their lessons.

Description: Our attempt has been to give educators an overview of content, scope and format. We try to indicate features of special interest which may extend students' knowledge of women's history. We give a "top rating" when the selection is unique, substantive, well written, and notably relevant to the secondary student.

Suggested Uses: While we always kept in mind the resource's potential for classroom use, sometimes we have provided specific activities. We hope these will suggest to teachers a variety of ways to use the material in the classroom.

Selection Choice:

Omitted from this bibliography are many fine selections that demand background information beyond the level of the secondary student. We did include, however, some novels, essays, and case studies for advanced readers when they provided information not available elsewhere. We tried to select only those pieces that most closely met the criteria of historical and cultural context, appropriate reading and maturity level, emotional impact and, where possible, allowed women to speak for themselves.

We continue to look for good material. Please send your suggestions to the *Women in the World* address listed in the Introduction.

AFRICA

INTRODUCTION

Since men and women in Africa have in the past tended to work and play in separate and complementary worlds, lessons on the history and culture of this continent are incomplete without the inclusion of the special perspective of African women. The resources here offer a view from the world of women from many periods and regions and from diverse lifestyles.

The strength of women, both individually and collectively, and the importance of their contributions to their societies are dominant themes. Materials from Africa's early history, with some exceptions such as Lesko's *Remarkable Women in Ancient Egypt,* tend to focus on female leaders. The lives of "ordinary" women, however, may be found in the curriculum and fiction. These most often depict women's lives in a traditional agrarian setting, which is then contrasted with modern lifestyles. Other historical readings demonstrate the often negative impact of colonialism on women's roles and status, again contrasted with their position in indigenous societies.

Modern pieces show women as resisters against political oppression, as for example in South Africa, or against the constraints of traditional customs which are no longer relevant. Contemporary pieces further illuminate women's enormous yet often unrecognized contribution to developing economies, while discussions of domestic roles reveal a deeply ingrained sense of responsibility, regardless of socioeconomic status, to bear and rear children.

The works of women writers offer exciting and often overlooked resources. By portraying their own female experience, these authors provide insights into women's multiple responsibilities and into the cross-cultural conflicts which engulf many contemporary women. Women's ancient role as storyteller comes alive through these artists whose work, one hopes, will find its way into many classrooms.

For the modern period, resources on North Africa (shaded on map) have been placed in the section on Middle East/North Africa.

Background/Reference

Fighting Two Colonialisms: Women in Guinea Bissau

by Stephanie Urdang
Monthly Review Press, 1979,
314 pages
Sr. High: Average - Advanced
Illustrations: Photos
Time Period: 1974-1976
Place: Guinea-Bissau

Themes: Military fight for independence; Background of PAIGC (liberation) Party; Amilcar Cabral; Life under Portuguese rule; Village customs; Life after Independence

Description: The author spent April - June, 1974, in the liberated zones of Ginuea-Bissau during that country's military struggle for independence. The last chapter is a 1976 update after independence. The focus is on the attempts to create new roles for women and men, such as shared domestic work, equal political and educational opportunities. The text allows women to speak about their "liberation," providing readings which counter the stereotype of the passive female and unchanging African male, while at the same time describing those aspects of traditional culture which are considered regressive. The text is descriptive and lively.

Suggested Uses: The book is long. Ask students to begin their reading from Chapter Four because this is where the book begins to focus on the position of women.

"In order to develop our country we women must do the same work as the men, which they believe we cannot do, and men must free women from the enormous amount of work they have to do in the home."
- Teenager in Guinea Bissau

For Their Triumphs and For Their Tears: Women in Apartheid South Africa

by Hilda Bernstein
International Defence and Aid Fund for Southern Africa, 1975, 70 pages
Jr. High: Advanced
Sr. High: Average - Advanced
Illustrations: Photos
Time Period: 1940-1975
Place: South Africa

Themes: Definitions of terminology surrounding Apartheid (homelands, Bantustans, endorsed out, influx control, etc.); Boycotts of 1943, 1944 & 1950; Banning of African National Congress (ANC); Past resistance campaigns, such as the anti-pass movements; Background to contemporary issues and struggles

Description: This is a classic for information on the situation of women in South Africa. It is full of specifics, facts and figures, and is comprehensive in scope. Topics range from migrant labour to a selection of women's freedom songs. There are also short biographies of important leaders.

Suggested Uses: Use as a basic text on South African women under Apartheid. The first pages which define terms students should know are particularly useful. For up-to-date information, a contemporary piece should be presented with this. Use one of the following excellent media: *Forget Not Our Sisters* (filmstrip, 15 minutes), Barbara Brown, 46 Waverly, Brookline MA 02146. This inexpensive, comprehensive and fast paced show uses first person accounts and lively music. *You Have Struck a Rock* (videocassette, 45 minutes), California Newsreel. Dramatic images of the women's 1950s protest demonstrations and recent interviews with old campaigners in the struggle. Some accents are difficult to understand. *South Africa Belongs to Us* (videocassette, 25 mins.), California Newsreel. Interviews with women from different levels of Black society.

"A vast superstructure of custom and law, in which the habits and institutions of an old, pastoral society are cemented into a modern industrialized state, rests on the backs of the black women of South Africa."

- Hilda Bernstein

Our Own Freedom
by Maggie Murray &
Buchi Emecheta
Sheba Feminist Publishers, 1981,
111 pages
Jr. High: Easy - Advanced
Sr. High: Easy - Average
Illustrations: Photos; Charts
Time Period: 1975-1980
Place: Africa

Themes: Labor of women in household, farming, trade and modern sector; Education and training; Childcare and health; Political influence; Development aid

Description: This is the best source for an overview of African women through dramatic, full page photos and descriptive, accompanying text. Emphasis is on hard work of women in traditional sector. This resource can be found in selected bookstores or available from *Sheba Feminist Publishers*, 488 Kingsland Road, London, E8, England.

Suggested Uses: Use to accompany curriculum, *Through Their Own Hard Work, Nigerian Women in Development.* (Reviewed in this bibliography) • There are a number of charts, such as "The Seventeen Hour Day" that can be used in class.

"Because they are unpaid, such tiring and boring chores are called 'women's jobs.' A girl who dares to grumble is reminded, 'But you are a woman.' That usually shuts her up."

- Buchi Emecheta

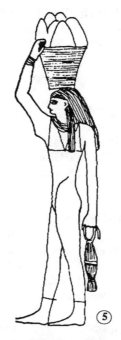

The Remarkable Women of Ancient Egypt
by Barbara S. Lesko
B.C. Scribe, 1986, 31 pages
Jr. High: Average - Advanced
Sr. High: Average - Advanced
Illustrations: Paintings; Photos; Line drawings
Time Period: 2664-30 B.C.
Place: Egypt

Themes: Egyptian mythologies; Royal lineage; Comparison between Greek and English women in 5th century B.C.; Industries; Change over time of freedom and opportunities of common people; Position of slaves; Marriage responsibilities; Property rights; Selected chronology of ancient Egyptian history

Description: Author cites as one of the "glories of ancient Egypt" women's independence, legal protection and equality with her husband. These short, beautifully illustrated chapters offer fascinating information about women's work and status in Egypt which could be used to bal-ance readings about women in more oppressed societies. Chapters include information from the royal women to the life and occupations of the average woman. Information also on priestesses, dancers and musicians in religious cults and on the legal position of women and women's status within the home. Available from *B.C. Scribe*, P.O. Box 2453 Providence, RI 02906. Top rating.

Suggested Uses: Using the chapter "Equal under the law," students could compare women's position in ancient Egypt with women in contemporary U.S. • Good as a classroom reference.

"Four thousand years ago women in the Nile Valley enjoyed more legal rights and privileges than women have in many nations of the world today. Equal pay for equal work is a cry heard now, but seems to have been the norm thousands of years ago in Egypt."

- Barbara Lesko

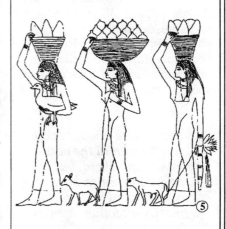

Women Under Apartheid

International Defence and Aid Fund for Southern Africa 1981, 50 pages
Jr. High: Easy - Average
Illustrations: Photos; Charts
Time Period: 1980
Place: South Africa

Themes: Women's anti-pass demonstrations, 1913-1959; Women's political action from 1960-1980; Migrant labor system; Resettlement; Squatter camps; Women's federations

Description: This picture book accompanied a photo exhibit. The text is short, covers many fundamental themes in the study of South Africa, and offers some solid historical analysis. Focus on women allows students to begin to understand their special role. For example, in 1959 after a peaceful women's demonstration was violently broken up by the police, the tactic of peaceful mass action was largely abandoned in favor of more direct, violent action. The photos are striking. Top rating.

Suggested Uses: Link with similar picture/text books, such as *Our Own Freedom*, or *Working Women*, or *A Portrait of South African Black Women*. (These books are reviewed in this bibliography.) For limited readers these books can provide an excellent way to integrate women's history into your lessons.

"Women have always taken part with men in the battle against Apartheid, but in addition women have campaigned on issues primarily affecting them as women."
- Hilda Bernstein

"End of the UN Decade: Advances for Africa Women?" *Africa Report* 30:4 (March-April)

African-American Institute, 1985, 82 pages
Sr. High: Average - Advanced
Illustrations: Photos
Time Period: 1985
Place: Nigeria, Ghana, Mozambique, Kenya, Zimbabwe, South Africa

Themes: Women in economic development; Reports on the status and changing attitudes about women in a variety of countries; Overview of political and economic changes since independence

Description: This special issue is a review of the achievement of African women at the end of the UN designated Decade of Women (1975-1985). The following articles seem the most appropriate for secondary classrooms and provide information from countries often overlooked: "Equal Partners in Development" (Mozambique), "Three Women of Kano" (Nigeria), "Women in Kenya," "Joyce Aryee, Secretary for Education, Ghana," "The Law in Southern Africa; Justice for All?", "Rural Transformation: Women in the New Society" (Zimbabwe). The photos, some a half page, are excellent.

Suggested Uses: Students could look for common threads in the articles which comprise a set of attitudes about and among women in the different countries. Then they could decide which differ from those in developed, industrialized countries. What values might benefit African women? Which are obstacles? • Students could do further research on the countries represented. Is the role of women discussed in the books students

found? If not, how does this contribute to the problem?

"Independence that was meant for all the people turned out to be a transfer of power from the British male elite to the Kenyan male elite."

- Joan Harris,
"Women In Kenya"

"Young Traders of Northern Nigeria," *Natural History* 90:1 (June)

by Enid Schildkrout
The American Museum of Natural History, 1981, 11 pages
Jr. High: Advanced
Sr. High: Average - Advanced
Illustrations: Photos
Time Period: 1980
Place: Nigeria

Themes: Work and lifestyle of Hausa women; Socialization of boys and girls; History of Kano; Education in the North

Description: This article shows the active economic role young girls play in a society where women live in strict seclusion. Until puberty girls are allowed in public and may trade their mothers' products on the streets and in the markets. The voices of young girls themselves describe their work. Text is interesting; pictures are beautiful. Top rating.

Suggested Uses: Link with "Three Women of Kano," *Africa Report*, March-April, 1985, and slide show, *Through Their Own Hard Work: Nigerian Women in Development*. (Both resources reviewed in this bibliography).

Autobiography/Biography

①

A Dakar Childhood
by Nafissatou Diallo
Longman Group Ltd., 1982,
134 pages
Jr. High: Average - Advanced
Sr. High: Easy - Advanced
Illustrations: None
Time Period: 1944-1968
Place: Senegal

Themes: Clothing, food, religious
and family celebrations of extended
Muslim family; Koranic and French
schooling; Pilgrimage to Mecca;
Rivalry over Caliphate for Islamic
sect, the Mourides; Socialization of
girls

Description: Diallo writes of a child-
hood and adolescence in a large, hier-
archical Islamic family. Here she
was taught the basic values of shar-
ing, humility and respect for those
above. The story also reveals the
warmth and love of the family and
the rebelliousness of a girl who was
a "tomboy," full of pranks and
plotting ways to avoid the ever
watchful eyes of relatives during her
teenage years. Top rating.

*"My girl-cousins were green
with envy. I was the first girl
in the family that Grandpa in
his old age had finally allowed
to go to school."*

- Nafissatou Diallo

A Window on Soweto
by Joyce Sikakane
International Defense and Aid Fund
for Southern Africa, 1977, 80 pages
Jr. High: Advanced
Sr. High: Average - Advanced
Illustrations: Photos
Time Period: 1947-1976
Place: South Africa

Themes: Background of establish-
ment of Soweto; Removal of Afri-
cans from Sophiatown; Treason
trials; Banning orders; Restrictions
under Apartheid; Conditions in jail

Description: The author, a
journalist now living in exile, was
raised in a middle class family
whose fortunes diminished under
the increasing restrictions of the
Nationalist government. Sikakane
received an education, however, and
became the first black African
woman reporter on the *Daily Rand*.
Because of her articles she
eventually faced trials for "treason,"
was jailed, spent seven months in
isolation and was banned. This
descriptive account of her struggles
and of the history and conditions of
life of the ordinary people in
Soweto reflects her journalist
training. Top rating.

②

All God's Children Need Traveling Shoes
by Maya Angelou
Random House, 1986, 206 pages
Jr. High: Average - Advanced
Sr. High: Average - Advanced
Illustrations: None
Time Period: 1960-1965
Place: Ghana, Liberia

①

Themes: Aims of Kwame Nkru-
mah's revolution; Visit of Malcom
X; Life at University of Ghana;
Strains between Black Americans
and Ghanaians

Description: Maya Angelou re-
counts her years in Ghana during
the exuberant period of national
pride in the early Nkrumah years.
Joining a "colony" of Black Ameri-
cans, she finds that while this
group has "never completely left
Africa," the differences between the
Americans and the Ghanaians
remain vast. Yet the most glorious
moments are when through "racial
memory" she connects with Afri-
cans, allowing the reader insights
into African lifestyles and aspi-
rations.

*"A poor, uneducated servant
in Africa was so secure he
could ignore established
White rudeness. No Black
American I had ever known
knew that security."*

- Maya Angelou

Call Me Woman

by Ellen Kuzwayo
Spinsters Ink, 1985, 163 pages
Sr. High: Average - Advanced
Illustrations: Photos
Time Period: 1910-1985
Place: South Africa

Themes: Rural South Africa, 1910-1920s; Christian education in 1930s; Soweto; Student uprising of 1976; African National Congress; Women's self-help associations; Prison life; Women's anti-pass demonstrations

Description: Ellen Kuzwayo has seen great changes in South Africa in her seventy-five years, and through her work in Soweto she has played an influential part in most of its major political and social movements. In this important autobiography, Kuzwayo not only discusses external events, but reveals her struggle for personal dignity. Of note are her eulogies to specific women and women in general whom she sees as better equipped than men to "take" discrimination because of the need to support their children. Her writing style is a bit stilted and some chapters contain too much detail about people she knew.

Suggested Uses: Shorten the reading assignment by asking students to read only these key chapters;"My Lost Birthright," "How the State Sees Me," "Minors are Heroines."

"'A thought crossed my mind, as if in a whisper from a friendly neighbour, 'Ellen, remember South Africa is your country of birth still. You have no business to give in to any form of intimidation or brain-washing by any human being.'"
- Ellen Kuzwayo

Part of My Soul Went With Him

by Winnie Mandela
W. W. Norton & Company, 1984, 150 pages
Jr. High: Advanced
Sr. High: Average - Advanced
Illustrations: Photos
Time Period: 1950-1980
Place: South Africa

Themes: Background of Afrikaner Nationalist laws and party's rise to power; Background of ANC; 1956 treason trials of Nelson Mandela, Oliver Tambo and others; Federation of South African Women and ANC Women's League; Sharpeville massacre; 1960 and 1964 treason trials; Soweto uprising in 1976; Black men and women in prison; Effect of banning; Black Consciousness Movement; United Democratic Front (UDF)

Description: Winnie Mandela has become one of South Africa's most visible foes of Apartheid. This autobiography comes from lengthy tape-recorded interviews conducted by Anne Benjamin. Winnie describes her childhood, school years, job as a social worker, meeting and marriage to Nelson, birth of their two daughters and her political involvement. What emerges is the strength of a woman who has had to live under a ban for the greater part of her adult life and has endured countless arrests and imprisonments and constant surveillance for the last twenty-two years. Winnie's willingness to put the needs of her people above her own and her unrelenting defiance of the authorities also help to describe her strength. An excerpt from this book appeared in a special issue of *Mother Jones* on South Africa, October, 1985. Both resources are top rated.

"The way I got the news of his arrest was terrible. I don't know how I reached home. I knew that this was the end of normal family life as was the case with millions of my people who have lived like that before - I was no exception. Part of my soul went with him at that time."

- Winnie Mandela

Suggested Uses: Use with the video *Nelson and Winnie Mandela*, California Newsreel, 1985. Winnie is the primary narrator and focus of this video which portrays the major events of her life and the police harassment of herself and her family. • A young adult biography on Mandela is also available as part of Viking, Penguin's Women of our Time series: *Winnie Mandela: The Soul of South Africa* (1986) by Milton Meltzer.

The Boy Child is Dying
by Judy Boppell Peace
Harper & Row, 1986, 88 pages
Jr. High: Average - Advanced
Sr. High: Average - Advanced
Illustrations: None
Time Period: 1985
Place: South Africa

Themes: Homelands policy; Work in the mines: Mistress-servant relationship; Bishop Desmond Tutu; Description of riots of 1985

Description: Short, emotional sketches by an American, Judy Peace, who lived for eight years in South Africa struggling against the daily frustrations and cruelty of "petty" Apartheid. Much of the story is about her maid, whom other whites accused Peace of encouraging to rise above her station. Students will also learn about the major events in South Africa during the last ten years.

Suggested Uses: Link with the interviews of domestics in the book, *A Talent for Tomorrow*, and the video, *Maids and Madams*. (Both reviewed in this bibliography).

"I have to protect myself. I can only stand so much pain. If I really showed who I am, most whites in this country would call me 'cheeky.'"
- Judy Peace's maid

The Flame Trees of Thika: Memoirs of an African Childhood
by Elspeth Huxley
Penguin Books, 1982, 281 pages
Jr. High: Advanced
Sr. High: Average - Advanced
Illustrations: None
Time Period: 1910-1929
Place: Kenya

Themes: Consolidation of British control of Kenya; Railroad building; Boer/British animosity; Effect of World War I on settlers; Masai - Kikuyu differences

Description: This entertaining narrative is similar to stories of Euro-Americans moving West and settling in strange lands inhabited by people whom they must take into account. Although Huxley clearly likes and befriends the "natives," the opinions in the book reflect those of Europeans who had no real understanding of the culture of those whose "virgin" lands they took.

Suggested Uses: • Students could look for attitudes of white settlers toward the ownership of the land, the desirability of British rule, evidences of the harsh life of both white and black women. • List these comments and attitudes. Compare them with attitudes toward Indians in the U. S. • What differences can students cite between the European and African view of the world?

West With the Night
by Beryl Markham
North Point Press, 1983, 294 pages
Sr. High: Advanced
Illustrations: None
Time Period: 1906-1936
Place: Kenya

Themes: European settlement of Kenya; Early aviation in East Africa; Influences of World War I and II on Kenya

Description: This is a true adventure story told with great beauty. The narrative describes Markham's childhood under the loose control of her father, a farmer and race horse trainer. Raised as a boy, Markham was allowed to play and hunt with the Nandi Murani warriors. As a woman she continued her unconventional ways. She has been a first rate trainer and breeder of race horses, the first female aviator in East Africa, and, in 1936, she was the first person to fly solo across the Atlantic from east to west. The book is also about an Africa that no longer exists. Although seen through the eyes of a white settler, Markham's perceptions and the elegance of her prose make this a highly recommended book.

Suggested Uses: The author writes only of her interactions with men, whether African or European. Students should be asked why. Also, how are the African women in the book described? The European women? How did their lives contrast with Markam's?

"I have lifted my plane from the Nairobi airport for a thousand flights and I have never felt her wheels glide from the earth into the air without knowing the uncertainty and the exhilaration of firstborn adventure."

- Beryl Markham

Women Leaders in African History

by David Sweetman
Heinemann Educational Books
(African Biographies Series), 1984,
97 pages
Jr. High: Easy - Advanced
Sr. High: Easy - Average
Illustrations: Photos
Time Period: 1490 B.C.-1921 A.D.
Place: Egypt, Sudan, Algeria, Nigeria, Ghana, Ethiopia, Angola, Zaire, Madagascar, Buganda, Zimbabwe

Themes: History of major events in twelve regions; Women as rulers, warriors and spiritual leaders

Description: We give this top rating not only because of its quality but because it reminds us that even the most warlike and male-oriented societies sometimes produced female leaders. These readable, short biographies show how these historical figures influenced the history of their people and important events in Africa. The women are: Hatshepsut (15th century B.C.); Candace of Meroe (1st century A.D.), The Kahina of the Mahgreb (ca. 575-702); Amina of Hausaland (15th or 16th century A.D.); Helena and Sabla Wangel of Ethiopia (16th century); Nzinga of Angola (ca. 1581-1663); Dona Beatrice of the Kongo (1682-1706); Mmanthatisi of the Sotho (1781-1835); Ranavolona I of Madagascar (1828-1861); Muganzirwazza of Buganda (1817-1882); Yaa Asantewa of Asante (1840-1921); Nehanda of Zimbabwe (ca.1863-1898).

Suggested Uses: Include at least two of these biographies in any course on the African Kingdoms.

"The heavy male bias of many historians has led to an even greater under-estimation of women and their role in our past than was true."
- David Sweetman

First Person Accounts

A Talent for Tomorrow: Life Stories of South African Servants
by Suzanne Gordon
Ohio University Press (for Ravan Press), 1985, 275 pages
Jr. High: Advanced
Sr. High: Average - Advanced
Illustrations: Photos; Maps
Time Period: 1902-1985
Place: South Africa

Themes: Life in rural South Africa; Nature of domestic work; Mistress-servant relationships; Lack of protection for domestics; Organization efforts; Attitudes toward servitude

Description: The author spent ten years collecting the experiences and views of these twenty-four domestics from diverse social backgrounds. The stories tell of survival and the limitations of work in this major industry for Black women in South Africa. Few have become servants as a first choice but see new opportunities as South Africa's servants begin to organize for a better deal. These first person accounts are short, but the language in some (the author sometimes quotes directly from the interview) might be difficult for the limited reader. The later interviews are from younger women with whom students might more easily relate.

Suggested Uses: For an equally powerful look at the ramifications of Black women as domestics, rent the award-winning video, *Maids and Madams*, Filmakers Library, Inc. 133 E. 58th Street, New York, NY. This video presents domestics discussing their chores, separation from their families, living conditions. Concerned groups, like Black Sash and South African Domestic Workers Association (SADWA) discuss how they are teaching women about their rights.

"You must be don't care. You must laugh. It is bad if you show your madam that you're very upset and say, 'Oh, where am I going?' You must say, 'Oh, I've been waiting for that. Good bye.'"
- **Violet Motlhasedi**

Cry Amandla! South African Women and the Question of Power
by June Goodwin
Africana Publishing Co., 1984, 200 pages
Jr. High: Advanced
Sr. High: Average - Advanced
Illustrations: Photos
Time Period: 1977-1980
Place: South Africa

Themes: Opinions about and impact of Apartheid on primarily Afrikaner and African women of diverse socio-economic backgrounds; History of contemporary issues and political parties, such as the Black Consciousness Movement, Black Sash organization, Kontak (Afrikaner women's association)

Description: Amandla is the word for power, and these insightful interviews are with both Afrikaner and African women, whom the author, an American journalist, calls the "power centers." As a white non-South African, Goodwin crosses the gulf between Blacks and whites, "listening to people who should have been talking to each other." Although the range of interviews among Black women extends from domestic workers to women scratching out a living in the "homelands," at the center of the book is the story of Thenjie Mtintso, a member of the Black Consciousness Movement, who is under banning orders and is restricted in her movements. Of interest also are the portraits of Afrikaner women who demonstrate their female obedience and loyalty to "die Volk" (their people). In appendices are National Party Pamphlets and Thenjie's banning orders. Top rating.

Suggested Uses: Use some of these interviews to enhance the curriculum on South Africa in *Women in Africa of the Sub-Saharan, vol. II.* (Reviewed in this bibliography).

"I wrote about the women. They were representative of more than themselves and close to the heart of the society."
- **June Goodwin**

South Africa: Coming of Age Under Apartheid
by Jason & Ettagole Laure
Farrar Straus Giroux, 1980,
175 pages
Jr. High: Average - Advanced
Sr. High: Easy - Advanced
Illustrations: Photos
Time Period: 1970-1980
Place: South Africa

Themes: 1976 student protests; Struggle at Crossroads; Border wars; Namibia

Description: This book was written for young people after the 1976 student protest against the enforced use of Afrikaans in the schools for Blacks. It consists of short interviews with eight teenagers of racially different backgrounds and diverse opinions. It offers an immediate way for some students to learn about the impact of Apartheid on people their age. Easy to read text which includes a brief chapter on the history of South Africa from the 17th century on.

Suggested Uses: Link this book with first person accounts of student revolts found in *We Make Freedom*. (Reviewed in this bibliography).

"For the majority of South Africans, the only issue is Apartheid."

- Jason & Ettagole Laure

We Make Freedom, Women in South Africa
by Beata Lipman
Pandora Press, 1984, 141 pages
Jr. High: Advanced
Sr. High: Average
Illustrations: None
Time Period: 1950-1970
Place: South Africa

Themes: Settlements in Crossroads and Nyanda Bush; Urban life; Anti-passbook demonstrations (1956-57); Student protest of 1976; Union organizing; Women as political leaders

Description: These are short first person accounts, some from important leaders such as Helen Suzman, Regina Ntongana, Leah Tutu and Nadine Gordimer. Most, however, are from "ordinary women" who are actively seeking to control their lives and to effect change in South Africa. The issues covered include women speaking on urban life, the destruction of squatters camps near Cape Town, the struggle to live in poor rural "homelands," a history of the women's anti-pass demonstrations and the student revolts of 1976. Also included are relatively new issues such as women in the trade unions and in politics, making this an unusually comprehensive collection. Very readable. Top rating.

Suggested Uses: • Create a small group project using the information from the section on the student revolts of 1976, pp. 93-103. The selected group reads and recounts these incidents to the class. A narrator might give the background and other students tell individual stories. Links to and the influence of the American Civil Rights movement could be noted. • Students might research the U.S. student movement during this period. Have them note the intergenerational conflict which is evident also in South Africa. Anne Moody's book, *Coming of Age in Mississippi*, about the U.S. Civil Rights Movement is pertinent to this theme.

"I used to sit and think, and worry, about what would happen to my children under Apartheid if I should die - that gave me the strength to fight."

- Annie Silinga
72 years old

Working Women, A Portrait of South African Black Women
by Lesley Lawson
Ohio University Press (Ravan Press), 1985, 142 pages
Jr. High: Easy - Advanced
Sr. High: Easy - Advanced

Illustrations: Photos; Charts
Time Period: 1980-1984
Place: South Africa

Themes: Work of women on farms, in the city, in industries, as maids, as entrepreneurs; Organization of women workers

Description: This exciting book depicts the struggles of women workers through interviews and photos at home and at work in the 1980s. Short background information on each general topic followed by short first person accounts. The images are of strong women challenging their government, their bosses and sometimes their own husbands. Top rating.

Suggested Uses: Students should be able to find comparisons with the condition of some women in the United States. They could look for articles and/or pictures of American women in similar working and family positions. Then they need to define areas where the situation of women in South Africa is different. How are American women trying to improve their way of life? What are women in South Africa doing?

"The women were taking the lead when we were on strike. They weren't scared even when the police were trying to thrash us and scare us with dogs. I think that's when the women realized that women can be determined"

- Mam'Lydia, branch secretary of Transportation and General Workers Union

Fiction

Cleopatra: Sister of the Moon
by Margaret Leighton
Farrar, Straus & Giroux, 1969,
211 pages
Jr. High: Average - Advanced
Sr. High: Easy - Average

Illustrations: None
Time Period: 66-30 B.C.
Place: Egypt

Themes: The last reign of Ptolemy Kings; Intellectual and physical life of Alexandria, including library and museum; Court intrigues; Cleopatra's rise to power; Cleopatra's and Egypt's alliances with Julius Caesar and Mark Antony; Cleopatra's travels down the Nile and to Petra, Greece, Rome; Famous Roman personalities; Background of Roman political life; Defeat of Antony at Actium

Description: Portrait of a perceptive, well educated queen who, assured of her own divinity and thus destiny as Queen of Egypt and perhaps Rome, lived in a world full of pomp and richness. A complex woman, her influence over the course of events, particularly as they relate to Rome, is abundantly clear in this informative biography. Out of print but found in many libraries. Top rating.

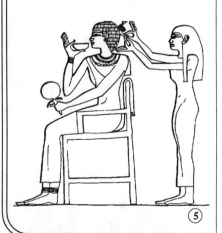

⑤

From a Crooked Rib
by Nuruddin Farah
Heinemann Educational Books,
1978, 182 pages
Sr. High: Advanced
Illustrations: None
Time Period: 1950-1960
Place: Somalia

Themes: Life of Somali nomads; Arranged marriages; Expectations of women and of men; Violence against women; Islamic Somali view of marriage; Underground activities against Italians in preparation for independence

Description: Ebla is a nomadic herdswoman who begins to question her life and women's fate when a marriage is arranged for her to a man old enough to be her grandfather. Equating freedom with escape, she runs off to town to live with distant relatives. But unsophisticated Elba finds that limitations on town women, while more subtle, are as harsh. This gripping tale of women's lot is for mature readers only.

"God created Woman from a crooked rib; and any one who trieth to straighten it, breaketh it."
- A Somali proverb

Mara, Daughter of the Nile
by Eloise McGraw
Viking Penguin Books, 1985,
280 pages
Jr. High: Average - Advanced
Illustrations: None
Time Period: 1485-1400 B.C.
Place: Egypt

Themes: Court intrigues in ancient Egypt; Description of Thebes, Abydos and tomb of Tutmose II; Power of noble families and priesthood; Count Senmut (Hatshepsut's

architect); Court lifestyles and spiritual beliefs; Life of slaves; Comparisons between a Syrian Princess and Egyptian women; Egypt's "empire" and army

Description: This is a tale of adventure, intrigue and romance. Mara, a slave, is clever and crafty and finds herself playing both sides as a spy for two masters - Queen Hatshepsut and Tutmose III - who are mortal enemies. Hatshepsut is portrayed by the author as a vain women who overtaxed her people and reduced the army simply to build extravagant palaces and personal memorials. Her attempts at peaceful solutions and her expansion of trade are not covered.

Suggested Uses: Students might compare this description of Queen Hatshepsut with the description of this queen found in Lesko's *The Remarkable Women of Egypt* or in the filmstrip, *Hatshepsut: The First Woman of History*. (Both reviewed in this bibliography).

Martha Quest
by Doris Lessing
The New American Library, 1970,
248 pages
Sr. High: Advanced
Illustrations: None
Time Period: 1930-1939
Place: Zimbabwe

Themes: Influence of the rise of Hitler in Germany on attitudes of white settlers; Tensions between Afrikaners and British; Diversity of peoples in Zimbabwe; Racial barriers

Description: In this book Lessing writes feelingly about all of the people of her native country, Blacks, Greeks, Jews, Afrikaners, British, and Coloured. This novel starts her series on Martha Quest, a

thoughtful girl who does not fit in her small provincial town. The novel details her abrasive relationship with her parents, the class and race structure of her society, and her attempts to combat the growing hostility toward a Jewish family.

Suggested Uses: Assign the first 80 pages only. This section describes Martha's teenage years during her transition from a rebellious adolescent into a woman who will go her own way. • There are many points of comparison between Rhodesia in the 1930s and the pre-Civil Rights American South. Students might list them and then describe the possible differences between the two societies.

"They were united for once, in genuine emotion, and began lecturing her on the consequences of her attitude. It ended with 'And they'll drive us into the sea, and the country will be ruined, what would these ignorant blacks do without us'. And the usual inconsequent conclusion: 'They have no sense of gratitude at all for what we do for them.'"
- **Martha Quest about her parents**

Muriel at Metropolitan
by Miriam Thali
Three Continents Press, 1979,
190 pages
Jr. High: Advanced
Sr. High: Average - Advanced
Illustrations: None
Time Period: 1970
Place: South Africa

Themes: Removal of blacks from Sophiatown and women's protest demonstrations; Black-white relationships in white collar jobs

Description: This first novel by Miriam Thali is a partly autobiographical account of her experiences working on the fringe of white society while employed as a clerk and the first black woman at the Metropolitan Radio shop. Much of her responsibility is to hound blacks who are behind on payment for their purchases. The discrimination she faces daily is carefully recorded as are broader events like the demonstrations of women over the removal of blacks from Sophiatown, a Johannesburg suburb. Out of print, but worth a check in the library.

"The crux of the matter was that the white workers did not want to acknowledge their commonness with their black colleagues... If they were treated the same, they grew resentful."
- **Miriam Thali**

No Sweetness Here: Short Stories
by Ama Ata Aidoo
Doubleday and Co, 1971,
165 pages
Sr. High: Average - Advanced
Illustrations: None
Time Period: 1960-1970
Place: Ghana

Themes: Urban dissipation and delusions; Subordinate status of women; New roles and choices for women; Life of the educated elite; Political corruption

Description: These easy to read, sometimes humorous short stories mainly show women torn between their traditional values and the new standards of the affluent westernized cities. Although women in many different walks of life are presented, the urban and professional women with whom students may more easily relate are the crux of Aidoo's pieces. Superb use of dialogue. Unfortunately out of print, but is in many libraries. Top rating.

Queen Nzinga, The Woman Who Saved Her Country
by David Sweetman
Longmans, 1971, 38 pages
Jr. High: Easy
Illustrations: Drawings
Time Period: 1582-1663
Place: Angola

Themes: Mbundu people in late 16th, early 17th century; Portuguese attempts to conquer hinterland; Dutch-Portuguese struggle; Mbundu resistance and five year march to safety into the hills in 1630

Description: This is a fictionalized account of a real Angolan heroine who was born in 1582 and lived

until her eighties. Because she clearly was superior to the male heirs, this daughter of a chief became leader of her people during their period of stiff resistance to Portuguese intrusion. Nzinga was also known for her military prowess, oratory skills and savvy at negotiating treaties. Although the book is easy to read, it is filled with important information told in a mature style. Top rating.

Something Out There
by Nadine Gordimer
The Viking Press, 1983, 204 pages
Sr. High: Advanced
Illustrations: None
Time Period: 1970
Place: South Africa

Themes: Underground resistance to Apartheid; Banning of political activists; Master-servant relationships; Class differences; British and Afrikaner differences; Black-white relationships

Description: This series of short stories illustrates black-white tensions and lifestyles in South Africa. Most focus on the dilemma of liberal whites. Gordimer is good at getting inside the skin of different types of people to allow the reader a beginning understanding of the toll that is extracted from living in this police state. The stories are not solely about women. Also available is Gordimer's short story collection, *Six Feet of the Country* (Penguin Books, 1983). It contains "A Chip of Ruby Glass," about family tension when an Indian woman dedicates her life to the struggle.

Suggested Uses: Gordimer's themes are for sophisticated readers. The following stories are particularly powerful; "A City of the Dead, A City of the Living," "Blinder,"

"Something Out There - a Love-letter." • Look for "A Chip of Ruby Glass" in other anthologies of African writers.

Song of Lawino/Song of Ocol
by Okot p'Bitek
Heinemann Educational Press, 1978, 96 pages
Jr. High: Advanced
Sr. High: Average - Advanced
Illustrations: Graphics
Time Period: 1960-1966
Place: Uganda

Themes: Effect of westernization and modernization on male/female relationships; Cross-cultural comparisons; Assertion of African nationalism

Description: This popular poem takes as its theme a common social problem in rural areas where wives see their husbands move beyond their range through education and travel. Lawino ends up defending the custom of her ancestors with profound comparison between Western and her tribal Acholi ways. Her rival is Clementine, who is modern, uses make-up, lightens her skin and tries to lose weight like a white woman. The poem is inspired by Acholi verse form which is a dramatic monologue in the form of a long lament.

Suggested Uses: A portion is also found in *Through African Eyes*. (Reviewed in this bibliography.) • Excerpts from the poem may be read aloud in class. • Students can make comparisons with their own strivings for beauty. What is the ideal for beauty in our culture? For women? For men? Are there any differences in the norms for looks and for accepted behavior between different cultures in America?

The Bride Price
by Buchi Emecheta
George Braziller, 1977, 168 pages
Jr. High: Advanced
Sr. High: Average - Advanced
Illustrations: None
Time Period: 1880-1983
Place: Nigeria

Themes: Founding of Ibo villages; Women's customary work; Colonial period (1880-1960); Culture clash; Impact of education and missionaries on women; Subordination of women; Intergenerational change; Women in a male-dominated environment

"Christianity brought Ma financial rewards. A number of smaller traders followed suit, and when the 'nobodies' saw that the rich were all going to this new place called church, many were converted to this fashionable religion."

- Buchi Emecheta, The Slave Girl

Description: Young Aku-nna falls in love with the son of a prosperous former slave. Village customs forbid them to marry and when they run off, her family refuses to accept her bride price. The feelings of this girl in her adolescent years should strike a chord with teenage readers. Emecheta's novels throw light on the changing expectations of women and the history of their contemporary position. Her often harsh themes are tempered by her sense of humor, and her books are rich in description. We also suggest; *The Slave Girl*, Braziller, 1977, about a girl sold into slavery by her own brother after European diseases take most of her family; *The Double Yoke*, Braziller, 1983, which explores the lives of female

university students and teachers in the context of ambivalent contemporary attitudes toward the "modern educated woman;" *The Moonlight Bride*, Oxford University Press, 1980, a young adult story about two young girls raised in a traditional village. All top rating.

Suggested Uses: Excerpts from Emecheta's work are used in the curriculum, *Two Voices from Nigeria* (Reviewed in this bibliography).

The Collector of Treasures and Other Botswana Village Tales

by Bessie Head
Heinemann Educational Books, 1977, 190 pages
Sr. High: Average - Advanced
Illustrations: None
Time Period: 1960-1976
Place: Botswana

Themes: Rural life; Roles of women; Migration of men to the cities; Imposition of "modern" ways

Description: Bessie Head is an exiled South African who lives in a village in Botswana and draws much of the inspiration for her stories from it. She says the stories about women in this collection come from the mouths of the villagers themselves. Most of these short stories focus on women and portray a wide variety of types. The unifying theme is women trying to adjust to a changing world.

"The ancestors made so many errors and one of the most bitter-making things was that they relegated to men a superior position in the tribe."

- Bessie Head

The Eighth Wife

by Miriam K. Were
East African Publishing House: Africa Writers Series, 1972, 167 pages
Jr. High: Advanced
Sr. High: Average - Advanced
Illustrations: Drawings
Time Period: 1850-1900
Place: Kenya

Themes: Traditional life in cattle owning village; Expectations of young men and women; Male circumcision rites; Importance of mother-son relationship; Match making and arranged marriage; Problems of polygamous households; Power of the chief

Description: This love story, so often told in contemporary African novels, depicts two young people caught between customary practices and the freedom to choose their own mates. Kalimonje is sought by the old village chief to become his eighth wife, but she loves his eldest son. In facing this dilemma she calls into question the expected roles of women. This novel is short, rich in details and not difficult to read. Another novel by Were, *Your Heart Is My Altar*, (East African Publishing Co., 1980) focuses on a young woman who comes of age at a time when Christianity and missionary schooling have introduced conflicts between the village Christian, Moslem and traditional clans. Were's novels are not published in the U.S., but are found in university libraries, select bookstores, and the *African Library Imprint Service*, Box 563, 75 King St., Falls, MA 02541. Worth the trouble because of the limited number of available books about East African women.

Suggested Uses: • Using the novel as a resource, students can list ways in which women received status and honor in this society. How did men receive status and power? • Assign the background reading on women in traditional Africa from the curriculum unit, *Sources of Strength: Women and Culture*. (Reviewed in the Cross-Cultural Section.) Use this book to analyze both male and female sources of status in the "Digging Activity."

"Kalimonje began to resent the kind of life a woman led. Look at her mother. She could hardly remember seeing her just sitting and taking it easy."

- Miriam Were
The Eighth Wife

①

Unwinding Threads: Writing by Women in Africa

by Charlotte Bruner, ed.
Heinemann Educational
Books, Ltd., 1983, 207 pages
Jr. High: Advanced
Sr. High: Average - Advanced
Illustrations: None
Time Period: 1891-1980
Place: Africa

Themes: Diverse portrayals of the female experience in Africa; Cross-cultural conflicts; National pride; Dissent against political and economic repression; Women's emergence from restrictive bonds of family

Description: This anthology of fiction by major writers from thirteen countries in Africa - all of whom enjoy international recognition - is the right choice for those who can purchase only one book of African literature. No single point of view characterizes the collection, and styles vary greatly, but the themes and literary value of these pieces offer a good way to introduce students to the world of women. Each excerpt or complete short story is short and readable. Works are grouped with major geographic divisions in chronological order with a map, brief introduction to the area and description of each writer. Some of these stories were sung and still exist in women's oral traditions. Top rating.

"May my story be beautiful and unwind like a long thread."
- Introduction to the Kabyle folksongs in Algeria

Curriculum

Hatshepsut: The First Woman of History (sound filmstrip)
Multi-Media Productions, 1975
Jr. High: Average - Advanced
Sr. High: Average - Advanced
Illustrations: 60 images
Time Period: 1480-1450 B.C.
Place: Egypt

Themes: Impact of the introduction of technology into a conservative society; Influence of the Hyksos; Early empire building; Tutmose II; Government organization; Pantheon of gods; Relationship between Pharaohs and gods; Senmut's contributions; Punt trading expedition; Reorganization of army; Restoration of the temples; Deir el Bahri; Golden obelisk; Opposition to female ruler; Tutmose II; Defacement of Hatshepsut's tomb and statues

Description: This is a filmstrip that presents Hatshepsut as a "revolutionary" who instigated new practices in conservative Egyptian society, such as the reorganization of the army. Above all, she was the first and only woman in history to become a "man" in order to rule. Script discusses anthropology, archeology, male/female roles and new scholarship in women's history in analyzing Hatshepsut's life. Good discussion questions in teachers guide. Top rating.

"Hatshepsut's 22 year career exhibits qualities generally considered masculine - courage, bold initiative -[yet her] feminine contributions of creativity in social relationships and appreciation of beauty persisted in the Egyptian psyche through the remainder of history."
- Hatshepsut filmstrip

Manomiya (simulation game)
Women, Education and Development Campaign, 1985
Jr. High: Advanced
Sr. High: Average - Advanced
Illustrations: Graphics; Line drawings
Time Period: 1980-1985
Place: Africa

Themes: The many roles women play in their communities; Invisibility of women in agriculture; Impact of development on women

Description: This simulation game is based on case-study material. The players are divided into male and female groups, each with their own crops; they draw cards which tell them what they can do over the span of four farming seasons. The board is beautifully colored and the cards contain illustrations with information, including figures, quotes and tables, on the back. 1 1/2 hours including 20 minute discussion time at the end. Not available from a U.S. distributor, but can be purchased from publishers, Returned Volunteer Action, 1 Amwell Street, London, EC1R 1UL, England.

Teaching Perspectives: Ideas from Nigeria, Plaiting and Weaving of Hair Among Yoruba Women
by Michael Adeyemi
African Studies Program, University of Indiana, 1984, 4 pages
Jr. High: Easy - Advanced
Sr. High: Easy
Illustrations: Drawings; Map
Time Period: 1984
Place: Nigeria

Themes: Body and hair decoration; Stereotyping of Nigerians by Americans and vice versa

Description: This short lesson emphasizes the importance Yoruba women attach to the head and to hair decorations. It provides fifteen drawings and the nomenclature for these hairstyles with information on the origins of the names. The sheet then delineates common American beliefs about Africa and stereotypical images Nigerians have about Americans. Also available from the *Indiana African Studies Outreach Program* are handouts on Senegalese dress and cuisine and three small units on Somalian cultures. All integrate information about women into the text and are easy to read. *Heinemann Educational Books* also has an attractive, illustrated book outlining the history and culture of African hairstyles, *African Hairstyles* by Esi Sagay.

Through African Eyes: Unit I, Coming of Age in Africa

by Leon E. Clark, editor
Frederick A Praeger, 1969,
116 pages
Jr. High: Average - Advanced
Sr. High: Easy
Illustrations: Photos
Time Period: 1900-1968
Place: Uganda

Themes: Division of labor based on sex; Socialization of Acholi boys and girls; How socialization perpetuates the values of a society; Values of traditional African women; Changes Westernization brought to Acholi and to Africa; Comparisons with U.S.

Description: This curriculum first uses readings and activities that help students analyse Acholi society to learn about male/female sex roles and responsibilities in traditional African society. The next reading, an excerpt from the popular poem, *Song of Lawino*, by Okot p'Bitek, describes the conflict surrounding changing values.

Suggested Uses: Students also enjoy reading the longer version of *Song of Lawino*. (Reviewed in this bibliography.)

Through Their Own Hard Work: Nigerian Women in Development

by Lyn Reese
Women in the World Curriculum Project, 1987, 50 pages
Jr. High: Easy - Advanced
Sr. High: Easy - Average
Illustrations: Drawings; Graphics; Charts
Time Period: 1980-1986
Place: Nigeria

Themes: Work of women in agriculture, small businesses and professions; Education of women; Status of women as mothers; Effect of colonial period on economic status of women; "Invisibility" of women in development programs; Differences and similarities between women's work in Nigeria and in the U.S.; Work in the informal and the formal economy

Description: Using Nigeria as a model, this unit illustrates the centrality of women's work in the economies of developing nations. The unit includes a Teachers' Guide, five Student Handbooks and a Slide Show. The Teachers' Guide contains background information, activities for each of the handbooks, a glossary and resource information. The Slide Show contains 40 slides to be used as an overview to the unit. The titles of the handbooks are; "The Farmer;" "The Small Entrepreneur;" "The Mother;" "The Struggle for Education;" "The Professional Woman." Each contains background information, first person accounts, questions and activities. The unit is easy to read yet offers important information on the problems and potentials of women from diverse socio-economic levels. Available from *Women in the World*, 1030 Spruce Streett, Berkeley, CA 94707.

"The basic things of life - water, fire, shelter, the care of the young and the sick, the growing of food - are almost entirely done by women. These are the basic necessities of life, and yet there is little or no compensation to the women who do them. Because they are unpaid, such tiring and boring chores are called 'women's jobs'. A girl who dares to grumble is reminded, 'But you are a women'..."
- Buchi Emecheta

Suggested Uses: After showing the slides, distribute the Student Handbook among different groups of students. Then use the "International Women's Forum" activity to help students consider the similarities and differences between the needs of women among different groups within Nigeria, and between the concerns of women in America and women in the developing world.

Two Voices from Nigeria: Nigeria Through the Literature of Chinua Achebe and Buchi Emecheta
by Lyn Reese & Rick Clarke
SPICE, 1985, 100 pages
Jr. High: Advanced
Sr. High: Average - Advanced
Illustrations: Drawings; Maps; Student charts
Time Period: 1890-1984
Place: Nigeria

Themes: Igbo history: Traditional economic life and culture; Men's roles and women's roles; Colonial period; Independence; Contemporary issues such as impact of the influence of the West, urbanization, modern education, migration

Description: This unit uses excerpts from novels to view Nigerian culture and history through the eyes of its people. It includes selections from a male and female writer to ensure representation of the experiences of both worlds. The discussion questions and activities also reflect this choice. Primarily the literature comes from the work of two of Nigeria's important novelists - Chinua Achebe and Buchi Emecheta. The readings are grouped around three historical periods (pre-colonial, colonial, and post independence) with an introduction and historical overview for each period. The unit begins with activity using proverbs to introduce students to this important element in African culture.

Suggested Uses: History teachers may wish to use only those readings which are appropriate for specific themes or periods they cover. For example, the readings on the colonial period can assess the perceptions of those being colonized. In literature classes the readings, activities and questions may be used to examine the themes and style of African writers.

Women in Africa of the Sub-Sahara, Vol. I: From Ancient Times to the 20th Century
by Susan Hall Gross & Marjorie Bingham
GEM Publications, 1982, 141 pages
Jr. High: Advanced
Sr. High: Easy - Advanced
Illustrations: Photos; Maps; Charts
Time Period: 3 Million B.C. - 1900 A.D.
Place: Africa

Themes: Ancient female leaders; Women's political, military, religious and economic roles; African family life; European conquest and settlement of Africa; Anti-colonial resistance struggles

Description: This useful unit extends from ancient to modern times. It is a basic primer for information about the diverse roles of women. Each chapter is divided into sub-topics. For example, family life looks at woman-marriage, the bond of support between sisters and brothers, the custom of polygamy and women's domestic use of their craft work. Much of the text is supported by first-person accounts. There is a useful glossary. A number of activities, usually group tasks, are suggested. An excellent sound filmstrip which enhances the textbook, *Women in Sub-Saharan Africa*, can also be purchased. 35 minutes.

Suggested Uses: There is a lot of information in these pages and you might want to focus on just one topic, using the information to lecture and assigning the activity. Example: The section on polygamy gives both arguments and explanations for and against the practice from the African point of view. Discuss these, then assign the short account of one Kenyan woman's marriage. Students note the advantages and difficulties in her situation and then select the most compelling arguments for and reasons against the practice.

Women of Africa of the Sub-Sahara, Vol. II: The 20th Century
by Susan Hall Gross &
Marjorie Wall Bingham
GEM Publications, 1982,
115 pages
Jr. High: Advanced
Sr. High: Easy - Advanced
Illustrations: Photos; Maps;
Charts
Time Period: 1900-1980
Place: Africa

Themes: Bantu and Afrikaner history; Women's anti-pass demonstrations; Impact of colonialism on women; "Women's war" in Nigeria; Resistance movements in Zambia, Kenya, Ethiopia and Guinea-Bissau; Urbanization; Education; Male leaders for women's rights; Projects aimed at women's concerns; Current status of African women

Description: The curriculum relies heavily on first person accounts. The first chapters are on women in South Africa, telling the story from the experiences of Afrikaner women in the Boer War to Black women's current struggle against Apartheid. The rest of the unit highlights women attempting to take control over their lives. Chapters are on women's organizations and support systems; the impact of colonialism on women; women's involvement in nationalist movements between 1900 and 1970; the

opportunities and problems of urbanization; education; men who have improved women's status; comparative statistics on women around the world. A teacher's guide accompanies the student book.

Suggested Uses: Biographies and autobiographies about some of the women mentioned in the book could be assigned. • Read aloud Helen Joseph's stirring account of the 1956 women's march to Pretoria, pp. 281-9. • Readings from the curriculum, *Two Voices from Nigeria*, could be linked with the activity on the colonial period. (Reviewed in this bibliography).

Women's Problems
by Kathy Bond-Stewart
Zimbabwe Publishing House,
1984, 42 pages
Jr. High: Average
Sr. High: Easy
Illustrations: Drawings; Charts
Time Period: 1984
Place: Zimbabwe

Themes: Male and female roles; Women's work; Cost of food; Education and the law; Relationships between men and women; The use of women's groups as a way to organize women

Description: This highly illustrated booklet was produced to be used in consciousness raising sessions to help women in Zimbabwe identify and find solutions to the diverse problems they face. It can, however, be used in American classrooms as a way to learn about the roles and needs of African women. In each chapter (about 2 pages long), there is a story (problem) to act out, a picture of the story and

discussion questions which include a question on how women can solve the problem. Notes in the back give some solutions to these problems. Easy to read and understand. Top rated. Available from *The African Library Imprint Service*, Box 563, 75 King St., Falmouth, MA 02541. This service distributes a number of hard-to-get African publications. Other titles from Zimbabwe include: *Young Women in the Liberation Struggle: Stories and Poems*, and *A Good Marriage and Other Stories by Zimbabwean Women*.

Suggested Uses: Students may act out some of the problems presented. One, "The future," is already scripted. • As they learn about women's problems in Zimbabwe, students could decide if women in the U.S. face similar problems. • Chapter 14 provides a comparison chart between the customary and civil marriages laws in Zimbabwe and between marriage laws in Portugal and China.

ASIA
INTRODUCTION

In traditional Chinese upper class homes a silk screen was placed at the entrance of the women's quarters to protect them from evil spirits and from the prying eyes of the public. Now there is a proliferation of material about women, not only in China but in many regions of Asia, providing opportunities for non-Asians to examine the lives of women, which have figuratively remained hidden behind the "silk spirit screen."

This material reveals that the image of Asian women as delicate, dependent, and submissive found in traditional paintings, writings, and moral lessons is an idealized vision of women and reflects only the lives of upper class women. This image quickly fades when one is presented with stories about the lives of Asian working class and peasant women. Here individuals emerge who are hardworking, important contributors to the well being of their families and who, within the strictures around them, sometimes are outspoken.

The centuries long subordination of women to men, ingrained through the precepts of the major religions and philosophies of the region, is vividly discussed in many resources. A close look, nonetheless, reveals great diversity in the expectations and roles of women in different cultures and historical periods. Women's experiences at any point in time should be juxtaposed with the choices open to them in order to appreciate the strength of those women who defied tradition and the cleverness of those who successfully maneuvered within their limited sphere.

We found a difference between countries in the types and amount of available resources. Much of the material on women in India is contained in curriculum packets and media presentations; Chinese women's twentieth century experiences, both pre- and post-revolution, are explored at length in stories and first person accounts; fiction is a prime source of information about women in Japan; the experiences of women from Southeast Asia, Korea, and the South Pacific are contained in many of the general background materials and in works found in the cross-cultural chapter. Resources that tell the historical story of Asian women are few and far between. But they do exist and can be found by a quick check of the *Time Period* category in each annotation.

Background/Reference

Beyond Stereotypes: Asian Women in Development
by Joel Rocamora and
Martha Winnacker, eds.
Southeast Asian Chronicle, no. 96,
1985, 32 pages
Sr. High: Advanced
Illustrations: Photos
Time Period: 1984-1985
Place: Asia, Philippines, Thailand, South Korea, Vietnam

Themes: Women's contributions to the economy of developing countries; International division of labor; Exploitation of women's sexuality; Impact of rapid urban development and cultural imperialism; Health and childcare issues; Immigration to Europe as brides or prostitutes; Organizations to protect women

Description: This special issue illuminates the global networks which exploit mainly poor urban women. Short and readable, the selections are primarily written by women from the countries represented and provide excellent materials for an understanding of the problems of Asian women in a global context. Availiable from: Southeast Asian Chronicle, P.O. Box 4000-D, Berkeley, CA 94704.

Suggested Uses: Assign articles as separate classroom readings.

"Asian women have demonstrated a stubborn resourcefulness in meeting family needs while maintaining their self-respect."

- Rocamora & Winnacker

China Shakes the World
by Jack Belden
Monthly Review Press, 1970,
330 pages
Jr. High: Advanced
Sr. High: Average - Advanced
Illustrations: None
Time Period: 1946-1949
Place: China

Themes: Chinese Civil War; Arranged Marriage; Mobilization of women and change in their status

Description: A journalist's first-hand account of the Civil War from 1946 to 1949. The detailed chapters on women and revolution are excellent. We recommend "Gold Flower's Story" (pp.275-307) which describes her early years, her romantic love, her arranged marriage to an old man and her attempt at suicide. It can set the stage dramatically for a discussion on women's status in traditional China. Available as a reprint: *The Revolt of Women: Gold Flower's Story: A Peasant Woman in the Chinese Revolution*, New England Free Press, Somerville, MA, 44 pp. with illustrations.

⑱

Suggested Uses: Teacher or students read some selections aloud in class • The reprint of *Gold Flower's Story* is inexpensive. Purchase class set to involve students emotionally in an analysis of the position of women in traditional and changing China.

⑥

Chinese Women: Past & Present
by Esther S. Less Yao
Ide House, 1983, 240 pages
Sr. High: Average - Advanced
Illustrations: Maps; Drawings; Photos; Paintings
Time Period: 1755 B.C.-1982 A.D.
Place: China, Taiwan

Themes: Description of position of women and changes in their status in antiquity (before 208 B.C.), ancient period (209 B.C.-960 A.D.), middle period (960-1642), modern period (1643-1949); Contemporary mainland China; Women in Taiwan

Description: The author, using Chinese sources, has divided Chinese women's history into five historical eras. Each chapter contains information on the period, the treatment and status of women, and stories of renowned women. It is an important source for a documentation of

changes over times with the "peak of women's suffering" occurring in the Ching period. Unique is a chapter on women in Taiwan, the author's place of birth.

Suggested Uses: Assign Chapters Two to Five (to the Manchu conquest) for research projects on the development of such customs as footbinding, female infanticide, prohibition of widow remarriage, proper etiquette for women, ideals of female beauty, female chastity, concubines and prostitutes.

"Many stories of jealous women are recorded throughout Chinese history....women found that expressing their jealousy helped them to maintain some degree of emotional balance and to cope with the suppression under which they lived."

- Esther Yao

Family Web: A Story of India
by Sarah Hobson
Academy Chicago, 1982,
284 pages
Sr. High: Average - Advanced
Illustrations: None
Time Period: 1970-1980
Place: India

Themes: Work of women in poor, joint family; Pregnancies and childbirth; Structure of joint family and relations of members

Description: This is a sociological study of a joint family, father and his wife, and their four sons and their wives and children. The mother-in-law here rules over her daughters-in-law but the women are also supervised in their work by the men. The following chapters hold

the best information about the lives of women: Chapter 4, "The Women" (the relationship of the wives to each other and to their mother-in-law); Chapter 6, "Daily Tasks" (the work of women in the house); Chapter 7, "Village Tactics" (women's work outside the house); Chapter 8, "The Virtuous Wife" (arranged marriages, importance of childbearing and training in obedience and duty); Chapter 11, "Birth" (details on birthing practices).

"The daughters-in-law of the house had no choice in their lives, and no right to make decisions, whether in household matters or something more personal."

- Sarah Hobson

Flowers in Salt: The Beginnings of Feminist Consciousness in Modern Japan
by Sharon L. Sievers
Stanford University Press, 1983,
195 pages
Sr. High: Advanced
Illustrations: Photos
Time Period: 1860-1945
Place: Japan

Themes: Women's rights in the Meiji period; Women textile workers in the silk and cotton mills, 1880; Women Socialists, including Kanno Suga; Japanese Bluestockings

Description: This study is scholarly and demanding. Teachers may use it as background reading to prepare a unit on early feminist consciousness of Japan or to use a chapter in class - in particular, Chapter Four, on the young women who went into the early silk and cotton textile mills. The experiences of these girls, some as young as ten years, should hold students' interest.

Suggested Uses: • Link the use of women in the textile mills in the early industrial period with experiences of the Lowell girls in the American textile mills of the 1830s. Assign Lucy Larcom's book, *Lowell Girls,* for comparison and contrast. • Link this chapter also with unit "Women in Industrialization in Japan" in curriculum, *In Search of Our Past,* (reviewed in this bibliography).

"Silk was one of the nation's few exportable commodities in 1868, accounting for nearly two-thirds of all export volume in that year; by the end of the Meiji period (1912), Japanese women had made their country the world's leading exporter of silk."

- Sharon L. Sievers

Focus on Asian Studies: Women in Asia, (Vol. III, no. 3), Spring, 1984
by Susan Rhodes, ed.
The Asia Society, 1984, 63 pages
Sr. High: Average - Advanced
Illustrations: Photos
Time Period: 1980-1984
Place: China, Pakistan, India

Themes: One-child family campaign (China); Female seclusion (Pakistan); Expectation of marriage partner (Indian); Life of a female filmmaker (India)

➡

Description: This special issue contains articles students can easily read and one activity using marriage ads from Indian newspapers. A short introduction to teachers on how to teach about women in South Asia and a listing of many resources make this a worthwhile purchase.

Hiroshima Maidens
by Rodney Barker
Penguin Books, 1985, 231 pages
Jr. High: Advanced
Sr. High: Average - Advanced
Illustrations: Photos
Time Period: 1945-1984
Place: Japan

Themes: History of Hiroshima; Individual experiences of the atomic blast; After-effects of blast; The survivors as outcasts; Efforts to make Hiroshima a peace center; Struggle of Americans to bring young Japanese women to U.S. for treatment; Cross-cultural experiences in the U.S.

Description: Twenty-five young female victims of the atomic blast were brought to America in 1955 to receive reconstructive surgery. This is a chronicle of their experiences during and after the bomb, when they were treated as outcasts, and of their reconstruction, physical as well as psychological, in the U.S. It is also a detailed account of a remarkable American humanitarian effort. The author had a special interest in this story because two of the "maidens" lived with his family during their American sojourn. Reads like a story. Top rating.

Suggested Uses: The poignancy of the experience of women who were teenagers when the bomb was dropped should touch students. Excellent opportunities for classroom discussion on the moral questions surrounding the use of the bomb and the harm of rigid aesthetic standards that make outcasts of people who are physically different.

"When she walked down the street, children call her 'Pikadon,' slang for atomic bomb, and when she entered a store adults would make excessive room for her, as though she had something that was somehow contagious."

- Shigeko Nimoto

Holding Up the Sky: Young People in China
by Margaret Rau
E.P. Dutton, 1983, 129 pages
Jr. High: Average - Advanced
Sr. High: Average
Illustrations: Photos
Time Period: 206-1982
Place: China

⑥

Themes: Treatment of women in old China; Sun Yat-sen and the Duomin Dang; Northern campaign of the united Revolutionary Army; Mao Zedong and the Long March; Impact of Cultural Revolution on youth; "Four Modernizations" and "Family Responsibility;" Importance of university examinations; Contemporary weddings; National Federation of women; The work of neighborhood committees; Communes; Minorities - Uygurs, Mongolians and Tibetans

Description: These portraits of today's post-Cultural Revolution generation include many women. A chapter devoted to women, "Women Hold Up Half the Sky," delineates differences between women's status in old China and today. Careful attention to the historical background of places and events plus descriptions of the lives of some of China's minority peoples make this a good way to learn about history through the eyes of contemporary young people. Top rating.

Suggested Uses: • Students will need to locate places mentioned on a map. • Assign students to read different chapters and list things that are different from American life and things that are similar. Lists can be shared with class.

"Dochen's... commune has promised that mechanization will come in the form of a bright red harvester that will do some of the work of reaping. And Dochen has been told she will be taught how to drive that harvester and how to service it and, if necessary, make repairs on it."

- Report from Tibet

Lives of Working Women in India
International Resource Exchange, 1980, 21 pages
Sr. High: Average - Advanced
Illustrations: Photos
Time Period: 1979-1980
Place: India

Themes: Work of "unclean" women; Women in coal mines; "Hamal" women

Description: "This collection of five articles is from India's women's journal, *Manushi*. They provide intimate insights into the daily work lives of the 'unclean' who clean the city streets, the women who do the unskilled and semi-skilled labor in India's coal mines, and the Hamal women who transport various kinds of goods on their heads or by hand-carts to and from railway stations." (Reviewed by Fenton and Heffron, *Third World Resources*.)
Manushi is the leading feminist journal in India and is used throughout the country in literacy programs for women. It also has a large readership outside the country. U.S. distributors: % Esther Jantze, 5008 Erringer Place, Philadephia, PA 19144.

Suggested Uses: Subscribe to *Manushi* as a source of interviews, essays, short stories, news reports, photographs, advertisements, audio-visual reviews, and so forth.

Marriage East and West
by David & Vera Mace
Dolphin Books, Doubleday & Co., 1959, 357 pages
Jr. High: Advanced
Sr. High: Average - Advanced
Illustrations: None
Time Period: 1950-1959
Place: China, Korea, India, Japan, United States

Themes: The patriarchal system; Women's status according to Confucius, Buddha, laws of Manu; Women's changing status in the East; Comparisons with position of women in western world; Sexual mores; Marriage in China

Description: This is the clearest description of the patriarchal system we've encountered. It would be a useful beginning for any examination of the role and status of women. Full of facts and analysis with the greatest emphasis on China and India. Good comparisons with the traditional and the changing family models in the West. Remind students of the date of the book, particularly in regards to statements about polygamy and descriptions of marriage in the P.R.C. Not in print, but can be found in most libraries. Top rating.

Suggested Uses: For a classroom assignment select Chapter One, "The Reign of the Patriarch."

• Chapter Six, "Who Picks Your Partner?" illustrates attitudes toward arranged marriage of young Indian women in the l950s. Ask students to research attitudes in India today. Or, students might react to Kusina's statement: "Western type marriage is a sort of a competition in which the girls are fighting each other for the boys... (A girl) can't relax and be herself. She has to make a good impression to get a boy."

"The patriarchal family was rooted in land tenure....So long as the family kept its land, the future was assured....Uprooted from the land, the patriarchal family loses its stability."

- David & Vera Mace

The Death of Woman Wang
by Jonathan Spence
Penguin Books, 1979, 139 pages
Sr. High: Advanced
Illustrations: Maps; Diagrams
Time Period: 1644-1672
Place: China

Themes: System of tax collections; Peasant life; Effects of earthquake, drought, and pestilence; Banditry; Manchu armies, collapse of Ming dynasty and accession of Ch'iang; Corvee labor and military duty; Power of central government and landlord families; Confucian beliefs; Crops and farming methods; Expectations of women; White Lotus rebels

Description: Relying on rural and local accounts, fiction and personal memoirs of officials, Spense has created this excellent historical reconstruction of 17th century peasant life. The title refers to one of his

stories about a woman named Wang who was "unwilling any longer to face an unacceptable present and chose to run away from her husband," later to be killed by him. But this story is only a minor part of the book and students will learn more about these turbulent times and the unmitigating pressures on peasants. Good information about the low status of women, notably women who were widowed.

Suggested Uses: Chapters Three, "The Widow" and Five, "The Woman Who Ran Away," contain the most information on women.

The Heart of the Dragon
by Alasdair Clayre
Houghton Mifflin Company, 1985, 41 pages
Sr. High: Average - Advanced
Illustrations: Photos; Paintings; Drawings
Time Period: 479 B.C.-1984 A.D.
Place: China

Themes: Origins of misogamy; Image of powerful women in stories and legends; Confucian ideals; Status of women within the traditional family and changing attitudes; Work of poor women; Sexuality in old China and post-liberation; Customs such as concubinage, footbinding; Description of village wedding; The new "Responsibility System;" Childcare; Education; Neighborhood mediation

Description: Two chapters explore the history and contemporary situation of women - "Marrying: Wives and Concubines," and "Mediating: Caring and Control." This richly illustrated resource was produced to accompany the video series of the same name. In the video the most informative segment on women is "The Wedding," which offers comparisons between the status of women and wedding rites in old China and the "new" society.

"Her daughter will live only three miles away, but will be part of another village, another family and will owe allegiance to them."

- "The Wedding", The Heart of the Dragon T.V. series.

The People of New China
by Margaret Rau
Julian Messner, 1978, 126 pages
Jr. High: Easy - Advanced
Sr. High: Easy
Illustrations: Photos
Time Period: 1254-1977
Place: China

Themes: Taiping Rebellion; Manchu dynasty; Sun Yat-sen; Mao Tsetung; Civil war; Japanese invasion; Work in a rice growing village; Village brigade; Description of commune; Acupuncture; Health care; River boat families; Street life in cities; Neighborhood committee; Kiangmen (a river port); Kuangchow; Shanghai; Wusih on the Grand Canal; Tsinan; Beijin; Construction of Forbidden City; Imperial Court Life; The Great Wall.

Description: Each chapter of this informative book focuses on the daily life and work of a teenager and their families from different regions. Most of the protagonists are young women. Historical background is integrated well with descriptions of Chinese life. Changes in lifestyles since the establishment of the PRC are stressed.

Suggested Uses: Each student reads a different chapter. Then lists things that are different from American life and things that are similar. Shares list with class.

④

The Women of Suye Mura
by Ella Wiswell & Robert Smith
University of Chicago Press, 1985, 193 pages
Sr. High: Advanced
Illustrations: Photos
Time Period: 1935-1936
Place: Japan

Themes: Traditional rural family life; Hard work of farming; Women's concerns with marriage, divorce, adoption, childbirth, and health; Power of women in pre-war Japan

Description: This book comes from Ella Lury's daily journal, kept during a one year stay, 1935-36, with her husband in the village of Suye Mura. It is a refreshing look at women in the traditional Japanese family structure, women whose work is burdensome and harsh; they are sustained by a "women's world" of mutual support and shared experience. It is a detailed book, filled with quotes and images revealing women making life work for themselves. A fine book and top rated.

"(Women) are not the drones, depersonalized by their lives, whom we are all too often led to believe they must have been. If they were victimized, they were not merely victims."
- Ella Wiswell

The World of the Shining Prince: Court Life in Ancient Japan
by Ivan Morris
Penguin Books, 1979, 298 pages
Sr. High: Advanced
Illustrations: None
Time Period: 950-1050
Place: Japan

Themes: Political, social and religious life of Heian period; Court life and the cult of beauty; Position of upper class women and their relations with men; Life of Lady Murasaki

Description: A reconstruction of aristocratic life during the flowering of the Heian period. Rich details on all aspects of women's life and on Lady Murasaki, author of *Tale of the Genji* (The Shining Prince). Author leans heavily on this novel as well as other women's fiction and diaries, such as Sei Shonagon's *Pillow Book*.

Suggested Uses: To shorten this somewhat scholarly work, refer students to chapters 8, "The Women of Heian and their Relations with Men," and 9, "Murasaki Skikibu."

"'Pretty yet shy, shrinking from sight, unsociable, fond of old tales, conceited, so wrapped up in poetry that other people hardly exist, spitefully looking down on the whole world - such is the unpleasant opinion that people have of me.'"

- Murasaki Shikibu

Women and Revolution in Vietnam
by Arlene Eisen
Zed Books, 1984, 286 pages
Jr. High: Advanced
Sr. High: Average - Advanced
Illustrations: Photos; Maps

Time Period: 200 B.C.-287 A.D.
Place: Vietnam

Themes: Women under feudalism and Confucianism; French and American occupation; Pol Pot and Kampuchea; Reunification; Vietnamese socialism; The Viet Nam Women's Union; Women's work inside and outside the home; Health; New family roles; Women's leadership; History of women's resistance.

Description: An examination of women's oppression from feudal times to the time of the U.S. involvement in Viet Nam. Drawing on interviews and reports, Eisen describes what has happened to women under "collective mastery," the Vietnamese style of socialism. Text is sprinkled with first-person accounts. The vocabulary and style make the book readable. It contains some graphic descriptions.

Suggested Uses: Perfect for the student who is curious about Viet Nam and as a general reference. For classroom use, have the students read Chapter Sixteen, "Riding the Tempest," for an overview of the history of women's resistance to patriarchy and foreign domination.

"The Vietnamese have a saying, 'Women are the greatest victims of the war, but they are also its greatest heroes.'"

- Arlene Eisen

Women in China
by Katie Curtin
Pathfinder Press, 1975, 89 pages
Jr. High: Advanced
Sr. High: Average - Advanced
Illustrations: None
Time Period: 1644-1973
Place: China

Themes: Confucian code; Prerevolution status of women; Impact of industrialization and western democracy; Taiping rebellion; Early 20th century women's movements; Changing civil laws; 1927 purge against women's associations; Guomindang and Communist Party; Long March; Post-revolution policies toward women

Description: The central question of this book is the degree to which Chinese women have been freed from their traditional inferior status. It is an excellent source book for students researching topics about women in China from the end of the Manchu dynasty to the mid-seventies. The clear and thorough text also provides teachers with good lecture material. Although she praises many accomplishments of China's revolution, the author is concerned with the rationalizations that continue to restrict women's advancement.

"Women of China"
Guoji Shucian (China Publication Center)
Jr. High: Average - Advanced
Sr. High: Average
Illustrations: Pictures; Drawings
Time Period: 1986
Place: China

Themes: Contemporary life of Chinese women

Description: This magazine is full of attractive colored photos and easy to read articles of varied topics: women in history, child care, friendship with women from other countries, etc. The intent is to present a positive image. Good for a sense of topics of current interest. Available at: *East Wind Books*, 1986 Shattuck Avenue, Berkeley, CA 94720.

Anthology

In Search of Answers: Indian Women's Voices from Manushi

by Madhu Kishwar &
Ruth Vanita, eds.
Zed Press, 1984, 312 pages
Sr. High: Average - Advanced
Illustrations: Photographs;
Tables; Drawings; Map
Time Period: 1977-1982
Place: India

Themes: Struggles of ordinary women; Women's struggles to organize; Violence against women; Women's politics; Day to day operations of the feminist magazine, Manushi

Description: This anthology of articles, editorials and letters to the editor comes from the first five years of the influential Indian women's journal, *Manushi*. Acknowledging the vast differences which "distinguish the life of women in different parts of the country," the editors manage to offer a fascinating look at current issues in India. See information about *Manushi* under our review of *Lives of Working Women in India*.

"If our aim is to bring about structural changes, our slogan should be not just 'More rights for women' but 'We will leave no basis for power which oppresses women'"

- Madku Kishwar

Sourcebook on Philippine Women in Struggle

by Sergy Floro & Nana Luz
Philippine Resource Center, 1985,
172 pages
Sr. High: Average - Advanced
Illustrations: Logos; Drawings
Time Period: 1723-1985
Place: Philippines

Themes: Basic conditions of Filipino women; Women and militarization; Women workers in multinational industries; "Hospitality" girls; Women political prisoners; Women political leaders; The women's movement and the creation of GABRIELA (a broad coalition of women's groups)

Description: A collection of articles, poems, and first person accounts. Books which feature the voices and concerns of Filipinas are hard to find, so this is a rare resource. These are the women who helped overthrow the Marcos regime. Those imprisoned have how been freed by President Corazon Aquino.

Suggested Uses: Student readings can be taken from Part III: "Testimonies of Philippine Women," and Part IV: "Portraits of Women Leaders in the Philippine Struggle." See especially the account of Nelia Sancho-Liao, a former beauty queen who became a woman activist.

Autobiography/Biography

A Daughter of Han: The Autobiography of a Chinese Working Woman
by Ida Pruitt
Stanford University Press, 1976, 249 pages
Sr. High: Advanced
Illustrations: Map; Photos
Time Period: 1860-1938
Place: China

Themes: The Boxer Rebellion and end of the Ching dynasty; Description of a poor household; Patriarchal family hierarchy; Customs such as footbinding, opium abuse, female suicide, female seclusion; Fear of foreigners; Lives of beggars, peddlers and servants; Status of widows; Japanese occupation of Peking

Description: This extraordinary document of a poor woman raised in the old traditions is full of fascinating facts detailing a variety of Chinese lifestyles and attitudes. Ning Lao Tai-tai's husband "ate" opium and forced her to "go out" to become at different times a servant, a peddler, and even a beggar to support herself and her children. More mobile than protected women, her life affords us rare views of the hard work, responsibility and oppression that were the lot of common women. Ning Lao also repeatedly asserts herself against authority, defining her life as an important link in the Chinese hierarchy. Her story is told to Ida Pruitt. The average student could handle excerpts from the book. Top rating.

> *"I have seen the sea floating with dead bodies like gold fish in a pond when bread is thrown to them. I have seen the great of this world and have eaten the food that was prepared for them. I have suffered hunger and have suffered the sight of my children sold. All have I had in a superlative degree."*
>
> **- Ning Lao Tai-tai**

A Friend of China
by Joyce Milton
Hastings House, 1980, 120 pages
Jr. High: Average - Advanced
Sr. High: Average
Illustrations: Photos
Time Period: 1911-1949
Place: China

Themes: Poverty in Northern cities in the 1920s; Sun Yat-sen and the Guomindang Party; Women silk workers of Canton; Communist work with peasants; Massacre of April 12, 1927; Feudal landlord system; Mao Tse-tung and the Red Army in Yenan; Japanese invasion and guerilla fighting; F.B.I. and UnAmerican Activities Committee

Description: Agnes Smedley became a living legend in China for her heroism and compassion toward the revolution in the years 1928-1941. Starting her journalistic career in Shanghai as a reporter for a German magazine, Smedley soon became, with Edgar Snow, one of the first journalists to recognize the importance of the revolutionary Red Army. She suffered and worked with the revolutionaries during their crucial mobilization years and produced invaluable reports, some of which are excerpted in this book. Her perspective on well known people, events, and particularly on women make this book an invaluable source of information. Top rating.

Suggested Uses: Students who become interested in Smedley's life will like her semi-autobiographical novel, *Daughter of Earth.* • Students might research Smedley's clash with the House UnAmerican Activities Committee after her return to America.

> *"They were all poor peasants between the ages of fifteen and fifty. They reminded me of descriptions in books about the Peasants' War in Germany. Their eyes were inflamed, many had no shoes at all, and their feet were scarred and bloody and had callouses an inch thick. On the day following the uprising I was filled with a sense of history in the making."*
>
> **- Agnes Smedley on the Red Army**

An Indian Dynasty
by Tariq Ali
G.P.Putnam's Sons, 1985,
318 pages
Sr. High: Advanced
Illustrations: Photos
Time Period: 1947-1984
Place: India

Themes: Politics and government under Indira Gandhi

Description: The rule of the Nehru family is described - Jawaharlal Nehru, Indira Gandhi, Sanjay and Rajiv Gandhi. The book covers the family history from independence in 1947 to 1984. It is critical of Mrs. Gandhi's political leadership and of her determination to see her sons inherit that leadership.

Suggested Uses: The fullest treatment of Indira Gandhi may be found in the following Chapters: "Mother India" and "The Brothers Gandhi."

"This attempt to project Sanjay Gandhi as her successor created a generalized feeling of disgust in a country with a real democratic tradition, however weak and frayed at the edges it might have become."

- Tariq Ali

Autobiography of a Chinese Girl
by Ping-Ying Hsieh
Pandora Press, 1986, 216 pages
Jr. High: Advanced
Sr. High: Average - Advanced
Illustrations: Photo
Time Period: 1903-1928
Place: China

Themes: Descriptions of practices such as footbinding, seclusion of women, restricted education for women; Impact of missionary education and ideas of women's emancipation; May Fourth Movement; Sun Yat-sen and the Guomindang Party; Chiang Kai-shek and the Wuchang Military School; 1927 conservative reaction and retribution

Description: First published in 1936, this autobiography of a well known literary figure recalls the details of her childhood, school days, life in the revolutionary army, and political persecution. This is an excellent source for the May Fourth period when new cultural movements debated the woman question and discredited the old Confucian ideology. The heart of the narrative, however, is the clash between Hsieh Ping-Ying, a born rebel, and her mother. Students will enjoy reading of her sojourn in the Army against her mother's wishes and her repeated attempts to escape from an impending arranged marriage. Top rating.

"I believe that all the girl students who wanted to join the Army had as their motive, in nine cases out of ten, to get away from their families, by whom they were suppressed."

- Ping-Ying Hsieh

Eighth Moon
by Bette Bao Lord
Avon Books, 1983, 222 pages
Jr. High: Average - Advanced
Sr. High: Average - Advanced
Illustrations: None
Time Period: 1949-1962
Place: China

Themes: Effect of political indoctrination in school and forced student labor in farms and towns; Campaigns to encourage greater output; Effect of self-criticism sessions; Failure of the Great Leap Forward

Description: The story of Bette Bao Lord's younger sister, Sansan, who was left behind in the care of foster parents when her family fled China during the Civil War. Schooled during the 50s and early 60s, she recounts a dismal tale of being forced on labor-service assignments and of learning not to speak her convictions. Shows mistakes of early years of Communist government.

"On these assignments to the farms, I always suffered, either from hunger or from thirst or from exhaustion...Despite these hardships, I had to be enthusiastic and alert...because at the end of each day's work there was a student meeting."

- Sansan

In the Shade of Spring Leaves: The Life and Writings of Higuchi Ichiyo, a Woman of Letters in Meiji Japan
by Robert Lyons Danby
Yale University Press, 1981,
355 pages
Sr. High: Average - Advanced
Illustrations: Photos
Time Period: 1872-1896
Place: Japan

Themes: A female writer trying to make a living in the literary world; The "houses of pleasure" in Meiji Japan; The declining fortunes of a peasant family with aspirations to be middle class; Literary movements in Meiji Period (1868-1912).

Description: The book is a biography of the Japanese Meiji Period writer, Higuchi Ichiyo. It includes a selection of her short stories which examine the lives of the inhabitants of Tokyo's brothel district, "the pleasure quarter." Higuchi's depictions of the demimonde made her a success as a writer, although she died of consumption at age 24, impoverished despite all her struggle to bring respectability to herself and her family.

Suggested Uses: Most of Higuchi's short stories can be read not only for their insights into Meiji Japan but also for their relevance to contemporary social conditions in America. Students might compare and contrast the social and economic conditions depicted in her tales of the people of the demimonde with life in similar sections of today's major cities.

⑥

**Madame Sun Yat-sen
(Soong Ching-ling)**
by Jung Chang with Jon Halliday
Penguin Books, 1986, 139 pages
Jr. High: Average - Advanced
Sr. High: Average - Advanced
Illustrations: None
Time Period: 1893-1981
Place: China

Themes: Influence of Soong family on China's history; Teaching of Sun Yat-sen and background of 1911 Revolution; The Sun marriage - years of power and years of exile; Ching-ling's opposition to her sisters and Chiang Kai-shek; War against Japan and Civil War; Formation of the People's Republic of China (1949-66); The Cultural Revolution

Description: Soong Ching-ling was one of China's most prominent female leaders, a woman who was a living symbol of the continuity of the ideals of the Revolution of 1911 until her death in 1981. An early champion of women's rights, she also helped alter traditional female roles. This description of Soong Ching-ling's role in the major events of China in the 20th century makes this a rich source of historical information. Includes excerpts from her writings and observations from people who knew her. Sometimes the language is stilted and the vocabulary difficult.

"She could have had almost any position for the asking. At great cost of physical hardship, she gave up everything for what she said her husband stood for. She gave up family, wealth, and privilege."

- John Gunther

Mother Teresa: Sister to the Poor
by Patricia Reilly Giff
Viking, 1986, 57 pages
Jr. High: Average
Illustrations: Drawings
Time Period: 1900-1985
Place: Albania, India

Themes: Skopje in the early 19th century; Life as a Sister of Loreto; Hindu/Muslim conflicts; Religious beliefs of the Hindus; Life of India's "poorest of the poor;" Precepts of the Sisters of Charity

Description: The style of this biography is crisp and clear. The sentences are short and the more difficult words are explained. Covering Mother Teresa's life from her poor childhood in Skopje to the founding of Sisters of Charity throughout the world, the book shows us an enduring, creative woman who manages to stay on course by dedicating herself to God and working with just one person at a time. This book is part of a series by Viking called *Women of Our Times.* Other personalities featured are Margaret Thatcher, Golda Meir, Winnie Mandela.

"She was determined. She would not stop. Instead of thinking of the crowds, the thousands, she thought of the one - the one closest, the one she was helping."

- Patricia Giff

My Japan, 1930-1951
by Hiroko Nakamoto
McGraw-Hill, 1970, 157 pages
Jr. High: Average - Advanced
Sr. High: Average
Illustrations: None
Time Period: 1930-1951
Place: Japan

Themes: Socialization of Japanese women in Hiroshima in the 1930s; Effect of Japan's war with China; Hardships in final months of war and devastation of atomic bomb; Post-war changes and influence of foreign beliefs - Communism and western democracy; American assistance to Japan

Description: Hiroko was a high-spirited teenager who came of age in Hiroshima during the war. Malnourished and obliged to work in the factories, she saw the life of her happy youth disappear. Most vivid and horrifying, of course, is her detailed chronicle of the day the bomb dropped, killing members of her family, inflicting deep burns on herself and changing forever the city she knew. Her post-war story depicts enormous changes in Japan. A must to show the effect of World War II from the perspective of the Japanese "homefront." No longer in print, but libraries may have this important book.

Suggested Uses: Link with stories of World War II in Europe. • Read aloud Hiroko's account of the day the bomb was dropped. Ask students: How could this story be used to educate people around the world of the horrors of this "new type of bomb?" • Students research the decision to drop the bomb and then debate the pro and con arguments for the question: Was America justified in using the bomb? • Students might write fictional accounts of what it might mean to them if America were defeated in war as Japan was. Using Hiroko's life as a model, would they use similar coping strategies?

⑥

"When I was one year old, Japan was at war with Manchuria, and when I was seven years old, Japan went to war with China. When I was eleven years old, we entered into war with America. I was fifteen when American solders dropped the A-bomb on my city Hiroshima, and my life was changed forever."

- Hiroko Nakamoto

Old Madam Yin: A Memoir of Peking Life
by Ida Pruitt
Stanford University Press, 1979, 129 pages
Jr. High: Average - Advanced
Sr. High: Average - Advanced
Illustrations: None
Time Period: 1918-1926
Place: China

Themes: Manchu Dynasty and western encroachment; Traditional architecture; Life of urban well to do family; Family hierarchy position and rules; Importance of male heir; Role of women in extended family; Opium use; Wedding and funeral ceremonies; Value of beauty

Description: Author was a friend of this elderly matriarch and she writes lovingly of her life. Madam Yin has been the head of the family since her husband died and does many of the things that would have been expected of him, demonstrating the "political" role of the female as head of the house. The author's straightforward explanations and minute descriptions placed in the context of Chinese values and concepts of beauty, make this an ideal resource for students. Top rating.

Suggested Uses: • Students can compare Madam Yin's role with those of other females in the house, such as daughters, daughters-in-law, concubines, female servants. They can also discuss the hierarchy among the male relations. • List areas in family life which reflect adherence to centuries old customs and those which indicate change. • Analyze areas of family tension. Discuss Madam Yin's role in this and whether tension was resolved. • Use this bibliography to find an account of a woman from another culture who held similar power. Assign good students to compare and contrast.

"To say that her daughter-in-law's feet were big was to criticize her. The size of a woman's feet in old China was something the women and especially their mothers, and so their families, could control."

- Ida Pruit

One of the Lucky Ones: The Inspiring True Story of a Girl's Triumph over Blindness
by Lucy Ching
Doubleday & Company, Inc., 1982, 323 pages
Jr. High: Average - Advanced
Sr. High: Average - Advanced
Illustrations: None
Time Period: 1938-1959
Place: China; Hong Kong; United States

Themes: Attitudes toward and treatment of the blind; Impact of the 1949 Revolution on middle class family; Explanation of Confucianism and Buddhism; Japanese occupation of Canton and Hong

Kong; Influence of Christianity and western technology; Anti-Communist refugees

Description: In a society where most blind girls were abandoned or sold to become trained entertainers or prostitutes, Lucy Ching was "lucky" because her parents "merely" ignored her. Slowly and resourcefully she sought an education and eventual recognition that she was a person equal in intelligence to her peers. There are glimpses of the Helen Keller story as Ah Wor, her illiterate but loving servant-companion, becomes her inspiration. Unfortunately out of print.

Suggested Uses: Students could research the treatment of handicapped people in American history. When did U.S. ideas begin to change? What are some continuing problems that handicapped people might encounter today? Why, in old China, would it be considered especially unfortunate if a girl were handicapped.

> *"I still remember an afternoon when a neighbour called to see Mother. 'What a pity you have a blind daughter,' she remarked. 'You or your husband, or perhaps even an ancestor must have done something to displease the God in Heaven.'"*
> - Lucy Ching

Sadako and the Thousand Paper Cranes
by Eleanor Coerr
G.P. Putnam's Sons, 1977,
64 pages
Jr. High: Easy - Average
Sr. High: Easy
Illustrations: Paintings
Time Period: 1954-1955
Place: Japan

Themes: The effect of the atomic bomb on the health of the Japanese; Peace Day; Death; Friendship and family life

Description: This biography, based on the letters of Sadako Sasaki, a 12 year-old girl who died from leukemia as a result of exposure to atomic radiation, is a moving story of her courage in facing death. Children bring paper cranes to her memorial at Hiroshima Peace Park. In her last days, Sadako made paper cranes, believing that if she made a thousand she would recover from leukemia.

Suggested Uses: The obvious use for this book is to read it in connection with a discussion of the atomic bomb, the decision to drop it, and its immediate impact on the post-World War II world. • Make origami paper cranes dedicated to the cause of Peace. An ambitious teacher might want to have children write their names on the cranes and exchange them with Japanese children in Japan. Look into the "Folded Crane Club," a Japanese organization that honors Sadako on August 6 every year.

Second Daughter: Growing Up in China - 1930 - 1949
by Katherine Wei and Terry Quinn
Little, Brown and Company, 1984,
243 pages
Jr. High: Average - Advanced
Sr. High: Average - Advanced
Illustrations: Photos
Time Period: 1930-1981
Place: China

Themes: Life of westernized family in Peking; Emancipated women of the 1920s; Japanese invasion and evacuation of Peking; Power of family patriarch; Wartime Chungking; Civil war; Post-war Shanghai; Student anti-government demonstrations; Cultural Revolution

Description: This lively memoir covers the years from Katherine Wei's (Hsiao-yen) childhood as the daughter of a Yenching University professor in the 1930s to her coming of age in the province of Hunan during the war years to her departure for America at 18. The narrative juxtaposes the life of this westernized, Christian family with that of their clan relatives, who follow centuries old traditions, and with those of poverty-stricken war refugees and the urban poor. The drama of family life and the underlying mother-daughter tension make this a very readable account.

Suggested Uses: Students might list ways in which the mother, for her generation, would be considered a liberated female; ways Katherine was liberated; and ways women in China today might have achieved further liberation.

> *"My mother was a woman of prodigious intelligence, energy, passion, ambition, but a woman born decades too early. Had she not been raised during the last years of the Ch'ing dynasty with its petrified social conventions, she would certainly have excelled in a profession."*
> - Katherine Wei

Six Records of a Floating Life
by Shen Fu, translated by
Leonard Pratt & Su-hui
Penguin Books, 1983, 144 pages
Sr. High: Advanced
Illustrations: None
Time Period: 1763-1809
Place: China

Themes: Daily life of government officials; Intellectual life of scholars; Patronage system; Imperial bureaucracy of Ch'ing Dynasty; Role of wife and of courtesan; Proper filial behavior; Description of diverse people and places throughout China

Description: Six Records is well known among the Chinese as a love story between husband and wife set in traditional society. This true account by Shen Fu, a secretary in the vast imperial bureaucracy, reveals much about his life at home and about the life of his resourceful wife, Yun. The fact that Shen Fu loved and deeply respected Yun modifies the usual picture of the habitually mistreated wife. A good portrayal, too, of inter-generational relationships between family members and of Yun's difficulty in trying to please her father- and mother-in-law.

Suggested Uses: • To shorten this reading, assign only parts I through II, 99 pages. • Creative students might make up Yun's "autobiography" using the same account of events but looking at them through her eyes.

So Far from the Bamboo Grove
by Yoko Kawashima Watkins
Lothrop, Lee & Shepard Books,
1986, 173 pages
Jr. High: Average - Advanced
Sr. High: Average - Advanced
Illustrations: Maps
Time Period: 1945-1946
Place: Korea, Japan

Themes: Situation of Japanese in Korea at the end of World War II; Plight of refugees; High value placed on education; Life in post-war Kyoto

Description: It is 1945 and the Kawashima family, Japanese who live in North Korea, must flee from the Korean Communist anti-Japanese army. Twelve-year-old Yoko, her mother, and her fifteen-year-old sister become separated from the rest of the family. Terrifying adventures follow as they elude capture, only to find that their refugee-style poverty must continue when they finally reach Japan, the "homeland" Yoko has never seen. The cleverness and adaptability of the three women is a dominant feature of this easy-to-read, intensely personal memoir. Top rating.

Suggested Uses: Link with other accounts of young women who have become refugees. For the Chinese in World War II, *Destination Chungking* by Han Suyin. For Germany, *Transport 7-41-R* by T. Degens. • Use this story to discuss the plight of today's refugees, most of whom are women and children.

The Crippled Tree
by Han Suyin
Bantam Books, G. P. Putnam, 1965, 502 pages
Jr. High: Advanced
Sr. High: Average - Advanced
Illustrations: Map
Time Period: 1885-1927
Place: China

Themes: History of the Hakka, or the "guest people," in Szechuan; Taiping and Central Asian uprisings; Impact of Western alliance with Manchus; Events shaping revolution of 1911; "New Learning" and the upper class; Railroad building; Life and customs of a gentry family and poor families; Work of missionaries and anti-Christian resentments; Warlords; Eurasians

Description: Excellent writing with a wealth of information about China's history as the author tries to understand the fortunes of her family by placing them in the political, social and economic milieu of this tumultuous era. To shorten the story, assign Part Two, 1913-1927, which details the marriage and coming to China of Chou Yentung and Marguerite Denis - Suyin's mother and father. The plight of this inter-racial couple and of the Eurasian in both China and Europe is sensitively told. This is first of six informative autobiographies by Han Suyin: *The Mortal Flower* (Han Suyin's coming of age); *Destination Chungking* (account of World War II among the civilian population in the cities); *Birdless Summer* (The story of her unhappy marriage told against the confusion and corruption of China, 1938-48); *My House has Two Doors* (Improvements in living conditions and early days of the Cultural Revolution, 1949-65); *Phoenix Harvest* (Upheaval of Cultural Revolution, fall of Gang of Four and opening China to the West).

The Story of Yamada Waka: From Prostitute to Feminist Pioneer
by Tomoko Yamazaki
Kodansha International, 1985,
159 pages
Sr. High: Average - Advanced
Illustrations: Photos
Time Period: 1879-1937
Place: Japan

Themes: "White Slavery;" Feminism in Japan; Protestant efforts to save women from prostitution

Description: The author of this book was working with slim historical sources and depended on the memories of people in Japan and the U.S. who knew Yamada Waka, a woman who escaped from life as a prostitute to become a leading spokesperson for the feminism which emerged in the early twentieth century. The resulting study of Yamada includes details about how the author pieced together her subject's life story. The story is delicately told and placed in social context.

Suggested Uses: Yamada Waka's story would make good material for a play, which students could write and act out. Students could try to fill in more scenario than the author could provide about Yamada's feelings about specific topics, i.e., duty to family, motherhood, prostitution, women's rights.

To the Storm
by Yue Daiyun &
Carolyn Wakeman
University of California Press,
1986, 387 pages
Sr. High: Advanced
Illustrations: Photos
Time Period: 1931-1979
Place: China

Themes: Civil War; Guomindang oppression; Chairman Mao's principles and policy, "Let a Hundred Flowers Bloom"; Anti-right campaign at Beida University; Wall poster campaign, interrogation sessions and parading of "enemies;" Zhaitang commune

Description: Author was a Beida University professor who suddenly in 1958 was exiled to the countryside, leaving behind her young daughter and son. A detailed tale of the tribulations of intellectuals over the decade of the Cultural Revolution. After the fall of the Gang of Four, Daiyun's husband was then accused of forwarding the aims of that group. Will hold the interest of advanced readers.
 An excellent film to accompany this text and which can contribute significantly to the study of China and women's role in a changing society is *Women in China* (Betty McAfee, Open Window Films, 1921 Oregon Street, Berkeley, CA 94703). Filmed during an extensive early visit in 1973, the film reflects what was happening during the Cultural Revolution period but provides a more positive view of advantages for women in China.

"Wall posters attacking our magazines greeted me...Some announced 'The Traitor Yue Daiyun must be expelled.'"
- Yue Daiyun

Tokyo Rose: Orphan of the Pacific
by Masayo Duus
Kodansha International, 1983,
248 pages
Jr. High: Advanced
Sr. High: Average - Advanced
Illustrations: None
Time Period: 1916-1949
Place: Japan, United States

Themes: World War II propaganda tactics; Racial prejudice; Nisei experience in war years; Cold-War psychology as it influences the treasons trial

Description: A biography that goes into detail about the trial of Iva Toguri D'Aquino, a Nisei woman who found herself in Japan when the war broke out and who became a broadcaster on Radio Tokyo. After the war, she was accused of being "THE" Tokyo Rose and eventually was brought to trial for treason by the U.S. government. Advanced students will find this story fascinating, but teachers should be aware that the book is detailed in its research and analysis of the trial.

Suggested Uses: A natural extension of this study is a research project which involves primary sources. Students will find plenty of coverage on Tokyo Rose in the newspapers and magazines of the time of the treason trial, summer of 1949. • Students could recreate the event in a mock trial in class.

"Throughout the trial Iva, her face rather pale, usually sat scribbling penciled notes on a yellow legal-size pad on the table in front of her. Her rather solemn expression was a far cry from the image of sensual beauty the name 'Tokyo Rose' conjured up."

- Masayo Duus

First Person Accounts

A Half Step Behind: Japanese Women in the 80s
by Jane Condon
Dodd, Mead & Company, 1985, 319 pages
Sr. High: Average - Advanced
Illustrations: None
Time Period: 1981-1985
Place: Japan

Themes: Contemporary Japanese women within their families at work; Women's education

Description: Interviews with women throughout Japan about their lives and their aspirations for the future. The author concludes that although the status of Japanese women "is by far the lowest of women in advanced industrial societies," the majority are "satisfied with their lot in life." The author's style is journalistic, the tone sometimes patronizing, suggesting that Japanese women are responsible for the inequities the author sees.

Suggested Uses: The interviews are timely and readable. Alert students to the cultural issues involved. How honest were the interviewees with their American interviewers? Does the use of an interpreter influence the answers? Is the author measuring the status and opinions of her Japanese informants against an American model of feminism?

"As sure as cherry blossoms bloom in the spring...there's a quiet revolution going on in Japan."

- Jane Condon

China Homecoming
by Jean Fritz
G.P. Putnam's Sons, 1985, 138 pages
Jr. High: Average - Advanced
Sr. High: Average - Advanced
Illustrations: Photos
Time Period: 1913-1984
Place: China

Themes: Anecdotes about emperors and empresses; Taiping Rebellion; Uprising of 1911; Nationalist and Communist struggles; China under Mao; Cultural Revolution; Description of street life, schools and children's activities

Description: This is a warm personal account by the author who returns to her place of birth for a three week stay in 1984. Born in Hankou and raised there until age 13, Jean Fritz relives old memories and documents changes since 1929 in this historic region. The text includes good descriptions of China's history. Notes and a brief outline of Chinese history, at the back of the book, help explain events. Very readable and the pictures are marvellous. Top rating.

"On the table beside her bed [the Empress Dowager, Cixi] kept a picture of Queen Victoria. It was as if she and this other queen were engaged in a private contest. And when Queen Victoria died, the Empress celebrated. She had outlived her rival. Now she was the only important queen in the world."

- Jean Fritz

Clara's Diary: An American Girl in Meiji Japan
by Clara A.N. Whitney, Stelle & Ichimata, eds.
Kodansha International Ltd., 1984, 353 pages
Jr. High: Advanced
Sr. High: Average
Illustrations: Photos
Time Period: 1875-1886
Place: Japan

Themes: Social and political developments in early Meiji Japan; Westernization of Japanese culture; Protestant Christianizing efforts; Everyday life in an American household in Japan; Japanese customs; Cross-cultural comparisons

Description: Clara Whitney was fourteen years old in 1875 when she went to Japan with her mother, a missionary, her father, a businessman, and her brother and sister. This diary, from the daily records she kept over a twenty-five year period, touch primarily on personal and social aspects of Japanese society of the time. The entries show an evolution in Clara's attitudes towards the Japanese over the years as she acculturates and matures, although she never questions or challenges her own role as daughter, mother, or woman.

Suggested Uses: The length and great detail of this book may discourage the average reader, but teachers could pick and choose those sections that relate to the topic being taught.

"His wife seems very American. When I say this I do not mean to be unpatriotic, but I have grown to dislike the rude ways, loud voices, inquisitiveness and slang of our women."

— Clara Whitney

Daughters of Changing Japan

by Earl Herbert Cressy
Greenwood Press, 1975, 305 pages
Jr. High: Average
Sr. High: Easy - Average
Illustrations: None
Time Period: 1945-1953
Place: Japan

Themes: Post-World War II society; Family, marriage, work, education in a democratizing Japan

Description: Written in 1955 by ten Japanese young people, this book can be used in conjunction with the study of post-World War II. It is very easy reading, colored by the political atmosphere of these years. For example, the author hopes that the book will "contribute to a liking of the Japanese people." Part three, "Atomic Dust," recounts the story of a young woman's experience as a consequence of Hiroshima.

④

Halls of Jade, Walls of Stone: Women in China Today

by Stacey Peck
Franklin Watts, 1985, 315 pages
Jr. High: Average - Advanced
Sr. High: Average - Advanced
Illustrations: Photos
Time Period: 1983-1984
Place: China

Themes: Cultural Revolution; Four Modernizations and the Family Responsibility System; Work of the All China Women's Federation; Statistics on women; New sexual morality; Description of the Long March; Women in the professions; Comparisons between women in the U.S., in China, and Chinese living in U.S.

Description: The author, a syndicated journalist, has produced a very readable book full of short interviews with women ranging from a university president to athletes. A predominant theme is life during the Cultural Revolution and the contemporary changes in China. The enormous improvement in women's situation is countered with discussions of the great distance women have yet to go. Each chapter is divided into occupations and is well introduced. Also included are western women who have devoted themselves to the "new" China and Chinese women who are now living in the U.S. The result is a balanced book. Top rating.

Suggested Uses: These interviews are brief. Students could each choose one chapter and look for divergent views among the women interviewed in it as well as for themes which could be compared with the situation for American women. Students report to the class on the situation of women in China today from the perspective of women in different occupations.

"Western countries have influenced life-styles in China, especially among the younger generation. They learned some good things like modern technology, but they also learned bad things. The worst was wanting to make their own lives better and not caring about other people."

— Wang Li-Jean
Chemical Engineer

Haruko's World: A Japanese Farm Woman and Her Community

by Gail Lee Bernstein
Stanford University Press, 1983, 199 pages
Sr. High: Advanced
Illustrations: Photos
Time Period: 1974-1982
Place: Japan

Themes: Changing lifestyles of farmers through mechanization and private ownership of land; Intergenerational conflicts; Part-time industrial work for women; Provincial politics and importance of women's and men's associations; Expectations of women and men; American-Japanese cross-cultural differences.

Description: This readable portrait of a contemporary rural Japanese woman is presented through the eyes of an American woman who lived with Haruko and her family in 1974 for one year. Haruko's life story breaks stereotypes by revealing a strong, sometimes aggressive and completely self-reliant woman. Important, too, is this view of a way of life which is now disappearing. When the author returns in 1982, the change in the family's lifestyle is enormous.

→

Other farm women are also interviewed. Unusual account because it includes the Japanese reaction to the author as a foreigner. Top rating.

Suggested Uses: Page 8 contains a floor plan drawing of the Utsunomiyas house in Bessho village, Shikoku, Japan. Students could draw a floor plan of their own homes and compare the two household's physical arrangements to see what they can discover about Japanese family life vis-a-vis privacy, sanitation, comfort, etc.

"Since the Japanese housewife and farm woman is never put on a pedestal, they must rely on their own practical know-how and physical stamina. They are never made to feel helpless. 'She breaks her bones working' is an expression of respect."

- Haruko

Lives: Chinese Working Women
by Mary Sheridan & Janet Salaff
Indiana University Press, 1984,
242 pages
Sr. High: Average - Advanced
Illustrations: None
Time Period: 1911-1983
Place: China, Taiwan, Hong Kong

Themes: Improvement in women's status after the 1911 Revolution; Description of the May Fourth Movement, the second revolution of 1926-27, the Civil War and Communist victory; Changes since 1949 and life in contemporary China; Women's work in urbanized and industrialized Hong Kong and Taiwan; Labor in multinational factories; Expectations of Taiwanese women and filial piety in new contexts

Description: Fourteen first-person accounts from women of China, Taiwan, and Hong Kong provide a wide range of reactions to the social and economic forces at work in both agrarian and industrial societies. The women's occupations range from arduous manual labor to the new, equally arduous, work in textile and electronic factories. In each of the histories details of everyday life and family pressures also are revealed. The histories show women in all the regions represented determined to pursue their own interests in spite of male domination and rigid social norms.

Suggested Uses: The book is long. The following are the most appropriate first person histories: For China: "Spinster Sisterhood," "Village Wives," "Yeman Women in Revolution," "On the Eve of her Departure," "Contemporary Generations." For Taiwan: "Garment Workers," "Electronic Workers." For Hong Kong: "Hakka Women," "Wage Earners in Hong Kong." • Each student could select one life history

and report on it. Then the class might look for comparisons/contrasts among the Asian cultures and finally, with family life and work of young women in the U.S.

"This sacrifice of the daughter's long-range chances in favor of short-term gains for the family, especially for the brothers, typifies the narrow range of opportunities of Hong Kong elder daughters."

- Janet Salaff, "Wage Earners in Hong Kong"

Portraits of Chinese Women in Revolution
by Agnes Smedley
The Feminist Press, 1976,
165 pages
Jr. High: Average - Advanced
Sr. High: Average - Advanced
Illustrations: Photos
Time Period: 1900-1944
Place: China

Themes: Taiping Rebellion; Influence of Western ideas; Sun Yat-sen and Republic of 1911; Feminists and feminist associations in the early 20th century; Life of wealthy patriarchal family; May 4th Movement; "White Terror" and demoralization of progressive youth; Impact of Industrialization; Canton silk workers; "Sister" societies; Japanese invasion; Refugees; Red Army in the countryside

Description: This is a documentation of the slow progress of women's revolution and the reactionary backlash to it primarily in the 20s and 30s. Both upper class educated women and an awakening lower class from the mines, textile mills and fields are featured here.

Smedley's journalistic style has produced dramatic easy-to-read narratives, although some stories demand prior knowledge. Top rated.

Suggested Uses: Each chapter is very short and stands on its own. Assign each student to read one and make a report to the class. Together they form a complex composite of the currents and cross-currents in China at this seminal time. • Read aloud some of the inspiring and positive stories such as "The Silk Workers," "The Women Take a Hand," "The Dedicated."

"Even as a little child I could never forget the tears of the girls as they said 'yes' to some rich man as they were being sold, and in my childhood fantasies I thought of myself as the general of a powerful army going forth to fight and free all the slave girls."

- Chang Siao-hung

Report from a Chinese Village
by Jan Myrdal
The Pantheon Village Series, 1981, 220 pages
Jr. High: Average - Advanced
Sr. High: Average - Advanced
Illustrations: Drawings; Photos
Time Period: 1900-1963
Place: China

Themes: Practices such as opium use, selling of women, footbinding; Status of widows; Life in the Yenan caves; Role of the Communist Party in mobilizing women; Organization of communes; Education of women; Birth control campaign; Continuing importance of male heirs

Description: Myrdal wrote this book after his sojourn in a small village in northern Shensi in the early 1960s. We suggest you use the dramatic and poignant short (2 - 7 pages) oral histories he collected on peasant women. In these narratives women discuss their life in "old" China, the process of change and how they are working out ways to fit into the new society. Valuable for a look at this transitional stage. Top rating.

Suggested Uses: Students select one story to report on to class. They read parts or act it out. Assign some oral histories from men also. Class notes the main points of change since the revolution in the lives of both sexes. They also assess differences between the sexes.

"When I got back, the women said: ' We didn't think grown-ups could learn to read and write, but you have.' Because of that, the women now wanted to learn to read too, and I told them all...that she who could read could see; and she who couldn't was blind."

- Li Kuei-ying

The Diary of a Japanese Innkeeper's Daughter
by Robert & Kazuko Smith, eds.
Cornell University, East Asia Papers, 1984, 182 pages
Sr. High: Average - Advanced
Illustrations: Photos
Time Period: 1936
Place: Japan

Themes: Daily life and responsibilities of an 18 year-old girl in a small town; Seasonal changes; Attitudes toward women's fate

Description: This diary was kept for nine months in 1936 at the request of John and Ella Embree, American social scientists studying agricultural community life in rural Japan. Yaeko Yamaji is the daughter of a small Innkeeper couple. The diary is interesting for its failure to mention women's rights issues, women's education, birth control, all of which were current among feminists in the Japan of the 1930s. The rural town environment of Yaeko's experience explains this failure and indicates the irrelevancy of these issues to her life.

Suggested Uses: Teacher might use selections from this diary to serve as a view of the common experience of Japanese young women in the years before World War II. • Yaeko's discussions of domestic skills such as cooking, flower arranging, or dancing could be read in conjunction with the study of this aspect of Japanese cultural life.

Fiction

Chemeen
by Thakazhi Sivasankara Pillai
Heineman, Asian Writers Series,
1978, 228 pages
Sr. High: Advanced
Illustrations: None
Time Period: 1970-1977
Place: India

Themes: Role of women in a small fishing village; Power of taboos and traditions

Description: This story tells of two young people who grow up as friends in a fishing village of South India and eventually fall in love. The girl is Hindu of a fisherman caste and the boy is a Moslem trader. Love between them is forbidden by their religious and cultural traditions. Finally the girl is married to a fisherman. Questions about her past lead to tragedy, illustrating the strong hold that dharma and tradition have on the lives of the people in this and similar fishing villages.

Suggested Uses: Think of other tragic stories of young lovers such as Romeo and Juliet or West Side Story. Or, link this story with similar stories from other nonwestern cultures, such as *The Bride Price* (reviewed in the chapter on Africa). What were the societal rules that these couples broke? How do they compare with Chemeen?

"Why do you think all the men who go out there come back safely? It is because of the women at home who live clean lives. Otherwise the currents in the sea will swallow them up. The lives of the men at sea are in the hands of the women on shore."
- Chemeen's mother

Chinese Women Writers: A Collection of Short Stories by Chinese Women Writers of the 1920s and 1930s
by Jennifer Anderson & Theresa Munford
China Books & Periodicals, Inc., 1985, 178 pages
Jr. High: Average - Advanced
Sr. High: Average - Advanced
Illustrations: None
Time Period: 1900-1940
Place: China

Themes: Corruption of Manchu Dynasty juxtaposed with the onset of Western technology and thought; Revolution of 1911; May 4th Movement; Urban poverty and work in textile mills; Prostitution, polygamy, sale of women and children; Peasant life; Generation gap; Power of matriarch; Sexual liberation and independent women with new careers

Description: The authors of these short stories were primarily young intellectuals who, in spite of ostracism from their families and society, created an important body of literature about women from the point of view of women themselves. The stories provide a range of topics from depictions of women's place in society to women who were a part of the enormous change occurring in Chinese society in these years. Many of the stories are autobiographical. Short biographies of the authors accompany each piece. Included are the works of Ding Ling, Bing Xin and Xiao Hong. The brevity of the stories (3-10 pages) plus the subject matter gives this a top rating.

Suggested Uses: Linked with more advanced reading in *Fragment of a Lost Diary*, this collection supplies a full complement of literature produced in these revolutionary years.
• For curriculum background use the appropriate sections in *Sources of Strength*, *Woman and Culture* and the Gross and Bingham *Women in China, vol. II*.

Eighteen Songs of a Nomad Flute: The Story of Lady Wen-Chi
by Robert Rorex & Wen Fong
The Metropolitan Museum of Art, 1974, 35 pages
Jr. High: Average - Advanced
Sr. High: Average - Advanced
Illustrations: Paintings; Drawings
Time Period: 195-207A.D.
Place: China

Themes: Account of the decline of the Han dynasty and nomad invasions; Wealth and architecture of Chinese cities; Description of military hardware; Life on the steppes; Culture clash between the Han and nomads; Artistic style of the 12th century

Description: This text accompanies pictures from a narrative handscroll from the 12th century that tells the historical drama of Lady Wen-chi who was abducted from her father's home in Honan in the 2nd century and taken by her captors, the Southern Hsiung-nu, into Inner Mongolia where she was made the wife of the commander and chief. She had two sons and grew to love her family

but painfully had to leave them when she was ransomed. This story is told through poems by Liu Shang of the T'ang dynasty (773), but they are partly based on extended poems Lady Wen wrote herself. Notes explaining the beautiful, colorful paintings are included. Top rating.

Suggested Uses: Students might illustrate another, perhaps contemporary event using this handscroll format. They could compose an "epic poem" to help explain the events. • Link with Gross and Bingham's *Women in Traditional China* where there is further discussion of the fate of noble women abducted by invading tribes.

"My children pull at my clothes, one on either side; I cannot take them with me, but in leaving them behind, how I shall miss them! To return home and to depart in sorrow-my emotions are mixed."

- Lady Wen

Li Ch'ing-chao: Complete Poems

by Kenneth Rexroth & Ling Chung, translators
New Direction Books, 1979, 82 pages
Jr. High: Advanced
Sr. High: Average - Advanced
Illustrations: None
Time Period: 1084-1151
Place: China

Themes: Literary life; Clothing and customs of gentry; Rival factions of Sung Dynasty; Court intrigues and effects of court disfavor; Clan rivalry; Defeat of Sungs by Tatars; Court in exile; Life in the women's quarters.

Description: Li Ch'ing-Choa is considered to be China's greatest woman poet. Not only was she a scholar of history and the classics, she was a literary critic, an art collector, a specialist in bronze and stone inscriptions, a painter and a political commentator. She is noted for her lyrical poems on comradeship, love, and loneliness, written to her husband when they separately had to flee from the invading Tatars. She also produced political and satirical poems, such as on the corruption of the Chi'ing officials or the weakness of the defenders of the court. These are short, beautifully translated, easy to read poems. Top rating.

The authors also produced: *The Orchid Boat: Women Poets of China*, McGraw-Hill, 1972; in paperback, as *Women Poets of China*, New Direction, 1972. These concise poems come from the pen of court courtesans, Tao priestesses and modern writers. There are notes on the poems and biographies.

Suggested Uses: These poems give you a wealth of primary source documents. Read aloud in class to analyse aspects of the life of a well to do female scholar and the political fortunes of the Sung Dynasty.

⑳

"I remember the happy days in the lost capital. We took our ease in the women's quarters. The Feast of Lanterns was elaborately celebrated- Gold pendants, emerald hairpins, brocaded girdles, New sashes - we competed To see who was most smartly dressed."

- Li Ch'ing-chao

Little Sister

by Margaret Gaan
Dodd, Mead and Company, 1983, 189 pages
Jr. High: Average - Advanced
Sr. High: Average - Advanced
Illustrations: Map
Time Period: 1900-1925
Place: China

Themes: Unequal treaties and concessions to foreigners in Shanghai; Sun Yat-sen and the Revolution of 1911; Communist Party attempts to organize urban workers; Conditions in the silk mills; Student nationalist movement and strikes; Confucian obligations and customs; Inter-racial marriages.

Description: This novel is an informative source on the unrest in China and causes of the May 30th Movement in Shanghai. There is a truly exciting description of a demonstration. Family conflicts mirror the political events as one Eurasian family works out the tension between Confucian and revolutionary ideals. The female protagonists are Grandmother, who with her crippling bound "Lily Feet" begins to recognize why revolution is inevitable, Celia, her daughter, who loves a member of the growing Communist Party and Little Sister, the grandchild, whose six year-old voice recounts much of the tale. Top rated.

➡

Suggested Uses: Students write about an important political event that happened in their lifetime. Then they do research on the event to judge their recollections with some of the reported facts.

"Grandmother explained to me about strikes. 'Sometimes they're necessary. Confucius was a silly old man, you know. Heaven doesn't give the ruler the right to rule. That makes him think he owns the people.'"

- Little Sister

Of Nightingales That Weep
by Katherine Paterson
Avon, 1980, 208 pages
Jr. High: Average - Advanced
Sr. High: Average
Illustrations: Graphics; Drawings
Time Period: 1180-1185
Place: Japan

Themes: Feudal Japan during the Gempie War; Details of battles between rival clans with imperial family caught in the middle; Courtly life and world of upper class women; Peasant family life; Life of nuns; Power of strong, influential court figures, such as Lady Kiomori

Description: Students who like Japanese movies featuring battles and Samurai will enjoy this book. Takiko, whose Samurai father is killed early in the story, moves with her mother into the farming and potter household of her new stepfather. Later she is chosen to reside in the imperial household as a handmaiden and musician to the women. Here women are the pawns in battle, ineffective to do more than fearfully watch the ebb and flow of war. Yet strong women do

emerge and through Takiko's eyes the worlds of both peasant and upperclass women come alive. Takiko ultimately gains insight into the value of internal beauty when she is transformed from a self-centered court beauty into a weathered, scarred farm woman; "I have learned that beauty is a mockery."

Suggested Uses: A perfect novel to use as comparison with feudal Europe, especially aspects of courtly love, poetry and songs, class differences, fierce clan loyalties, use of nunneries as an escape valve for women. • Since writing, particularly verse, is so important in this period, link this book with women's literature from this period found in the *Rice Bowl Women* (reviewed here) and/or books on poetry (Cross-cultural section) reviewed in this bibliography.

Out of India
by Ruth Prawer Jhabvala
William Morrow, 1986, 288 pages
Sr. High: Advanced
Illustrations: None
Time Period: 1957-1986
Place: India

Themes: Women and their relationships with men

Description: These short stories revolve around the concept of love in the setting of contemporary India. The following are most appropriate: "My First Marriage"- an upper-class Indian woman wonders where she will find love as she considers her upcoming second marriage to a childhood friend she once rejected when she ran away to marry a visionary; "The Widow" - a young widow does not want to follow the traditional practice of shaving her head or of giving all her money and property to her new husband; "The Interview" - a young man in an extended family who depends financially on his brother

is sexually interested in his sister-in-law more than in his own wife. Other novels by Jhabvala include *Nectar in a Sieve*, a classic on the role of women in rural Indian life, and *The Householder*, a wonderful story about a young couple who fall in love after their arranged marriage and in spite of a visit by his mother.

④

Rebels of the Heavenly Kingdom
by Katherine Paterson
Lodestar Books, E.P. Dutton, 1983, 227 pages
Jr. High: Average - Advanced
Sr. High: Average - Advanced
Illustrations: None
Time Period: 1850-1853
Place: China

Themes: Battles of the Taiping Rebellion; Influence of teachings of Western missionaries; Secret anti-Manchu societies; Precepts and organization of the Taiping Society; Women trained as militia; Hakka, Han, and Manchu animosities

Description: The main protagonist is Wang Lee, a young peasant who joins the Taiping rebels. But a second important voice is Mei Lin, a fiery devotee of the "Heavenly Kingdom of Great Peace." Now that women no longer had to bind their feet they could develop non-traditional skills and learn ideas of the equality of women and men. An important movement, which set the stage for later feminist organizing. Story is full of adventure.

➡

Suggested Uses: Use to balance presentation of women as despised victims in China. The image of woman as warrior appears in the Wah Mu Lan story and later as trained guerillas in the Red Army.

"On horseback, San-niang looked like a warrior goddess of the ancient stories. Her long black hair streamed out behind her like a banner as she rode."
- Katherine Paterson

Rice Bowl Women: Writings about the Women of China and Japan
by Dorothy Blair Shimer, ed.
New American Library, 1982,
384 pages
Sr. High: Advanced
Illustrations: None
Time Period: 618-1970
Place: China, Japan

Themes: Confucian traditions; Male/female relationships; Ideas of beauty; Impact of western values on Asian life; Court literature; Social realism literature

Description: These short stories and memoirs come from the rich literature of China (early Tang, Ming Ch'ing dynasties and modern period) and Japan (Heian, Kamakura and modern periods). Introductions to each period place the selections in their cultural settings. The editor has erred by including too many male writers in the modern period who do not always bring the most insightful look at women (for example the selection from Mishima Yukio, which we do not recommend). The book is, nonetheless, a valuable source of short writings from diverse eras.

Suggested Uses: The excellent introduction provides good teacher lecture material. • Students can read selections from comparable time periods in other parts of the world and look for similarities/differences.

"The rice bowl-whether full or reduced to a pitiful scattering of grains-has become the Asian symbol of traditional womanhood, of hospitality, security, and hope."

- Dorothy Blair Shimer

Rich Like Us
by Mayantara Sahgal
W.W. Norton , 1985, 236 pages
Sr. High: Advanced
Illustrations: None
Time Period: 1975-1976
Place: India

Themes: Life during the Emergency (1975-76); Lives of upper class Indian and British women; Suttee; Extended family and family roles; Political manipulating among the ruling elite

Description: Using the emergency declared in 1975 as a setting, Sahgal paints a picture of corruption and brutality imposed upon the Indian nation by her cousin, Indira Gandhi. The novel tells the story of two women: Rose, a British woman who married an Indian man and Sonoli, an unmarried Indian woman in the Indian Civil Service. The latter provides an excellent role model to counter the stereotype of the Indian woman as docile and dependent. Top rated for students who know something of recent Indian history. Sahgal has also written a non-fiction book, *Indira Gandi: Her Road to Power*, (Fredrick Ungar, 1982). She argues that Mrs. Gandhi turned her back on the democratic process of her predecessors by establishing a centralized government and party under her control and by preventing the judicial processes of the opposition Janta government from prosecuting her son, Sanjay.

"The bride burnt to death by her in-laws not more than two miles from where I lived because her family could not satisfy their greedy demands for more dowry. She was one of three hundred such women burnt during one year in this our capital city."
- Sonali

Samurai
by Hisako Matsubara
Times Books, 1978, 218 pages
Sr. High: Average - Advanced
Illustrations: None
Time Period: 1880-1940
Place: Japan

Themes: Training of a samurai; Japanese immigration to U.S.; Patriarchal family life

Description: A highly involving story of Tomiko, the daughter of a samurai father whose rapidly declining fortunes prompt him to send her husband, his "yoski" (adopted son), to America to make his way. An alliance is made against the father between the daughter and the husband's mother, who wants to help her daughter-in-law either get to America or bring the husband home. The story is a fascinating account of the ways in which women try to have some control over conditions made by the family patriarch.

"She wondered if it was right to do something in secret; even starting her own bank account seemed to her like the beginning of betrayal."

- Tomiko

Seasons of Splendour: Tales, Myths and Legends of India
by Madhur Jaffrey
Antheneum, 1985, 128 pages
Jr. High: Average
Illustrations: Paintings
Time Period: 1940-1945
Place: India

Themes: Stories of the seasons; Roles of men and women

Description: These are stories that are told to Indian children by their mothers and other women of the household. Right and wrong are clear in the tales, whose purpose it is to prepare children for life and death as well as to provide them with entertainment. The stories are arranged in order as they might be told at religious festivals throughout the Hindu calendar year.

Suggested Uses: Present a story which depicts the ideal woman. Have students read the "Story of Savitri and Styavan." This tells of the devotion of the wife for her husband and of her persistence and cleverness in bringing him back from the dead. • Students might write stories based on one of our seasons using the model of the season in India.

Shallow Graves: Two Women and Vietnam
by Wendy Wilder Larsen & Tran Thi Nga
Random House, 1986, 278 pages
Jr. High: Advanced
Sr. High: Average - Advanced
Illustrations: None
Time Period: 1927-1980
Place: North Vietnam, China, South Vietnam, United States

Themes: Experiences of an American woman in Saigon during Vietnam War; Growing up as a middle class Vietnamese woman; Impact of French and American culture on Vietnamese life; Hardships endured by the emigrants to the U.S.; Cross-cultural comparisons

Description: In this dramatic book, two women, American and Vietnamese, use poetry to describe their lives in Vietnam. Larsen is the wife of a journalist who worked in Saigon during the war, and Tran Thi Nga grew up in North Vietnam, lived in China and later moved to South Vietnam where she befriended Larsen. Both meet again in New York City after the war and decide to collaborate in this book as a way to deal with important aspects of their lives as well as with the horrors of the war. The poems are intensely personal and moving. They are easy to read and can be used as a primary source documentation of the war. Top rating.

Suggested Uses: The Chronological Table of Vietnamese history and the Glossary of terms could be used in conjunction with teaching the political history of the Vietnam War. Choose quotations from both women to provide unique insights from civilian point of view. • Read some of the poems aloud. Or, one student chooses some of Larsen's poems to read aloud and another student selects some of Nga's. The class looks for commonalties and differences in the experiences of women from two different cultures.

The Adventures of Rama
by Milo Cleveland Beach
Freer Gallery of Art, 1983,
62 pages
Jr. High: Average
Illustrations: Paintings
Time Period: 500 B.C.
Place: India

Themes: The model standard for men and women as depicted in an ancient epic

Description: "The Adventures of Rama" is one of the oldest and greatest of Indian epics. It tells the story of Rama, the perfect man, who is exiled to the forest with his wife, Sita, and his brother, Lakshman. Sita is captured by the

evil, ten-headed Ravana, King of Lanka, and after a great battle is rescued by Rama, Lakshman and Hanuman, leader of an army of monkeys. After the rescue, Sita submits to an ordeal by fire to prove her purity. This legend illustrates the ideal for women in India. "May you be like Sita" is a favorite blessing because Sita idealizes wifely love, devotion and fidelity.

Suggested Uses: Teacher could read the story aloud, showing the illustrations to accompany the reading. Have students discuss what makes the "ideal" man and woman in "The Adventures of Rama" and in our society. How are the two sets of ideals similar and how are they different?

"He [Rama] and Sita had fallen in love instantly, and her beauty and gentleness perfectly matched his strength and bravery."

- Milo Beach

The Burning Heart: Women Poets of Japan
by Kenneth Rexroth &
Ikuko Atsumi, trans. and eds.
Seabury Press, 1977, 184 pages
Sr. High: Average - Advanced
Illustrations: Calligraphy
Time Period: 600-1977
Place: Japan

Themes: Courtly love; Erotic love; Nature; Social criticism; Poetic forms such as Tanka, Modern Haiku, free verse and geisha songs

Description: A collection of poems written over fourteen centuries by Japanese women poets including Princess Nakada and Lady Kasa, 8th century poets; Ono no Komachi, the greatest poet of 9th-century Japan; and Yosano Akiko

and Shiraishi Kazuko, important 20th century poets. The volume includes biographic sketches on each of the more than 75 women included and a 25-page essay on the history of Japanese poetic expression as it relates to women writers. The calligraphy is by Japan's "greatest woman calligrapher."

Suggested Uses: Serious poetry students might do more research to expand upon the brief biographical sketches of one or two of the poets. They also could test out the assertion that the poetic accomplishments of Japanese women is "unequaled by the women of any other culture" (editors' comment).

⑥

The Doctor's Wife
by Sawako Ariyoshi
Kodansha International, Tokyo, 1985, 174 pages
Sr. High: Average - Advanced
Illustrations: None
Time Period: 1760-1835
Place: Japan

Themes: Mother-in-law/daughter-in-law relationship; Medical profession in late 18th century; The invention of anesthetic "tsusansen;" Breast cancer and surgery research; Ideal behavior for women in feudal Japan

Description: This story tells of the rivalry between the mother and the wife of a doctor, who has devoted his life to researching and developing general anesthetics in the late 18th century. Each woman competes for the chance to serve as his guinea pig in experimenting with the new drugs and this battle provides fascinating insights into women's familial roles. The popularity of this novel among the Japanese in the 1980s hints that these traditional tensions may continue today. Top rating.

The Dream of the Red Chamber
by Hung Lou Meng
The Universal Library, Grosset & Dunlap, 1973, 582 pages
Sr. High: Advanced
Illustrations: Woodcuts
Time Period: 1729-1737
Place: China

Themes: Architecture of upper class family compound; Importance of scholars' examinations and rank; Education of upper class women; Arranged marriages, concubines and second marriages; Role of Buddhist nuns; Ceremonies, such as funerals; Expectations of men and women

Description: This novel was written ca. 1791 by an early male "feminist" and is said to be read by all adolescent girls in China. It details the life of an upper class family with the intricacies of women's world predominating. The main protagonist is young, neurotic and effeminate Pao Yu, but the family's matriarch, the Ancestress, and her granddaughter, Black Jade, also play central roles. Fascinating for details of the social life of the period and the elaborately arranged marriages. Not difficult to read, but many characters and events.

The Family

by Pa Chin
Doubleday Anchor Books, 1972,
329 pages
Sr. High: Advanced
Illustrations: None
Time Period: 1919-1930
Place: China

Themes: Description of the "ideal" Chinese family; Dispute over education for women; Student nationalist movement; Inter-generational conflicts; New Year's and funeral customs; May Fourth Movement; Battles of competing warlords; Influence of progressive student periodicals and societies; Influence on young intellectuals of women's movement in West

Description: One of the most popular Chinese novels of the 1930s, this story details the struggle of the young generation against the social system which produced the powerful patriarchal family. The story is told by a male, Chueh-hui, who takes the strongest stand for the "right to freedom, love and knowledge." There are, however, important female characters such as the servant, Ming-feng, the student, Chin, and Mei, widowed young and destined therefore to remain unmarried all her life. Good for an understanding of how young men as well as women were constrained by the overwhelming power of the patriarch, Grandfather Kao.

The Serpent's Children

by Laurence Yep
Harper & Row, 1984, 275 pages
Jr. High: Average - Advanced
Illustrations: None
Time Period: 1843-1865
Place: China, United States
Themes: Manchu-Han animosity; British in Canton and the Opium wars; Secret brotherhoods; Village life with clan relationships and feuds; Sharecropping and the effect of a drought; Power of bandits: Prestige of scholars; Immigration of young men to "Gold Mountain" (U.S.)

Description: Cassia's parents are both involved in a revolutionary secret society, The Brotherhood, dedicated to driving out the Manchus and the British. But when mother dies and father is wounded, both practical Cassia and her dreamy brother, Foxfire, must struggle to endure and survive. A good tale for its descriptions of peasant life and for portrayal of a strong heroine who uses her strength to try to save the family's lands from drought, bandits and neighboring clans. Includes a description of ocean passage and life in the United States.

Suggested Uses: Link with *Rebels of the Heavenly Gates* which also details the workings of anti-Manchu secret societies from an earlier period.

"I had time to parry the blow from his sword, though its force made my arms feel numb. Then I managed a counterstroke, chopping at his leg with the blade of my hoe. Startled, the boy jumped back so that he fell among the rice plants."

- Cassia

The Tale of the Shining Princess

by Donald Keene & Sally Fisher
Viking Press and Metropolitan Museum of Art, 1980, 70 pages
Jr. High: Average - Advanced
Sr. High: Average - Advanced
Illustrations: Paintings
Time Period: 800-900
Place: Japan

Themes: Clothing, architecture, and court lifestyle of the Heian period; Power of beautiful and wealthy women; Universality of theme of suitors competing for hand of marriageable girl; Concepts of beauty

Description: This is one of the earliest and most popular tales of the Heian period. Also known as The Bamboo Cutter and The Moon Child, it recounts the story of a moon princess, Kaguya-hime, who comes to earth in human form, is discovered as a tiny child inside a stalk of bamboo, and because of her beauty, becomes the most powerful woman in the land. The delight a daughter can bring to the lonely bamboo cutter's wife, the princess's cleverness in repulsing her suitors and the artist's depiction of Heian upper-class life make this a valuable resource. The illustrations, beautifully reproduced in five colors plus gold and silver, come from a manuscript of the tale executed for a daughter of the Tokugawa family ca. 1800.

Suggested Uses: Students recall comparable stories on competition for the hand of a daughter in Western literature. • Students read both the notes about the story and about the illustrations. As an exercise before reading the notes, they could analyze the illustrations for clues about Japanese upper-class culture.

The Three Daughters of Madame Liang
by Pearl Buck
The John Day Company, 1969,
315 pages
Sr. High: Average - Advanced
Illustrations: None
Time Period: 1900-1968
Place: Hong Kong, China, United
States

Themes: Teachings of Confucius, Lao Tzu and Daoism; Struggles of middle class to adapt to Communist austerity; Life in the communes; "Hundred Flowers" era; Personal struggles against individualism; United States-China estrangement

Description: In this period of extreme tension between the U.S. and China, Madame Liang is torn between her friendship with Americans and her belief in the superiority of Chinese ways. Although she has educated her three daughters in the U.S., she is a constant defender of China's enduring traditions and believes that China's "eternal way" will survive the "Great Change"-the Revolution. The story is also about the three daughters who choose diverse paths, showing differing views of the "new society." Shows tensions in China at the beginning of the Cultural Revolution. Buck's other books about women include: *Imperial Woman* (Tzu Hsi, whom Buck says "was a woman so diverse in her gifts, so contradictory in her behavior") and *The Mother* (the enduring struggles of a peasant woman).

"Confucius was now an outcast in the new society. Forbidden though he now was, and even ridiculed, she did not doubt that one day he would be recalled by a wiser generation and order restored to the nation."

- Madame Liang

Curriculum

Chiliying: Life in a Rural Commune in China
by Burton Beers & Barbara Parramore
North Carolina State University Curriculum Publs., 1979, 69 pages
Jr. High: Easy - Average
Illustrations: Graphics; Drawings
Time Period: 1970-1978
Place: China

Themes: Work on a Commune; Production brigades; Duties and responsibilities of members; Reasons communes were established; Change in women's status since the Revolution; 1954 Marriage Law

Description: The last four chapters of this curriculum focus on women. Here women recount the memories of the "bitter past" while others discuss the present and students do an activity to assess change. The general principles of the marriage laws and other chapters on "Family Routine" and "Passages of Life" illuminate the expectation on women of hard work and the socialization of boys and girls. Activities and discussion questions are included in the booklet. Has large, some full page, striking black and white illustrations. It is, however, a bit dated as it does not reflect changes in the commune system in China. Available from North Carolina State University, Curriculum Publications, P.O. Box 5096, Poe Hall, Raleigh, NC 27650.

Chinese and American Women in Stamps (Slideshow)
East Asian Outreach Program
Jr. High: Average - Advanced
Sr. High: Average
Illustrations: 55 slides
Time Period: 1930-1975
Place: China

Themes: Indications of governmental positions on equal treatment for women as shown through stamps; Cross-cultural comparisons; Chinese women's contributions and active role in the revolutionary struggles of the present and the past

Description: The colorful stamps presented in this slideshow depict Chinese women in a variety of roles. The stamps all date from 1966. U.S. stamps related to women are also shown; most of them honor a famous woman or group of women. Script, discussion questions, and activity suggestions are included.

Suggested Uses: These bright stamps may encourage students to design a series or one single stamp that pictures women in modern roles in the U.S.

Chinese Women in History and Legend, Volumes 1&2
by Lu Yu
A.R.T.S. Inc., 1981, 66 pages
Jr. High: Average
Sr. High: Easy
Illustrations: Drawings; Chinese characters
Time Period: 722 B.C.-1908 A.D.
Place: China

Themes: Women of great character, their sacrifice and determination; How women coped with conflicting responsibilities; Women who held political power and the vilification of powerful women by historians

Description: These stories of Chinese heroines in history and in leg-

end are attractively presented. Each includes a drawing of the woman with accompanying text in Chinese. The lives of the women are simply told and easy to read. Available from A.R.T.S., Inc., 32 Market St., New York, NY 10002.

Suggested Uses: The Teacher's Guide, vol. 3, is full of simple classroom projects to further students' understanding of a particular woman or time in history.

Chinese Women: Now We Hold Up Half the Sky
by Nancy Henningsen
East Asian Outreach Program, 1980
Jr. High: Easy - Advanced
Sr. High: Easy - Average
Illustrations: 69 slides
Time Period: 1950-1980
Place: China

Themes: Confucian beliefs about women and position of women in pre-revolutionary China; Women's status in post-revolutionary China including laws protecting women, work and child-care facilities; Areas where difference in male/female treatment continues

Description: The packet contains a slide show and audio-tape which delineates differences between women's life in "old" and "new" (post-1949 revolution) China, a copy of the magazine *Women in China* (December 1980) and an article about women in the 1960s-70s, "Women's Lib is Real in China" (Nancy Southwell, *The Westside*, June 1975). Although the information is dated, the basic concept of dramatic change for women in China is presented in a clear and colorful way.

Contemporary Japan, a Teaching Workbook and China, A Teaching Workbook

by Roberta Martin, ed.
East Asian Institute, 1985,
12 pages
Sr. High: Average - Advanced
Illustrations: None
Time Period: 1984-1985
Place: China, Japan

Themes: Resources on women in China and Japan

Description: The following resources which focus on women are: An analytical framework for using material about women in China; Synopsis and questions for discussion on the film *Four Women/Four Choices*; Reprint of the article, "Japanese Women and the Law" with accompanying questions for discussion. Available from *East Asian Institute*.

India's Working Women (A sound filmstrip)

by Geraldine Forbes
Asian Society, 1978
Sr. High: Average
Time Period: 1970-1978
Place: India

Themes: Variety of work of women; Statistics on women's employment

Description: The filmstrip begins with an overview of women's employment in India (80% work in agriculture, 10% in industry and 10% in services). Filmstrip then examines the lives of two women; one is a village woman who is the head of an extended family and the other is a city woman who works as a receptionist in a large company. Excellent information on the work

of each woman and what they think about their lives. 15 minutes. A Teacher's Guide is included. Top rating.

Suggested Uses: As students watch the filmstrip they might write down the work each woman does, and then compare the two lists. Which woman has more work to do and less help?

India: A Teacher's Guide

Asian Society, 1985, 120 pages
Jr. High: Advanced
Sr. High: Average - Advanced
Illustrations: Map and pictures
Time Period: 1983-1985
Place: India

Themes: Arranging a marriage and the dowry Caste system; Love and marriage

Description: The following chapters include good information on women and some were written by leading Indian writers: "Marriage"- readings bring out the importance of caste in arranging a marriage and point out that in India marriage is considered a precondition for love; "A Coward," Premchand; "We Nehrus," Krishna Nehru Hutheesing; "Punjabi Century," Prakash Tando; "The Financial Expert," R.K. Naray; "Bengali Women," Manisha Roy; "Remember the House," Santha Rama Rau.

Suggested Uses: Students study Indian newspaper advertisement for a marriage, then write their own advertisement.

Indian Women

by Sharada Nayak &
Charles Heimsath
Educational Resources Center,
1977, 108 pages
Sr. High: Average
Illustrations: Photos
Time Period: 1976
Place: India

Themes: Position of women in Indian society; Women in the family and at work

Description: This unit consists of two booklets. The first, "A World of Difference," provides a general introduction to the role and status of the Indian woman. The second, "Profiles of Indian Women," consists of sixteen profiles of contemporary women from many social classes and geographical regions; street sweeper, doctor, tribal dancer, businesswoman, night club singer, and widow. Information is given in the women's own words. Out of print, but available from the *South Asian Area Center Outreach Office*, University of Wisconsin, 1249 Van Hise Hall, Madison, WI 63706. May be borrowed for one month free of charge. Top rating

Suggested Uses: Includes a Teacher's Guide and suggested activities.

"Jyoti," India: Our Asian Neighbors Series (film)

Australian Information Service
Jr. High: Average - Advanced
Sr. High: Easy - Average
Illustrations: None
Time Period: 1970-1980
Place: India

Themes: Family life; Life of young women

Description: "Jyoti," a film, is part of a series on life in India. In it, Jyoti, twelve years old, is shown studying dance, attending school, ➡

and at home in her middle class family. 15 minutes. Also in this series: "Padma," a South Indian dancer. Shows the dedication necessary in the discipline of dance. "Rana," a twenty-one year old Moslem, follows the practice of purdah when she leaves her house to attend the university. Her father is arranging her marriage. Good description of Moslem women's life in the household.

Small Interventions (Slides)
Oxfam America, 1983
Sr. High: Average
Illustrations: 135 slides
Time Period: 1980-1983
Place: India

Themes: Role of women in India's development; Work of SEWA (Self Employed Women's Association)

Description: Describes the traditional role of Indian woman as being secondary to men and the work of SEWA, which has initiated a multi-faceted approach to helping rural women improve their lives. SEWA has helped women in cottage industries, helped village women borrow money to buy dairy buffalo, and organized day care centers. 138 slides plus script. 13 minutes.

Their Place in the Sun: Images of Japanese Women (Slideshow)
SPICE, 1977
Jr. High: Average - Advanced
Sr. High: Easy - Average
Illustrations: 47 slides
Time Period: 1970-1976
Place: Japan

Themes: Stereotypes about Japanese women; Statistics on women in the Japanese and U.S. workforce; Occupations in which women's work is essential; Variety of women's work; Marriage and family life; Exceptional women; The consumers movement

Description: Activities and 47 slides from ads to show how the media perpetuates the stereotype of Japanese women as beautiful and gracious and dedicated to serving others. Some of the slides depict women in a variety of occupations. Included is reprint of *Women in Changing Japan*, Westview Press, by Ledbra, Paulson and Powers. This provides excellent oral history excerpts from a rural woman, factory worker, woman who lived through World War II, office women, and a woman who works in her family's business.

Through Chinese Eyes: Revolution: A Nation Stands Up, Vol. 1
by Peter Seybolt
Praeger Publishers, 1974, 136 pages
Jr. High: Average - Advanced
Sr. High: Average
Illustrations: Photos
Time Period: 1900-1973
Place: China

Themes: Confucian code; Pan Chao's "Lessons for Women;" Filial piety; Footbinding and resistance to it; Chiang Kai-shek and Nationalist government; Villages controlled by Communists; Civil War; Communes; Marriage Law of 1954

Description: China is shown through the eyes of the Chinese themselves. We suggest the following chapters on women: "The Traditional Family Ethic," "Meng Hsiang-ying Stands Up," "Lessons for Women - Status of Women," "Old Customs, New Laws," "Homelife of a Sales Woman." The short (3-7 pages) chapters emphasize the pre and post revolution changes for women, although the material on "new" China is a bit dated. Good focus questions precede the chapters.

Through Indian Eyes, Vol. I, "The Wheel of Life"
by Donald J. & Jean E. Johnson, eds.
Praeger, 1981, 156 pages
Jr. High: Advanced
Sr. High: Average
Illustrations: None
Time Period: 1900-1980
Place: India

Themes: Personal aspects of Indian life such as family relations, marriage, dowry and role of women within the family; Extended family; Education of women

Description: This material was written by Indians and consists of a good mix of autobiographies, fiction, poetry, newspaper and magazine articles, and historical documents. Women's perspectives are found in the following chapters: "Arranging a Marriage: A Dialogue on the Indian View of Marriage," "Viewing a Prospective Bride," "Selling the Bride - The Role of Dowry," "Procreation or Recreation: Mother and Creator," "Stories My Mother Told Me."

Suggested Uses: Students read "Arranging a Marriage" and give two reasons for arranged marriage in India. They also explain the wife's role in making an Indian marriage work. How is this role different/similar to that of a wife in the United States?

"Our women make our homes smile with sweetness, tenderness and love... We are quite happy with our household goddesses, and they themselves have never told us of their 'miserable condition.' Why, then, should the Meddlers from beyond the seas feel so bad about the imagined sorrows of our women?"
- **Letter by Rabindrondth Tagore**

Through Japanese Eyes Vol. II
by Richard H. Minear
CITE Book, 1981, 147 pages
Jr. High: Advanced
Sr. High: Average
Illustrations: Photos
Time Period: 1600-1964
Place: Japan

Themes: Rules for female behavior, 1600; Feminist attitudes in 1929; Volleyball for women, 1960s; Women in the workforce, 1978

Description: A few selections are relevant to women, although this is a very eclectic collection that jumps from topic to topic over a broad period. The selections are short and should serve well as food for thought and a stimulus for discussion.

We the Chinese: Voices from China
by Deirdre & Neale Hunter
Praeger Publishers, 1971,
286 pages
Jr. High: Average - Advanced
Sr. High: Average

Illustrations: Photos
Time Period: 1950-1970
Place: China

Themes: Life of the Manchu rulers; Influence of Western ideas, Sun Yatsen and Revolution of 1911; Efforts to break the power of the landlords; New Marriage Law of 1954; Education for girls; Self-criticism sessions; New roles for women

Description: These selections for young adults are designed to introduce the changes in China from the Communist victory to the 1970s. The narratives come from magazines, fables, plays, speeches. The Cultural Revolution was in progress when the book was published and much of the text is devoted to explaining that phenomenon. The following readings highlight the experiences of young women: "The White-Haired Girl, Act I and Act V," "The Marriage," "Yuan-Yuan and her Friend," "The New Technician."

Suggested Uses: Students may act out or read aloud the excerpts from "The White Haired Girl," which is a classic moral tale of the vengeance sought by the peasants after the overthrow of the landlords.

Women in Japan
by Marjorie Bingham &
Susan Gross
Glenhurst Publications, 1987,
312 pages
Jr. High: Average - Advanced
Sr. High: Average - Advanced
Illustrations: Photos; Paintings; Charts
Time Period: 2000 B.C.-1985 A.D.
Place: Japan

Themes: Diversity of roles and variations in women's status according to time and class; Contradictory traditions between one of power and influence (female deities and queens) and other of subordinate roles as shaped by Confucian philosophy; Lives of peasant women; Influence of Samurai code on women; Cross-cultural comparisons (primarily with West); Neo-confucianism; Diverse opinions about the role of the geisha; Impact of West; The women's rights movements; Discrimination against minorities; Women's role in early Japanese industrialization and in postwar recovery; Women's experiences in World War II and the Allied occupation; Discrimination against women workers; Complementary marriages; Diverse contemporary roles

Description: This important text offers a wealth of information from women's sometimes powerful roles in early history(including the Heian period) to some of the contemporary problems Japanese women face. These short chapters on many themes challenge the "Madame Butterfly" image by revealing the complexity and diversity of women's experiences. Liberal use of first person accounts and good exercises (such as an analysis of *The Tale of Genji* by Murasaki Shikibu). Larger format than other *Women in World Area Studies* texts. Top rating. A two part sound filmstrip containing very attractive images is also available.

Suggested Uses: Good source of background information for teachers to use in lectures. • Section on women in medieval Japan includes interesting parallels with women in feudal Europe. (See curriculum: *Women in the Middle Ages* (Europe) and "Women in Feudal Europe," *In Search of Our Past* (Cross-Cultural) • The filmstrip contains many themes and images. Teachers might first read the script and select one theme s/he wishes to emphasize, such as women's role in Japanese industrialization (found in both Part I and Part II), women's work for world peace, the suffrage and equal rights movement in Japan (again, Part I and Part II), ways in which the western image of "Madame Butterfly" can be countered by presenting strong, active, self-sufficient women both in history and in modern life.

Women in Modern China: Transition, Revolution and Contemporary Times
by Susan Gross &
Marjorie Bingham
GEM Publications Inc., 1980,
106 pages
Jr. High: Advanced
Sr. High: Average - Advanced
Illustrations: Photos; Maps; Graphs
Time Period: 1700-1980
Place: China

Themes: Manchu emperors; Influence of missionaries; Reforms of the Guomindang; 1931 Civil Code; Women's rights organizations; Chinese take-over of Tibet; Tibetan culture; Differences between Han and Manchu peoples; Long March; Cultural Revolution

Description: The curriculum examines reform for women, beginning with the influence of early Christian missionaries who brought education and new ideas on women's status. Stories of women's resistance follow, including defiance of early marriage, foot binding, and limited education. Other topics are: women in Tibet; the Norsu people; Mongol and Manchu women; histories of famous personalities such as Ding Ling, Jiang Quing and Deng Ying Zhao; peasant women and change in the villages; persistence of discrimination in China. A teacher's guide accompanies the student booklet. An excellent sound filmstrip is available that offers a good overview of many of the themes in both the early and modern period. Called *Women in China*, it is 19 mins. and includes a guide and discussion questions.

Suggested Uses: • The booklet abounds in first person accounts. Assign it as a general reading resource. • Link with stories of the early 20th century reform movement in books such as *My Revolutionary Years, Fragments of a Lost Diary.* • Enhance the material with the *Sources of Strength: Women*

and Culture curriculum which gives a slightly fuller treatment of pre and post revolution change for women.

"We find, to our horror, that she has joined a band of girls who have made a vow, writing it with their blood, that, rather than become wives to husbands not of their own choice, they will cross the River of Death."
- **Mother writing to her family in the 1920s**

Women in Traditional China
by Susan Gross &
Marjorie Bingham
GEM Publications Inc., 1980,
120 pages
Jr. High: Advanced
Sr. High: Average - Advanced
Illustrations: Drawings; Paintings; Photos; Maps; Charts
Time Period: 206 B.C.-1900 A.D.
Place: China

Themes: Confucian and Daoist ideals; Anecdotes from Han through Ching Dynasties; Court Strategies; Uprisings, such as White Lotus and Taiping rebellions; Patriarchal family and family hierarchy; Filial piety

Description: This curriculum is an ideal way to illustrate points in lectures. It is divided into two sections: 1) women in exceptional roles as empresses, imperial concubines, warriors, nuns and scholars; 2) common roles for women from about Soong Dynasty to modern times. Chapters focus on the stages of women's lives, family relations

and tensions, specific roles for women, such as the adopted daughter-in-law, widows and divorced women. The custom of footbinding is also treated.

Suggested Uses: The text is infused with short first person accounts. Assign chapters to different students to be used as research. Let them select the most informative accounts to read aloud to class. Class analyzes what the narratives tell about women in historic China. Student "researcher" provides greater detail.

Women of Asia: Patterns of Civilization
Cambridge Book Co., New York
Times Media, 1974, 47 pages
Jr. High: Average - Advanced
Sr. High: Average
Illustrations: Photos; Paintings
Time Period: 5000 B.C.-1971 A.D.
Place: Japan, China, India

Themes: Traditional rights and duties of women and change in their status over time; Contemporary rights for Asian women and comparisons with women in the West

Description: Unit shows the traditional roles of women and contemporary situation of women in three nations. Focus is on contrasting "passive positions of yesterday with their active roles today." It uses photos, overview essays, excerpts from primary sources, and discussion questions. Although it is out of print, we urge teachers to try and track it down because of its good background on historical figures and on women's history.

Suggested Uses: Compare/contrast with the lives of women in traditional and contemporary China, Japan, India, and the U. S. Example: "Based on the readings in this unit, what do you think is the primary quality which all three countries urged their women to cultivate? How would a woman demonstrate this?"

CROSS-CULTURAL
INTRODUCTION

There isn't a hamlet in the world that has not felt the impact of change in the lives of its women. The changing status of women is one of the major revolutions of our time. Propelled by international movements for the improvement of the conditions of women, this revolution has found fertile ground in what Robin Morgan calls the "indigenous feminism that has been present in every culture in the world and every period of history."

This revolution is now on the world's agenda. The breadth of the resources contained in this section attests to the strength of this global focus on women's concerns, verifying the long and universal struggle of women to achieve dignity and acknowledgment. These resources reveal the universality of such issues as the violence against women within the family, women's efforts to achieve adequate education and health, and women's increased participation in economic development.

A number of materials provide information about international networks and conferences, such as that held in Nairobi, Kenya, in the summer of 1985. In these forums Third World women discuss and prioritize the problems they see as important to themselves and their communities, thereby broadening the definition of feminism and placing the concerns of the American women's movement within the context of global issues.

Most of these cross-cultural resources fall into the General Reference/Background category. They offer information about often overlooked countries and historical periods, providing rich opportunities to compare and contrast women's status over time and between cultures. Women's personal experiences are recounted within many of these general background works and in the anthologies of fiction and first person accounts.

③

Background/Reference

A Dialogue On Third World Women: Learning Through The Humanities
Third World Women's Project of the Institute for Policy Studies, 1984, 140 pages
Sr. High: Advanced
Illustrations: Photos
Time Period: 1800-1983
Place: New Guinea, United States, Mexico, Puerto Rico, Jamaica, Argentina, Brazil, Peru, Bolivia, Cuba

Themes: Women and science; Women in art in Papua New Guinea; Women and international division of labor; Working women in Latin America; View of a Bolivian mining woman; The church, the unions, women and the opposition in Brazil; Racism and sexism, viewpoints from Cuba

Description: This pamphlet offers a series of nine talks by eminent women scholars from various fields. These are very readable; the informal tone and language help the lay person to understand the concepts presented. The speakers draw upon their experiences in the field, quoting from women they have met and interviewed and describing scenes and events they have witnessed personally. These are so thought-provoking and of such high quality that students should enjoy reading and discussing them. Top rating. Free of charge.

Suggested Uses: Each chapter could be used as a class reading. • Give students a list of terms to look up or provide definitions ahead of time. • Of particular interest is "Racism and Sexism: They Ain't Genetic You Know! A Look at the Cuban Revolution." It provides an opportunity for comparison of U.S. society with another; it also provides an organized presentation of facts and figures about pre and post revolutionary Cuba. • "Science and the Status Quo" by anthropologist

Karen Sacks presents a provocative hypothesis about reasons for our common beliefs regarding human nature. A lively discussion could follow the reading of this paper.

A Feminist Dictionary
by Cheris Kramarae & Paula A. Treichler
Pandora, 1985, 514 pages
Sr. High: Advanced
Illustrations: None
Time Period: 2000 B.C.-1985 A.D.
Place: World

Themes: Word-making and word-interpreting with a feminist perspective; Feminist contributions to linguistic creativity and scholarship

"I myself have never been able to find out precisely what feminism is: I only know that people call me a feminist whenever I express sentiments that differentiate me from a doormat . . ."
- Rebecca West

Description: This is a dictionary to contradict "Manglish" or the English language as it is used by men in perpetuation of male supremacy. Definitions collected from women throughout the ages challenge the traditonal acceptance of the Oxford English Dictionary as the final arbiter of correct usage. Serious, but with humor, the authors have provided a well-documented collection of words and terms which are provocative of further examination and discussion; i.e. "Girl, like boy, is a term that undoes any implications of status, authority, and true seriousness of purpose." (Harriet E. Lerner, 1967) A fine resource for research in controversial topics.

Suggested Uses: For history classes, assign words such as: Patriarchy, Matriarchy, Imperialism, Pioneer, etc. For English classes, use: Literary History, Language, Public Speaking, Anonymous. etc. Ask

students to compare the feminist definitions with those from a standard dictionary. What are the factors introduced by women's perspective? What impact would general usage of women's definitions have on people's attitudes toward the topics listed above?

Connexions: An International Women's Quarterly
Peoples Translation Service
Jr. High: Advanced
Sr. High: Average - Advanced
Illustrations: Photos; Graphics; Drawings; Cartoons
Time Period: 1982-1986
Place: World

Themes: Creativity; Environment; Women and militarism; Women and technology; Women's words; Prostitution; Global lesbianism; Culture clash; Rebellious women; Women's movements

Description: The themes indicate some of the special issues covered in this quarterly. Through articles excerpted from foreign journals, interviews, cartoons, and a listing of resources, students will learn of the common struggles and concerns of women around the world. Format is attractive and clearly laid out. Top rating

Suggested Uses: Of particular interest is Spring 1986, No. 20, "Marriage," which is recommended for mature student reading -- the courting and marriage customs in 21 countries provide interesting contrast with those of the U.S. • "Polygamy in the 80s," p. 8-10 is a question-and-answer article providing information on a cultural institution about which most Americans know very little. • Show the diagram of a family compound in Burkina-Faso, so that students can follow the discussion with greater understanding. • List the three reasons given for the custom of polygamy in Africa. • What are today's reasons? • Does polygamy as a system benefit women in general?

Development Strategies and the Status of Women: A Comparative Study of the United States, Mexico, the Soviet Union, and Cuba

by Margaret E. Leahy
Lynne Rienner Publisher, 1986,
128 pages
Sr. High: Average - Advanced
Illustrations: None
Time Period: 1860-1985
Place: United States, Mexico,
U.S.S.R., Cuba

Themes: Comparison of liberal/capitalist and Marxist theories of development; Women's progress in the twentieth century in U.S., Mexico, U.S.S.R. and Cuba; Current economic, political, and social status of women in these countries

Description: The author devotes a chapter to each of the four countries under comparison. The background overviews and up-to-date analysis are clearly written and evenhanded -- although Cuba comes out on top having "done quite well in promoting women's equality because of its policy of linking the process of women's equality with national development." Final chapter points out conditions that create a positive thrust for greater equality for women.

Suggested Uses: A good vehicle to help students learn basic differences in the policies of socialist and liberal/capitalist societies. • Groups could be assigned different chapters as background information for a classroom debate on the merits and progress of the approach of "their" country toward equality for women.

> *"Billboards and posters abound in Cuba. Rather than promoting products, they are primarily used to educate and resocialize the population. Examples of the way women are portrayed in such billboards suggest how the government perceives women's social role."*
>
> **- Margaret E. Leahy**

Her Space Her Place: A Geography of Women

by Mary Ellen Mazey &
David R. Lee
Assoc. of American Geographers,
1983, 74 pages
Sr. High: Advanced
Illustrations: Charts; Maps;
Diagrams
Time Period: 1870-1980
Place: World

Themes: Major themes of human geography reinterpreted on basis of feminist scholarship; Cultural comparison, mainly using American data and examples

Description: In the preface to this small gem of a book, the two geographer-authors state that "it is now the time that geographers discover women." The following chapters illustrate women's world through topics such as the geography of the male/female sex ratio, women's migration patterns, spatial patterns of the women's rights movement, sex differences in environmental

perception, and women and the built environment.

Suggested Uses: The authors' style is to raise provocative questions. A quick reading will provide the teacher with numerous class discussion topics. Some of the charts and maps are especially useful, such as the diagram of homes and a neighborhood by the *Women Homemakers for a More Egalitarian Society*, and the map which shows the diffusion of suffrage for women in the United States

> *"It is ironic that in many regards, the detached, isolated, single-family house is more discriminatory against American females than is the Arab house against Arab women."*
>
> **- Mazey & Lee**

I Am Because We Are: Because We Are I Am

by Maria Riley
Center for Concern, 1985, 43 pages
Jr. High: Average - Advanced
Sr. High: Easy - Advanced
Illustrations: Photos; Charts;
Statistics
Time Period: 1980-1985
Place: World

Themes: U.N. End of Decade for Women Conference; Work and economic status; Development; Militarization and war; Health and motherhood; The gender gap; Peace

➡

Description: This booklet places the women's issues in a religious perspective by beginning each chapter with a biblical quote. Most chapters include personal stories from women around the world, raise critical issues and questions about the Decade for Women's goals, and provide nicely illustrated charts for analysis. Well laid out and easy to read. Top rated.

②

Suggested Uses: Limited readers will be able to work with some of the charts and graphics, such as the full page one on "The World of Mothers and Women's Health."

"It should come as no surprise that the World Conferences for Women should have as their goals the survival of the whole human family."
- Maria Riley

Images of Women in Antiquity
by Averil Cameron &
Amelie Kuhrt, eds.
Wayne State University Press,
1983, 282 pages
Sr. High: Advanced
Illustrations: Architectural plans; Drawings
Time Period: 1550 B.C.-1100 A.D.
Place: Iraq, Greece, Turkey, Egypt, Israel, Syria

Themes: Status of women and their roles in Mesopotamia, Greece, Rome, 18th-century Egyptian dynasty, Byzantium (600-1100), Graeco-Roman Palestine and Graeco-Latin Christianity

Description: This series of papers reports on new interpretations of the varied roles of women in the ancient world. Using primary sources, such as illustrations on vases, cuneiform texts, and information from excavations, these essays give evidence about women from poorly documented societies. The papers most easy to follow are: "Women and Witchcraft in Ancient Assyria," "Influential women" (in Greek and Roman literature and history), "The God's Wife of Amun in 18th Dynasty Egypt" (includes Hatshepsut), "Women's Housing in Ancient Greece," "Women on Athenian Vases," "In Search of Byzantine Women," "The Naditu Women of Sippar" (Babylon), "Women in Early Syrian Christianity," "Jewish Women in Religion in Graeco-Roman Palestine."

④

Suggested Uses: Good students might summarize the conclusion of one article, then describe the types of sources and methodology employed. Excellent practice for budding historians.

⑮

Listen Real Loud: News of Women's Liberation
Nationwide Women's Program of the American Friends Service Committee, 1986, 20 pages
Jr. High: Advanced
Sr. High: Average - Advanced
Illustrations: Photos; Graphics; Drawings; Cartoons
Time Period: 1986
Place: World

Themes: Multinational corporations; Chemicals and women's health; Women's international organizations; Contemporary feminist concerns

Description: *Listen Real Loud* is a quarterly publication intended to promote communication between feminist groups worldwide. It contains essays on current issues with an emphasis on linking U.S. concerns with global ones and reviews new resources. Of particular interest is the special section on "Women and Global Corporations" which comes with each issue. We highly recommend this section.

Suggested Uses: A good resource for economics classes and for students interested in the global economy.

Of Common Cloth: Women in the Global Textile Industry
by Wendy Chapkis &
Cynthia Enloe, eds.
Institute for Policy Studies, 1983,
141 pages
Jr. High: Advanced
Sr. High: Average - Advanced
Illustrations: Photos
Time Period: 1600-1983
Place: Australia, Britain, Canada,
France, Hong Kong, Ireland, Italy,
Netherlands, the Philippines,
United States

Themes: Patriarchy and history of
exploitation; Racism; Strikes and
strategies; Union-busting; Feminist
consumer; Multinationals

Description: This account of the
transformation of the textile trade
into a multinational industry with a
great impact on women workers all
over the world is made dramatic
through the first person accounts.
These make clear the concerns com-
mon to women workers in the U.S.
and their underpaid sisters in for-
eign nations. The possibilities for
women organizing on an interna-
tional scale as workers and con-
sumers are illustrated by life experi-
ences. Short chapters, attractive
graphics, and a bibliography of
books, journals, and films for each
country mentioned make this a use-
ful classroom resource.

Suggested Uses: The first chapter,
"The Patriarchal Thread: a History
of Exploitation," could be used in
conjunction with a unit on The Mill
Girls in New England or Effects of
Industrial Revolution on Women in
England.

> *"Hundreds of millions of
> women are involved in the
> chain that runs from cotton
> fields through spinning
> factories, textile mills,
> apparel sweatshops right on
> through to the final
> consumer..."*
> **- Wendy Chapkis &
> Cynthia Enloe**

One Way Ticket: Migration and Female Labour
by Annie Phizacklea
Routledge & Kegan, 1983,
145 pages
Sr. High: Advanced
Illustrations: Tables
Time Period: 1980-1981
Place: Turkey, Netherlands

Themes: Sexual division of labor
among migrant women; Racism and
chauvinism as discriminatory fac-
tors; Traditional patriarchal cus-
toms reinforcing oppressive work
conditions for migrant women

Description: This tiny book is full
of scholarly facts about the reasons
for the poor condition of migrant
women workers in the Western
industrial countries. Only Chapter
6, "Living in between: Turkish
women in their homeland and in the
Netherlands," is appropriate for sec-
ondary students, and it is good read-
ing. Interviews with ten women in a
little Turkish village reveal the hier-
archal relationship between men
and women and the way in which
women have adapted to the migra-
tion of their men to the Nether-
lands. Women from both the Turk-
ish village, Arpa, and from
localities in the Netherlands discuss

gender identity, marriage, labor,
migration (The Women Left Be-
hind), and life in the Netherlands.
The footnotes are a useful source
for further interesting information.

Suggested Uses: The teacher
should read the Introduction which
explains purpose and methodology
of the research. Divide sections of
the study according to the topics.
Have students report on the village
mores first, making a list of tradi-
tions, and then compare these with
the material gathered on the
Netherlands. How has the migra-
tion affected women's roles and
behavior both in Arpa and in the
host country? • For another book
on European migrant women, see
Caroline Brettell's *We Have
Already Cried Many Tears: The
Stories of Three Portuguese
Migrant Women.* (Reviewed here)

> *"In the beginning I found it
> very hard to go out to work.
> But now that I am almost
> forty it is not so difficult
> anymore. It is not so bad for
> older women to go out to
> work."*
> **- Gul, a religious Turkish woman**

Sisterhood is Global: International Women's Movement Anthology
by Robin Morgan, ed.
Anchor Press, Doubleday, 1984,
815 pages
Jr. High: Advanced
Sr. High: Average - Advanced
Illustrations: None
Time Period: 4000 B.C.-1984 A.D.
Place: World

Themes: Women activists through-
out the ages; Pervasiveness of patri-
archy; Significance of the growing
global network among women;

Women as food producers of the world; Women's invisibility in the Gross National Product statistics; Women on the global assembly line; Feminist diplomacy

Description: This encyclopedia of facts, figures, and feminist commentary from 70 nations is a well organized classroom and library research source. Short paragraphs appear under the following headings: Geography; Demography; Government; Economy; Gynography (issues of special import to women); Herstory (historical survey answering the question "What were women doing?"); Mythography (legends, folk tales, myths relating to women's lives); Commentary, written by women native to each country summarizing the current status of its women citizens; and Suggested Further Reading. The book provides students with a wealth of information. Top rating.

Suggested Uses: Comparative studies could be undertaken on a variety of topics: Education for Girls, Infant Mortality, Marriage Age for Women, etc. • Make a list of Unknown Heroines Around the World and have a contest to see which students can find the most information about them.

"Our emphasis is on the individual voice of a woman speaking not as an official representative of her country but rather as a truth teller, with an emphasis on reality as opposed to rhetoric."

- Robin Morgan

The Book of Women's Achievements
by Joan & Kenneth Macksey
Stein & Day, 1975, 276 pages
Jr. High: Average
Sr. High: Average
Illustrations: Drawings; Photos
Time Period: 1500 B.C.-1975 A.D.
Place: World

Themes: Feminine achievers and originators; Intelligence and determination of women; Politics, religion, social reform, law, science, literature, art, music, stage, exploration, sports

②

Description: Twenty-two chapters of varying lengths cover diverse topics (See Themes) in this informative and amusing book. Individual women are given different amounts of attention according to their importance or how interesting their lives were. Fame is not the sole requisite; the authors delight in discovering women who have achieved in modest ways and have been either overlooked or forgotten. This is a profusely illustrated book with one or more drawings or photos on almost every page which add to its appeal for student readers. Top rating.

Suggested Uses: An excellent classroom resource to be used for browsing or assignments according to field of endeavor. A two-page list of Women Rulers, years of rule and country, provides a beginning for more detailed reports.

"It has been our delight to rediscover many women who were celebrated in their day but who are now largely forgotten. Who could imagine that a book by Mrs. E. Ellet written in 1859 could detail over 500 women artists?"

- Joan & Kenneth Macksey

The Family of Woman: A World-wide Photographic Perception of Female Life and Being
by Jerry Mason, ed.
Grosset & Dunlap, 1983, 192 pages
Jr. High: Easy - Advanced
Sr. High: Easy - Average
Illustrations: Photos
Time Period: 1950-1978
Place: World

Themes: Woman's progress through life; The universality of the female experience at play, work, grief and death, at sexual exploitation, and as a wife and mother

Description: Dramatic photos taken by photographers around the world. Most are full page; some show nude bodies and depict the sexual exploitation of women. The strength of the collection is that it represents views of women from every level of society and from many different cultures, and that each picture tells a story of some aspect of women's life. The limited text which accompanies the photos helps to provide a theme. Text most often is a poem. Top rated.

Suggested Uses: There is action and emotion in these pictures. Use with students who are limited readers to discuss what is going on, what the picture represents about that woman's experience, and whether we can generalize to see in it the experiences of all women. • Which pictures can be used to describe the male experience as well? Which only relate to the female? • Students might discuss what pictures they would take if they were to compile a book on women in their community. Or, a book on men.

*"There is no savor more
Sweet, more salt
Than to be glad to be
What, woman, and who,
Myself I am"*

- Denise Levertov

The Neglected Resource: Women in the Developing World

by Kristin Helmore
International Women's Tribune
Centre, 1985, 17 pages
Jr. High: Advanced
Sr. High: Average - Advanced
Illustrations: Photos; Charts
Time Period: 1985
Place: India, Senegal, Kenya, Bolivia, Nepal

Themes: Education; Work in the informal economy; Decade of women; Marriage; Physical abuse of women; Self-help associations

"After three months' travel throughout the developing world, an astonishingly simple answer (for male domination) emerged; because in much of the world, little boys are raised to use and dominate women, and little girls are raised to accept such treatment as normal"

- Kristin Helmore

Description: This is a reprint of an excellent series of articles in *The Christian Science Monitor* (Dec. 17-23, 1985). It offers concise coverage of many of the major problems women in developing countries face. Very readable information, interspersed with first-person accounts, offering ideas on how developed nations can help. Type is small. Top rating.

The Sisterhood of Man: The Impact of Women's Changing Roles on Social and Economic Life Around the World

by Kathleen Newland
World Watch Institute, 1979,
203 pages
Jr. High: Advanced
Sr. High: Average - Advanced
Illustrations: None
Time Period: 1970-1979
Place: World

Themes: Women's legal rights; World-wide struggle for equality; Women's health; Women and the media; Women in politics; Women's work and wages; Women in the family

Description: This comprehensive study draws on examples from over 70 countries to demonstrate the role of women in profound contemporary changes. Each section illustrates the universality of women's struggles and pinpoints challenges for the future. Easy to read and a rich source for research on the international women's movement.

"One thing is certain: changes in economic and social life around the world during the next quarter-century will be intimately connected to changes in the status and roles of women."

- Kathleen Newland

The Tribune: A Women and Development Quarterly

International Women's Tribune
Centre, 1986, 30 pages
Jr. High: Average
Sr. High: Easy - Average
Illustrations: Graphics; Drawings; Cartoons; Charts
Time Period: 1980-1986
Place: Third World

Themes: Women and water; Women organizing; Women and food; Women and global corporations; Women and technology

Description: The list of themes indicates the scope of information in these newsletters and bulletins. The Tribune Centre's primary goal, however, is to serve the needs of women in developing countries, so these really are "how to" bulletins. We include them because they are a source of lively graphics and occasional cartoons. The text is easy and by looking through one or more students will see the extent of international organizing, networking, and resources available. "Clip-art" books provide line drawings of women from different countries which can be reproduced.

The Underside of History: A View of Women Through Time
by Elise Boulding
Westview Press, 1976, 791 pages
Jr. High: Advanced
Sr. High: Average - Advanced
Illustrations: Charts; Drawings; Photos
Time Period: 2000 B.C.-1975 A.D.
Place: World

Themes: Paleolithic age; Transition from hunting and gathering to herding and planting; Life inside and outside ancient cities; Nomadic societies; Forest dwellers; Primary civilizations of Middle East and Asia; European history from middle ages to twentieth century; Historical survey of Third World

Description: This "long walk" through history emphasizing the crucial forces in women's experiences is the textbook that Boulding thought would be the first of many and is surprised to see it still is not. Although the author acknowledges "excessive attention to Western History," her book does treat third world women in the ancient world and chapter twelve is "a breathless summary of 1,000 years of third world history."

Suggested Uses: Use as a basic World History reference.

"The status of women ... is indeed a useful indicator of how society is doing in its historical enterprise of making humans more humane."
- Elise Boulding

The Woman's Encyclopedia of Myths and Secrets
by Barbara G. Walker
Harper & Row, 1983, 1103 pages
Jr. High: Advanced
Sr. High: Average - Advanced
Illustrations: Photos
Time Period: Pre-history - 1980
Place: Africa, Asia, The Pacific Islands, North America, Central America, South America, The Caribbean Basin

Themes: Transition from female-oriented to male-oriented religions in western civilization; History of popular fantasies relating to gender; Presentation of hidden facts which contradict prevailing myths; Origins of words and common expressions

Description: This well-organized encyclopedia is easy to use: marginal notes offer alternative names or terms; a cross-reference system eliminates duplication; references are made to an extensive bibliography; and an informal, "chatty" style of writing will engage most students. The entries are short, but full historical context is provided for several major topics. Most of the entries give the origins and variations of terms and names relating to myths, legends, and religion. Top rating.

Suggested Uses: Use as an alternative source of information on any religion, mythology or ancient culture. The viewing of Christianity through myths and legends may be offensive to some students. Teacher should review entries before assigning. • Find the origin of old sayings, i.e. "heart to heart."

"Through making God in his own image, man has almost forgotten that woman once made the Goddess in hers. This is the deep secret of all mythologies, and the fundamental secret of this book."
- Barbara Walker

Third World-Second Sex: Women's Struggles and National Liberation
by Miranda Davies, ed.
Zed Press, 1983, 252 pages
Jr. High: Average - Advanced
Sr. High: Easy - Advanced
Illustrations: Photos; Cartoons; Graphics
Time Period: 1930-1980
Place: Zimbabwe, Namibia, Eritrea, Mozambique, Lebanon, Oman, Iran, India, South Korea, Sri Lanka, Peru, Grenada

"Join the women's struggle"
"I'll have to ask my husband"

Themes: Women in political organizations and national liberation movements; The experience of armed struggle; Women's post revolution roles; Women and health; Women organizing in the labor force ➡

Description: Women in women's organizations from over twenty Third World countries talk about their experiences and perspectives. All represent their nation's "feminists" and give accounts of their struggles to change their societies. A great way for students to see how Third World women analyse their problems and attempt to solve them. Many anecdotal accounts. Top rating.

Suggested Uses: The cartoons and single readings are especially appropriate for in-class use.

"The leaders are hypocritical....They talk about liberating women but they really believe...that a woman does her revolutionary duty by ironing her husband's shirts, cooking his dinner and providing a cosy and restful ambience for the warrior."

- Abir, a Palestinian

Who Really Starves? Women & World Hunger
by Lisa Leghorn &
Mary Roodkowsky
Friendship Press, Church World Service, 1977, 40 pages
Jr. High: Advanced
Sr. High: Average - Advanced
Illustrations: None
Time Period: 1971-1975
Place: World

Themes: Worldwide hunger; Women as victims of starvation; Women as food producers; Exploitation of women as consumers; Women ignored by development programs

Description: This slim booklet provides evidence of the commonality of hunger as a problem for all of the world's women in both industrialized and developing countries. Through statistics and narrative we learn of the plight of women as mothers, workers and wives who do not receive their share of food or training, most of which is allotted to men. Short chapters and easily read statistics make this a good resource for students wishing to compare conditions for men and women.

Suggested Uses: Use section, "The Problem," as a student reading.

"I am pounding for John, He is sitting idle, With his big stomach."
- Lozi pounding song

Women and Development
by Miriam Miller, ed.
UNICEF NEWS, (Issue #82), 1974, 39 pages
Jr. High: Advanced
Sr. High: Average - Advanced
Illustrations: Photos; Charts
Time Period: 1970-1975
Place: Third World

Themes: The female factor in population; Life of women in the country and in urban slums; Female dependence on males; Women's self-help efforts; Modernization and women; Female illiteracy

Description: This booklet looks at issues confronting women in development in different parts of the world. Each article is short, contains direct quotes or short case histories and ends on a positive note, showing ways women are helping themselves and are being helped. The areas covered are: women in UNICEF programs in Asia, women in Africa including an interview with a Senegalese childcare worker, nine Indian women from many walks of life, Syrian women volunteers, and a Peruvian mother in Lima. The booklet highlights a meeting held to explore ways of improving the lives of Latin American women. Top rating.

Women Creating a New World, (Issue #3)
by Leslie Tuttle, & Haleh Wunder
Oxfam America, 1985, 5 pages
Jr. High: Average - Advanced
Sr. High: Average
Illustrations: Photos
Time Period: 1980-1985
Place: World

Themes: The work and struggle for survival of poor women in developing countries; Women's self-help associations (SEWA in India and MARKALA in Mali); Strategies for change

Description: This pamphlet is full of pictures and information presented in a format that is manageable for class use. Oxfam's "Facts for Action" educational materials (in both text and illustrations), prominently feature women in the family, in agriculture, and in grassroots development projects. They also frequently include short case histories with comments from women.

"Now the whole world comes to see us. When they see and talk about all the activities women do, people begin to say 'Why don't we start these activities in our village? Why not our women too?'"

- Gulal, member of India's SEWA project

Women in Development; A Resource Guide for Organization and Action
by ISIS
New Society Publishers, 1984, 225 pages
Jr. High: Advanced
Sr. High: Average - Advanced
Illustrations: Photos; Cartoons; Drawings
Time Period: 1960-1983
Place: The Philippines, Korea, Vietnam, Thailand, Malaysia, Afghanistan, India, Mali, Mexico, Peru, Bolivia

Themes: Multinationals; Rural development; Health; Education and communication; Migration and tourism

Description: Essential for any study of women's role in developing countries, this large size resource guide focuses on women's relationship to the five major categories listed above under Themes. An overview, historical context, current information, footnotes, annotated lists of resource centers, and a bibliography are included for each section. Short paragraphs and bold print headings make research easy and the graphics are stimulating and provocative. Top rating.

Suggested Uses: Students could choose cartoons and create a layout to illustrate a particular point or tell the story of one factory dispute. • Each chapter has an overview which could be used as a class reading.

"We lived with no knowledge of what was happening in the rest of the world. An 80 day onion strike of 3000 workers in 1978 changed my life forever. The strike woke me up. I started to become active in the world around me."

- **Virginia Rodrigues, Mexico**

①

Women in the Global Factory
by Annette Fuentes & Barbara Ehrenreich
South End Press , 1984, 59 pages
Jr. High: Advanced
Sr. High: Average - Advanced
Illustrations: Photos; Cartoons; Drawings
Time Period: 1960-1983
Place: The Philippines, Malaysia, Hong Kong, Taiwan, Guatemala, South Korea, Thailand, Mexico, Puerto Rico, United States

Themes: History of the global factory; Health hazards; Hospitality girls; U.S. sweatshops and America's role in global factories; Third World women organizing

Description: This attractive booklet is packed with up-to-date information prepared by well-known anthropologists, economists, and journalists. Direct quotes, personal accounts, and cartoons are interspersed with the text to help bring the topic to life. Much of the same material is also covered in a special issue of *Multinational Monitor*, "By the Sweat of Her Brow: Women and Multinationals" (August 1983, vol. 4, #5). Available from Ralph Nader's *Corporate Accountability Research Group*, 1346 Connecticut Ave., N.W., Room 411, Washington, DC 20036. Another source for this same information is "Life on the Global Assembly Line" by Barbara Ehrenreich and Annette Fuentes in *Ms. Magazine*, (vol. IX, No. 7) January, 1981.

Suggested Uses: Use either of the above with the film *The Global Assembly Line*, (16 mm, color, 56 min.). Available from *New Day Films*, 22 Riverview Dr., Wayne, NJ 07470; (201) 633-0212. This documentary does excellent job of showing the lives of women and their attempts to organize in the "free trade zones" in Mexico and the Philippines.

"Multinationals want a workforce that is docile, easily manipulated and willing to do boring, repetitive assembly work. Women, they claim, are the perfect employees, with their 'natural patience' and 'manual dexterity.'"

- **Fuentes & Ehrenreich**

Women in the Third World: A Directory of Resources
by Tom Fenton and Mary Heffron
Orbis Books and Zed Press, 1986, 160 pages
Sr. High: Advanced
Illustrations: Line drawings
Time Period: 1980-1986
Place: Third World

Themes: Organizations, books, periodicals, pamphlets and articles, audiovisuals from and about women in the Third World

Description: This bibliography is a recent and definitive source of information. Some entries are annotated at length, others are listed as supplement. The resource is for advanced students and teachers who wish to find "what's out there" in a subject they are researching. Items are not annotated with secondary student in mind. Available from: *Third World Resources*, 464 19th Street, Oakland, CA 94612. For an audiovisual catalogue we suggest *Powerful Images: A Women's Guide to Audiovisual Resources*, 1986. Available from *Isis International*, Via Santa Maria dell 'Anima 30, 00186, Rome, Italy.

Women in the World: 1975-1985, The Women's Decade
by Lynne Iglitzin &
Ruth Ross, eds.
ABC-CLIO, 1986, 462 pages
Sr. High: Advanced
Illustrations: Charts
Time Period: 1940-1985
Place: World

Themes: Changing status of women; General resistance to change for women; Patriarchal heritage; Evaluation of institutional practices in law, politics, family, media and education as it relates to women

Description: These essays reflect the latest scholarship on women in twenty countries. Many include historical overviews. All cite where there have been major changes, examining the impact of the international Decade of Women. All also detail areas where resistance remains. Although the essays are detailed, they are not difficult to read, are short (approximately 17 pages) and provide insights into countries often overlooked, such as Iran or Singapore.

Suggested Uses: The introduction includes a list of questions students could use to analyze any nation's policies vis-a-vis women. For example: "A 'women's issues' on the political agendas of the parties and candidates," or "Are women clustered into sex-stereotyped jobs?" Before disclosing this list, the teacher might have class draw up their own list.

"Not a country described here has gone untouched by the emergence of "women's issues" in the forefront of political agendas everywhere....However, in not a single country have women gone much beyond the reality gap - the contrast between doctrine and deed, pronouncement and enforcement, superficial rather than profound, change."
- Iglitzin & Ross

Women in the World: An International Atlas
by Joni Seager & Ann Olson
Touchstone Book, Simon & Schuster, 1986, 128 pages
Jr. High: Advanced
Sr. High: Average - Advanced
Illustrations: Maps; Charts; Graphics
Time Period: 1985-1986
Place: World

Themes: Patterns of women's lives in industrialized countries; Differences between developed and developing countries; Statistics that show that women, in both rich and poor countries, are worse off than men

Description: Over 96 beautifully-designed maps and numerous accompanying charts illustrate the world of women in this concise atlas. That women's lives are both absolutely and relatively better off in industrialized nations is disputed by some striking patterns. To name a few: Women make up less than 20 percent of the university faculty, but almost 100 percent of primary school teachers in both Saudi Arabia and Austria. In Haiti women constitute five percent of media employees, in Japan, two percent. The atlas also presents startling differences between women in

the poor and the rich world, such as the 4% of Afghani girls that are enrolled in secondary school compared to Australia's 88 percent, and Jamaica's maternal mortality rate of 106 deaths for every 100,000 births as compared to Norway's fewer than eight deaths. (Reviewed by Laurien Alexandre).

Women's Human Rights Denied
Amnesty International, U.S.A., 1985, 9 pages
Jr. High: Advanced
Sr. High: Average - Advanced
Illustrations: Photos
Time Period: 1985
Place: South Africa, Ethiopia, El Salvador, Taiwan, Argentina, Iran

Themes: Official campaigns to deny human rights; Female victims of illegal arrest, detention, and torture

Description: This well-designed nine-panel leaflet would be an excellent handout for study groups concerned about the 'silencing' of women around the world, through detention, banning, and murder. The leaflet provides capsule summaries of the cases of individual women, such as Winnie Mandela (South Africa), Kongit Kebede (Ethiopia), Marianela Garcia Villas (El Salvador), Lu Hsiu-Lien (Taiwan), Mothers of the Plaza de Mayo (Argentina), and women and children incarcerated in Iran's "Women's Prison." (Reviewed by Fenton and Heffron). The leaflet is free.

Women's Role in Economic Development
by Ester Boserup
St. Martin's Press, 1970, 225 pages
Sr. High: Advanced
Illustrations: Charts; Graphs
Time Period: 1930-1970
Place: World

Themes: Division of male/female labor; Women as agriculturalists; Economic basis for polygamy; Women's loss of status under European rule; Women's revolts against loss of rights; Women and factory work; Education and work of educated women; Women in the urban hierarchy

Description: This book was one of first to examine the often negative impact of development policies and modernization on the lives of women in developing countries. Using data culled from censuses and surveys, it details the introduction of new technologies favoring the advancement of men over women. It is a valuable resource for a study of women's tasks in pre-industrial societies.

Suggested Uses: The text is ideal for economic and sociology classes. The following chapters provide the easiest readings: Chapter Three: "Loss of Status under European Rule," Chapter Five, "Women in a Men's World," Chapter Nine: "The Lure of the Towns."

"In no other field do ideas about the proper role of women contrast more vividly than in the case of market trade. To most Hindus and Arabs, the idea of female participation in trade is an abomination Among African and most people in South East Asia ... a very large share of market trading ... is left entirely to women."

- Ester Boserup

①

Women: A World Report
by Debbie Taylor
Oxford University Press, 1985, 376 pages
Jr. High: Advanced
Sr. High: Average - Advanced
Illustrations: Photos; Charts; Statistics
Time Period: 1975-1985
Place: Norway, Kenya, U.S.S.R., India, Indonesia, Cuba, Egypt, United Kingdom, Australia

Themes: Cross-cultural comparisons of the family, work, education, politics, health, and sex

Description: This indispensable reference combines recent statistics with essays by ten leading women writers. The writers were part of an international exchange. Third World writers (Anita Desai, Manny Shirazi, Buchi Emecheta, Nawal el Saadawi, Elena Poniatowska) describe their impressions of selected developed countries and writers from the rich world (Toril Brekke, Marilyn French, Jill Tweedie, Germaine Greer, Angela Davis) write of their experiences in the poor world. For example, Toril Brekke (Norwegian) describes the family in Kenya while Anita Desai (Indian) writes of her personal views of Norwegian families. These essays are descriptive and chatty in tone. First chapters give brief worldwide overviews on

women in work, marriage, education and politics. Final chapters offer statistics on these themes from every country in the world. Top rated.

Suggested Uses: After reading selected comparative essays, students delineate and discuss aspects of being male and female in American society that might provide subjects for a foreign author to investigate.

"I wanted to embrace these women, lift and carry them off to a place where men take equal responsibility for human well-being; where people do respect 'the divine' in each other, whatever their colour or status But where?"
- Marilyn French on India

①

Women: The Fifth World
by Elise Boulding
Foreign Policy Association, (Headline Series #248), 1980, 62 pages
Sr. High: Advanced
Illustrations: None
Time Period: 12000 B.C. - 1979 A.D.
Place: World

Themes: The "Fifth" World, the invisible world of women; Price to women for "civilization"; Women's alternatives; Global nature of women's movement; The Fifth World today; The Vision of the Future

Description: Plain language in short paragraphs and short chapters make understandable to the student reader Boulding's profound insights regarding the relationship of

➡

women to the power systems of ancient and modern worlds. This book should be required reading for anyone wishing to understand the historic roots of today's complex problems of hunger, distribution of wealth, and development. Statistics are provided to prove women's direct participation in the world economy in spite of their "invisibility" to the organizers of "development" plans. Boulding questions whether technological progress will bring a higher standard of living to the world's women, but urges international networks to cooperate in designing new ways of solving economic problems from the woman's viewpoint. Top rating

Suggested Uses: Chapter 1, "The Invisible World of Women," is a good class reading. Students should be able to define what author means by First, Second, Third, Fourth and Fifth worlds.
• Ch. 2, "The Price of Civilization," provides historical and anthropological data to show how the origin of "women's work is in the home." Have students list the factors that forced women into shouldering the burden of domestic responsibility.

> *"The fifth world exists invisibly, uncounted and unassisted, on every continent, in the family farms and kitchen gardens, in the nurseries and kitchens of the planet."*
> **- Elise Boulding**

"Impressions of Forum '85", *Global Pages*, (Aug/Sept, Vol 3 #4)

by Laurien Alexandre
Immaculate Heart College Center, 1985, 16 pages
Jr. High: Advanced
Sr. High: Average - Advanced
Illustrations: Drawings; Charts; Photos
Time Period: 1980-1985
Place: World

Themes: End of Women's Decade world conference in Kenya (Forum '85); Women in development; Family; Migration; Industrialization; Health; Education; Equality; Peace; Convention of the Elimination of All Forms of Discrimination

Description: A lively, richly illustrated analysis of the key topics examined during the Decade of Women and discussed at the Forum. The best and most concise treatment of this important decade we have read. Includes an activity on conducting an oral history interview and information about nations which have and have not ratified the U.N. document to end all forms of discrimination. It is free. Two excellent videos on the Forum are : 1) *Equality, Development and Peace: Visions from Nairobi*, a seven-part series from *InVision Productions*, 275 Magnolia Avenue, Larkspur, CA 94939, and 2) *It's Up to Us;* cameras follow a Black Georgia-based self-help health group to Nairobi, from Bea Milwe, 107 Harbor Road, Westport, CT 06880.

Suggested Uses: Perfect for classroom handouts during Women's History Week (week of March 8th). Write the Center and ask for a class set. The Center also has another excellent *Global Pages* free issue called "Women: The Issue" (Jan/Feb 1985).

"Notes from Abroad"

Ms. Magazine
Jr. High: Average - Advanced
Sr. High: Average - Advanced
Illustrations: Photos
Time Period: 1970-1985
Place: World

Themes: Contemporary personalities and issues; Historical figures

Description: Back issues of *Ms. Magazine* often contain short, readable articles about women around the world in the section "Notes from Abroad" or "World" or "Lost Women." Some examples: "President Lydia Gueiler Tejada-Bolivia's Answer to Strongman Politics," May, 1980; "Can Two Women Stop the Killing in Ireland?, Interviews with Betty Williams and Mairead Corrigan," December, 1976; "Six Faces of India," December, 1974; "The Woman Who Runs Portugal is a Feminist!," December, 1979; "Olive Schreiner - Woman of the Karroo," August, 1977; "First Feminist Exiles from the U.S.S.R.," November, 1980.

Suggested Uses: Going through back issues of *Ms.* in the library from the years 1975 - 1985, students find articles. Each reads one and answers question: What main points about the woman (women) in the article did the author try to make?

"Women In A Changing World," *Cultural Survival Quarterly*

Cultural Survival Quarterly, 1984, 66 pages
Sr. High: Advanced
Illustrations: Photos
Time Period: 1958-1983
Place: Third World

Themes: Effect on women from tribal groups and ethnic minorities of contact with larger economic and political systems; Imposition of patriarchal standards on egalitarian cultures; Denigration of women's work and status; Exploitation by transnational corporations of women's work; Resistance by women

Description: This special issue of *Cultural Survival Quarterly* presents the findings of twenty-three eminent anthropologists and sociologists as a result of field studies in the areas listed above in themes.

The articles, two and three pages in length and appropriate for advanced students, provide rich information and insights into the lives of people rarely studied whose connection to our own lives is becoming increasingly apparent. Of special importance is the concept of a sexually egalitarian society in which men and women share status and responsibility and in which attempts by "civilized" intruders to alter social system and attitudes are resisted. Only one article about sexual abuse of refugee women in Djibouti, "Reluctant Witnesses," offers material too sensitive for students. Top rating. Available from *Cultural Survival*, 11 Divinity Avenue, Cambridge, MA 02138.

Suggested Uses: Any one of the articles, with the exception noted, could be used for class reading. Ask the students to list the environmental, traditional, or religious factors in the egalitarian societies which have facilitated women's equal status with men. How are these same factors affected by the encroachment of industrialized society? What provisions for women must be made to insure their equal status in industrialized societies?

"Women in a number of Third World countries have begun to communicate in meetings and through newsletters. They have begun to trace the connections between foreign investors' patriarchal assumptions and the sexist notions of their own local officials."

- Cynthia H. Enloe

Anthology

I'm On My Way Running: Women Speak on Coming of Age
by Lyn Reese, Jean Wilkinson, & Phyllis Koppelman, eds.
Avon Books, 1983, 384 pages
Jr. High: Average - Advanced
Sr. High: Average - Advanced
Illustrations: None
Time Period: 3000 B.C.-1982 A.D.
Place: World

Themes: Female coming-of-age in a cross-cultural perspective; First loves and romantic feelings; Concern with appearance; Mother and daughter relationships; Breaking traditions and longings for adventure

*"Looking toward me is the edge of the world
I am trying to reach it.
The edge of the world does not look far away,
To that I am on my way running."*

- Traditional song for Papago girls puberty ceremony

Description: Through personal accounts, excerpts from novels, diaries, songs, letters and poems, young women from different cultures and time periods talk about the years of transition between childhood and womanhood. Conceived as a way of balancing the myriad of writings about males at this age, the editors have grouped their selections around themes that are universal to the female experience. Composed of short and often deeply moving pieces, this collection receives a top rating.

Suggested Uses: Perfect for assignment to Junior High good readers. Older girls might read and then write essays or poems on their own recent "coming of age."

My Country Is the Whole World: An Anthology of Women's Work on Peace and War
by Cambridge Women's Peace Collective
Pandora Press, 1984, 278 pages
Jr. High: Advanced
Sr. High: Average - Advanced
Illustrations: Photos; Drawings; Charts
Time Period: 600 B.C.-1982 A.D.
Place: World

Themes: History of women's protests against war; Women and aggression; Nonviolence as ideology; Women's collusion in war

Description: This collection of women's writings about peace and war is arranged chronologically beginning with a poem by Sappho. Although most selections are from Europe and North America, there are also very moving poems and personal accounts from Japanese survivors of World War II. Several women from different parts of the world have had to face the dilemma of support or opposition to their nation's war policy. The women represent such a variety of backgrounds that their views provide provocative material for thoughtful reading and discussion. The format is attractive with photos and graphics breaking up blocks of print. Top rating.

Suggested Uses: Have students choose a selection and make a report on the woman author. Find out what her role was in the context of her writing. Did she actively support or protest the conflict?

"As a woman I want no country. As a woman my country is the whole world."

- Virginia Woolf

Seasons of Women: Song, Poetry, Ritual, Prayer, Myth, Story
by Penelope Washbourn, ed.
Harper & Row, 1979, 163 pages
Jr. High: Average
Sr. High: Easy - Average
Illustrations: Photos
Time Period: Pre-history - 1979
Place: World

Themes: Girlhood; Menstruation; Wedding; Marriage; Woman's body as sexual center; Motherhood; Aging

Description: In these songs and poems women express their spiritual sensibilities about their identities as women. They reflect the experience of women from an earlier period when fertility was of primary importance in a woman's life. Most originate from North American Indian cultures although a few examples come from Asia and Europe. Much beauty and feeling as well as anthropological information can be found in this little volume; it is a treasure for young girls who may need positive reinforcement about being female.

"The centrality of a woman's fertility... was the cause of much joy and pain and was experienced as connecting woman with the forces of life itself."

- Penelope Washbourn

Autobiography/Biography

Great Jewish Women: Profiles of Courageous Women from the Maccabean Period to the Present
by Greta Fink
Menorah Publishing Co. & Bloch Publishing Co., 1978, 181 pages
Jr. High: Advanced
Sr. High: Average
Illustrations: Photos
Time Period: 104 B.C.-1977 A.D.
Place: Israel, Portugal, Germany, Poland, Russia, United States, Lithuania, Rumania, England

Themes: Achievements of Jewish women in diverse fields; Courage and self-assurance of notable Jewish women

Description: Twenty two women are honored in this small book which begins with women from biblical times to a few living Americans. Of special historic interest are Beruriah, Dona Gracia, Glückel of Hameln, Rebecca Gratz, Emma Goldman, Ana Pauker and Golda Meir. Among the literary and artistic achievers are Rachel, who preceded Bernhardt as a tragedienne, Nelly Sachs, winner of Nobel Prize for Literature, Gertrude Stein, and Louise Nevelson, foremost contemporary sculptor. Honored for their humanitarian accomplishments are Rebecca Gratz, Hannah G. Solomon, Henrietta Szold, Lillian Wald, and Sarah Schenirer, while Rosalind Franklind's scientific discoveries are given the attention they deserve. This is an opportunity to learn about women whose dedication, courage, and energy have benefited the world community. Out of print, but available from Jewish community libraries.

Suggested Uses: Assign chapter on Rosalind Franklin as a report to illustrate the difficulties faced by women who are engaged in research in a field dominated by men. Have other students look for evidence that shows that today's female scientists are operating in a more favorable atmosphere.

Hypatia's Heritage
by Margaret Alic
Beacon Press, 1986, 190 pages
Jr. High: Advanced
Sr. High: Average - Advanced
Illustrations: Drawings; Portraits
Time Period: 12000 B.C. - 1900 A.D.
Place: Iran, Iraq, Egypt, Tunisia, Greece, Italy, France, Switzerland, Germany, Russia

Themes: Rediscovery of the history of women in science; Women, the Food Gatherers; Effect of patriarchal societies on the scientific work of women; Technology developed by women based on their own scientific work

④

Description: From Pre-History to the Nineteenth Century, women's scientific endeavors are described in such a way that even those not versed in science will find the information interesting. Not only are individual women described, but the obstacles of tradition and prejudice which they had to overcome are documented in historical and social context. Lady Anne Conway, for example, had the greatest influence on the development of eighteenth century philosophy and modern science and yet her name is unknown except to scientific scholars. Alic also gives credit to women generally as the "discoverers," beginning with the agricultural innovations of the food gatherers and continuing even through the Dark Ages and the Middle Ages when some women were engaged in important scientific pursuits. In the nineteenth century many upper class women were able to devote their time and talent to scientific pursuits; Mary Somerville was known as the "Queen of Nineteenth-Century Science." Top rating.

Suggested Uses: Use the Prologue as assigned reading for an overview of history of women in science.
• Of special interest for oral reports are: "The Medical Women of Classical Greece," Ch. 2; "Hypatia of Alexandria," Ch.3" Hildegard of Bingen," Ch.5; "James Miranda Stuart Barry," Ch.7;" Caroline Herschel," Ch.9; "Sophia Kovalevsky," Ch.11;" Mary Somerville," Ch.12.

"Had our friend Mrs. Somerville been married to La Place, or some mathematician, we should never have heard of her work. She would have merged it in her husband's and passed it off as his."

- Charles Lyell

The International Dictionary of Women's Biography

by Jennifer S. Uglow
The Continuum, 1985, 534 pages
Jr. High: Advanced
Sr. High: Average - Advanced
Illustrations: Portraits
Time Period: 1200 B.C.-1985 A.D.
Place: World

Themes: Women's strength in action; Women's achievements; Women defiant of their society; Pioneering women "firsts"

Description: This treasure of more than 1500 biographies belongs in every classroom, or at least in every school library. Although the entries are predominantly from Europe and North America, there are enough personalities from the rest of the world to make this truly a cross-cultural resource. For example: Trotula from 11th century Salerno wrote a treatise on gynecology used for hundreds of years; Shigera Takayama, who died in 1977, was a feminist member of the Upper House of Japanese Parliament; Pola Salavarrieta, from Colombia, was executed as a republican spy in 18th century; Omu Okwei of Nigeria was elected the last Market Queen allowed by the British Colonial government; Kang Kequng, widow of Chu Teh, was one of few women Communist leaders to make the Long March. The entries are short but make fascinating reading. A Subject Index and Additional Resource List are included. Top rating

Suggested Uses: Ask one or two students to bring in a list of women's names from the country or area under study. Assign one name per student for the following information: In what time period did she live? What major events took place during her life? Did she have power? If so, how did she use it? Why is she listed? • Ask another student to check the textbook for mention of any of these women in the context of the period or country being studied.

"In writing it (Dictionary) I came to realize that far from presenting a book which was representative of women's experience, I was compiling a book of deviants - - independent, odd, often difficult women who had defied the expectations of their society as to what a woman's role should be."

- Jennifer S. Uglow

First Person Accounts

But I Am Danish, Occasional Papers in Intercultural Learning
by Julie Gehl
AFS International/Intercultural Programs, 1984, 14 pages
Jr. High: Average - Advanced
Sr. High: Average - Advanced
Illustrations: None
Time Period: 1979-1980
Place: Kenya, Denmark

Themes: European-African cross-cultural comparisons in family life and male/female relationships; Racism in Kenya and Denmark; Development issues in Kenya

Description: As a teenager, this young Danish woman participated in an AFS Program and spent a year in Kenya. This account is of her impressions during her stay and her difficulty in readjusting to Danish life upon her return. Her sensitive portrayal of the Africans with whom she became friends and her analysis of the differences between developing and developed countries and African and European values make this an excellent resource. Top rating.

"The relationships between sisters and between girls generally is much stronger than in Denmark. Because of this, my stay in Kenya gave me a much stronger sense of female identity, which was reflected in my attitudes toward people in Denmark. I could be more open and confident with women, but sometimes quite shy in the presence of men."

- Julie Gehl

Revelations: Diaries of Women
by Mary Jane Moffat & Charlotte Painter
Vintage-Random House, 1975, 404 pages
Sr. High: Advanced
Illustrations: None
Time Period: 990-1974
Place: Netherlands, France, Germany, England, U.S.S.R., Sweden, Scotland, Japan, Israel, Brazil, New Zealand, United States

Themes: Significance of the diary as format for women's literary expression; Motherhood as an outlet for women; Making moral choices according to a personal code; Conflicting demands of love and work

Description: These excerpts from the diaries of 32 women from widely different backgrounds and time periods reveal women in an intimate relationship with their surroundings. In "The Pillow Book," Sei Shonagon allows a glimpse of court life in 10th-century Japan by describing the perfect lover's leave-taking. Carolina Maria de Jesus, in "Child of the Dark," records her own life as a Black woman raising children in the slums of Rio de Janeiro in the middle of the 20th century and making her voice heard through grit and determination. Her diaries have been sold in greater numbers than any other book in Brazil's history. Selma Lagerlof, first woman to win the Nobel Prize for Literature, wrote her diary at the age of 14 in Stockholm, Sweden. In this excerpt she recounts a visit in 1872 to a medical school where she was shown among other exhibits, gruesome cadavers. The language of the diaries is simple and straightforward, but the content in some selections requires maturity in the reader for maximum understanding and appreciation.

Suggested Uses: Use an excerpt, from " Child of the Dark," for student reading. • Discuss with class some of these ideas: Can they remember the first time they realized they could read? Are there adults in our communities who do not know how to read? How has it affected their lives? How did reading and writing change the life of this woman? • Assign a student to report on the favelas that exist today in the large cities of Brazil. What is being done to raise the standard of living there? Compare the problems of the favela with those of the inner cities of the U.S.

"I hope that you give the poor people what they want and stop putting the tax money into your own pocket. Sincerely, Carolina Maria de Jesus."

- Letter to a senator

74

Women in War
by Shelley Saywell
Viking , 1985, 315 pages
Jr. High: Advanced
Sr. High: Average - Advanced
Illustrations: Photos
Time Period: 1940-1984
Place: England, France, Italy,
Poland, U.S.S.R., Palestine/Israel,
Vietnam, The Falklands,
El Salvador

Themes: Women in combat;
Women's perspective on war

"To shoot a plane down was something else. We loved it when we had a busy night, just loved it. The men would put up their hands and cheer and the girls were quieter but we felt great."

- Joan Cowey, England

"The presence of women in combat units blurred and decreased the harshness of military life; it lent substance to the… concept of an armed force free of militarism…"

- Yigal Allon, Palestine

Description: Twenty two women from different countries in different wars recount their experiences as nurses, soldiers, guerilla fighters and resistance members. The author provides factual context but never allows it to interfere with the personal accounts of these women about a traditionally male experience. Saywell spent three years traveling and interviewing these veterans whose motivations were not glory but necessity. Most were volunteers who willingly returned to normal peacetime activities. This is an exciting book and will provide material for good class discussion especially about the American participation in the war in Vietnam. Top rating.

"It is hard for people who have never experienced combat to understand the deep fraternity among soldiers that is normally reserved only for males. It is very deep and lasts forever…"

- Brigitte Friang, France

Fiction

A Book of Women Poets from Antiquity to Now
by Aliki Barnstone &
Willis Barnstone
Schocken Books, 1980, 573 pages
Jr. High: Advanced
Sr. High: Average - Advanced
Illustrations: None
Time Period: 2300 B.C.-1979 A.D.
Place: World

Themes: Famous women writers; Women's works found in oral traditions; Universality of women's experiences

Description: This definitive book on women's oral and written poems offers an important vehicle for uncovering women's voice. As the editors state, "the one art in which women have always excelled is poetry. In poetry, from the earliest periods, the highly developed civilizations have produced important women poets. And in the oral traditions of Africa, the American Indian, southeast and central Asia, there have always been women's songs." Selections are from many cultures, tend to be short, and are easy to read.

Suggested Uses: A teacher might choose some of these poems to illustrate the period being studied.

Fragment from a Lost Diary and Other Stories: Women of Asia, Africa and Latin America
by Naomi Katz &
Nancy Milton, eds.
Beacon Press, 1975, 310 pages
Sr. High: Advanced
Illustrations: None
Time Period: 1900-1972
Place: Asia, Latin America, Africa

Themes: Arranged marriage and child brides; Sexual double standards; Life of peasants; Women's status in traditional family structure; Importance of childbearing; Working women in industrial towns; Higher education; Women in revolutionary work; Apartheid

Description: These stirring short stories, many by male authors, examine women's problems primarily in situations where women have limited control over their lives. Some stories show women resolving problems in the context of changing social norms. Stories will be eye openers for students unfamiliar with women's lives in traditional societies. Countries represented: China, South Korea, Indonesia, Japan, India, Vietnam, Philippines, Cuba, South Africa, Sierra Leone, Ghana, Tanzania. Good, sophisticated readers will especially enjoy these selections.

Suggested Uses: Choose one or two for homework and then class discussion. Students will need opportunities to talk about what they have read.

Women Poets of the World
by Joanna Bankier &
Deirdre Lashgari, eds.
Macmillan Publishing Co., 1983, 430 pages
Sr. High: Advanced
Illustrations: None
Time Period: 2300 B.C.-1980 A.D.
Place: World

Themes: Social, economic, literary, and historical conditions from many periods and places; Universality of women's experiences; Famous women writers; Persecution of some women because of their writing

Description: Poems, offering concise descriptions of places, events, and feelings, are an often overlooked source of historical accounts. This collection gives us glimpses of the women's world from times and places as diverse as the Heian period in Japan, when women dominated the literary tradition, or upper class women in 7th century Iran, and a shocking account of the torture of an Algerian woman in the 1930s.

Each chapter has a helpful introduction and contains approximately ten poems. The areas covered are: China, Japan, India, Sumero-Babylonia, Iran, the Arab world, Israel, Latin America, and Africa (including ancient Egypt). The editors have another anthology: *The Other Voice: Twentieth-Century Women's Poetry in Translation*, (W.W. Norton, 1976).

Suggested Uses: Students choose one or two poems from different cultures to be read aloud in class. Class looks for differences and commonalties in themes.

Womenfolk and Fairy Tales

by Rosemary Minard
Houghton Mifflin Company, 1975,
163 pages
Jr. High: Average
Illustrations: Drawings
Time Period: Pre-history - 1975
Place: World

Themes: Women and girls who are moving forces in folk and fairy tales; Women who use their wit to succeed

Description: Collection of readable tales of fine literary merit from China, Ireland, England, Scandinavia, Japan, Syria and Africa. Each features active, intelligent women and are provided as an antidote to the usual wicked witches and insipid princesses.

Suggested Uses: After reading book, students select stories from a more "typical" collection for contrast/comparison. Students discuss the characteristics of the heroes and heroines found in these tales? What attributes and morals is society trying to inculcate through these tales?
• A group either acts one story out or selects one to read aloud.

Curriculum

In Search of our Past: World History Unit
by Susan Groves, et al.
Education Development Center, 1980, 26 pages
Jr. High: Average - Advanced
Sr. High: Average
Illustrations: Drawings; Charts
Time Period: 385-1949
Place: China, Japan, South Africa, Cuba

Themes: Status of peasant women in traditional China compared to feudal Europe; Japanese women in industrialization in the Meiji period; Women and the Chinese Communist revolution in 1949; South Africa women in the anti-pass book demonstrations of the 1950s; The Cuban Family Code

Description: Includes oral history excerpts, readings, discussion questions, role-playing activities, and background information on women during three major periods -- traditional China; industrializing Japan, and during the social and political revolutions in China, Cuba, and South Africa. Profusely illustrated, easy to read, and containing oral history exercises for each section, this resource is top rated.

Suggested Uses: The Teachers Guide includes the readings in the student manual. The guide also con-tains historical information that can be assigned to better readers and older students. • Use the section on "Cultural Comparison: Western Europe and China" to help students identify present-day attitudes and practices which stem from the patri-archal system.

Listen to Women for a Change
by Isabelle Chester, ed.
The Women's International League for Peace & Freedom, 1986, 56 pages
Jr. High: Advanced
Sr. High: Average - Advanced
Illustrations: Drawings; Photos; Maps; Logos
Time Period: 1840-1986
Place: World

Themes: Women changing their own lives and noting the change in the lives of other women in their countries; Problems unique to women in specific countries; Women activists

Description: Women working for change has been a predominant theme for WILPF since its inception in 1915 by Jane Adams and other leaders of the international women's suffrage movement. This attractive, inexpensive book carries on this theme by presenting accounts from 28 women activists from 20 countries. Each woman identifies personal concerns and the general situation of women in her country. The entries are short, some 1/2 a page. Top rating.

Suggested Uses: A perfect vehicle to honor women on International Women's Day (March 8th). Assign different accounts to different students. Students then report to class by answering some of the discussion questions. Example: to what degree did the woman you read about come into conflict with her government and society? How does the woman in your reading define peace? What is your definition of peace?

Sources of Strength: Women and Culture
by Lisa Hunter, et. al.
Educational Development Center, 1977, 108 pages
Sr. High: Average - Advanced
Illustrations: None
Time Period: 551 B.C.-1976 A.D.
Place: China, Nigeria

Themes: Status of women in traditional China and Ibo (Nigeria) culture; Assessment of changes in women's lives over time; Identification of women's power in political, economic, and social spheres

Description: This unit helps students relate information about how women live in other cultures-traditionally and in modern times-to their own lives and choices. Through readings, films, activities, and interviews, students trace the ➡

exercise of political, economic, and social power among Nigerian, Chinese, African-American, and Asian-American women. A section on how to conduct an oral history interview and other activities which allow students to concentrate on decision making in their own lives. Each section can be purchased separately.

Suggested Uses: Teacher can use the background reading as lecture notes. • Assign sections of the background readings on political, economic and personal power in both the traditional and changing society chapters to different groups. Ask each group to list and report to class the major points of information. As a whole, the class could then discuss strategies women used to try to exert some influence over their lives.

The World's Women: A Profile (Poster)
The Population Reference Bureau, 1985, 1 page
Jr. High: Average - Advanced
Sr. High: Average - Advanced
Illustrations: Poster; Graphs; Photos
Time Period: 1985
Place: World

Themes: Population figures by country; Women of childbearing age; Numbers using contraception; Married women; Education enrollment; Women in labor force; Women in national legislatures

Description: The figures in this wall poster are the latest available data or estimates as of 1985. Pamphlets with fuller explanation of the figures are also available. Excellent for student research projects.

①

The World's Women: A Teaching Kit
The Population Reference Bureau, 1985, 50 pages
Jr. High: Advanced
Sr. High: Average - Advanced
Illustrations: Charts; Maps; Graphs; Cartoons
Time Period: 1950-1985
Place: World

Themes: Statistics and analysis on changes for women which have occurred since World War II in areas such as population growth, family size, work, health, economic development, legislation, education, political advancement; Gender comparisons; Cross-cultural comparisons

"The 'silent revolution' is slowly gaining in strength. Women are more educated, more active economically, more successful politically than they were a few decades ago."

- Ruth Sivard

Description: This comprehensive packet contains a large wall poster, "The World's Women, A Profile," a book, *Women, a World Survey*, by Ruth Sivard, and worksheets that ask students to analyze the data, design graphs, analyze cartoons and answer a true-or-false fact sheet based on the readings. The readings and charts bring together the latest available data as of 1985. Top rated.

Women and Men: Changing Roles in a Changing World, *Intercom*, (#81)
by Andrea Karls
Center for Global Perspectives, 1976, 31 pages
Jr. High: Average - Advanced
Sr. High: Average
Illustrations: Charts; Graphs; Cartoons
Time Period: 1900-1975
Place: Africa, China, Latin America, Indonesia

Themes: Proverbs about women from diverse cultures; African women in agriculture; Muslim women secluded at home; Latin American women and economic dependency; Change from the top for women in China; Change over three generations in Indonesia; Attitudes toward childbearing in developing countries

Description: This curriculum examines traditional roles men and women have assumed in society throughout history and then brings this information home through classroom role playing exercises and activities which allow students to examine their own culture. Essays and first-person readings also show how male/female roles are changing with the impact of technology, education, and changes in laws. Top rating.

➡

Suggested Uses: Use more recent data found in Ruth Sivard's *Women, A World Survey*, (reviewed in *The World's Women: A Teaching Kit*) for the activities which rely on statistics.

"What is a woman's role? Why have women assumed responsibility for some tasks and men for others? Is that division universal? What factors -- cultural, economic, political, or social -- have defined women's roles in the past?"
- **Andrea Karls**

Women in a Hungry World
by Lucy Richardson, Herald Ciekot and Judith Sherk
American Friends Service Committee, 1979, 52 pages
Jr. High: Advanced
Sr. High: Easy - Advanced
Illustrations: Photos; Maps
Time Period: 1974-1978
Place: Third World

Themes: Lives of poor women; Similarities of conditions for women throughout the third world; Effect of development policies of both U.S. and developing countries on women; Women and population; Women working for change

Description: Three packets of readings: "What's happening to women?", "Population: What's Good for Women" and "Solutions and Action Suggestions: Who Can Do What." Although this is designed for three study/action sessions, the readings can stand on their own and provide an ideal set of approximately 22 resources. Good for mixed reading levels as they range from short (one page) case histories and interviews to more complex (four pages) reprints of articles, many by well known scholars. Discussion question for each packet, an audio-visual resource list and a list of action suggestions are found in the teachers guide.

Suggested Uses: Divide class into three groups based on packet themes and assign appropriate readings to students within the groups. Each group polls the information they have read, draws up a list of 6 main ideas contained within their packet and reports to full class. After the first "action" group has reported, students brainstorm things they might do, the U. S. might do and developing countries might do to improve the conditions of poor women throughout the world.

EUROPE
INTRODUCTION

In this section educators will find wide-ranging resources on European history from Bronze Age Greece to the Russian Revolution to current campaigns for nuclear disarmament. Recent historical scholarship provides evidence that women played an important role in the development of western civilization. Primary source material indicates that women, although excluded from roles in government and religion, were neither silent nor inactive. Through songs, sayings, diaries, letters and journals we learn about the lives of ordinary women who did not command official attention, but who made significant contributions to their society. Nuns in the early Middle Ages, for example, were in the mainstream of intellectual life even though denied employment in cathedral schools and universities.

This new information places women in their own historical context in contrast to the traditional interpretation which focuses on the status of men. For example, historical periods traditionally considered sentinals of human progress, such as Athenian Greece, the Renaissance and the

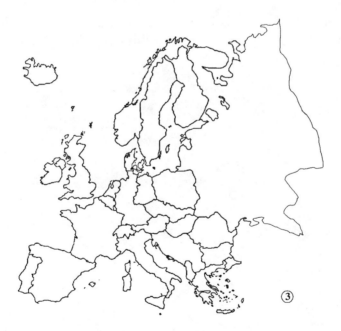

Enlightenment, were actually periods of low status for women. Scholarship on women also reveals the persistant belief that women's reproductive abilities determined their social and political role, an attitude that permeated mainstream thought throughout European history. Female nature was seen as unchanging and opposite from the male's even when new beliefs supported a changing view of the nature of men. Not until the mid-nineteenth century did women's claim to dignity and equal status begin to be considered, and resources in this section show that this struggle continues into the twentieth century.

With the new interest in social history, women's important roles in the European family have also come to light. Often materials in a specific historical period which appear under the heading of "daily life" or "family" will contain interesting information on women. For further research about women's place in other spheres, however, such as the economy, politics, literature, science, and culture, students will have to consult other sources.

Unfortunately, resources for the secondary student do not cover all the important historical periods or areas of women's activities. Much more needs to be done on eighteenth century women, women's lives in Greece and Rome, in the Byzantine Empire, and in regions such as Spain, Central Europe and Scandinavia. In contrast, some periods have a plethora of resources, such as World War II and the Elizabethan Age.

There are fewer recent historical books about European women for average readers and junior high students than for advanced high school readers. We therefore included some excellent out-of-print historical fiction and biographies for young adults when we thought they might still be available in public libraries. We suggest that teachers keep abreast of new Young Adult titles by reading the listing in publishers catalogues, library collections, women's book stores, museums, such as the new National Museum of Women in the Arts, and publishing houses that feature women's material, such as Glenhurst, the Feminist Press, Pandora, and Scarecrow Press.

With very few exceptions, our selections from the USSR focus on life in European Soviet Union. For this reason, our map shows only a small part of this country.

Background/Reference

A Small Sound of the Trumpet: Women in Medieval Life
by Margaret Wade Labarge
Beacon Press, 1986, 238 pages
Sr. High: Advanced
Illustrations: Drawings; Paintings; Sculpture
Time Period: 1100-1500
Place: England, France, Holland, Belgium, Germany

Themes: Position of women and ideas about their role; Queens and noble women; Nuns, Beguines, mystics and recluses; Townswomen and peasants; Outlaws and prostitutes; Women's contributions to medieval culture

Description: This very readable book details the achievements of women from all levels of society in medieval western Europe. It emphasizes women's active role in daily life. Description also of well known personalities such as Hildegard of Bingen and Christine de Pisan, and lesser-known women such as Marie of Oignies (the founder of the Beguine movement) or Isabella de Fortibus (the richest women in 13th century England).

Suggested Uses: This long book is best used as a reference source. Each chapter covers the life of women in different levels of society.

"When we observe medieval married couples in their everyday surroundings, there seem to be a suspiciously large number of dominant wives as well as examples of real affection between husband and wife."

- Margaret Laborge

A Woman's Touch: Women in Design from 1860 to the Present Day
by Isabelle Anscombe
Penguin, 1985, 197 pages
Jr. High: Advanced
Sr. High: Average
Illustrations: Photographs
Time Period: 1848-1981
Place: England, France, Scotland, Russia, Austria, Germany, United States

Themes: The role of design in the mass production resulting from the Industrial Revolution; Women artists and their relationship to the changing concept of art

"There are arts which have no deep message to give the world save that of their own beauty and the artist's joy in making, intimate arts that make life gayer, and yet have all the seriousness of a thing that is felt intensely and worked out with the utmost care..."

- Vally Wieselthier, potter

Description: The book is full of black and white and color illustrations which show not only the women artists but also examples of their work; textiles, tableware, furniture, pottery, and china. The major role of women in the applied arts is documented through accounts of their lives. These accounts are woven into a text which provides the social history necessary to understand the changing concept of art resulting from the Industrial Revolution. Some of the more famous artists are Vanessa Bell, Sonia Delauney and Elsie de Wolfe. Top rating.

An Experience of Women: Pattern and Change in Nineteenth-Century Europe
by Priscilla Robertson
Temple University Press, 1982, 593 pages
Jr. High: Advanced
Sr. High: Advanced
Illustrations: None
Time Period: 1815-1914
Place: England, France, Germany, Italy

Themes: Women's occupations, paid and unpaid; Responsibilities assumed by women; Ways by which authority was exercised by and over women; Attitudes toward women's role; The "woman question" as a new phenomena in the nineteenth century

Description: This is a scholarly work, but a readable one, full of quotes and excerpts from fiction as well as biographies and general reference material. It is divided into

two sections: The Pattern and Breaking the Pattern. Part I covers domesticity, rules for young girls, courtship and marriage, ignorance of sex before marriage, the significance of marriage vows in England, France, Germany and Italy, housekeeping, extramarital affairs, divorce and unmarried women. Part 2 describes the women's movement in France, individual French feminists, German women in politics and as academics and artists, Italian women as nuns, revolutionaries, mothers and workers, and the education and professions of English women. Research of individuals and topics is made possible by voluminous chapter notes providing documentation, an extensive Index, and forty five pages of Bibliography.

Suggested Uses: Refer students to this volume for research on individuals or topics relevant to nineteenth century Europe.

"Mr. Mill presented to the Commons a petition signed by 21,757 women, who asked for the Franchise. The first signature was that of Mrs. Somerville, Mechanist of the Heavens; the second that of Miss Florence Nightingale, Healer on Earth. Right or wrong, the request ought to have been granted to such petitioners."

- Punch, 1868

Becoming Visible: Women in European History
by Renate Bridenthal &
Claudia Koonz
Houghton Mifflin Company, 1977,
486 pages
Sr. High: Advanced
Illustrations: Photos; Drawings; Charts
Time Period: 7000 B.C.-1945 A.D.
Place: Europe

Themes: How structural change has affected women's lives; The family as a definer of women's roles and status; Women as an active historical force as producers, consumers, contributors to family income, and in politics; Change in women's position over time

Description: Twenty essays written to explore women's unique and complex historical experiences from prehistoric times to the mid-twentieth century. Some analyze new sources and reevaluate traditional ones to discover women's history. Others redefine categories which we have used to analyze history, such as the Renaissance as a valid way to describe women's experiences in that time period.

Suggested Uses: The following essays are the most appropriate for the secondary level reader: "Women in Transition: Crete and Sumer," "Sanctity and Power: Medieval Women," "Pedestal and Stake: Courtly Love and Witchcraft," "The Reformation Era," "Women in the Age of Light," "Women in the French Revolution," "Women Revolutionaries in the Russian Populist Movement," "Women and the Spanish Anarchism," "Women in Nazi Germany."

Comrades: Portraits of Soviet Life
by Alan Bookbinder,
Olivia Lichenstein &
Richard Denton
New American Library, 1985,
171 pages
Jr. High: Average
Sr. High: Easy - Average
Illustrations: Photos
Time Period: 1983-1985
Place: U.S.S.R.

Themes: Soviet education; Komsomol, youth group; Directing films; Soviet court system; Fashion industry; Collective farming; Women as Communist Party officials

"Film directing isn't woman's work, but Dinara does such interesting work that I think she's probably the envy of many men."

- Head of Lenfilm studios

Description: This book, a companion to the TV program, *Comrades*, shown on public TV channels in 1986, includes many photos and a chapter about each of the people interviewed on film. Six were women: A young teacher in Moscow; A well-known film director in Leningrad; A people's judge in Moldavia; A peasant grandmother on a collective farm in southern Russia's Kuban Valley; A clothes designer in Estonia; A Communist Party official in Nakhodka on the Pacific Coast. Such great geographical and cultural diversity makes this an important educational tool for understanding the Soviet Union. Woven into the text are historical and cultural facts on each area. This is also a rare opportunity to meet Soviet citizens in their own environment, to read about their daily work, family and friends, and the problems they face. The film, produced by BBC, is available from *Films, Inc.*, 1112 Wilmette Avenue, Wilmette, IL 60091. Top rating. ➡

Suggested Uses: Assign a student to each chapter for oral reports. For each woman compare education, family arrangements, work situations, career opportunities and woman's status with those in U.S. • Of special interest is Chapter 1, "Educating Rita," which contains a lot of information about young people: dating, sex, marriage, education, recreation. This would provide students with interesting data for a discussion to compare with customs in U.S. • Compare the Soviet and the American attitude toward the teacher as a role model. What does the description of Rita's first day in a new teaching job reveal about the status of a teacher?

European Women: A Documentary History
by Eleanor Riemer & John Fout
Schocken Books, 1980, 236 pages
Sr. High: Average - Advanced
Illustrations: None
Time Period: 1789-1945
Place: Europe

Themes: Kinds of paid work for women and their attitudes toward work; Women's organizations to improve work; Variety of political involvement of women; Development of reform and feminist movements; Women and socialism and Nazism; Changing attitudes toward family and motherhood; Women's health; Affect of industrialization and urbanization on women

Description: Short, readable selections written mostly by "average" women - factory workers, shop clerks, housewives. Many are poignant accounts of hard work and miserable conditions. Some are clarion calls for women's rights. There is wide geographic diversity; many selections come from France and Central Europe. Each document is prefaced by an introduction. Top rating.

④

Suggested Uses: The first two chapters on women's work and political involvement are the most appropriate for social studies classes.

"The history of women since the late eighteenth century is to a large extent the history of women forming associations to meet their own needs and promote their special interests. These associations were established by women of all classes and addressed a wide variety of issues."

-Eleanor Riemer & John Fout

Florence Nightingale's Cassandra: An Angry Outcry Against the Forced Idleness of Victorian Women
by Florence Nightingale
The Feminist Press, 1979, 58 pages
Sr. High: Advanced
Illustrations: None
Time Period: 1820-1907
Place: England

⑥

Themes: Discussion of female nature and conventional expectation of women; The restrictions of middle-class Victorian family on women and the resultant restriction of the female intellect and spirit; Rigid class structure; Plea for equality of women in the professions, education, marriage and in the exercise of the intellect

Description: Florence Nightingale's essay reminds us that middle class women in Victorian times were perceived to be without passion, without intellect and incapable of performing active, useful work outside the home. In this angry condemnation of the "cold and oppressive atmosphere" of her society, Nightingale shows herself to be a champion of women's rights. In fact, writing Cassandra (1852) moved Nightingale out of years of immobile desperation into rebellion and reform activities. A good, short biography by Myra Stark precedes the essay. It places Nightingale in the context of her period and describes her as a superb administrator as well as part of the first feminist thrust of the 19th century. Top rating.

Suggested Uses: Students first read the biography which outlines the limitations and expectations of women. Then they read Cassandra and make a list of women's problems as Nightingale sees them. Next to this, they list the reasons this situation existed. Example: Women have nothing important to do. Reason: Women's role was limited to responsibilities of the home and these jobs were not highly valued. • Students might read Virginia Woolf's *A Room with a View* for comparison.

Hellraisers, Heroines, and Holy Women: Women's Most Remarkable Contributions to History
by Jean Blashfield
St. Martin's Press, 1981, 200 pages
Jr. High: Average - Advanced
Sr. High: Average
Illustrations: None
Time Period: 800-1980
Place: Europe, United States

Themes: Unusual, bizarre and often one-of-a-kind experiences of women; Women's "firsts" in history

Description: This compendium of experiences of what the author calls the "tilt-makers" - women whose lives attracted attention for their out-of-the-ordinary feats. Some items are trivial, others bring attention to important female accomplishments. The book is balanced between American and European women. The short (one paragraph) accounts are grouped under such headings as "homebodies," "career girls," "politicos," "amazons" (often women who passed as men), "witches and holy women," "glamour girls," "test tubes and telescopes," etc.

Joan of Arc: The Image of Female Heroism
by Marina Warner
Alfred A. Knopf, 1981, 275 pages
Sr. High: Advanced
Illustrations: Paintings; Posters
Time Period: 1380-1430
Place: France

Themes: The Papal Schism; The Hundred Years' War between England and France; Divisions, civil war and instability in France; Decline of the feudal way of life; Joan's rise to power, decline in her fortunes and resurrection after her death; The religious beliefs and political struggles that made Joan acceptable both during her life and posthumously

Description: This provides detailed analysis of Joan's historic life and role in France, and a look at the legends which grew up around Joan after her death. Using documents from the period, Warner tries to reach the real Joan beneath the myths created by both her detractors and supporters. This fascinating work of historiography is only for readers who already know the story of Joan and who will not be intimidated by the wealth of information about French history, literature and personalities.

"There is no record of what Joan of Arc looked like. The colour of her eyes, the colour of her hair, her height, her weight, her smile, none of it is described until later. The face of the heroine is blank; her physical presence unknown."

- Marina Warner

Suggested Uses: The story of Joan is found in Albert Paine's *The Girl in the White Armor* (reviewed here). After reading the straightforward account, good students can use this resource by selecting any of the following relatively simple chapters to make a report on one aspect of Warner's thesis: One, "Maid of France" (Joan in the Christian tradition of the cult of the virgin); Four, "The Prophet" (Does Joan fit into the tradition of mystical prophets?); Nine, "The Vindication" (The efforts to restore Joan's name and prestige).

liberazione della donna: feminism in Italy
by Lucia Chiavola Birnbaum
Wesleyan University Press, 1986, 263 pages
Sr. High: Advanced
Illustrations: Graphics; Cartoons; Photos
Time Period: 1870-1985
Place: Italy

Themes: Female deities, madonnas and saints; Women in 19th century socialism; Women in the industrialization of Italy; Workers' movement before World War I; Women's interpretations of Marxism; Tacit and open resistance to Nazis and Fascists; Cultural revolution under John XXIII; Political and cultural evolution of Italian feminism from 1968 to the present; Women in the peace, ecology and non-violent movements; Women and the world of Catholicism and communism; Struggles for feminist legislation, such as divorce and abortion rights

Description: This historical study brings us the thoughts and deeds of women who, as feminists, have participated in the enormous change that has occurred in Italy since the mid 19th century. The varying threads of the women's movement and the development of a feminism that seeks the genuine equality and integrity of differing interpretations are explored through the experiences of a galaxy of contemporary women, from Catholic matrons and housewives to prostitutes, nuns and feminist writers and thinkers.

Suggested Uses: Teachers will have to provide a focus for the material in this large book. The following chapters may be assigned as single readings: "Earth mother, Godmothers and Socialists" (Women's historic symbols and feminist strivings in the 19th century); "Women Under Fascism/Resistance;" "Unedited Feminism" (different paths of groups in the 80s). • Hand out some of the pages of feminist graphics and posters. Students decide what issues these were designed to address. Then they do research on American graphics and cartoons which are used to forward a cause.

> *"Mussolini said the test of his fascist regime would be the increase of population for the military purposes of the state. On this text, Italian women answered the fascist dictator in an effective manner: the Italian birth rate fell during Mussolini's regime and has continued to fall to this day."*
>
> *- Lucia Birnbaum*

Life in Russia
by Michael Binyon
Pantheon Books, Random House, 1983, 280 pages
Jr. High: Advanced
Sr. High: Advanced

Illustrations: None
Time Period: 1970-1982
Place: U.S.S.R.

Themes: Difficulties of daily life for women; Changing attitudes of young people toward sex and marriage; New image of the ideal woman

Description: Author, a British journalist who lived in Soviet Union several years, describes Soviet life with affection and objectivity. Chapter II, "Women and Families," presents the same story of women's greater burden of work and domestic responsibilities that is found in the feminist literature. Ch. IX describes Soviet Youth and its changing attitudes and behavior. Style is informal and anecdotes make it pleasant reading.

Suggested Uses: The chapter on women and families can be used to compare with material in *Moscow Women* by Hansson and Liden, *We Live in the Asian U.S.S.R.* by Ryabko. (Reviewed here). • International Women's Day, p. 35, is described. Compare it with U.S. celebration. Discussion: What is it women in the Soviet Union want that they do not have now? Are American women concerned about the same issues? How do they differ? On which demands would American and Soviet women agree?

> *"It is the state that now wants to get women off the shopfloor and back to the hearth, while the younger generation has taken over the ideals of the early revolutionaries--free love, the smashing of traditional patterns of life."*
>
> *- Michael Binyon*

Medieval Women
by Eileen Power
Cambridge University Press, 1976, 144 pages
Sr. High: Advanced
Illustrations: Portraits; Drawings
Time Period: 1100-1600
Place: Europe

Themes: Medieval attitudes about women; Roles of working women in town and country; The lady; Nunneries; Education of women

Description: This attractive little book makes an excellent resource book for advanced students who will delight in the many illustrations as well as the short pithy quotations from original sources. Each chapter contains enough factual information to provide one or more students with material for reports.

Suggested Uses: Make a list of the rights and restrictions of Medieval women. • Compare these with 20th Century American women. • Compare the ideal budget of a lady as suggested by Christine de Pisan with that of a modern middle class housewife of U.S. • What were some of the duties of Medieval women not asked of today's wives? • Compare attitudes toward children and their care then and now.

Most Dangerous Women: Feminist Peace Campaigners of the Great War

by Anne Wiltsher
Pandora, 1985, 217 pages
Sr. High: Advanced
Illustrations: Photos; Cartoon
Time Period: 1914-1948
Place: England, Scotland, Sweden, Austria, Germany, Holland, U.S.S.R., United States

Themes: Connection between feminist and peace movements during World War I; International activities carried on by pacifists and feminists from many countries; Founding of Women's International League for Peace and Freedom; Split between suffragists over issue of supporting World War I

Description: Half of the leaders of the suffrage movement in Britain opposed the First World War. The Pankhurst group enthusiastically undertook war work, but the others joined forces with feminists from other countries to develop a strong international peace movement. This lively little book documents that activity which resulted in the Women's International League for Peace and Freedom, still providing leadership in the cause of peace. Wiltsher makes her heroines come alive through her vivid descriptions and use of direct quotes. These were women who braved public ridicule and arrest for their beliefs, true foremothers for today's women of Greenham Common. Although the activities of British women are emphasized, such leaders as Rozika

Schwimmer and Jane Addams are also included. Top rating.

Suggested Uses: Use first page and a half of the Introduction as a class reading. Ask: What were the goals of these suffragists? Which countries did they represent? • Assign individual women to a few students for oral reports. What backgrounds did they represent? How effective were they? • How did the Russian Revolution create dissension among the ranks of feminists and pacifists? • Have one or two students report on Greenham Common, British women's peace camp in England. See *Greenham Common: Women At The Wire* (reviewed here) for an account of women's peace activities today in Britain.

> *"War is the enthronement of force and the dethronement of reason, and the history of women's progress makes it plain that women have everything to gain by the dominance of reason... it has only been where militarism has been brought under control that women have made headway in any progressive direction."*
>
> **- Patrick Dollan**

Night Witches: The Untold Story of Soviet Women in Combat

by Bruce Myles
Presidio Press, 1981, 278 pages
Jr. High: Advanced
Sr. High: Average - Advanced
Illustrations: Photos
Time Period: 1941-1945
Place: U.S.S.R.

Themes: Struggle of women to overcome traditional opposition to women in combat; Skill, bravery and femininity of women in air regiments

Description: Three female regiments of fighter pilots, bomber pilots and night bomber pilots and their crews, played a critical role in the defense of the Soviet homeland against the Nazi invaders. Through interviews with survivors we hear first hand accounts of thrilling air battles as well as poignant memories of personal wartime relationships. These lively anecdotes lend themselves to dramatic supplementary class readings in study of World War II.

Suggested Uses: Following references are especially good: Struggle of women to participate as equals, pps. 87-108; Bombing raid on Stalingrad tractor factory, 131-133; Night drop of supplies to Soviet troops, Novorossisk 203-206; Special concerns of women in wartime, 213-218; Dogfight over Stalingrad, 209-212. In reading aloud some accounts, keep gender of pilots unknown until very end for dramatic effect. • For special research, compare this experience with that of women flyers in U.S., England or France, during same time period.

> *"...admiring a beautiful girl was one thing, and wanting to fly with her was quite another. Lily and Katya Budanova were in for a terrible time before they were allowed to do the job they'd come to do."*
>
> **- Bruce Myles**

Not In God's Image: Women in History from the Greeks to the Victorians

by Julia O'Faolain &
Lauro Martines, eds.
Harper, 1973, 331 pages
Jr. High: Advanced
Sr. High: Average - Advanced
Illustrations: Photos; Drawings; Cartoons
Time Period: 1600 B.C.-1893 A.D.
Place: Greece, Italy, Turkey, Palestine, Germany, France, England, Spain

Themes: Woman's image in male eyes; Close-up picture of ordinary women's lives: status, social roles, degrees of freedom or tutelage, and mental conditioning; Origins of present day attitudes toward women

Description: The lives of ordinary women from different social classes are presented through excerpts from writings by and about women. Present day attitudes toward women have their origins in religious and political restrictions on women which became institutionalized under patriarchy. Social and historical context for the extracts is provided in short pithy sentences which lend ironic humor to much of the material. The chapters are arranged chronologically, so students can easily research the status or social roles of women in any particular period.

Suggested Uses: Of great appeal to students would be the many examples of instructions to daughters, wives, and women in general of proper behavior as decided by fathers, husbands, rulers. • Chapter X, section 3, is about education for girls. What subjects were encouraged for girls? How did social class determine the kind of education thought important? • Chapter IX, section 5 on witches, provides information on the extent of witch hunts during the Renaissance/Reformation period. • Develop a chart with topics such as Marriage, Education, Work, Punishment, Protestant wives, Nuns, etc. and ask students to find direct quotes applicable to each. Compare with modern sayings on same topics.

"The image of God is in man and it is one. Women were drawn from man, who has God's jurisdiction as if he were God's vicar, because he has the image of the one God. Therefore woman is not made in God's image."

- Gratian, a jurist

One Hand Tied Behind Us: The Rise of the Women's Suffrage Movement

by Jill Liddington & Jill Norris
Virago, 1978, 304 pages
Sr. High: Advanced
Illustrations: Photos; Drawing
Time Period: 1867-1918
Place: England

Themes: English suffragists; Working women; Radical politics; Working class political activism; Winning the right to vote; Working class labor conditions

Description: This is a thorough, well-documented historical account of the efforts and experiences of women who demanded more widespread radical reforms than just the vote to better women's lives. Using

statistical data and first hand descriptions of working conditions in Northern England, the authors make clear the reasons for the difference in attitudes and methods of these working-class women suffragists from their middle-class sisters led by Evangeline Pankhurst. Education, child care, health measures, and unemployment insurance were basic concerns of these women, and they did not always approve of the violent tactics of the Pankhursts.

Suggested Uses: The chapter on daily life of working women could be used as supplemental text material to provide breadth for the social history segment of this era. • Use as research source for advanced students. Report on specific attitudes and experiences which led to political differences between suffragists of the north and those of the south (London). • Choose one woman leader (Esther Roper) and compare with an American suffrage leader (Susan B. Anthony). Were they interested in the same issues? How did their audiences compare? How did they learn to be effective speakers? In what respects did they have similar experiences?

"Women working in the cotton mills could call on an unusually long tradition of both radicalism and feminism, and by the 1890s had become by far the best organized group of women workers in the country..."

- Jill Liddington

④

Picking Up the Linen Threads: A Study in Industrial Folklore
by Betty Messenger
University of Texas Press, 1978, 228 pages
Jr. High: Advanced
Sr. High: Average - Advanced
Illustrations: Photos
Time Period: 1900-1935
Place: Ireland

Themes: History of linen manufacturing; Types of work in textile mills; Children's labor; Clothes, tools, songs, customs of the mill workers; Mill social hierarchy

Description: An account of the folklore and reminiscences of women who worked in the flax spinning mills and linen weaving factories. Conversations with these workers reveal a brighter side to this work than is usually described, and show the importance of the mill as a means for social interaction. The author wishes to document job satisfaction as a way to show the pride and creativity women brought to this otherwise repetitive work. Full of technical details about the working of the mill.

Suggested Uses: Assign or read from chapter three, "The Spinning-Room Workers," for information about children's labor and life in the mills. • Use as a reference book for research on the makeup of textile mills.

"Never marry a reeler,
For you wouldn't
know her pay.
But marry a good
old spinner,
With her belly wet all day."

- Mill Song

Riding The Nightmare: Women & Witchcraft
by Selma R. Williams & Pamela J. Williams
Atheneum, 1978, 208 pages
Jr. High: Average - Advanced
Sr. High: Average
Illustrations: Engravings; Paintings
Time Period: 500-1500
Place: Europe, United States

Themes: Focus on circumstances of some individual women as victims; Contrast in attitudes of ancient world revering women as goddesses and killing of witches in Middle Ages; Church as source of anti-woman attitudes; Precarious life of women healers; Connection between anti-semitism and misogny; Malleus Maleficarum; Papal Bull silencing critics of witch-burning; Predominance of women over men as accused witches

Description: The book is divided into three parts: Part I covers the route of the witch craze across Europe: Part II describes witch hunting in Britain: Part III treats the Salem, Massachusetts, witch trial as a case study showing the reason for the preponderance of women among "witches." The authors describe the changes in European attitudes toward women, from their worship as goddesses before the Christian era, to the honor accorded Abbesses as Earth Mothers, to the fear and hate toward women perceived as witches during the Middle Ages. They trace the legendary and Biblical sources of this hysteria. Women, as the daughters of Eve, were suspect by the Church who considered them inferior beings and a source of temptation to men. The use of torture for obtaining confessions of guilt was heightened by the publication of the encyclopedia of witchcraft and demonology by two inquisitors who persuaded Pope Innocent VIII to issue a papal bull silencing opponents of witch hunts. Many illustrations help to illuminate the contemporary image of witches including an etching by Albrecht Dürer.

Suggested Uses: Look at John Knox's "The First Blast of the Trumpet against the Monstrous Regiment of Women" (excerpt on p. 65) to illustrate the reason for the fear of women's power. Have students report on the women rulers of Europe in the 16th century. • Student could report on sayings of Church fathers which denigrated women as objects of fear or suspicion.

"Where the devil finds greatest ignorance and barbarity... there assails he grossliest, as I gave you the reason wherefor there was more witches of women kind than men."

- King James of Scotland

Roman Women: Their History and Habits
by J.P.V.D. Balsdon
Barnes & Noble Books, 1983,
284 pages
Sr. High: Average - Advanced
Illustrations: Geneological tables;
Paintings; Statues
Time Period: 753 B.C.-337 A.D.
Place: Italy

Themes: Areas where women achieved some power and restrictions on their lives; Well-known women, such as Julia, Livia, Zenobia; Political intrigues during Republic and within courts of emperors; Customs such as marriage, divorce, concubinage, daily life

Description: Drawing on documents, speeches and accounts from the period, Balsdon describes incidences of the nature of women's experiences in different historical periods. All these women appear in male writings, of course, because nothing written by a woman has survived. A variety of women from slaves and concubines to vestal virgins and noble women appear in this readable and sometimes gossipy book. There are two parts; the first is on women in Roman history, the second is on the habits

and lifestyles of women throughout many periods. Students should have a basic knowledge of Roman history before undertaking the book. Top rating.

Suggested Uses: Students might use index to pick a topic or a personality or a theme to research in the book. • In Part Two (Habits) student selects a topic (ie. children or women's daily life) to read and report to the class.

"The increasing emancipation and self-assertion of women was symptomatic, and in 195 B.C. a tremendous issue was made in the Senate of the repeal of the Oppian law. Passed twenty years earlier under the critical stress of war, it appeared to women and those who shared their views to have lost its reason for being. Women even went as far as to behave like early twentieth-century suffragettes to demonstrate publicly in the streets at the time of the debate."

- J.P.V.D. Balsdon

Soviet Sisterhood
by Barbara Holland
Indiana University Press, 1985,
264 pages
Jr. High: Advanced
Sr. High: Advanced
Illustrations: None
Time Period: 1970-1985
Place: U.S.S.R.

Themes: Soviet view of feminist theory; Soviet philosophy on child development

Description: This collection of scholarly essays by nine British women is very adult reading. The

introduction, however, presents three letters printed in the Soviet press and quoted in a recent Soviet book. Each of the three women letter writers describes a different aspect of the same problem, the reality of inequality for women in today's Soviet society. The letters make interesting and provocative reading for students.

Suggested Uses: Reproduce the three letters and use as class readings. Compare the problems presented with the condition of life as described by other Soviet women in such books as 1) *We Live in the European U.S.S.R.* by Ryabko, and 2) *Moscow Women* by Hansson and Liden. What are the chief concerns of Soviet women? How do they compare with problems American women face? Have students bring in letters from the American press which express dissatisfaction with women's role today.

"Apparently, to be in charge of a male workforce is unfeminine. It's as if I've applied to be the attendant in a men's bath house."

- Tamara, a technician

The Obstacle Race: The Fortunes of Women Painters and Their Work
by Germaine Greer
Farrar, Straus & Giroux, 1979,
327 pages
Sr. High: Advanced
Illustrations: Paintings
Time Period: 970-1900
Place: Europe, United States

Themes: Women who were pioneers in art; Common motivations, psychological as well as social barriers, and general experiences of women artists; Nature of women's art in primitive, still-life and

➡

portraiture; Amateur female artists; Art in the cloisters; Women in the 18th and 19th century academies; Well known artists

Description: Greer strives to give an impression of women artists as a group; therefore, some of the best known, such as Cassat and Morisot, are not prominently featured. There is, however, a fascinating chapter on Artemisia Gentileschi, and on Bolognese painters (15th and 16th centuries). The rest of Greer's book offers insights into tantalizing topics such as women artists in relation to their families, why women's art tends to be small and limited in output, women artists' perception of love and sex, and so forth. A handsome book with many of the reproductions full page and in color.

Suggested Uses: The following chapters provide the fullest historical information: "The Cloister," "The Renaissance," "The Magnificent Exception," "The Bolognese Phenomenon," "The Age of Academies," "The 19th Century."

"In the nineteenth century we find intrepid young women setting out to find the kind of art instruction that suited their talent, often quite alone and very far from home. It is astonishing that their parents allowed it, and argues a power of motivation which few female artists, with magnificent exceptions, had ever exhibited before."
- Germaine Greer

The Russians
by Hedrick Smith
Random House, Ballantine, 1976, 682 pages
Jr. High: Advanced
Sr. High: Average - Advanced
Illustrations: Photos
Time Period: 1972-1975
Place: U.S.S.R.

Themes: Inequality of women's status; Generational tensions; Youth attitudes; Lack of child care facilities; Political conformism of youth

Description: The entire book is fascinating reading because Smith combines historical and political context with anecdotal material in a conversational style. Chapters 5,6,7, on Women, Children, and Youth, however, provide the greatest amount of information on the status of women. Smith, his wife and four children lived in Moscow for three years and had the opportunity to share and observe the daily life of Soviet citizens. His comments bear out the findings of other Western commentators regarding the double burden borne by Soviet working women as well as the enthusiasm of the youth for Western pop music and clothes.

Suggested Uses: Chapters 5, 6, and 7 would make good reading for students to provide them with some insights into the Russian people and their style of living.

"One practical impact of Soviet Puritanism is that birth control winds up being more a matter of reacting after pregnancy than of planned prevention."

- Hedrick Smith

The Weaker Vessel
by Antonia Fraser
Alfred A. Knopf, 1984, 470 pages
Sr. High: Advanced
Illustrations: Paintings: Drawings
Time Period: 1603-1702
Place: England

Themes: Arranged marriages and constant child bearing; Women's role in the Civil War; Women as authors, actresses, prostitutes, market women, nurses and midwives, holy women and women condemned as witches; Bluestockings; Quakers and Puritans; Women who spoke out

Description: The freely employed prescription of women as the "weaker vessel," spiritually, morally and physically, is challenged in this portrayal of the varied lives of 17th century England. Drawn from letters, journals, anecdotes and other contemporary accounts, the book delineates beliefs about the nature of women, and then describes the varied roles of women from ladies of the court to the ordinary housewife. Fraser's descriptive prose gives a feel of the period.

Suggested Uses: There is an overwhelming amount of information. To focus, students might read

one of the following chapters: Chapter Three, "Crown to her Husband" (woman as wife and her housewife duties); Chapter Four, "The Pain and the Peril" (childbearing); Chapter Ten, "His Comrade" (women in the Civil War); Chapter Twelve, "Sharing in the Commonwealth" (Women speaking out); Chapter Nineteen, "The Delight of Business" (Small entrepreneurs); Epilogue: "How Strong?" (women at the end of the 17th century). • Use as a reference book. Select one topic, such as, appearance, Aphra Behn, witchcraft, etc.

"Most admirable wives spent their adult life... burying children, in a great cycle of birth and life, birth and death, but at any rate birth and birth and birth, which meant that they were generally either crescent or descendent."

- Antonia Fraser

The Women Troubadours
by Meg Bogin
W.W. Norton, 1976, 179 pages
Sr. High: Advanced
Illustrations: Photos; Maps
Time Period: 1150-1250
Place: France

Themes: Attitudes toward women from early to late Middle Ages; Response of ladies as objects of "courtly" love

Description: This scholarly work is appropriate only for advanced students with a special interest in poetry and music. It provides rich historical detail and quotes in English as well as Old Provencal from many of the famous, as well as little known songs sung by troubadours.

Suggested Uses: ONLY for advanced students interested in music and poetry and/or culture of Medieval France.

*"... the lover ought to do her bidding
as toward a friend and lady equally,
and she should honor him the way
she would a friend, but never as a lord."*

- Maria de Ventadorn

Victorian Working Women: Portraits from Life
by Michael Hiley
Godine, 1980, 133 pages
Jr. High: Advanced
Sr. High: Average - Advanced
Illustrations: Photos, Drawings
Time Period: 1851-1873
Place: England, Belgium, Wales

Themes: Working women in mid-nineteenth century England; Henry Mayhew's accounts of London street life; Diary entries of Arthur Munby; Strength and courage of women doing hard work; Campaign to save the work of pit-brow lasses; Female gymnasts; Women miners in Belgium and South Wales

Description: This is a unique historical document from the nineteenth century. If it had not been for the extraordinary interest in the lives of working class women shown by Arthur Munby, a London barrister, there would be little pictorial documentation of the appearance of women laborers and a record of their comments. Munby kept a diary of his conversations with these women as well as the photos he paid to have made of them. Although he romanticized their physical strength and appearance and the spirit they showed, he showed his support of their cause by leading a delegation to Parliament in defense of women's right to work on the pit brow of coal mines. In this book Hiley gives us these pictures, excerpts from the diaries, and a text which sets the background for the work and the political implications it had for Parliament. This book can be used to illustrate women's work in the Industrial Revolution and the mores and values of the Victorian Era. Top rating.

Suggested Uses: Use with units on The Industrial Revolution and/or the Victorian Era in Britain. Use in conjunction with the following curriculum (Reviewed here): *Coalmining Women* by Angela John, Cambridge University Press; "Women and the Industrial Revolution" from World History Units, *In Search of Our Past*, Education Development Center.

We Live in the Asian U.S.S.R.
by E. Ryabko
The Bookwright Press, 1984,
57 pages
Jr. High: Average
Sr. High: Easy
Illustrations: Photos
Time Period: 1980
Place: U.S.S.R.

Themes: Interesting variety of occupations in an "exotic" land; Kazakhstan, Samarkand, Uzbekistan, Siberia, Uzbekistan; Equality of women's job opportunities

Description: Only seven women are interviewed in this book, but they are especially interesting since we know comparatively little about life in Soviet Asia. Attractive women speak enthusiastically of their lives and allow students to identify with their common interests, an important objective of global education. There are two or three color photos on every page. Also available is *We Live in the European U.S.S.R.* by E. Ryabko.

Suggested Uses: Use in classroom as reference or reading assignments of very short biographical sketches. Each woman could be a topic for oral or written report to illustrate variety of jobs available, child care facilities and living conditions.

"I do exactly the same job as my male colleagues."

- Natalia Gellert, tractor driver, Kazakhstan.

Witches, Midwives, and Nurses: A History of Women Healers
by Barbara Ehrenreich &
Deirdre English
The Feminist Press, 1973, 41 pages
Jr. High: Advanced
Sr. High: Average - Advanced
Illustrations: Woodcuts; Portraits
Time Period: 1300-1799
Place: Europe

④

Themes: Church and secular attitudes toward women healers from Middle Ages to Age of Reason; Witch-hunts in Medieval Europe

Description: This attractive booklet presents a short history of women as healers from Medieval to Modern times and has a bibliography for further study. The focus is on witch-hunts as part of the social upheavals in Europe during 14th - 17th centuries. Included is the story of Malleus Maleficarum, a book of instructions to witch-hunters and judges on how to recognize and convict women as witches, which resulted in the death of millions of women.

Suggested Uses: • The first paragraph of the Introduction could be used on an information sheet regarding the history of women as healers, followed by an assignment based on the rest of the 18 pages dealing with the Middle Ages. • Through individual or group reports, explore these questions: 1. What was the extent of the witch-hunts over four centuries in Europe? 2. Quote from Malleus Maleficarum to show its influence. 3. What were the supposed "crimes" of the accused women? 4. List the healing methods or medicine used by "witches" which are today accepted as good medical practice. 5. How did the official European medical profession change in the 13th century? Why? 6. Use the case of

Jacoba Felicie to illustrate the suppression of women healers by the university authorities.

"If a woman dare to cure without having studied she is a witch and must die."

- Malleus Maleficarum

Women at War; Five Heroines who Defied the Nazis and Survived
by Kevin Sim
Wm. Morrow & Company, Inc.,
1982, 286 pages
Jr. High: Advanced
Sr. High: Average - Advanced
Illustrations: None
Time Period: 1930-1945
Place: France, Poland, Norway, Germany

Themes: German invasion of Norway, France and Poland; Life in occupied countries; Reign of terror in Poland; Survival strategies of enemies of the Reich; Reaction of German people to Hitler; Analysis of Nazism; Special problems of women resisters

"My mother was outspoken and outspokenly patriotic. She didn't know what fear was. Her heart was in the job one hundred percent - and she knew how to communicate it. That made a lot of people follow her, I mean blindfoldedly they used to follow her."

- Maurice, Mary Lindell's son

Description: These are extremely readable, dramatic stories of courageous resistance and survival by women who were still living at the time of the book's publication.

➡

Included is the life of an aristocrat who organized major escape routes from France; a Norwegian pacifist whose whole family clandestinely worked against the German and Quisling government; a Polish Communist who gave birth to twins while imprisoned for her resistance activities; a German girl's long and lonely work comforting people in German prisons; and a Jewish girl's ordeal and survival in Auschwitz. The details of these women's lives are set against interesting background information on each country and on the effects of occupation and the nature of resistance. Originally written to accompany a British television series, *Women of Courage*. Top rating.

Women Impressionists
by Tamara Garb
Rizzoli International, 1986,
79 pages
Sr. High: Advanced
Illustrations: Photos
Time Period: 1870-1887
Place: France

Themes: Condescension shown women artists by the art establishment; Discrimination against women in art education and availability of facilities; Contributions of women to the Impressionist movement

Description: Using the lives and art of four women, Eva Gonzales, Berthe Morisot, Marie Bracquemond, and Mary Cassatt, Garb describes the struggles of women artists to be accepted by other artists and by the critics during the Impressionist period. No free state education in fine art or classical education was available for women and so they were said to be incapable of handling complex subjects. The critics suggested that women should confine their artistic interest to domestic objects and consider their art as a hobby. This is written in a lively style, has many

illustrations and should be especially important for students interested in art. Top rating.

Suggested Uses: Students might also read the chapter, "The Nineteenth Century," in *The Obstacle Race*, Germaine Greer's work on women artists (Reviewed in this bibliography).

Women in the Middle Ages
by Frances & Joseph Gies
Thomas Y. Crowell, 1978,
232 pages
Jr. High: Advanced
Sr. High: Advanced
Illustrations: Woodcuts; Paintings
Time Period: 506-1399
Place: England, France, Italy

Themes: Decline of opportunities for women in later Middle Ages and Renaissance; Life of women in High Middle Ages, 1100-1500; Effect of obstetrical practice on women's lives; Women as victims of infanticide; Patriarchy as influence on pervasive misogamy; Women in the city; Piers Plowman's Wife; Eve and Mary

Description: Advanced students can find fascinating detail for special reports in any of the chapters, either of general background material or on lives of individual

women. Variety of women revealed in biographical detail: Blanche of Castile, Eleanor de Montfort, Hildegarde, Margaret Paston, Margherita Datini. A chapter each for a city working woman and Piers Plowman's wife presents a picture of women who were not famous or rich and powerful, but who were much more equal partners with their husbands than their upperclass sisters.

Suggested Uses: This could provide a good exercise in learning documentation, a historian's skill, by becoming aware of the prejudices of the recorder and the political conditions which prevailed at the time of the account. • Assign a chapter to determine the kind of documentation used, original or secondary, and give examples of each.

"They (women) murder no one, nor wound, nor harm,... Nor wage war and kill and plunder..."

- Christine de Pisan

Women In Western Civilization
by Elizabeth Miller Walsh
Schenkman Publishing Co., Inc.,
1981, 285 pages
Jr. High: Advanced
Sr. High: Average - Advanced
Illustrations: None
Time Period: 4000 B.C.-1963 A.D.
Place: Palestine, Greece, Italy, England, France, Germany, U.S.S.R.

Themes: The attitude of the Church toward women from Jesus to St. Augustine; Women in Medieval literature; Decline of women's commercial enterprise; Daily life among nobility and peasantry; Notable women; Beginning of the home as women's special sphere; Witchcraft persecutions

➡

Description: Written as a text for a college course on Western Civilization, this provides a good reference for advanced readers and a source of interesting quotes and anecdotes for teacher's use in class. Short concise chapters provide factual data from original sources to reveal basis for historic attitudes toward women. Generalizations about women are interspersed with short biographical sketches of individual notable women showing their response to prevailing standards for female decorum. Of particular focus is the long period of witch-hunts which is given serious analysis as a social and political force.

Suggested Uses: Use as reference for advanced students. Excerpts from Ch. 6, "Early Christianity," shows variety of attitudes toward women as expressed by Church fathers. Ask students for modern sayings or practices which reveal the same point of view. Provocative quotes re witchcraft trials on pps. 125-129 can be compared with McCarthy/Army Hearings of the 1950s. What is the real aim of such trials? Why are they often successful in winning public support?

"Widowhood, ill-health, or want of bread, these three explanations or excuses are supposed to justify a woman taking up an occupation."

- Florence Nightingale

Women of the Reformation in Germany and Italy
by Roland H. Bainton
Beacon Press, 1971, 266 pages
Sr. High: Advanced
Illustrations: Woodcuts; Portraits
Time Period: 1500-1600
Place: Germany, Italy

Themes: Reformation movement in Italy and Germany in early years of 16th century; Role of women in conflict between Catholics and Protestants

Description: Most of the information about these important and courageous women comes through the writings of men who provide documentation and interesting details of women's lives. Because of the scholarly language, we suggest that only Chapter One be used by students as a reference. In it the life of Katherine von Bora is recounted with such wit and warmth of feeling by her husband, Martin Luther, that both husband and wife come alive.

④

Suggested Uses: Interesting assignment might be to find reasons for Martin's marriage, evidence from his writings that he really loved her, and how she influenced his attitudes and behavior. An intriguing report could be titled, "Katherine von Bora's contributions to the Protestant Movement."

"If I should lose my Katie I would not take another wife though I were offered a queen."

- Martin Luther

Women Workers and the Industrial Revolution 1750-1850
by Ivy Pinchbeck
Virago, 1981, 316 pages
Sr. High: Advanced

Illustrations: None
Time Period: 1750-1850
Place: England

Themes: Women in agriculture, 18th century; The Agrarian Revolution; Women day labourers; The Poor Law; Rural conditions in mid-19th century; Women in textile industry: cotton workers, spinners, weavers, factory workers; Domestic industries: lace making, straw plaiting, glove making, hand knitting, button making; Exploitation of child labour; Domestic workers; Women in coal mines; Women in metal trades; Craftswomen and business women

Description: Ivy Pinchbeck's social history study is still the classic work describing the changes over a century in English women's work and domestic lives in agriculture, trade, and industry. Using contemporary literature, newspaper reports, parliament and parish records, Pinchbeck makes these women workers come alive as they leave the home as a place of production and move to the factory, mill, and mines. Although she recognizes the terrible poverty, crowded living conditions in the cities, and the domestic chaos, she feels that the Industrial Revolution was beneficial to women's social and economic position. The small print may discourage all but the most serious students of World History or Women's Studies. Top rating.

⑥

Suggested Uses: Use the Introduction in connection with the study of the Industrial Revolution. • What role did women have in pre-industrial production? Chapter I describes these chores in detail. How did that role change? • Have students list the occupations women engaged in during post-industrial times. See Chapter III, p. 57 for an account of women as Day-Labourers. • Students could research individual trades; ie. glove-making, straw-plaiting, chain-making, etc. to illustrate the variety of work by women. For younger students, see the unit, Women and the Industrial Revolution from the World History Units, *In Search of Our Past* (Reviewed here).

"It is only necessary to contrast the vigorous life of the eighteenth century business woman, traveling about the country in her own interests, with the sheltered existence of the Victorian woman, to realize how much the latter had lost in initiative and independence by being protected from all real contact with life."

- Ivy Pinchbeck

Women's Roots
by June Stephenson
Diemer, Smith Publishing Co., 1986, 307 pages
Jr. High: Advanced
Sr. High: Average - Advanced
Illustrations: Photos; Drawings; Maps
Time Period: Pre-history - 1985 A.D.
Place: Middle East, Europe, United States

Themes: Women's roles among hunting/gathering peoples; Women as agriculturalists; Transition to patriarchy; Goddess worship; Women in ancient civilizations of Sumeria, Eygpt, Israel, Greece and Rome; Women in Europe to the Renaissance

Description: This book details women's status during the development of Western civilization from prehistoric times to 20th century America. Written expressly for students, it offers clear descriptions of major periods and phenomena in women's history primarily up through the Renaissance. Each chapter contains general historical information, and background on religion and discussion of male/female relationships. There is also a good section of definitions, such as concubine, patrilocal, etc.

Suggested Uses: The pre-history sections lend themselves to anthropology and sociology courses, ie. the world of the hunter/gatherers, the transition to property owning, patriarchal societies, and so forth.

Women: Past Into Present Series
by Katharine Moore
B.T. Batsford Ltd., London, 1970, 24 pages
Jr. High: Average - Advanced
Sr. High: Average
Illustrations: Photographs; Drawings
Time Period: 1344-1688
Place: England

Themes: Church and feudal attitudes toward women; Daily life of nobility and peasants; Education; Women and the Civil War

Description: Charming illustrations and interesting quotes make this an attractive resource and a stimulus for further research on English women into the 20th century. Out of print, but is available in some libraries.

Suggested Uses: Use in class for short assignments: Chaucer's women, Shakespeare's heroines, as examples of variety of types; Education for women; Ladies and the Civil War.

"'It is a wyves occupation to wynowe all manor of cornes, to make malte, to washe and wrynge, to make hay, shere corn and in tyme of nede to helpe her husbande to fyll the muck-wayne and dryve the plough.'"

- Wyf of Bath

Anthology

Strong-Minded Women and Other Lost Voices from Nineteenth-Century England
by Janet Horowitz Murray
Pantheon Books, 1982, 437 pages
Sr. High: Average - Advanced
Illustrations: Photos; Drawings
Time Period: 1805-1909
Place: England

Themes: Middle and upper class women's struggle to escape the confinement of home; Working class women's struggle for survival; Large role played by women in economic and social changes during industrialization; Women reformers; Influence of religion in women's lives; Debate over women's nature and roles; Rigid class structure

Description: An excellent collection arranged according to the pro and con arguments about women's mission in life and her proper sphere, the attitudes and experiences of women who worked outside the home, and a final section on "fallen women." The selections are short, with an introduction, offering students a wide range of lively documents about such well-known women as Florence Nightingale, Josephine Butler, George Eliot, the Brontës and Queen Victoria. Top rating.

Suggested Uses: The following chapters offer the best selections for secondary level students: "The Girls of the Period" (expectations of young women), "Suffering for Beauty," "The Household General" (women's housework, including suggested menus), "The Transition to Marriage" (young women and love), "Domestic Life in Poverty," "The New Institutions" (accounts of girls in school), and anything from Part IV, "Women's Work."

"So many changes occurring within one century led to startling incongruities. Some women were considered too frail to walk alone in the streets, while others were working underground in coal mines."

- Janet Murray

Victorian Women: A Documentary Account of Women's Lives in Nineteenth-Century England, France, and the United States
by Erna Hellerstein, Leslie Hume & Karen Offen
Stanford University Press, 1981, 508 pages

Sr. High: Advanced
Illustrations: Drawings; Charts
Time Period: 1809-1900
Place: England, France, United States

Themes: Victorian attitudes about gender, the family, work and division between private and public spheres; Affects of industrialization on women; Forces that politicized women; Growing autonomy of women; Commonalties of transatlantic Victorian culture

Description: This collection draws from autobiographies, medical and legal records, diaries, letters, investigative committee reports, poems and songs. The book is divided into the stages of the female life cycles: "The Girl," "The Adult Woman: Personal Life," "The Adult Woman: Work," "The Older Woman." Each section is introduced in a long, informative essay and many documents feature the words of the women themselves.

Suggested Uses: Use as a reference for primary source documents. Students can select a topic from the Index and then read the appropriate documents. • The section introductions can be assigned as class readings.

Woman as Revolutionary
by Frederick C. Giffen
New American Library, 1973, 256 pages
Jr. High: Advanced
Sr. High: Average - Advanced
Illustrations: None
Time Period: 1363-1972
Place: Australia, France, Spain, England, U.S.S.R., Germany, Italy

Themes: Conditions that motivate women to action; Women's efforts to affect change in politics, medicine, creative arts and women's rights

(17)

Description: Anthology of writings by and about women's roles in progressive or revolutionary movements documenting women's work for human liberation across a broad spectrum of issues. Each short chapter is devoted to one woman and contains an excerpt from her own writings as well as biographical information. Excellent source of primary documents on Christine de Pisan, Joan of Arc, St. Teresa of Avila, Mary Wollstonecraft, Olympe De Gouges, Rosa Luxemburg; Dolores Ibarruri, Sister Elizabeth Kenny. American women also included. Not in print, but may be in your library. Top rated.

Suggested Uses: These short selections could be read aloud in class, for example Joan of Arc's trial as recounted in Mark Twain's *Personal Recollections of Joan of Arc*.

Women in Music: An Anthology of Source Readings from the Middle Ages to the Present
by Carol Neuls-Bates, ed.
Harper & Row, 1982, 351 pages
Sr. High: Advanced
Illustrations: Drawings; Engravings; Photos; Paintings
Time Period: 1st Century A.D.-1980
Place: England, Germany, Italy, Austria, France, United States

Themes: Women as singers, troubadours, minstrels, instrumentalists, conductors, composers, and patrons; Women's limited access to musical instruments and the machinery of music; Well-known female musicians

"For four years a wonder has appeared here. She sings at sight the most difficult music. She accompanies herself, and accompanies others who wish to sing, at the harpsichord, which she plays in a manner which cannot be imitated. She composes pieces, and plays them in all the keys asked of her... and she still is only ten years old."

- Newspaper account of Elisabeth-Claude De La Guerre, 1677

Description: These primary source accounts reach back to the medieval nunneries and bring the reader up to contemporary times. Written from a feminist point of view, women's roles in music are depicted through songs, poetry, letters, journal accounts and diaries. In spanning five centuries of women's musical achievements, the author dismisses those arguments that insist women are not able to reach musical heights. Included in the sections on nineteenth and twentieth century musicians are some familiar names: Fanny Mendelssohn Hensel, Clara Schumann, Cosima Wagner, Nadia Boulanger, Marian Anderson, Ruth Crawford-Seeger, and Antonia Brico. Although appealing especially to students interested in music,

this collection has such fascinating personal anecdotes that it should please the casual reader of history as well. Top rating.

(6)

Women, the Family, and Freedom: The Debate in Documents Volume One, 1750-1880 & Volume Two, 1880-1950
by Susan Groag Bell & Karen M. Offen
Stanford University Press, 1983, 949 pages
Sr. High: Advanced
Illustrations: None
Time Period: 1750-1950
Place: Europe, United States

Themes: Women's search for freedom; Men's fear of women's sexuality; Role of women in Western society: motherhood, legal position in family; Employment, educational and political restrictions on women

Description: From the Enlightenment to the mid twentieth century, the debate on the "woman question" is described through contemporary documents offering the pros and cons on diverse issues relating to

women's role in the family and their struggle for equality. The documents come from a variety of published sources, including excerpts from fiction, and represent the views of religious and secular authorities as well as a wide range of opinions from traditionalists, liberals and radicals. The two volumes are divided into six parts according to the periodization most often used by European historians. There are introductions to each part as well as to each group of selections. These short essays offer historical context for the documents while a Suggested Further Reading list for each section increases the usefulness of the extensive Bibliography. This is a scholarly work, but it can be used by advanced students as a source for research into almost every topic covered in a European History course. Of especial interest are the documents expressing ideas and opinions of individual women about contemporary issues because such information cannot be found in the traditional secondary textbook. Top rating.

Suggested Uses: Volume Two, Chapter 4, deals with education for women. Three documents (p. 172-180) expose the hypocritical attitudes of 19th century society toward sex education for young girls. The first is an excerpt from a play and could be dramatized in class as a means to stimulate discussion. Is such information necessary? Should it be given by the parents, the church, or the school? What are the contemporary attitudes about this issue? What suggestions do Nelly Roussel and Leon Blum offer?

"No honors are too great, no praise too high, for those brave soldiers who are mutilated in battle. But on our own battlefield, we mothers find no glory to be garnered. So-called civilized society has placed the work of death above the work of life by reserving, by some inconceivable aberration, its homage for the destructive soldier, its disdainful indifference for the woman who creates life."

- Nelly Roussel

Autobiography/Biography

A London Child of the 1870s
by M.V. Hughes
Oxford University Press, 1977, 141 pages
Jr. High: Advanced
Sr. High: Average - Advanced
Illustrations: None
Time Period: 1870-1879
Place: England

Themes: Victorian family life in London; Teacher-training programs; Railway journey to Cornwall; Victorian expectations of and education of women; Welsh sayings and attitudes

Description: This is the first book in an autobiographical trilogy, *A London Girl of the 1880s*, and *A London Home in the 1890s*. The author's reminiscences begin as a small child and continue through her career as an educator, her marriage and motherhood. The anecdotes about childhood in the first book will be most appealing to students as they reveal a great deal about Victorian family life in urban London. Descriptions of Christmas, walks and picnics around the greater London area and carriage and train trips to Cornwall are delightful. These books will only interest students who like to read and who enjoy characterizations and personal comment rather than a fast-paced story line.

A Servant of the Queen: Reminiscences
by Maud Gonne Macbride
Boydell Press, 1983, 350 pages
Sr. High: Average - Advanced
Illustrations: None
Time Period: 1879-1914
Place: England, Ireland, France, Russia, Turkey, United States

Themes: Fight for Irish independence; Strategies of the Land Leaguers; Debate over Home Rule; Class structure in Ireland and life of the poor; Efforts to publicize the Irish cause abroad; Expectations of upper middle class women in Victorian Era

Description: A legend in Irish politics, Maud Gonne was a beautiful and incredibly independent young woman. This autobiography details her years until her marriage with a fellow revolutionary at age 35. Gonne organized demonstrations, fought evictions, raised money on lecture tours for Irish political prisoners and for famine relief. In a warm and witty style, she tells of her adventures, including her friendships with many notables of the day. William Yeats wrote many of his love poems to Maud Gonne. Distributed by: *Academy Chicago*, 425 N. Michigan Ave., Chicago, IL 60611. Top rating.

Suggested Uses: The first five chapters are on Gonne's young years to womanhood. Students might most enjoy reading of this young woman's verve and travels in a period when the dominant expectation on women was to prepare for marriage.

"Whenever I did really want to get rid of the G. men, I had only to turn down certain poor streets, where the police never ventured after dark and where the least misfortune that would happen to them would be well-aimed rotten fish or eggs, and possibly something much worse, if they were seen to be after such a popular young woman as Maud Gonne."

- Maud Gonne

And All Her Paths Were Peace: The Life of Bertha Von Suttner
by Emit Lengyel
Thomas Nelson, Inc., 1975, 136 pages

Jr. High: Average - Advanced
Sr. High: Average - Advanced
Illustrations: None
Time Period: 1843-1921
Place: Austria, Hungary

Themes: Lifestyles of wealthy aristocrats in Austro-Hungarian empire; Expectations of aristocratic women; Mingrelia, the Casucasus; The Circassians; Shamyl's guerilla warfare against the Russians; Russo-Turkish War; Alfred Nobel; Description of anti-war novel, *Lay Down Your Arms*; International Arbitration and Peace Association; Schleswig-Holstein War: Battle of Solterino; Theodore Roosevelt and American beliefs; The Dreyfus Affair; Theodor Herzl; Hague Peace Tribunals of 1899 and 1907

"Unfortunately, the world is more inclined to remember the names of historic evildoers than of humanitarians, so the time has now come for us to get better acquainted with this tenderhearted woman, who gave her best to promote man's noblest causes."

- Emit Lengyel

Description: Bertha Von Suttern, a member of one of Austria's famous old military families, reacted against the growing militarism of the garrison states of Europe during the period when armies were sacrosanct. She fought discrimination against Jews, national minorities, women and pacifists. Her weapon was her prolific pen and the lecture platform. Among her triumphs was her influence on Alfred Nobel to create the Nobel Prize for Peace, which she won in 1905, and the popularity of her major anti-war novel, *Lay Down Your Arms*. The story of Bertha's life-long romance and collaboration with her husband,

Arthur, is also told in this important biography of an extraordinary woman.

Suggested Uses: • Good readers may want to read *Lay Down Your Arms*, a two volume book that has been compared to *Uncle Tom's Cabin* because of its influence in igniting public action for peace.

Anne Boleyn
by Norah Lofts
Coward, McCann &
Geoghegan, Inc., 1979, 186 pages
Jr. High: Advanced
Sr. High: Average
Illustrations: Portraits; Drawings; Maps; Photos
Time Period: 1505-1536
Place: England

Themes: Court life of Henry VIII; Relationship of Henry with advisors (Wolsey, Cranmer, Cromwell) and friends; Grooming by an ambitious father of a daughter for marriage; Struggle between Henry VIII and Church; Widespread belief in witchcraft

Description: Large print, wide margins and illustrations on almost every page make this book attractive to students. Anne's life is traced from birth to execution in fascinating detail to help explain her unpopularity with the English public. Out of print, but worth looking for in libraries. Top rating.

"Commend me to His Majesty and tell him that he hath ever been constant in his career of advancing me; from a private gentlewoman he made me a Marchioness, from a Marchioness a Queen and now that hath left no higher degree of honour he gives my innocence the crown of martyrdom."

- Anne Boleyn, the day before her execution

Catherine The Great
by Miriam Kochan
Wayland Publishers, Ltd., 1976, 91 pages
Jr. High: Average - Advanced
Sr. High: Average
Illustrations: Maps; Portraits; Drawings
Time Period: 1729-1796
Place: Russia

Themes: Role of nobility in maintaining serfdom even with enlightened monarch; Influence of French Revolution on autocratic rulers; Expansion of Russian Empire; Place of Russia in family of European kingdoms

Description: This is an interesting study of how one woman cultivated public favor and affection even where the average woman was denied equal rights in ordinary affairs. Catherine was a strong and determined woman who became a scholar with intent to rule by herself, but who always had lovers . Her childhood typifies the training of young women to marry wealth and power. This book has an attractive format, big print, short chapters, wide margins, one or more illustrations on each page, a good bibliography, a time line, a list of principal characters, and an Index.

Suggested Uses: Use selected chapters as class readings. Format makes it appropriate for almost every level of student. • This is an excellent source of factual material in quotes from official papers, letters and contemporary illustrations.

"...I tried to be as charming as possible to everyone and studied every opportunity to win the affection of those whom I suspected of being in the lightest degree ill-disposed towards me. I showed no preference for any side, never interfered in anything, always looked serene and displayed much attentiveness, affability and politeness all around."

- from Catherine's Memoirs

Early Spring
by Tove Ditlevsen
The Seal Press, 1985, 222 pages
Jr. High: Advanced
Sr. High: Advanced
Illustrations: None
Time Period: 1918-1937
Place: Denmark

Themes: Constraints of a working-class girlhood; Young girl's dreams of becoming a poet; Mother-daughter tensions; Impact of Hitler's growing power on life in Denmark

Description: One of Denmark's best loved writers, Ditlevsen remembers her childhood as a long narrow coffin from which she longed to escape to adulthood when she could be free to write poetry. Against the backdrop of pre-war tensions in Europe, as a young girl she struggles with poverty, her mother's indifference, and her own sense of inadequacy to cope with adulthood. Critics praise the literary style and rank it as a classic memoir. Top rating.

Suggested Uses: To discover how much historical content can be found in fictional or authentic memoirs, assign for comparison: *The Diary of Helena Morley* (Brazil), *Her People*, by Kathleen Dayus (England), *Anne Frank's Diary* (Holland), (All reviewed here). For U.S. contrast: *Rumors of Peace* by Ella Leffland. • Compare the role of a young girl in family life. How important is the mother-daughter relationship in these accounts? How do the political events of the period effect these young girls?

Eleni
by Nicholas Gage
Ballantine Books, 1983, 623 pages
Sr. High: Advanced
Illustrations: Map
Time Period: 1940-1949
Place: Greece

Themes: Italian and German occupation; Civil War; Life of village women; Author's search to uncover facts about mother's life

Description: Fictionalized account of author's mother, Eleni, who was executed by communist guerillas for refusing to allow her children to

be relocated in Albania. The engrossing story takes place in the small mountainous village of Lia and is told against the backdrop of World War II and the series of civil wars that followed liberation. Eleni becomes one of many Greeks who were caught in the middle of the violence that accompanied the struggles for power. In the process, the villagers chose sides, and sometimes turned against each other. Top rating

Suggested Uses: Use this book and Eleni Fourtouni's *Greek Women in Resistance* (reviewed here) to contrast two conflicting views of the civil wars. The former depicts the experience of villagers who are terrorized by the leftist group, ELAS; the latter shows the harsh treatment of Communists who were detained in political camps. Ask: How can you reconcile these conflicting views of the treatment of civilians? Considering that both accounts are based on recollections, are these sources reliable? In what ways do the women in both books respond to adversity? Are their strategies different from those of men? Describe incidences showing women going against their traditions.

Elizabeth I
by Alan Kendall
St. Martin's Press, 1977, 89 pages
Jr. High: Average - Advanced
Sr. High: Average
Illustrations: Prints: Portraits
Time Period: 1533-1603
Place: England

Themes: Reasons for Elizabeth's popularity and effectiveness as a monarch; Religious strife between Catholics and Protestants; Elizabeth, the diplomat in relations with France and Spain; Elizabeth and the Earl of Leicester; Elizabeth and Essex

Description: With a picture-book format and many short, pithy quotes in the margins, this biography provides many personal anecdotes as

well as rich historical context. Elizabeth is depicted as a wise and powerful ruler whose great love for her nation overcame her own personal sentiments as a woman. Rather than risk the complications that might follow a marriage with a person beneath her rank or a foreign prince with unwanted alliances with other nations, Elizabeth remained unmarried. Her infatuation with Essex did not prevent her from ordering his execution when his treachery became known. This book is out of print but worth looking for in public libraries.

"I am your annointed queen. I thank God I am endued with such qualities that if I were turned out of the Realm in my petticoat I were able to live in any place in Christome."

- Elizabeth to Parliament

Elizabeth Tudor: Portrait of a Queen
by Lacey Baldwin Smith
Little, Brown and Company, 1975, 219 pages
Sr. High: Advanced
Illustrations: Drawing
Time Period: 1533-1603
Place: England

Themes: The paradoxes of Elizabeth's personality; Effects of the Reformation; Doctrine of dynastic legitimacy and divinity of kingship; Elizabeth's style of governance; Foreign policy and religious struggles vs. Catholics and Puritans; Question of marriage and succession; Treatment of Mary, Queen of Scots

Description: Author strives to answer the question of what made Elizabeth successful by offering a fairly deep analysis of this queen's life in the context of the major

movements of the period. Revealed are the special problems Elizabeth faced as a female ruler and the impact of her complex personality on national and court politics. Known to be one of the best Gloriana biographies. Also good, but longer: *The First Elizabeth*, Carolly Ericksen, Summit Books, 1983.

Suggested Uses: Students take one theme in Elizabeth's life and use the book to research it: examples are Puritanism, Elizabeth's childhood, The influence and long reign of Sir William Cecil, the Armada, etc. • Assign chapter four, "To be a King and Wear a Crown," for a good analysis of Elizabeth's view of herself as a monarch.

> *"Elizabeth succeeded in living through four decades of rather shoddy history without forfeiting her glamour . . . it was an indisputable political feat to become a living myth."*
>
> - Lacey Smith

Eminent Victorian Women
by Elizabeth Longford
Alfred A. Knopf, 1981, 247 pages
Sr. High: Advanced
Illustrations: Paintings; Photos
Time Period: 1796-1914
Place: England

Themes: The struggles of unconventional women; Women's frail health and spirituality; Education and

types of work available to educated women; Expectations of Victorian women; Women's role in reform movements

Description: The author has chosen eleven women who "did exceptionally well in an age that had not yet yielded even their elementary rights." These are strong-willed women who carved out names for themselves most often in male dominated arenas. The accounts are lively and the illustrations, many in color, are lush, but the language and sometimes obscure references make this a resource only for good students. The women included are: The Brönte sisters; George Eliot; Florence Nightingale; Josephine Butler; Annie Besant; Ellen Terry; Mary Kingsley and James Barry (a woman who disguised herself as a male physician).

> *"'The Sex' was how members of Parliament would refer to women. The words were spoken archly and generally followed by loud laughter. One had to laugh off the fact that Victorian women were becoming discontented, unwomanly and a political problem."*
>
> - Elizabeth Longford

False Dawn: Women in the Age of the Sun King
by Louis Auchincloss
Anchor Press, Doubleday & Co., 1984, 175 pages
Sr. High: Advanced
Illustrations: None
Time Period: 1643-1715
Place: France, England, Spain, Sweden

Themes: War of Spanish Succession; Unification of France; Louis XIV, divinity of the king and

reestablishment of absolute male authority; Life in major courts of Europe; Wars of the Fronde; Catholic/Protestant disputes during reign of James II of England; Women's influence and contribution in courts, battles, salons, church and literature

Description: These readable, even chatty accounts, are only of noble women because, as Auchinloss states, "in the 17th century, had these women not been born high in the social scale they would never have been heard of. It was not the time for self-made men or women." In spite of this, the author describes strong and ingenious women whom he feels would have been unable to flourish in the next two centuries. In France the women discussed include Madame de La Fayette (author of *La Princesse de Clèves*), Madame de Sevigne, the Arnauld sisters (abbesses and Jansenist church reformers), Marquese de Montespan and Madame de Maintenon. Women from other countries are: Mary Beatrice (consort of James II), both Queens, Mary II and Anne, the Duchess of Malborough, Queen Christiana of Sweden and the Princesse des Ursins (adviser to Philip V). The biographies are short (approximately 11 pages), but demand some prior knowledge of the personalities and events of the time.

Suggested Uses: Student might use as reference for research about one woman. • Students could compare the lives of two vastly different personalities; for example Queen Anne of England and the Princesse des Ursins. They might describe how these women achieved power and how far-reaching was their influence.

"I like to speculate that the suffragettes of the twentieth century picked up where Madame de Maintenon, the princesse des Ursins and good Queen Anne left off."

- Louis Auchincloss

Ferdinand and Isabella
by Melveena McKendrick
American Heritage Publishing Co.,
Harper & Row, 1968, 147 pages
Jr. High: Advanced
Sr. High: Average
Illustrations: Drawings; Paintings
Time Period: 1400-1500
Place: Spain

Themes: Unification of Spain (Aragon and Castile); Campaign against Moors; Inquisition against Jews

Description: Isabella is presented as the stronger of the effective husband-wife team. Intelligent and brave, she had a lively interest in the new learning of the Renaissance. As a middle-aged woman she learned Latin well enough to converse with foreign ambassadors and read about a variety of topics during her leisure hours. Profusely illustrated.

Suggested Uses: Illustrations could be used to show class costumes and castles and other evidences of the social life of that period.

Five Sisters: Women Against the Tsar
by Barbara Alpern Engel &
Clifford N. Rosenthal, eds.
Knopf, 1975, 249 pages
Sr. High: Advanced
Illustrations: Photos
Time Period: 1870-1930
Place: Russia, U.S.S.R.

Themes: Russian revolutionaries; Russian anarchists; Women as strong political activists; Women's courage, strength and independence; Male-female equality in revolutionary era

Description: This work depicts the activism of five Russian women during the period preceding, during, and after the revolution. Vera Figner, Vera Zasulich, Praskovia Ivanovskaia, Olga Liubatovich, and Elizaveta Kovalskaia were all anarchists, a group viewed with hostility by the majority of Russian Socialists/Marxists. These five women represented the courage, intelligence, and overriding dedication to their cause which characterized women revolutionaries of this period. They make dashing and romantic heroines. Top rating. Out of print, but available in libraries.

"It would have been far easier, of course, had I been a boy: then I could have done almost anything... And then, the distant spectre of the revolution appeared, making me equal to a boy; I, too, could dream of 'action,' of 'exploits,' and the 'great struggle.'"

- Vera Zasulich

Suggested Uses: Incorporate one or more of the memoirs as background material for the study of the Russian Revolution since they provide interesting information on the attitudes of the intellectuals as well as male-female relationships among the upper classes prior to the outbreak of the revolution. For a study of style, English literature students could study one of the memoirs.

④

Flora Tristan: Feminist, Socialist, and Free Spirit
by Joyce Anne Schneider
William Morrow and Company,
1980, 249 pages
Jr. High: Average - Advanced
Sr. High: Average - Advanced
Illustrations: None
Time Period: 1803-1844
Place: France, England, Peru

Themes: Émigrees from Reign of Terror; Simon Bolivar; Saint-Simón; Prosper Enfantin; Charles X; Louis Philippe; George Sand; Female general Pencha Zubiaga Gamarra; George Fourier; Robert Owens; Paris in 1818; Attitudes about illegitimate children; Rights of women in marriage; London and lifestyle of British upper-middle class; The Vindication of the Rights of Women; French recession of 1839; Early Socialism; Chartist movement; Slavery in the Caribbean and Peru; Description of Lima and Arequipa; Effects of industrialization in England; The Workers Union and early union organizing in France

➡

Description: As the themes suggest, Flora Tristan was involved with major 19th century reform movements. A fiery writer and speaker, she fought to improve the plight of women and oppressed workers and was ahead of her time in seeing human rights in both a sexual and international context. Her own life was tempestuous. Poor, and caught in an abusive marriage, her decades-long efforts to seek a divorce was an impetus to her work for female liberation. Top rated.

"The most oppressed worker can oppress yet another being, who is his wife. She is the proletariat of the very proletariat."

- Flora Tristan

Kathe Kollwitz: Life in Art
by Mina C. & H. Arthur Klein
Schocken, 1975, 168 pages
Jr. High: Advanced
Sr. High: Advanced
Illustrations: Photos; Drawings
Time Period: 1867-1966
Place: Germany

Themes: Life and personality of Kollwitz; Family and girlhood; Artistic training; Socialist Art; Mourning mothers; Nazism and art; Children as seeds for war

Description: This large format art/biography was written for the "nonspecialists" in art who are unfamiliar with the work and life of Kollwitz. Its size and design enable the class to have a good look at the drawings, etchings, and sculpture. This is an engrossing account of a life full of love with family, friends and artistic success, but also of intense personal tragedy. Art students will appreciate the attention to the artistic critique of Kollwitz's works, while history students can learn a great deal about the effect of

war and political repression on civilians and on artistic expression. Top rating.

Suggested Uses: Use the print series, The Weavers, found in the book, to assign a report on the revolt of Silesian weavers. • Assign a student to prepare an exhibit of Kollwitz's women in war to represent the traditional role of women in wartime. • After showing the class a series of her works from both world wars, have them explain how her art illustrates her statement, "Every war already carries within it the war which will answer it. Every war is answered by a new war, until everything, everything is smashed."

"With my whole heart I am for a radical end to all this insanity. Only from world-wide socialism do I expect anything."

- Kathe Kollwitz

Kathe Kollwitz: Woman and Artist
by Martha Kearns
The Feminist Press, 1976, 225 pages
Jr. High: Advanced
Sr. High: Average - Advanced
Illustrations: Photos; Woodcuts; Drawings
Time Period: 1867-1945
Place: Germany

Themes: Childhood and adolescence in an intellectual family; Kollwitz's training as an artist; Women as revolutionaries; Use of working-class people as subjects in art; Left-wing sympathies; Marriage; World War I; World War II and the Nazis; Kollwitz's commitment to peace

Description: This will appeal to students because of the format: short chapters, large print, and many fine photos of the Kollwitz family and her art works. Taken from Kollwitz's own diaries and letters to a life-long friend, the material is so personal that one feels that the artist herself is telling the story. Women and children as war victims were her subjects, and through them Kathe Kollwitz has become a symbol of anti-war activism. She believed that "pacifism simply is not a matter of looking on; it is work, hard work." Her work was considered "degenerate" by the Nazis and removed from museums and exhibits. She was threatened with the concentration camp, but she continued to express her ideas in her work. Top Rating.

Suggested Uses: After showing class photos of Kollwitz's work, read aloud pp. 211-212 which describes a visit by the Gestapo. Ask students what did the Nazis object to in her art? Why was she considered "dangerous"?

"In Kollwitz' work . . . it is the women who confront the crises head on: they brave war, poverty, homelessness, their husbands' unemployment, servitude, widowhood, sexual abuse, and their children's hunger. In the darkest despair, the women continue to support the life of others."

- Martha Kearns

Lise Meitner, Atomic Pioneer
by Deborah Crawford
Crown, 1969, 186 pages
Jr. High: Advanced
Sr. High: Average - Advanced
Illustrations: None
Time Period: 1900-1968
Place: Austria, Germany, Denmark, Sweden, United States

Themes: Overcoming prejudice against women in higher education; Formula for splitting the atom; Hitler's lack of interest in atomic research

Description: This is a portrait of a woman scientist who found happiness in scientific research even though she was not given the honor she deserved for her remarkable achievements. Surrounded by all male colleagues and forced to flee Nazi persecution, she developed the formula which led to the splitting of the atom. Unfortunately, her partner was awarded the Nobel Prize for this achievement and she was not mentioned. She is to be remembered as a pioneer woman scientist who succeeded in spite of the obstacles of negative social and racial attitudes. Her great sorrow was that her work led to the development of the atomic bomb.

Suggested Uses: Use as reading for Hitler's Germany; illustrates the international cooperation among scientists during World War II.

Little Sparrow: A Portrait of Sophia Kovalevsky
by Don H. Kennedy
Ohio University Press, 1983, 318 pages
Sr. High: Advanced
Illustrations: Portraits
Time Period: 1850-1891
Place: Russia, France, Germany, Sweden

Themes: Struggle of women intellectuals for professional recognition; Life among the Russian gentry; Status of serfs before Emancipation Act of 1861; Polish uprisings against Russia; International intellectual community in Europe; Women's movement (Progressives, Nihilists, Revolutionists)

Description: Although women were not welcomed into institutions of higher education in most European countries, a few young intellectual women of the upper classes succeeded in breaking these barriers. Sophia Kovalevsky entered into a marriage of convenience in order to leave Russia as a married woman, and using her husband's name, found a tutor who recognized her genius. After many struggles against traditional opposition to women students, Kovalevsky became the first woman in the world to achieve a high degree of mathematical knowledge and was honored throughout Europe. This biography documents the political and intellectual ferment of pre-revolutionary Russia and Europe and is full of anecdotes involving famous literary and scientific figures of 19th century Europe; George Eliot, Dostoevsky, Turgenev, Darwin, Poincare. This is an exciting book especially for young women interested in mathematics or science. Top rating.

Suggested Uses: First seven chapters could be read for picture of life of gentry in Pre-Revolutionary Russia, a description of the education of young girls from that class, and the status of serfs before the Emancipation Act of 1861.

"I feel that I am meant to serve truth in science, but also to work for justice by breaking a new path for women in science. I am very glad I was born a woman, as this gives me the opportunity to work at the same time for both truth and justice. But it is not always easy to persevere."

- Sophia Kovalevsky

Manya's Story
by Bettyanne Gray
Lerner Publications Company,
1978, 127 pages
Jr. High: Average - Advanced
Sr. High: Easy - Average
Illustrations: Photos
Time Period: 1917-1975
Place: U.S.S.R., United States

Themes: Jewish life in the Ukraine in the Pale of Settlement; Traditional life in the shtetl; Civil war among Ukrainian Nationalists, the anti-Bolshevik White Army and the Bolshevik Red Army; Pogroms in the Ukraine; Treaty of Brest-Litovsk

Description: In memory of her mother, Manya Polevoi, and the other family members, victims of anti-Semitic pogroms and the Holocaust, the author has recounted a story of terror and heroism set in the years following the Russian Revolution. The small shtetls (small Jewish villages) in the Ukraine were caught in the fighting among the Ukrainian Nationalists, the Russian White Army and the Red Army. Through the vivid description of the loving family relationships, the joyous feasts and festive holiday events it is easy to understand how difficult it was for families to believe that their way of life would not continue in spite of the marauding armies. Finally, however, the survivors of the bloody massacres in each village would try to find their way to Palestine or to the United States. A Glossary of Yiddish and Hebrew terms is helpful in explaining traditional rituals and expressions of speech. Very explicit scenes of brutality call for discretion in assigning to students.

Marie Curie
by Mollie Keller
Franklin Watts, 1982, 116 pages
Jr. High: Average
Sr. High: Easy - Average
Illustrations: Photos
Time Period: 1867-1932
Place: Poland, Belgium, France

Themes: Struggle with poverty; Devotion to science; Personal and professional integrity; Contentment and joy in marriage; Dedication to cause of Peace; Nobel Prize in Chemistry; Danger to scientists working with radium

Description: This lovely young adult biography tells the story of a remarkable family. Marie and Pierre, her husband, had an unusually happy relationship personally and professionally and both were uncommonly modest about their marvelous scientific achievements. This account provides a very personal look at their family life and a glimpse into their laboratory for a simple explanation of their work. Marie's involvement in the international struggle for World Peace reveals her to be also a person of conscience and courage. Easy to read format with lots of pictures and wide margins. Top rating.

Mistress Anne
by Carolly Erickson
Summit Books, Simon &
Schuster, 1984, 260 pages
Sr. High: Advanced
Illustrations: Portraits
Time Period: 1514-1536
Place: England, France

Themes: Cruel and willful nature of Henry VIII; Decadent customs of the French Court; Vulnerability and helplessness of women subject to royal marriages; Unscrupulous plotting for power by Cardinal Wolsey and Cromwell; Precarious life for Henry VIII's courtiers

④

Description: This biography, which reads like a novel, is based on original as well as secondary sources. Anne is depicted objectively, neither over-romanticized nor vilified. Although she had a strong and independent personality, she was also the creature of the decadent and politically corrupt royal circles in which she had spent her life. The use of arranged marriages to further political advantages, the role of the Church and its representatives, and the insecurity of life for even the most favored courtier are all vividly illustrated in this account.

"To fall in love was bad enough, but to marry for love was simply inexcusable. . . . It was in a word, immature. And what was infinitely more dangerous, it was disobedient."

- Carolly Erickson

Olga

by Justin Beecham
Two Continents Publishing Group, 1974, 126 pages
Jr. High: Average
Sr. High: Easy - Average
Illustrations: Photos; Diagrams
Time Period: 776 B.C.-1973 A.D
Place: U.S.S.R., Germany, United States

Themes: History of gymnastics and Olympic Games; Training of gymnast; Attitudes of Russians toward sports in emphasis of self-discipline

Description: A paperback picture book which highlights the career of Olga Korbut, the Soviet gold-medal winner in gymnastics, is a good source of information about the education and training of girls in U.S.S.R. It presents briefly an historic background of Olympic Games and gymnastics which helps explain the modern focus on sports for young people in the Soviet Union. Olga is shown as an intense but likeable and thoroughly human teenager with whom American students can identify.

Suggested Uses: Use to help students' awareness of those qualities and constraints shared by teenagers in many different cultures.

"In modern Russia, as in classical Greece, government encouragement is never absent from the pursuit of sports."

- Justin Beecham

On Top of the World: Five Women Explorers in Tibet

by Luree Miller
The Mountaineers, 1984, 203 pages
Jr. High: Advanced
Sr. High: Average - Advanced
Illustrations: Photos; Drawings; Maps
Time Period: 1870-1920
Place: India, China, Tibet, France, England

Themes: Individualism of women travelers; Imperial conquests that fostered travel; Isolation and intrigue of Tibet; Amateur explorers; Women's struggles for acceptance in male sphere; European women's observations of life of women in Asian countries; Methods and accouterments of mountaineering

Description: Students who love adventure stories will enjoy the exploits of these three British women (Nina Mazuchelli, Annie Taylor, Isabella Bird Bishop), one American (Fanny Bullock Workman) and one French woman (Alexandra David-Neel). These unconventional women acted on impulse, often traveled alone, and had curiosity, judgment and courage - all attributes not generally ascribed to 19th century women. In the process they developed considerable self confidence and gloried in their independence. As the author states, "one of the delights that women travelers discovered was the pleasure of decision-making. At home they seldom had the opportunity. Out in the world, alone, every move was up to them." Top rated

Suggested Uses: Students might write an essay on a trip or adventure in which they were called upon to exhibit characteristics portrayed by the women in this book. • Students could list 1) each woman's motivation for travel and 2) circumstances which made such travel possible.

"What decided me to go to Lhasa was, above all, the absurd prohibition which closes Tibet. I had sworn that a woman would pass the Tibetan frontier and I would."

- Alexandra David-Neel

Pavlova: Portrait of a Dancer

by Margot Fonteyn
Viking, 1984, 150 pages
Jr. High: Advanced
Sr. High: Average - Advanced
Illustrations: Photos; Drawings; Posters
Time Period: 1885-1931
Place: Russia, U.S.S.R., England, Sweden, Germany, France, Australia, Italy, Japan, China, India, Cuba, Argentina, Mexico, United States

Themes: The Imperial Ballet School and the Tsar; Training of a ballet dancer; Pavlova's tours; Public's adoration of Pavlova; Effect of World War II on entertainment; Pavlova's ideal of beauty and commitment to the dance

Description: This biography presents Pavlova's life through press reports, writings by people who knew her, and excerpts from her dairy. Interspersed are comments by Margot Fonteyn about Pavlova and the art of ballet. What emerges is a portrait of a woman with enormous discipline and zeal

to succeed. Pavlova's life style, her feelings about her craft, her style of dance, and impressions of the countries she performed in are also described. This is a large, profusely illustrated book.

"I learned my art under as nearly perfect conditions as are ever found on this earth. The Russian ballet owes its subtle perfection of detail, its greatness, its rank to the fact that it is made up of dancers who from the day they went to live in the dormitories of the Imperial School saw nothing - were surrounded by nothing - but beauty - beauty! - and the highest standards physically, mentally, morally and spiritually."

- Pavlova

Polish Greats
by Arnold Madison
David McKay Company, Inc., 1980, 108 pages
Jr. High: Average
Sr. High: Easy
Illustrations: None
Time Period: 1370-1934
Place: Poland

Themes: Polish independence struggle; Pride of Poland

Description: These short but interesting accounts of Polish "Greats" should appeal to reluctant readers unfamiliar with biography. As an introduction to women's history, the lives of the three women included in this collection (Chapters 1, 7, 11) provide romance and excitement. Jadwiga, the Polish Joan of Arc, as king of her country brought access

to the Baltic and Black Sea enabling Poland to achieve independence from the Russians in 14th century. Helena Modjeska enhanced the artistic world of Europe during the 19th and early 20th centuries by her beauty and her dramatic and musical talents. A personal and lively account of Marie Curie describes her youthful ambitions as well as her marriage to Pierre Curie and their partnership in the science laboratory.

Suggested Uses: Have two students make a comparison of lives of Jadwiga and Joan of Arc of France. Jadwiga was proposed for sainthood. Was she ever canonized?

Queen Eleanor: Independent Spirit of the Medieval World
by Polly Schoyer Brooks
J.B. Lippincott, 1983, 166 pages
Jr. High: Advanced
Sr. High: Average
Illustrations: None
Time Period: 1122-1204
Place: France, England, Palestine

Themes: Role of alliances through marriages to consolidate power; Introduction of ideal of Courtly Love; Troubadours and romantic ballads; Limitations on a woman's activities

Description: This is a lively story of a spirited woman who defied conventions and lived as much as possible according to her own standards. Made very clear are the contributions she made to the improvement of life in France and England. Calculated to whet the appetite for more stories about the people and times of 12th century Europe, this biography is a success. It includes a bibliography and a time line of Eleanor's life and those of her ten children. Top rating.

Reconstructing Aphra: A Social Biography of Aphra Behn
by Angeline Goreau
The Dial Press, 1980, 339 pages
Jr. High: Advanced
Sr. High: Average - Advanced
Illustrations: Engravings; Portraits
Time Period: 1640-1689
Place: England

Themes: Feminist heroism; Seventeenth century male-female roles and moral strictures; Feminism and anti-slavery activism

Description: Aphra Behn was the first woman in England to earn a living by writing, and her personal life as well as her plays, poems and novels kept her in the public eye continually. She was so much ahead of her time with her views on slavery, sexual double standards, and independence for women, that after her death, her writings and even her existence were called into question. In presenting her life, the author creates the social and political context in which Aphra lived. This is a delightful biography because the subject was a witty and unusual woman in a time when women were not supposed to be either one. Her book about slavery,

➡

Oroonoko, represents the beginning of an alliance between feminism and abolitionism. History and literature students will find a great deal of information about the politics and social mores of the seventeenth century in this account. Top rating.

Suggested Uses: Section 4 in Chapter 5 tells the story of the slave hero of her novel, *Oroonoko*. Assign to a student for an oral report. Use pps. 287-290 to make clear the historical and literary significance of this novel. • Compare the effect of *Uncle Tom's Cabin* on the anti-slavery sentiment in U.S. How did the women's suffrage movement and the abolition movement work together? What issue caused dissension? • Literature classes should look for the qualities in Aphra's fictional heroines which mirrored the values of the day. In what ways were they different? • Why did her writings disappear from public view after her death? • What was the significance of her earning a living as a writer?

"It was she who demonstrated that a woman -- if lucky, if willing to surrender respectability, comfort, approval, perhaps even love; if prepared to risk ridicule, loss of reputation, vilification or attack -- might declare her autonomy and make a living by writing in an age when her only social and economic alternative was to marry or to find a wealthy 'protector'."

- Angeline Goreau

Revolutionary Women: Gender and the Socialist Revolutionary Role

by Marie Marmo Mullaney
Praeger, 1983, 401 pages
Sr. High: Average
Illustrations: None
Time Period: 1855-1977
Place: Italy, England, Spain, U.S.S.R., Germany

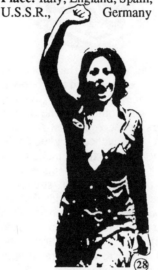

Themes: Women heroines and the nature of women's role in and contributions to left movements; Feminism; Marxist socialism; Prejudice against revolutionary women; Similarities and differences between women revolutionaries; Russian revolution; Attempts at socialist revolution in Poland, Germany and Italy; Spanish Civil War; Communist Party

Description: The central characters are five prominent revolutionary socialist women: Eleanor Marx (Karl Marx's daughter), Alexandra Kollantai, Rosa Luxemburg, Angelica Balabanoff, and Dolores Ibarruri. The book describes the how and why of women's participation in revolutionary movements as well as the personal choices women, more than men, often had to make. The author theorizes on the nature of socialist women, seeking to analyze the woman revolutionary as a type.

Suggested Uses: The reader will need a working knowledge of Marxism, as well as be familiar with the other European socialist movements. Since each biography is approximately 40 - 50 pages long, a student might read one account and formulate a report.

"The goals of revolutionary women have been totally different from those of revolutionary men. Although in the final analysis, revolutions are all about the seizure and consolidation of political power, these women were seeking power of a totally different sort: the chance to exercise power not over others but finally over themselves."

- Marie Marmo Mullaney

Sasha: The Life of Alexandra Tolstoy

by Catherine Edwards Sadler
G.P. Putnam's Sons, 1982, 131 pages
Jr. High: Advanced
Sr. High: Average
Illustrations: Photos
Time Period: 1890-1982
Place: Russia, U.S.S.R.

Themes: Pre-revolutionary life among the gentry; Famine and other problems affecting the peasants; Family conflicts over Tolstoy's humanitarian philosophy; Sasha's difficult early relationship with her father

Description: Like many other children of famous parents, Sasha found her famous father a special problem rather than a source of comfort and joy. Not until she was in her late teens was she able to convince him that she was a serious

➡️

believer in his humanitarian and anti-religious philosophy. He then allowed her to become his secretary, a job she held until his death. A good picture of Russia is presented in this small book written for students; activities of the gentry, the Coronation of Nicholas II, Tolstoy's work with the peasants, and incidents of repression during the Stalinist era. In an Epilogue, Sasha's work in establishing the Tolstoy Foundation as a resettlement center for Russian emigrants is described. Top rating.

Seven Sovereign Queens
by Geoffrey Trease
Vanguard Press, 1968, 178 pages
Jr. High: Advanced
Sr. High: Average - Advanced
Illustrations: Photos; Maps
Time Period: 500 B.C.-1796 A.D.
Place: Egypt, Europe

Themes: Female royalty; Heroic resistance of royal women against male authority; Unique power and courage of women in brutal, patriarchal times

Description: This book devotes a chapter to each of seven famous queens in world history: Cleopatra, Boudicca, Galla Placidia, Isabella, Christina, Maria Theresa, and Catherine the Great. Each chapter describes the circumstances of the queen's birth, upbringing, rise to power, and death or downfall. The attempt here is to provide basic historical facts, and to explore the actions and motivations of the ruler and her family and other related persons in power. The emphasis is on the uniqueness of each queen and in portraying the particular qualities that made each one especially memorable as an unusually powerful ruler. It is an especially useful source because it spans over two thousand years of history. Top rating.

(4)

Suggested Uses: The book is highly recommended for book reports for average (or below) readers who could take one or two chapters and compare two of the queens. • Advanced readers could read the entire text and make comparisons between the queens in terms of achievements, strengths, weaknesses, etc. • Individual chapters could be used as adjuncts to the regular curriculum; after class reads one chapter (i.e. Catherine the Great), compare the portrayal with that given in the textbook.

> *"There were no 'years between' Maria Theresa and Catherine. Their lives overlapped. For a whole generation Europe's two vast empires, the Habsburg and the Russian, were controlled by two forceful but utterly different women."*
>
> **- Geoffrey Trease**

Significant Sisters: The Grassroots of Active Feminism 1839-1939
by Margaret Forster
Oxford University Press, 1974, 321 pages
Sr. High: Advanced
Illustrations: None
Time Period: 1839-1939
Place: England, United States

Themes: Feminist progress in context of general social, economic, and political changes; Struggle to educate women to their need for change in status; Historical view of the women's rights movement in England and the U.S.

Description: Through diaries, letters, autobiographies, and unpublished papers, the lives of eight women are revealed in their relationship to the feminist movement; Caroline Norton, Elizabeth Blackwell, Florence Nightingale, Emily Davies, Josephine Butler, Elizabeth Cady Stanton, Margaret Sanger, and Emma Goldman. The struggles to persuade women as well as men that gender equality was essential to the democratic ideal of political life are well documented. The long and honorable history of women activists who withstood the taunts and insults of their peers in order to establish a precedent for women's rights must not be forgotten in the excitement of today's campaigns.

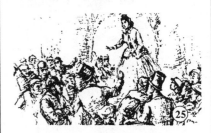

(25)

Suggested Uses: Use Norton and Blackwell as examples of two women who fought for certain rights even though they both denied being feminists. Find in their own words how they felt about sex equality. • The Introduction offers many insights into the feminist movement in both countries. Use this as a basis for discussion: Are all feminists anti-male?

> *"Feminism is not something new that sprang up fully armed in the 1970s; it has a long and worthy history."*
>
> **- Margaret Forster**

The Annals of Labour: Autobiographies of British Working Class People, 1820-1920

by John Burnett, ed.
Indiana University Press, 1974, 364 pages
Jr. High: Advanced
Sr. High: Average - Advanced
Illustrations: None
Time Period: 1820-1920
Place: England

Themes: Experiences of working class people at work and at home; Women in domestic service; Women as straw plait workers, munitions factory workers, and shop assistants; Hard struggle for basic necessities of life; Remarkable writing skill of people of little formal education

Description: These short excerpts from the autobiographies of ordinary people are delightful to read because they provide thought-provoking, insightful glimpses into their daily lives as they saw themselves. Only seven out of twenty-seven are about women, but even in the four accounts about domestic service there is great diversity of background and experiences. Rich detail of everyday life and Victorian expectations of women's role are made very clear. The small print and the 19th century prose may deter some readers, but most students will find these entertaining as well as informative. Out of print but available in libraries.

Suggested Uses: Use the four women in domestic service to show the variety of personal backgrounds as well as the different work experiences. Ask: Why were there so many working class girls "in service" during 19th century? Compare the working conditions found in the four accounts. How did the isolation of domestic service affect the ability of the servant girl to better her conditions? Compare her situation with that of the girl in the munitions factory. For easy reading, use the story of the girl in domestic service in the unit, "Women and the Industrial Revolution," from *In Search of Our Past*, (Reviewed here).

> *"Would the job last, or would she find herself out of work when the war was over? Would the organization of women's membership continue after the war? . . . she might have to go back to domestic service when the war ended, as she would not be wanted in the factory..."*
>
> **- Jenny, Munitions Worker**

The Girl in the White Armor

by Albert Bigelow Paine
Macmillan Co., 1967, 240 pages
Jr. High: Average - Advanced
Sr. High: Average
Illustrations: Drawings; Maps
Time Period: 1412-1431
Place: France

Themes: Widespread belief in spirits, magic and witches; Struggle for Kingdom of France between various regions; Power of Church and its threat of ex-communication over ruler and ruled; Continuing effort of English to gain control of France

Description: Paine sets this familiar legend in historical context and uses the sworn testimony of Joan and her peers as documentation to reveal a believable and honorable heroine. The description of the real people from Joan's childhood and military period helps to personalize the complicated struggle for France. An attractive format and lovely line drawings make this a real classroom asset. This is a young people's version of Paine's classic book about Joan of Arc, and although out of print, is well worth looking for in libraries. Top rating.

Suggested Uses: Chapter 19, "Rouen," divided into many short sections, describes Joan's trial in detail. Copies of different sections could be assigned to students to analyze what they understand constitutes a "fair" trial. What guarantees do we have under the US Constitution that Joan was denied? After reading to class pps. 147-149, ask students to list the evidence that this was an unfair trial; Compare with other witch trials (Anne Boleyn, Salem, Mass.), or modern ones (Joe McCarthy Hearings or trial of Ethel and Julius Rosenberg).

The Hard Way Up

by Hannah Mitchell
Virago, 1977, 260 pages
Sr. High: Average - Advanced
Illustrations: None
Time Period: 1871-1956
Place: England

Themes: Women's suffrage; Female courage and perseverance despite hardship and lack of education; Victorian feminism; Working class women and socialism

Description: Hannah Mitchell may not be a well-known heroine of this era, but as a working class socialist and feminist she became a recognized and honored leader among

➡

her peers. Her autobiography provides a welcome departure from the usual 'famous woman' hero stories and offers an engaging personal account of life among the poor. Mitchell found the period of her lifetime especially unique and remarkable and had no difficulty showing the reader why: the changes in technology and industry, the fervent cry of socialism, and the increasing demand of women for suffrage and reform. Top rating.

> *"...men are not so singleminded as women are; they are too much given to talking about their ideals, rather than working for them. Even as Socialists they seldom translate their faith into works, being still conservatives at heart, especially where women are concerned. Most of us who were married found that 'Votes for Women' were of less interest to our husbands than their own dinners. They simply could not understand why we made such a fuss about it."*
> **- Hannah Mitchell**

Suggested Uses: Recommended for student pleasure reading and/or research for advanced high school student. • Use short chapters from section on her life as a suffragette and compare the description of her activities to those of more famous women, like the Pankhursts. How did women's class membership affect their view of suffrage? What happened to the suffrage movement when World War I broke out? • Students in an English class could read to analyze the writing style.

The House on Prague Street
by Hana Demetz
St. Martin's Press, 1980, 186 pages
Jr. High: Average - Advanced

Sr. High: Average - Advanced
Illustrations: None
Time Period: 1914-1944
Place: Czechoslovakia

Themes: Life of Jewish middle class in pre-World War II Prague; Family splits and decisions over emigration; German occupation of Prague; Effect of war on citizens of Prague; Treatment of Jews, of half-Jews and, after the war, of Germans

Description: Adolescent Hana's mother was Jewish and her father German, and as a "Jew mongrel" her life in wartime Prague reflects this split. Falling in love with a German soldier, the letters from him at the front often arrive with letters from her relatives who have been sent to the concentration camps. The effect of war on the inhabitants of Hana's neighborhood is chilling as one by one they scatter, commit suicide, are imprisoned, or are deported. As part of the genre of war and holocaust stories, this provides a perspective on the treatment of both Jews during the war and Germans after the war. Top rating.

> *"When the new ration cards were handed out the following month, the cards issued to my father were just like the ones my mother had always received: instead of JUDE JUDE they had GERMAN GERMAN printed all over them. But I could go and return them because my father was dead."*
>
> **- Hana Demetz**

The Princess of Siberia
by Christine Sutherland
Farrar, Straus & Giroux, 1984, 325 pages
Sr. High: Advanced
Illustrations: Photos
Time Period: 1771-1873
Place: Russia

Themes: Defeat of Napoleon; Movement for abolition of serfdom; Young Pushkin, the poet; Decembrist Uprising; Life of exiles in Siberia

Description: This dramatic biography personalizes the ill-fated Decembrist uprising against the Tsar in 1825 which sent hundreds of Russia's elite to Siberian exile. Based on diaries and letters of high born Princess Maria Volkonsky, it describes vividly the life of the wealthy nobility before the uprising and the suffering and brutality of their Siberian experience in exile. Maria learned to love the beauty and the people of Siberia and became known as "Our Princess" because of her efforts in their behalf. An excellent way to learn history and geography while following the stories of interesting characters.
Top rating.

Suggested Uses: Provide to the class or read aloud the following: pp. 136-140, an account of the first leg of Maria's journey from Moscow to Siberia; pp. 140-142, Russian dreams for the future of Siberia as part of the United States; pp. 142-147, description of country and legends of folk heroes; pp. 161-165, conditions in the mines where the prisoners worked.

④

The Short Life of Sophie Scholl

by Hermann Vinke
Harper & Row, 1984, 216 pages
Jr. High: Advanced
Sr. High: Average - Advanced
Illustrations: Photos; Drawings
Time Period: 1921-1943
Place: Germany

Themes: Childhood in Pre-Hitler Germany; Adolescence in Nazi Germany; Influence of family upbringing in development of independent thought and moral conviction; Problems for citizenry who opposed Hitler

Description: This account of the life of Sophie Scholl is made intensely personal by photos, letters, diary excerpts, and interviews with a sister and several friends. By the time Sophie joins the White Rose, the secret resistance group, the reader feels the tension and horror surrounding the inevitable fate awaiting her and her brother, Hans, and their friends. This is an important book because it shows a segment of non-Jewish German society which recognized the evil in the Nazi movement and struggled to remain independent in spite of repressive laws. Students will identify with Sophie's experiences as a teenager in school, camp, college, love and friendship. Top rating.

"In school they told us that a German's attitude to his country is deliberately subjective and partisan. Unless it is deliberately objective, impartial, and evenhanded, I can't accept it."

- Sophie Scholl

The Story of Dona Gracia Mendes

by Bea Stadtler
United Synagogue of America, 1969, 136 pages
Jr. High: Average
Sr. High: Easy - Average
Illustrations: Drawings
Time Period: 1561-1569
Place: Portugal, Italy, Belgium, Turkey

Themes: Terror of the inquisition for Jews in Spain, Portugal, Venice; Effort for survival by Marranos (Spanish Jews) throughout Europe; Catholic Church and the Jews

Description: This is a fictionalized account of the life of a Jewish heroine, a remarkable woman whose great wealth and business skills did not protect her from harassment

from the Inquisition throughout Europe. She finally found safety under the protection of the Sultan in Constantinople and was able to rescue thousands of Jewish refugees. The characters are one dimensional, but the account of complicated trade between seaports and powerful rulers and the constant threat of the Inquisition is interesting. Out of print, but available in Jewish community libraries.

Tudor Women

by Alison Plowden
R.R. Donnelley & Sons Co., 1979, 169 pages
Sr. High: Advanced
Illustrations: Seventeen portraits of royal Tudor women
Time Period: 1452-1602
Place: England

Themes: Importance of women in the Tudor reign; Rituals around lying-in period for pregnant Queens; Interest in classical education and involvement in the "New" religion, a more liberal form of Protestantism; Strength of Elizabeth as ruler; Restrictions on opportunities for women other than motherhood and the household.

Description: Only for advanced students, this book provides a great deal of background information about the daily lives of the ladies of nobility who were either Queens or wanted to be. Interesting details are given about the preparations for a royal birth, considered a "lady's affair" and usually arranged by the maternal side of the mother-to-be. Classical education and an interest in the new form of Protestantism by ladies of the Court and especially Catherine Parr are described.

Suggested Uses: Students could use this for advanced research to learn more about an individual Tudor Queen.

Upon the Head of the Goat: A Childhood in Hungary 1939-1944
by Aranka Siegal
New American Library, 1981,
183 pages
Jr. High: Average - Advanced
Sr. High: Average - Advanced
Illustrations: None
Time Period: 1939-1944
Place: U.S.S.R., Germany, Hungary

Themes: Increasing repression of Jews in Hungary; Jewish refugees, mostly women and children; Zionist underground; Life in the ghetto and transportation to camps in Germany

Description: Piri comes of age in the years when Jews saw great changes in Hungary. With the men taken to fight the Russians, Piri's grandmother, mother and activist sister, unwilling to be passive victims, conjure up strategies to survive. Based on the life of the author and her family, the story ends in 1944 as the family boards the train for Auschwitz. Also available in two color filmstrips which tell the story using black-and-white photos from the period and watercolor illustrations (Social Studies School Service). Top rating for both resources.

Suggested Uses: • If you use the filmstrip, you might read or assign the first part of the story and use part of the filmstrip to complete it. • Students may compare/contrast situation of Jews in Hungary as described in this book with treatment of Jews in Holland, *Anne Frank*, or in Czechoslovakia, *The House on Prague Street*.

"Piri, you will unbraid your hair and hide it all under the kerchief. Smudge your faces with ash from the stove. Make yourselves as unattractive as possible. Soldiers after a victory behave like animals. I remember that from the last war, and these are Germans."

- Piri's mother

Victorian Lady Travellers
by Dorothy Middleton
Academy Chicago, 1982,
176 pages
Sr. High: Advanced
Illustrations: Photos; Drawing
Time Period: 1831-1900
Place: China, U.S.S.R., Nigeria, Australia, Brazil, United States, Russia, Sri Lanka, Kenya, India, Zaire

Themes: Motivations of primarily middle-aged women for travel; Anecdotes about their adventures; Descriptions of countries visited and non-western people observed; The "new woman" of the late Victorian period

Description: Amusing accounts of the adventures of seven American and English women based on their diaries or published works. An introductory chapter, "Well-Qualified Ladies," gives an excellent overview of commonalties among the women, stressing the reasons for their need to seek out explorations in distant parts of the world. The considerate but condescending tone they assumed when dealing with non-westerners is noted throughout the book. Spirited and humorous writing style, but vocabulary demands a good reader.

"From about 1870 onwards more women than ever before or perhaps since undertook journeys to remote and savage countries . . . they were mostly middle-aged and often in poor health, their moral and intellectual standards were extremely high and they left behind them a formidable array of travel books."

- Dorothy Middleton

Woman Composers
by Carol Plantamura
Bellerophon Books, 1983,
48 pages
Jr. High: Average
Illustrations: Drawings
Time Period: 100 B.C.-1983 A.D.
Place: Greece, Italy, Germany, France, Austria, England, Scotland, Japan, United States

Themes: Explanation of the Muses; Sappho's and Greek poetry as lyrics for the lyre; Legends of St. Cecilia; Success of women as musicians in spite of traditional restraints; Performance artists

Description: This paperback has a coloring-book format and may

➡

appear too juvenile for secondary students. It is, nevertheless, a worthwhile source of information about women composers. It provides short and interesting biographies and sketches of the following: Sappho; Cecilia; Hildegard von Bingen; Tarquinia Molza; Francesca Caccini; Barbara Strozzi; Elizabeth Claude Jacquet de la Guere; Maddelena Lombardini Sirmen; Maria Theresia von Paradis; Fanny Mendelssohn; Clara Schumann; Dame Ethel Smyth; Amy Beach; Nadia and Lili Boulanger; Ruth Crawford Seeger; Mary Lou Williams; Dame Elisabeth Lutyens; Thea Musgrave; Betsy Jolas; Pauline Oliveras; Toshiko Akiyoshi; Laurie Anderson; Cathy Berberian. It could serve as a stimulus for further research on individual women artists using *Women in Music: An Anthology of Source Readings from the Middle Ages to the Present* by Carol Neuls-Bates (reviewed here).

Suggested Uses: Use the text, perhaps without the drawings, as class readings to indicate the continuous presence of women as musicians throughout history. Bring in recordings of some of the music for students to enjoy and compare with that of male composers.

"Jazz is a certain rhythm. . . It's a street music, with a certain earthiness… I'm trying to draw from my heritage and enrich the jazz tradition without changing it. I'm putting into jazz, not just taking out."

- Toshiko Akiyoshi

Woman's Work: The Housewife, Past and Present
by Ann Oakley
Vintage Books, 1974, 241 pages
Sr. High: Average - Advanced
Illustrations: None

Time Period: 1500-1973
Place: England

Themes: Roles of women in non-industrialized societies; Ways in which role of housewife emerged with industrialization; "Privatization" and "domestication" of women; Perspectives of contemporary women on their role of housewife; Ideology of equation of femininity and domesticity; Myth of motherhood

④

Description: An analysis of the nature and history of women's work at home. Author cites women as equal partners in the family and as having significant amounts of independence in pre-industrial society. She contrasts this with women's work in the home today. The major question asked is how the present position of women came about and what strategies for change can occur.

Suggested Uses: Chapters two (women in pre-industrial society, 31 pages) and three (women and industrialization, 26 pages) stand on their own and may be assigned for student reading.

"The modern housewife… is both acting out a feminine role, and is a worker involved in an occupation which has all the characteristics of other work roles except one - it is unpaid."

- Ann Oakley

Women of Action in Tudor England
by Pearl Hogrefe
Iowa State University Press, 1977, 233 pages
Sr. High: Advanced
Illustrations: Portrait, Drawing
Time Period: 1443-1610
Place: England

Themes: Tudor England; Plot to put Lady Jane Grey on throne; The influence of the "New Religion" on Catherine Parr and other women of the court; Interest in women's education and use of classical scholars as tutors for young women

Description: This attractive book presents nine energetic and interesting women whose intellectual and social drive made them influential as individuals. They represent the Renaissance of Britain with a variety of interests in education, religion, politics, philanthropy, and literature. Among the better known personalities are: Catherine of Aragon, Queen Elizabeth, Catherine Parr, Margaret Beaufort, and Bess of Hardwick, the Countess of Shrewsbury. The format makes it an ideal reference book; each chapter divided into short sections, easily readable by students, and an appendix with an historical background and resource notes for each chapter. Top rating.

"She owned a theological library so subversive that 'it was kept locked up in a chest under the seal of the Bishop of Lincoln.'"

Lawrence Stone re the Duchess of Suffolk

⑥

Women Who Changed History: Five Famous Queens of Europe

by Mary L. Davis
Lerner Publications Co., 1975,
99 pages
Jr. High: Average
Sr. High: Easy
Illustrations: Portraits
Time Period: 1122-1796
Place: England, France, Spain, Russia

Themes: Eleanor of Aquitaine, Isabella of Spain, Elizabeth I of England, Marie Antoinette of France, Catherine the Great of Russia; Interplay of personality and politics

Description: In these short accounts, five queens are presented as individuals responding to the pressures of their role as rulers. Personal anecdotes make each woman seem real and vulnerable while the historical context provides reasonble explanation for their behavior.

Suggested Uses: Students could list the evidence showing exactly how each queen "changed history". How did the personality, the education and training for queenship of each woman effect her behavior? Compare the women in terms of the times in which they lived. Would Marie Antoinette have become a strong ruler like Elizabeth or Catherine in similar circumstances? Imagine Eleanor of Aquitaine as the wife of Louis XVI faced with a revolution. How might she have responded?

First Person Accounts

A Woman's Life in the Court of the Sun King
by Liselotte von der Pfalz
Johns Hopkins University Press,
1984, 277 pages
Jr. High: Advanced
Sr. High: Advanced - Average
Illustrations: Drawings, Paintings
Time Period: 1660-1722
Place: France, Germany

Themes: Social life and customs of Versailles Court; Hierarchical order of society, the cult of the king and the centralized machinery of State; Women, ministers and confessors surrounding Louis XIV; Gossip and description of major personalities of period, such as Peter the Great, George I of England, William of Orange; Aggressive campaigns of Louis XIV; The Spanish succession; Devastation of the German Palatinate; Revocation of the Edict of Nantes; Famine of 1709 and upheavals of Parisian mob

Description: Liselotte, Duchesse d'Orleans, during her 50 years at the French court as wife of the King's desolate brother, wrote about 40 letters a week home to relatives in Germany. These letters are valuable first hand documents about the intellectual, social and political life of the court. Simply written with humor and frankness, the letters provided a vehicle for Liselotte to vent her feelings about her restricted life and about court practices. Top rating.

Suggested Uses: Students use the index to find references in Lisolette's letters about selected topics, such as raising children, health and physicians, or the Dauphin. In one column they make a list of information gathered from the letters and in another they list what other information they might need to get a fuller picture of the event or topic. They then might do further research in other books. • Compare the descriptions of court life by women in other cultures, such as Japanese, (*The Nightingales that Weep* and *The Shining Prince*) and Chinese, (*Dream of the Red Chamber*). (All reviewed here)

> *"The coiffures are getting higher every day. I think they will finally have to make the doors taller, for otherwise these ladies will no long be able to go in and out of the rooms."*
> **- Liselotte von der Pfalz**

Auschwitz: True Tales from a Grotesque Land
by Sara Nomberg-Przytyk
The University of North Carolina Press, 1985, 161 pages
Jr. High: Advanced
Sr. High: Average - Advanced
Illustrations: None
Time Period: 1944-1945
Place: Poland

Themes: Women's survival in Auschwitz; Mengele's performance as medical officer and determiner of fate; Strength of human spirit

Description: The author is a survivor of Auschwitz. Her book is notable because her account is not only of her own struggle for survival but that of other inmates and even the guards. Each of the short, one to two-page chapters, consists of an episode which introduces another individual woman, her background and her fate. The horrors of the camp are graphically described, but also are the instances of human kindness and compassion between prisoners. It is for mature students only.

Clara's Story
by Clara Isaacman
Jewish Publication Society of America, 1984, 119 pages
Jr. High: Average
Sr. High: Easy
Illustrations: Photos
Time Period: 1938-1945
Place: Belgium

Themes: Courage of Jews and the people in the Resistance; Power of faith and family in battle for survival

Description: After fleeing Romania, Clara's family lived prosperously in Antwerp for years before a series of reprisals against Jews led them to attempt to leave Belgium. Unsuccessful, they were hidden in a succession of homes by other Jews, members of the Resistance, nuns, priests, and others who risked their lives to help. Frustrated by inaction and fear, Clara's eighteen year old brother volunteered for a labor camp and died in Auschwitz. This story of daily fear of discovery conveys dramatically the heroism of ordinary people, those who hid and those who protected them. An excellent record of the Holocaust for younger students. Top rating.

➡

Suggested Uses: Compare experiences with other first person accounts of the Holocaust by young people; *The Diary of Anne Frank, Elli* by Livia E. Britton Jackson, *These I Do Remember* by Gerda Haas, and *Fragments of Isabella* by Isabella Leitner (all reviewed here). Were there similar factors which played a part in the survival of each? What qualities of personality seem to be important in a struggle for survival? • Have students write a child's view of the world through the eyes of each of these survivors. • Prepare an exhibit of drawings by students illustrating the experiences of these young women. • What is the relevance of these accounts for the world today?

"Our job, our sacred duty, is to stay alive. You must not see our hiding as an act of cowardice. We must struggle in order to preserve Judaism. We are soldiers in the struggle for survival, and our battle is just as important as what is happening on the front."

- Clara's father

Elli
by Livia E. Britton Jackson
Times Books, 1980, 248 pages
Jr. High: Advanced
Sr. High: Average - Advanced
Illustrations: None
Time Period: 1944-1947
Place: Hungary, Poland

Themes: Holocaust; Nazi occupation of Hungary; Adolescence in Auschwitz; Return home

Description: Thirteen year old Elli, typical adolescent, has her life brutally shattered by Nazi deportation to Auschwitz. Her dreams of boys and studies and becoming a poet give way to a daily desperate struggle for survival for herself and her mother. The horrors of the concentration camps as experienced and recounted by a young girl are an important lesson for today's students who may be indifferent to text book history. Top rating.

Suggested Uses: Compare Elli's experiences with cattle car transport to those of the young German girl's in *Transport 7-41* by T. Degens and Esther Hautzig's in *The Endless Steppe: Growing Up in Siberia* (reviewed here). What were the political and economic conditions which made it possible for one group of human beings to treat other humans like animals? What psychological factors are at work in such a situation? How did the history of anti-Semitism provide a psychological background for this inhumane behavior?`

Fragments of Isabella: A Memoir of Auschwitz
by Isabella Leitner
Dell, 1983, 125 pages
Jr. High: Average
Sr. High: Easy
Illustrations: None
Time Period: 1944-1945
Place: Hungary, Poland

Themes: Holocaust in Hungary; Struggle of families to remain together in concentration camp; Indomitable human spirit

Description: On her birthday, a teen-age girl and her family were deported from Hungary to Auschwitz where her mother and little sister immediately were sent to the crematorium by the infamous Mengele. Isabella and two sisters survive hunger, degradation, and the constant threat of death and are finally liberated. This small paperback was a Book of the Month Club selection. Its brevity as well as its powerful story makes it appropriate for students. Top rating.

Suggested Uses: Use with a study of anti-semitism in Europe. • Are there other places in the world today where one group of people is treated by another without regard for their humanity? Identify such regions and discuss the political and economic as well as psychological conditions which make such action possible. Ask: Do you think the world has learned anything from the Holocaust? • Ask students to bring in evidence from newspapers, magazines, radio and TV that human kindness is being demonstrated by one group of people towards another.

"Mama, I make this vow to you: I will teach my sons to love life, to respect man, and to hate only one thing - - war."

- Isabella Leitner

Greek Women In Resistance
by Eleni Fourtouni
Thelphini Press, 1985, 163 pages
Sr. High: Average - Advanced
Illustrations: Maps; Drawings; Photos
Time Period: 1940-1950
Place: Greece

Themes: German occupation and Greek resistance; Civil War; Transformation of women's roles; Effect of Truman Doctrine and suppression of the "left;" Women's resistance and organizing in concentration camps

➡

Description: In the first section there are short selections which describe courageous acts of resistance by leftist women, first against the Germans and then against the British and the right-wing and nationalist resistance groups. The second section gives us three journals by women who in 1949 secretly wrote of their experiences while they were still imprisoned in political camps for women. In this microcosmic world, women harnessed their resources and effectively resisted tyranny. These accounts of determination to survive and even resist in the face of brutality will remain with the reader a long time. This section contains descriptions of torture. Top rating.

Suggested Uses: Compare/ contrast with women's experiences as described in *Eleni* (see suggested activities under *Eleni*, reviewed here).

"By day we were still students and daughters, cramming for Latin and math exams... But at night the streets were ours. We'd cover the walls of the most remote neighborhoods with resistance slogans... like lightning we'd run in and out of coffee shops, distributing our handbills."

- Toula Mara-Mihalakea

Greenham Common: Women At The Wire
by Barbara Harford &
Sarah Hopkins, eds.
The Women's Press, Ltd, 1984,
168 pages
Jr. High: Advanced
Sr. High: Average - Advanced
Illustrations: Photos
Time Period: 1981-1984
Place: England

Themes: Greenham Common, a women's peace camp; A womanly culture without hierarchies; Changes in women's lives resulting from peace activities

Description: This is a collection of more than 50 testimonies from women participants in the peace activities around Greenham Common, a permanent peace camp established just outside the gates of an American missile base in England. The women represent all ages, social and economic classes, religious and racial backgrounds. Some entries are only a paragraph in length, others several pages, but all describe the impact on their lives of their involvement in this protest since the original march from Cardiff, Wales in 1981. Since then, 102 peace camps have been set up in Britain and the U.S., all in the tradition of collective non-violent protest against the proliferation of nuclear weapons. Top rating. Published by The Women's Press Ltd, 124 Shoreditch High Street, London E1, England. It can also be found in U.S. bookstores which carry women's and peace materials.

"I think it is crucial that women speak as loudly and as often as we can. We must create our own actions and write our own herstory to shape the identities and the world that we ourselves desire."
- Barbara Harford

Suggested Uses: Use pps. 14-18 which describe the reasons for the march from Wales and the conditions at the Greenham Common when the women first arrived there. Have students look up evidence in magazine and newspaper articles to determine if similar marches and camps have been held in the U.S. Why is it easier to keep public attention on Greenham Common in Britain than on a peace demonstration in the United States? • Have students find comments from women representing diverse backgrounds. Was there a unifying reason for their commitment?

Journey Into the Whirlwind
by Eugenia Ginzburg
Harcourt, Brace, & World, 1967,
418 pages
Sr. High: Advanced
Illustrations: Map
Time Period: 1934-1956
Place: U.S.S.R.

Themes: Stalinist purges; Prison life: arrest, interrogation, confinement, hard labor, starvation; Courage and integrity of Ginzburg who refused to admit guilt to save herself; Disbelief by loyal Party members that Stalin was involved in the purges; Evidence of human kindness and tenderness among prisoners and guards even under appalling conditions

Description: This is the first of two volumes recounting Ginzburg's life as a political prisoner during the Stalin purges beginning in 1934 and ending in 1953 (Vol. 2, *Within the Whirlwind*, Harcourt Brace Jovanovich, 1981). Ginsburg was a teacher, journalist, a loyal Communist, and wife of an important Party official in Kazan. She was accused of failing to denounce a former colleague whose theoretical position on Tartar history had been classified as Trotskyist. She spent nineteen years as a prisoner even during World War II, learning later that her oldest son had died of starvation in Leningrad. The point of view as well as the fine writing is what makes this an important book. It is honest, gripping and objective in its portrayal of the excesses of the Stalinist regime. For her, the victims were not only the accused as prisoners, but those who were forced to inform, accuse and carry out the hideous punishments. Her friendship with other women prisoners reveal the special difficulties which women suffered while incarcerated. This is an engrossing story full of horror, but it is also a tribute to the human spirit and its strength under the most appalling conditions. Recommended for mature students.

Suggested Uses: World Literature Class: Report on some of the poets whose work sustained Ginzburg and other prisoners during their incarceration. Look at the footnotes for full names and titles of their books. What American poets would sustain the spirit in a similar situation? • Prepare a factual report of the Stalinist period and the reason for its eventual fall from grace.

> *"I strove to remember all these things in the hope of recounting them to honest people and true Communists, such as I was sure would listen to me one day."*
>
> **- Eugenia Ginzburg**

Ladies on the Loose
by Leo Hamalian, ed.
Dodd, Mead & Co., 1981,
256 pages
Sr. High: Advanced
Illustrations: None
Time Period: 1800-1900
Place: Italy, Spain, Sweden, Palestine, Lebanon, China, India, Burma, Russia, Saudi Arabia, Zaire

Themes: The hardships and pleasures of women traveling in the 18th and 19th centuries; European view of the customs of the people they visited; The newfound freedom of the late Victorian era "new women"

Description: A lively collection of narratives written by women who traveled, many times alone, to remote places. They recorded in their own styles and with editorial comment, the strange customs, freedoms and hardships they encountered. Their experiences range from enjoying the glories of Naples to helping the lepers in Siberia, and from swimming in Scandanavia to bicycling in India. Top rated.

Suggested Uses: Supplemental reading for students of geography or Victorian culture. Excerpts could be used to describe the various countries written about. • Students read three accounts and list customs that seem particularly "strange" to the traveler, or are enjoyed by the traveler? Conversely, what about the woman traveler might have appeared odd to the natives of the country?

> *"Women in Burma are probably freer and happier than they are anywhere else in the world."*
>
> **- Mrs. Ernest Hart**

Méme Sauterre: A French Woman of the People
by Serge Grafteaux
Schocken, 1985, 165 pages
Jr. High: Advanced
Sr. High: Average - Advanced
Illustrations: None
Time Period: 1891-1975
Place: France

Themes: Rural proletarian life of weavers; Daily struggle for bread; Loving family relationships

Description: Méme, or Grandmother, tells her story from birth to very old age providing a unique view of French rural life among the weavers in Northern France. As workers in this domestic industry, her parents were part of the proletariat, dependent on wages for survival in this rural area. Méme began weaving as a tiny girl, wearing wooden blocks on her feet to enable her to reach the loom. Her life was hard but a happy one. Her parents were loving to the children and she had a happy marriage. This account is easy and interesting to read. Top rating.

Suggested Uses: Select passages to read which describe the working conditions of the weavers in their cellars and their meager diet. • What was the importance of a large family? What evidence is given to show the affection among family members? How is this hardworking family affected by the political events going on in France?

Mischling, Second Degree: My Childhood in Nazi Germany

by Ilse Koehn
Greenwillow Books, 1977,
240 pages
Jr. High: Average
Sr. High: Easy
Illustrations: None
Time Period: 1926-1945
Place: Germany

Themes: Youth activities in Nazi Germany; Repression of Social Democrats; Status of the Mischlings or part-Jews under Nazi law

Description: Told by a young girl who lived as a member of Hitler Youth, unbelieving but learning to keep quiet, this book belongs with Anne Frank's Diary as youthful testimony of historical events. Ilse's parents were divorced in order to save Ilse from persecution as a Mischling, since her father's mother was half-Jewish. By providing an account of daily life in school and recreational activities, Ilse's story helps document civilian life under Nazi rule. Fast-moving and easy to read, this is a good way to introduce an historical period to young readers. Top rating.

Moscow Women: Thirteen Interviews

by Carola Hansson & Karin Liden
Random House; Pantheon, 1983,
191 pages
Jr. High: Average - Advanced
Sr. High: Average - Advanced
Illustrations: Photos
Time Period: 1978-1978
Place: U.S.S.R.

Themes: Women's double work burden; Stereotypical attitudes toward male and female roles; Yearning of women for individual fulfillment; Importance of family ties; Desire for children.

Description: The myth of equality for women in the Soviet Union is revealed through non-judgmental interviews with young working mothers conducted in secret by two Russian-speaking Swedish journalists in 1978. The question and answer format makes easy reading and allows students to discover for themselves patterns of Soviet attitudes and behavior. The Introduction and Postscript provide historical and psychological analysis for present status of women in the Soviet Union. Suggestions for further reading are included.

Suggested Uses: Assign individual interviews for oral reports to compare problems. • Compare with U.S. women in similar situations. How do these attitudes compare with women's views in U.S.? In what kind of U.S. publication would one find similar attitudes? Do you ever hear such views expressed on American T.V.? By men or women? • With advanced students use Introduction and Postscript to analyze the historical context for women's present status: In what historical periods in U.S. have women lost economic gains previously held? What events in post revolutionary Russia would account for the present situation? Why is there no active Feminist Movement in Soviet Russia today?

Playing for Time

by Fania Fenelon with Marcelle Routier
Atheneum, 1977, 262 pages
Sr. High: Average - Advanced
Illustrations: None
Time Period: 1944-1945
Place: Germany

Themes: Testimony of survival and depiction of the strength of human relationships; Insight into the process of human degradation

Description: This is a document by one of the few survivors of a unique women's orchestra in Birdenau extermination Camp. The author describes her eleven months as one of the "orchestra girls;" charts the loves, the laughter, the hatreds, jealousies and tensions that racked this privileged group whose only hope of survival was to make music on the whim of Kommandant Kramer, leader of the Auschwitz complex.

Suggested Uses: Students can research and compare the similarities and differences of the women's orchestra in Birkenau and the men's orchestra in Auschwitz. • Students can pursue the differences of the women, from the Polish non-Jewish girls to the French Jewish girls to the German Jewish girls. What motivated each to act the way she did based on her background? • Compare with Kitty Hart's life in Auschwitz as described in *Women at War* (reviewed here).

"We had never played so much: there were two or three concerts every Sunday. Everyday, and often several nights on end, the SS came to our block to demand endless musical desserts. Hell has many faces, and for us this was one of them."

- Fania Fenelon

The Diary of Nina Kosterina

by Mirra Ginsburg, trans.
Crown, 1970, 192 pages
Jr. High: Average
Sr. High: Average
Illustrations: None
Time Period: 1936-1941
Place: U.S.S.R.

Themes: Growing up in Stalinist Pre-War Russia; Stalinist repression; Search for integrity

Description: This fifteen year-old Moscow girl describes her life in school, the Communist youth organization, the Komsomol, and at home with her family. Her hopes, fears, loves, and quarrels with friends and family seem universal. Yet, her own father and parents of friends have been arrested and sent away as "enemies of the state" and Nina does not understand why. When Germany invades Russia, she volunteers as a partisan in the hopes that her action will save her father.

The Endless Steppe: Growing Up in Siberia

by Esther Hautzig
Thomas Y. Crowell, 1968, 243 pages
Jr. High: Average
Sr. High: Easy - Average
Illustrations: None
Time Period: 1941-1946
Place: Poland, U.S.S.R.

Themes: World War II and Polish anti-Semitism; Russian occupation of Poland; Transport by cattle cars; Housing, education, food, and work for political prisoners in Siberia; A young girl's resiliency and strength of spirit

Description: A young girl's determination not only to survive under terrible conditions, but to excel, is dramatically conveyed in this memoir of life in a pioneer village in Siberia. From the first pages, the reader is caught up in a fast-moving account of this twelve-year old Jewish girl and her family's deportation as Polish capitalists to Siberia. Only at the end of the war, did they realize that through this action by the Russian army they had been saved from extermination by the Nazis. Through Esther's eyes we experience the hardships and the joys of being a young teenager trying to learn a new language and adjust to strange customs in school. This book conveys much about Siberian life before the development of industrialized cities. It is a valuable resource as a corollary to the study of the Soviet Union. Top rating.

Suggested Uses: The chapters lend themselves to being read aloud: Chapter 2 describes the trip in the cattle car; Chapter 3, the arrival in Siberia; Chapter 10, Esther's adjustment to school. • Recommend for a book report as it is fast reading. • Compare to conditions and attitudes on the American frontier.

"I had forgotten what life was like 'back there.' Beautiful things and lovely cars and delicious food had become dim memories; life in Poland, even our home, had become a fantasy. Reality was here, in Siberia; I could cope with reality."

- Esther Hautzig

The Memoirs of Glückel of Hameln

by Marvin Lowenthal, trans.
Schocken, 1977, 277 pages
Jr. High: Advanced
Sr. High: Average - Advanced
Illustrations: Engravings
Time Period: 1647-1719
Place: Germany

Themes: Restricted life of Jews in Europe; Women as merchants and manufacturers; Importance of marrying children off; Jewish customs; feasts, marriages, funerals; Importance of learning for sons

Description: We are grateful to Glückel, a middle class Jewish woman, for her lively and detailed account of life among wealthy Jews during the period following the Thirty Years War and prior to the age of Frederick the Great. She was happily married, bore fourteen children and saw most of them married successfully. Glückel describes weddings, feasts, journeys, attendance at the synagogue and gives us profiles of her family, friends and business associates. This is a charming self-portrait, combining piety with shrewd worldliness, and it allows us to share in her worries about her children, her disappointment in her second marriage, as well as the financial deals she engages in. Not mentioned by Glückel, but described in the Introduction, are the tremendous handicaps set for Jews in the governmental restrictions on every phase of their lives. Poll taxes, the wearing of yellow badges, the denial of the right to own land or a house, or to engage in certain businesses and manufacturing, made life precarious for most Jews. Glückel's financial success as a female entrepreneur is, therefore, even more remarkable and indicates her intellectual abilities as well as her strength of character. There are nine engravings which illustrate different aspects of Jewish life and testify to

the wealth of this family. This is a wonderful source of social history about the daily lives of people. It is not difficult to read, but the style may not interest all students. A simplified version is also available: *The Adventures of Glückel of Hameln* by Bea Stadtler, United Synagogue, 1967. This has additional drawings and would have special appeal to younger readers.

Suggested Uses: There are wonderful selections from which to read aloud to describe various aspects of the daily life of the Jewish middle class. Special events such as traveling either by land or by sea, feast days, or a terrible accident in the synagogue are rich in detail and emotion and would appeal to students.

The Secret Ship
by Ruth Kluger & Peggy Mann
Doubleday, 1978, 136 pages
Jr. High: Average
Sr. High: Easy
Illustrations: None
Time Period: 1939-1941
Place: Rumania

Themes: Illegal immigration into Palestine by "secret ships;" Importance of these immigrants to Israel's war for independence; Courage and audacity of Mossad, secret organization in charge of illegal operation; A young woman's personal sacrifice, courage and determination; Inability of middle-class European Jews to understand gravity of Nazi threat

Description: A beautiful young redhead from Palestine returns to Rumania, her birthplace, as the only woman member of the secret organization dedicated to rescuing Jews. Ruth Kluger was unable to persuade her own brothers and their families to leave because they did not recognize the terrible danger the Nazis presented to Jews and dissenters in each occupied country. Through sheer determination and ingenuity in overcoming impossible obstacles, she and her comrades were able to save several hundred men, women, and children in the old ship, Hilda. *The Secret Ship* is in print and is a simplified and shortened version of the original book, *The Last Escape*, by Peggy Mann and Ruth Kluger, which provides greater historical context, and documents the reason Ruth is known as the "Joan of Arc" of Palestine. *The Last Escape* is out of print but available in some libraries.

Suggested Uses: Chapter I and the Epilogue, "What Happened Then," provide an easy-to-read historical overview of the Holocaust, the gathering of Jews in Palestine, and the founding of the state of Israel. • Students could outline the information chronologically to show the march of Nazism across Europe. • The fate of most Jews who did not escape is recounted in other books reviewed here: *These I Remember* by Gerda Haas; *Fragments of Isabella* by Isabella Leitner; *Playing for Time* by Fania Fenelon; *Elli* by Livia Britton. Discuss some of the reasons many middle-class Jews refused to heed the warnings and danger signs of the impending Holocaust.

"Every Jew who struggles and suffers to keep alive… is a hero. You are our tomorrow."

- Ruth Kluger

These I Do Remember: Fragments from the Holocaust
by Gerda Haas
The Cumberland Press, 1982, 283 pages
Jr. High: Advanced
Sr. High: Average
Illustrations: Photos
Time Period: 1930-1945
Place: Germany, Poland, Holland, France, Belgium, Lithuania, U.S.S.R.

Themes: Need for present generation to know about the Holocaust; The enormous scope of Hitler's plans of conquest; Courage and ingenuity of people under terrible stress; Nine lives changed by history

Description: These gripping accounts are set in a geographical and historical context which enhances understanding of the scope of the Holocaust. Each section is introduced by a well-documented, brief history of Jewish life in one country and the chronology of the Nazi occupation there. Nine people, seven of them women, describe their experiences through their own words from diaries, letters, and memoirs. Haas has consciously chosen a variety of people in age, nationality and class. Among the nine are a "Mischling" or half-Jew, and a non-Jew, a six year old Catholic boy. A glossary, a bibliography, and a record of the sentencing of the Nazis mentioned make this an excellent supplementary text for the study of World War II. Top rating.

Suggested Uses: Students could dramatize any of these accounts by taking different parts and reading letters or diaries or making a script from the dialogue. • The Introduction for each section makes good class reading assignments as corollary to the study of World War II. • Posters could be made from old magazines and newspapers

showing the ads, news items of current interest, and indications of the progress of the war. • Discuss: What were Americans doing and thinking while the Jews were being rounded up and killed? • What groups of people besides Jews were put into concentration camps? Why? • Additional reading: *Fragments of Isabella: A Memoir of Auschwitz*, by Isabella Leitner and *Playing for Time* by Fania Fenelon. (Reviewed here).

> *"Since nearly the whole of Jewish youth under eighteen was killed, the few of us who have survived, the men and women who are now in our late fifties and older, have a special responsibility to share what we know and have experienced in the Holocaust."*
>
> **- Gerda Haas**

We Have Already Cried Many Tears: The Stories of Three Portuguese Migrant Women
by Caroline Brettell
Schenkman, 1982, 132 pages
Sr. High: Average - Advanced
Illustrations: Maps
Time Period: 1950-1980
Place: Portugal, France

Themes: History of migration in Portugal and women's motivations for migration; Legal position of women in Salazar regime; Class differences; Socioeconomic context of women's lives in rural villages and in working class neighborhoods; Traditional definitions of male/female role; Changes in lives of migrant families in France

②

Description: Three short (about 15 - 25 pages each) oral histories reflect the diversity among Portuguese women immigrants to France. The first woman was raised in a poor hamlet; the second in a larger, more economically diverse village; and the third, in a working class section of Porto. All women, however, moved across cultural differences to become integrated into a vastly different life. The women's lives in Portugal as well as in France are recounted. Includes an introduction to each oral history and a five years later report.

Suggested Uses: The long introductory chapter may be skipped so students can get right to the first person accounts. • Students might be assigned the book, *Women of the Shadows* (Ann Cornelisen, Random House) for contrast. This book describes isolated peasant women in neglected southern Italy who stay at home to farm while their husbands and sons migrate north.

> *"As in other Catholic countries of western and southern Europe, the Portuguese Church found its major support among the female population and through these women entered into the very soul of the Portuguese family. Religious dogma instilled the values of obedience, submission, and hard work in the hearts of female parishioners."*
>
> **- Caroline Brettell**

Fiction

A Night in Distant Motion
by Irina Korschunow
David R. Godine, 1983, 151 pages
Jr. High: Average
Sr. High: Average - Advanced
Illustrations: None
Time Period: 1944-1945
Place: Germany

Themes: Secret acts of resistance to the repressive Nazi laws; Harsh measures against lawbreakers; Relations of German citizens with prisoners of war

Description: A young German girl matures in a few short months through her contact with a Polish POW. She falls in love, learns to doubt and then reject Nazi propaganda, and finds refuge with a friendly farm family after being discovered with her lover. Like Anne Frank, she must learn to live quietly in one room with very little besides her thoughts for company. We learn about her childhood through her musings. This well written novel tells the story of ordinary Germans and how it was possible for even a well-meaning citizen to become misled by the Nazi movement.

Suggested Uses: After hearing this plot students could discuss a variety of situations where citizens might be unaware of the true character of their government's policies. Might choose examples from U.S. and from U.S.S.R.

A Proud Taste for Scarlet and Miniver
by E.L. Konigsburg
Atheneum, 1973, 201 pages
Jr. High: Advanced
Sr. High: Average
Illustrations: Drawings
Time Period: 1137-1204
Place: France, England, Palestine

Themes: Arranged marriages; Crusades; Eleanor as administrator in Aquitaine and England; History of troubadours and Courtly Love

Description: This sophisticated little fantasy has Eleanor in Heaven chatting with her mother-in-law, Abbot Suger, her old counselor, and William Marshall, her loyal knight. While they wait for Henry II to come up from Hell, they take turns recounting Eleanor's life story. To appreciate the wit and historical allusions a student must know basic facts about twelfth century English and French history.

Suggested Uses: Read aloud any chapter to an advanced class as a short and very simplified account of a particular event. The modern tone and language help to clarify complicated historical situations. Pps. 172-175 offer a humorous account of the practical aspect of chivalry and the code of honor among knights.

A Week Like Any Other Week
by Natalya Baranskaya
Emily Lehrman, 1974, 46 pages
Sr. High: Advanced
Illustrations: None
Time Period: 1969
Place: U.S.S.R.

Themes: Women's double burden, home and work

Description: This short story originally appeared in a Soviet journal, *Novy Mir*, No. 11, 1969, and attracted a great deal of attention.

The protagonist, young mother of two, is a specialist in scientific research who cannot advance in her profession because she must be absent so frequently to care for her two sick children. Her plight seems typical of most Soviet working mothers who get inadequate support in childcare from either the government or their husbands. Olga's husband is more of a help with the children than most Russian husbands, but even he does not feel that he has fifty percent responsibility for home chores nor does he recognize his wife's need for intellectual satisfaction.

Suggested Uses: Several short excerpts could be reproduced for class reading; Olga's trip home on the bus with shopping bags full of food; Her nightly chores after a day's work; Difficulties of completing research at the office while her mind is preoccupied with her duties at home. Compare these descriptions with the schedules of American working mothers. What percentage of American fathers help with home chores? What childcare facilities are provided in US? Are there any similarities in the problems of women of U.S. and U.S.S.R.? Do American women claim to have achieved full equality with men in the same way as the Soviet women do? Read further in the feminist protests coming out of the Soviet Union. Available in the U.S.: Massachusetts Review, Autumn 1974, pp. 657-703.

An Everyday Story: Norwegian Women's Fiction

by Katherine Hanson, ed.
The Seal Press, 1984, 246 pages
Jr. High: Advanced
Sr. High: Average - Advanced
Illustrations: None
Time Period: 1850-1983
Place: Norway

Themes: Problems within marriage; Rural and regional life; Urban culture and various classes within society; Girl's development into womanhood; Feminist strivings for freedom; Women's roles and expectations during the last century

Description: An excellent collection of short stories and poems by Norway's top writers, many translated for the first time. Although the setting is Norway, the universality of women's concerns consistently strikes the reader. The selections are short, cover a wide historical period, are well written and translated. Top rating

Suggested Uses: Use in English classes for a cultural comparisons unit. Draw upon other collections reviewed in this bibliography such as *Unwinding Threads: Women's Writing in Africa* or *Chinese Women Writers*.

"I don't know why it was that there began to be so many old maids in the community...I think it resulted from the fact that so many of those who took off for America were boys. The men weren't so generous with money for a ticket when it was for the girls. So they were stuck at home."

- Gro Holm, *Life on the Lostol Farm*

Another Place Another Spring

by Adrienne Jones
Houghton Mifflin, 1971, 285 pages
Jr. High: Advanced
Sr. High: Average - Advanced
Illustrations: Maps
Time Period: 1840-1841
Place: Russia, United States

Themes: Intrigue against Tsar Nicholas among nobles and gentry following Decembrist Uprising; Exile as punishment for political prisoners; Extension of Russian Empire to Fort Ross, California

Description: The heroine of this exciting story is a young serf girl whose bravery and initiative enables her to survive a harrowing journey across continental Russia. Geographical as well as social class differences are described in detail. Students should get an understanding of the vast and varied manifestations of unrest in 19th century Russia as historical background for the revolutions of the twentieth century.

Ariadne

by June Rachuy Brindel
St. Martin's Press, 1980, 244 pages
Sr. High: Advanced
Illustrations: None
Time Period: 1400-1390 B.C.
Place: Crete

Themes: Rule of Minos and creation of myth of the labyrinth; Decline in belief of Great Mother Goddess in Crete and throughout Mediterranean; Religious rituals and beliefs of goddess worshipers; Description of Knossos and Cretan culture; Description of Pasiphae, Taurus, Icarus, Daedalus, Theseus and Asterius (called the Minotaur)

Description: Ariadne carries the blessing of the Mother Goddess within her and is revered by the Cretans, whose culture is matrilineal and based on goddess worship. This story takes the patriarchal Greek labyrinth myth, which glorifies Theseus' destruction of Knossos, and reinterprets it to see that the elevation of the male God,

➡

Zeus, and male succession was done at the expense of the "old" female centered religion. Ariadne personifies the attempts to stem the forces of history which blotted out Mother worship in Syria and Egypt as well. The plot is not straightforward as many voices tell the tale. Some sections describe the torture of captives and priestesses. The book is well written and will hold the interest of students interested in Greek mythology.

Suggested Uses: Appendix I describes the traditional labyrinth myth. Students can outline it and then outline the reinterpreted tale. Using the story, list artifacts that the author used which encourage a retelling of the myth. How are legends created? How do they survive?

"My mother is dead. My daughter is dead… My sister is a slave. My son will be an Attic killer. And our story, like all the others, is being told by liars. That is why I must write this for you. So that you will know what really happened. So that you will listen for Her voice."

- Ariadne

Cat, Herself
by Mollie Hunter
Harper & Row, 1985, 278 pages
Jr. High: Average
Sr. High: Easy - Average
Illustrations: None
Time Period: 1980-1984
Place: Scotland

Themes: Growing up in the traveling "tinker" culture; Breaking the traditional restrictions on a girl's skills; Living outside the mainstream; Mother-daughter relationship

Description: This award-winning author has written a fine novel for young people about the difficulties of life outside the mainstream of society. The "travellers" are not gypsies, but tinkers, selling handmade articles and doing odd jobs as they wander through the countryside in wagons, vans, and trailers. Their lifestyle causes them to be looked upon with suspicion by most people and always by the local police who try to keep them moving. Cat, the heroine, has a loving father and mother who teach her dignity and a sense of her own importance as an individual. Through them she is persuaded to defy the travelers' traditional restrictions on girls' activities, and to learn her father's skills as a mechanic and a poacher. Cat also refuses to marry her sweetheart until he rejects the tradition that a husband owns his wife and has the right to beat her. One chapter explicitly and beautifully describes the birth of a baby. Top rating.

Deirdre: A Celtic Legend
by David Guard
Celestial Arts, 1977, 104 pages
Jr. High: Average
Illustrations: Drawings; Map
Time Period: 1-50 A.D.
Place: Ireland

Themes: Celtic customs and clan rivalries; Power of the Druids; Knights of the "Red Branch" (warriors recorded in Celtic prose epics)

Description: A retelling of a 2,000 year old Irish legend of a love story recounted against the brutality of clan fighting. Deirdre is not only beautiful but wise and brave as she struggles against a prophecy that dooms her as the bringer of destruction.

Eleanor the Queen
by Norah Lofts
Fawcett, 1977, 224 pages
Jr. High: Advanced
Sr. High: Average - Advanced
Illustrations: None
Time Period: 1137-1190

Place: France, England, Palestine

Themes: Crusades; Power of Church; Thomas à Becket; Henry's relationship with his sons; Eleanor's imprisonment; Eleanor as a song writer

Description: This novel is a fast-paced account of Eleanor of Aquitaine's life with greatest detail about her participation in a Crusade to Jerusalem and her fifteen years of imprisonment in Winchester Castle. Eleanor emerges as a strong woman thwarted in her potential because of the traditional limitations placed upon female participation in affairs of the state as well as the jealousy of political advisors. This little paperback would be a good introduction to historical fiction for students.

Flame-Colored Taffeta
by Rosemary Sutcliff
Farrar, Straus and Giroux, 1986, 130 pages
Jr. High: Average - Advanced
Illustrations: None
Time Period: 1746-1760
Place: England

Themes: Life of farm girl; The coastal smuggling trade: Animosity between England and France; Prince Charles Edward and the Jacobite cause

Description: An adventure story with a heroine, Damaris, who risks her life to save a young, mysterious man. Damaris lives near the sea (between Chichester and Selsey Bill), in smuggling country and the book imparts the feeling of living in an area where half the population seems engaged in this business. Another important character is "Wise Woman" Gentry. Damaris more than once relies on Gentry's skill in the herbal arts and on her good advice and craftiness.

Four Short Stories
by Elizabeth Gaskell
Pandora Press, 1983, 122 pages
Sr. High: Advanced
Illustrations: None
Time Period: 1847-1850
Place: England

Themes: Women in the Victorian Age in England: single, working, physically handicapped, and women with great internal fortitude; Social mores of Victorian era; Sexual double standard for women

Description: All of the protagonists in these stories are working class women, and three are single. They are, therefore, not typical of other fictional heroines of this period as they must support themselves and sometimes a family. The stories explore the inner thoughts of the women to show how they cope with their problems. Only approximately twenty five pages each, the stories are excellent for classroom use. The dialogue does contain British dialect which may put off less-skilled readers.

Suggested Uses: Divide four stories among the class. Have students compare and contrast the portrayals of "average" people in 19th century England. • One of the stories could be used to supplement the text where little or no social history is given. • Advanced students would find this highly informative pleasure reading.

Hadder MacColl
by Patricia Calvert
Puffin, Penguin, 1986, 134 pages
Jr. High: Easy - Average
Sr. High: Easy
Illustrations: None
Time Period: 1745-1746
Place: Scotland

Themes: Bonnie Prince Charlie and the Rising of the Forty Five; Divided loyalties among Highland clans; Impact of war on a young girl's family loyalties

Description: Hadder's upbringing by her father, a Clan Chieftan, doesn't prepare her for the reality of war or the change in her beloved brother on his return from school in Edinburgh. Loyal to the Stuarts, the fourteen year-old girl expects to join the men in battle, but is horrified to find her brother rejects the values of the Highland clans. This fast moving and believable story which helps clarify the reasons for the failure of the Stuart rebellion. Top rating.

Suggested Uses: Read pps. 61 - 65 aloud to illustrate conflicted feelings of Highlanders about their support for Bonnie Prince Charlie.

"'No, Haddie, it won't be a fine war at all. It will be a desperate and bloody one, just as most wars are. . . . We must look for better solutions to our troubles with our old enemies.'"

- Haddie's brother, Leofwin

How the Vote Was Won and Other Suffragette Plays
by Dale Spender & Carole Hayman
Methuen, 1985, 154 pages
Sr. High: Average - Advanced
Illustrations: None
Time Period: 1907-1912
Place: England

Themes: Women's suffrage; Reform of conditions of working women; Militant women; Chauvinist men; Civil rights; Male-female personal dynamics

Description: All of these seven plays were written and first performed in the early 1900s on the British stage, some of them to great commercial success. They are from ten to fifty-four pages in length, and are primarily farcical in tone.

Suggested Uses: Highly recommended as performance work for an English or Drama class. • Ideal as extra credit performance project in a History class. • Good for pleasure/supplemental student reading.

"Men make boast that an English citizen is tried by his peers. What woman is tried by hers?"

- Miss Levering

In the Time of The Russias
by Stella Zamvil
John Daniel, 1985, 115 pages
Jr. High: Average
Sr. High: Easy - Average
Illustrations: None
Time Period: 1890-1990
Place: Russia

Themes: Daily life among Jews in rural villages of Czarist Russia; Pogroms; Relations between Christians and Jews; "Next year Jerusalem"

Description: Beautifully written short stories convey the sweetness as well as the bitterness of life for Jews in Czarist Russia. Stories about single women, brides, housewives, mothers and grandmothers provide rich details about customs and rituals governing their daily life. In a very few pages the characters become important to the reader which makes their fate as victims of pogroms so shocking. While some tales of violent death contain graphic detail, it helps us understand the zeal of Jews to leave Russia for Jerusalem.

Suggested Uses: Each story can be used by itself, either read aloud or assigned different students, as prelude to a discussion of conditions in Czarist Russia. The literary style is so lyrical and spare that it could be used as a model for student writing. Comparisons with 20th century genocide campaigns could be made; ie. Cambodia, Guatemala, Lebanon.

Kristin Lavransdatter:
The Bridal Wreath,
The Mistress of Husaby,
The Cross
by Sigrid Undset
Knopf, 1961, 1047 pages
Jr. High: Advanced
Sr. High: Average - Advanced
Illustrations: Map
Time Period: 1306-1366
Place: Norway

Themes: Women in patriarchal Medieval Norway; The influence of the church on daily lives; Superstition and belief in witch craft; Female courage and fortitude; Love, passion, marriage, and mothering; The Black Plague

Description: Beautifully written historical novel, rich in details of daily life, engrossing in plot, this is a winner for students who enjoy reading. This edition contains all three parts of the trilogy telling the story of Kristin from childhood to death. Several pages of notes provide historical context and explain social and religious customs.

"A handmaiden of God she had been -- a wayward, unruly servant, oftenest an eye-servant in her prayers and faithless in her heart... yet had he held her fast in his service, and under the glittering golden ring a mark had been set secretly upon her, showing that she was His handmaid, owned by the Lord and King who was now coming... to give her freedom and salvation -- "

- Kristin Lavransdatter

Love of Worker Bees
by Alexandra Kollontai
Academy Press, 1978, 222 pages
Sr. High: Advanced
Illustrations: None
Time Period: 1918-1923
Place: U.S.S.R.

Themes: New Economic Policy under Lenin; Communal living; The New Morality; Conflict between feminist and socialist interpretation of women's oppression; Importance of sexual and personal relationships in a revolutionary society; Women's continuing economic dependence on men

"Why should women's matters be considered any less important than other things? ...How could you ever hope to have a successful revolution without enlisting women?"

- Vasya

Description: Under one cover a novel and two short stories show young attractive women struggling to reconcile their personal relationships with their revolutionary philosophy and activities. They are also fighting for survival in the period of scarcity, reconstruction, and political dissension immediately following the Revolution. Although we gain some historical perspective through the struggles of three women from the same family to achieve sexual freedom, it is necessary to read the Introduction to understand the political and personal significance of the woman question to Kollontai. The Glossary provides information about the political and economic terminology used in the stories.

➡

Suggested Uses: As a class reading, either "Sisters" (10 pages) or "Three Generations" (29) pages, would stimulate a discussion on sexual equality. The Glossary could be used as a reference to place the discussion in an historical context. For example: the NEP program provided men with money to support a family. Why did this affluence seem to bring trouble between husband and wife? Why were women not willing to be economically dependent on men as in traditional marriages? What had happened to them to make them have different dreams? What factors in the Russian men's experience made it difficult for them to understand those dreams?

Madselin
by Norah Lofts
Doubleday, 1983, 209 pages
Jr. High: Advanced
Sr. High: Average
Illustrations: None
Time Period: 1066
Place: England

Themes: Norman invasion of England; Arranged marriage; Women in medieval England; Female courage and fortitude

Description: Fascinating historical novel set during the Norman invasion of England. The mistress of the manor, now widowed, agrees to marry her Norman conqueror, in the hopes of forging a safe, peaceful community once again. Through

their mutual struggles during this tense time, they fall in love. Chock full of contemporary historical details. Top rating.

Suggested Uses: Delightful pleasure reading for Junior and Senior High school students for book reports. • Select and read aloud passages full of medieval vocabulary and have class identify the terms.

Red Bird of Ireland
by Sondra Gordon Langford
Atheneum, 1982, 175 pages
Jr. High: Average
Sr. High: Easy - Average
Illustrations: None
Time Period: 1845-1846
Place: Ireland

Themes: Potato famine; Restrictions on education for Irish Catholic children; Irish resistance movement against English rule; Great emigration to Canada and the United States

Description: A thirteen year old girl is faced with heavy responsibilities when her father is forced to flee Ireland to escape punishment as a member of the Irish resistance. Aderyn joins other brave and clever adolescent girls as a heroine in history proving that boys were not the only ones to accomplish daring deeds. She smuggled into her village the weekly newspaper that provided the only information about Irish opposition to the English masters and she helped her father who held classes in a cave defying English orders that no Irish Catholic children receive schooling. This

exciting story provides a substantial historical background of English rule in Ireland at the tragic period of the potato famine during which thousands died of starvation. This is an exciting story for younger readers. A guide to the pronunciation of Irish names and their English counterparts is very helpful.

Suggested Uses: Read aloud to class p. 29-34 to illustrate how the English enforced their many rules restricting Irish life.

"It is terrible to think that so many thousands of people should starve and die when Ireland has had such a good harvest. There is surely enough food here to feed everyone if only the landlords would share their bounty."

- Captain Burke

Set Her On A Throne
by Jan Westcott
Little, Brown & Co., 1972,
235 pages
Jr. High: Advanced
Sr. High: Average - Advanced
Illustrations: None
Time Period: 1470-1485
Place: France, England

Themes: Wars of the Roses between Lancaster and York; Ambitious fathers using daughters to gain power; Terror felt by children caught in court intrigue; End of Plantagenets; Death of young princes in Tower of London; Reign of Richard III

Description: Anne, daughter of the "kingmaker" Earl of Warwick, is the pawn of two husbands and her father in their desire for power. When Edward, her first husband, is

➡

killed, Anne longs for a quiet life with Richard, Duke of Gloucester, but he seizes the throne and she unwillingly becomes Queen. An historically documented novel. Out of print, but good chance it's in your library.

"I made a mistake in being born daughter to you... A pawn, I am. To you!... I'll having nothing to do with it! Nothing! You can do it without me! Put him back on the throne! But without me! I'm going to join a nunnery!"

- Anne Neville to her father, Earl of Warwick

Suffragettes: A Story of Three Women
by Gertrude Colmore
Pandora Press, 1984, 318 pages
Sr. High: Average - Advanced
Illustrations: None
Time Period: 1908-1911
Place: England

Themes: Tactics of activists in the women's suffrage movement, including demonstrations, arrests and hunger strikes; Women's Social and Political Union (WSPU); Division in the movement; Female companionship and sacrifice while working for the "Cause;" Limited rights of women; Class differences; Politics of the Liberal government; Pro and anti-suffragette arguments

Description: This is a dramatic and compelling story of the personal battles of three women who become social outcasts by taking up the "Cause." Each is from a different background; one is a servant girl, the other a titled lady, and the third a member of a respectable vicar's family. Written in 1911 by Colmore, who was a suffragette, both the characters and the arguments surrounding the battle for the vote are brought vividly, if sometimes melodramatically, to life. The characters in the story are based on well known historical figures, such as Christabel Pankhurst, "Christina Amhurst," and Annie Kenny, "Annie Carney," and on real events. Top rating.

"When the prisoners filed forth, immediately the band broke into the great world-known song of liberty, the song to which those same women had set out a month ago on their way to the House of Commons. Then they were marching to prison; now freedom was theirs once more; for a space, for a spell of fresh effort."

- Gertrude Colmore

Suggested Uses: Students discuss, or find in news reports and articles, pro and con arguments for ratification of the ERA. They then use this book to find similar pro and con arguments which were marshalled when women tried to win the vote in Great Britain. • Students use this book to document areas where women in the suffragette movement split. Then they do further research on the movement and the final outcome after 1911, when the book ends. • As they read the story, students list the reasons that finally led each protagonist into an activist position. What were the differences in their motivations? What commonalties?

The Awakening
by Kyra Petrovskaya Wayne
Grosset & Dunlap, 1972,
185 pages
Jr. High: Advanced
Sr. High: Average
Illustrations: None
Time Period: 1930-1935
Place: U.S.S.R.

Themes: Adolescence during Stalin period; Education and political activities for young people in Young Pioneers; Oppression and anti-Semitism under Stalin; Communal living in city flats

Description: The young heroine of this novel finds solace and self-expression through her school and Young Pioneer activities unaware at first of the repressive nature of Stalinist regime. Her awakening comes with her growing maturity as a person. The story allows American students to identify with another teenager with similar aspirations and dilemmas such as family conflicts, school rivalries and romantic attachments and all this in a Soviet setting. It is not an anti-Soviet story, but rather a sympathetic portrayal of human beings caught in very difficult times whose response is remarkably similar to those we might expect in the United States.

④

The Battle Horse
by Harry Kullman
Bradbury Press, 1981, 183 pages
Jr. High: Average - Advanced
Sr. High: Average - Advanced
Illustrations: None
Time Period: 1930-1940
Place: Sweden

Themes: Class and gender differences in Stockholm in the 1930s; Institutional maintenance of class and gender hierarchy

Description: This fast paced story is timeless in its vividness and power. Boys from upperclass schools have created make-believe boys-only tournaments in which their "horses" are poor public school kids. Undefeated is the mysterious Black Knight who appears regularly to battle the winners. By the end of the story readers will have guessed that this knight is the beautiful and feisty Rebecca. A deeper element has been introduced, however, through another female character, Kossan. Kossan, strong, but poor, is chosen by the rich boys' hero, Henning, to disguise herself as a boy and be his "horse" in a final battle with the Black Knight. Who is the reader to cheer for, Rebecca as the Black Knight or Henning on his horse, Kossan? The shocking ending will bring home the reality of what it means to be female and poor in a patriarchal society. Author is an honored writer of young adult books. Top rating.

Suggested Uses: Readers will need opportunities to digest the book and discuss their feelings. Possible discussion questions: Was it more or less effective for the author to choose a boy, Roland, to tell the story? How does the author indicate that these fun tournaments had unpleasant overtones? Why did the rich boys enjoy the tournaments? The poor boys? Why didn't Kossan defend herself? Could Kossan's humiliation scene occur anywhere in U.S. society today? Did the story have any heroes or heroines?

"One day we horses will travel over the Seven Seas like Gulliver and we won't carry the rich and powerful on our backs anymore. We'll take control of our lives and everybody will have the same opportunities and the same rights in the kingdom, the Kingdom of the Horses, and there won't be any words for lying or deceit, no words for rich or poor."

- Kossan

The Clan of the Cave Bear
by Jean Auel
Bantam Books, 1980, 495 pages
Sr. High: Advanced
Illustrations: Map
Time Period: 35000-25000 B.C.
Place: Europe

Themes: Technological and intellectual advancement of Neanderthals; Description of land during late Pleistocene epoch; Flora and fauna utilized by Neanderthals; Early spiritual beliefs; Women's roles, including women as healers

Description: The Others (Cro-Magnon people) are living in the same ice-age world as the Cave Bear Clan (Neanderthal people). One day the Cave Bear Clan finds one of the Others - a baby girl they call Ayla, who they raise as their own. In this, the best written and most evocative of Auel's series, the author portrays Neanderthals as people with a rigid clan hierarchy and unchanging gender roles. Ayla, being different and at the same time clever and resourceful, develops "male" characteristics and is forced to break the traditions of the clan.

Suggested Uses: An excellent way to begin discussion of sex-roles, the myths/realities of gender differences, and the impact of a society's concept of physical beauty on its members. Good for Sociology, Anthropology and World History. • Although the book is long, the intriguing story line may hold the interest of the average as well as advanced reader.

The Concubine
by Norah Lofts
Doubleday, 1963, 310 pages
Jr. High: Advanced
Sr. High: Advanced
Illustrations: None
Time Period: 1523-1536
Place: England

Themes: Henry VIII's desire for a son as heir; Catherine of Aragon's resistance to being deposed as Queen; Scheming of Wolsey, Cranmer and Cromwell to help Henry in his struggle with the Church; Anne Boleyn's determination to be Queen and not a concubine

Description: Each chapter of this novel is based on quotes from contemporary sources, documenting the tone as well as the story line. All the characters around her are fleshed out in dramatic detail, especially the five men executed with her. Very dramatic. Out of print, but Nora Lofts is a popular author and the book may be in your library.

Suggested Uses: This novel is only for students who enjoy reading a long novel with a great deal of historical detail interwoven into the story.

The Defiant Muse: French Feminist Poems from the Middle Ages to the Present
by Domna C. Stanton
The Feminist Press, 1986,
206 pages
Sr. High: Advanced
Illustrations: None
Time Period: 1100-1980
Place: France

Themes: Love and friendship; War and peace; Loneliness and family; Religion, nature, and work

Description: One of a series of four bilingual anthologies, this book presents French feminist poetry as early as the 12th century in the original language, and on the facing page the English translation. The introduction provides historical and literary context for each of the poets and there are short biographical

sketches of the thirty-five poets at the end of the book. Some of the poets included are: Christine de Pisan (1364 - c.1430); Anne de La Vigne (1634 - 1684); Louise Colet (1810 - 1876); Joyce Mansour (1928 -). Other titles in this series are *The Defiant Muse: Italian Feminist Poems*, ed. by Beverly Allen et al; *The Defiant Muse: German Feminist Poems* edited by Susan L. Cocalis, and *The Defiant Muse: Hispanic Feminist Poems* edited by Angel & Kate Flores. These provide a rich source of poetry on a variety of themes for classes in World Literature and World History, and reveal women's significant role in the literary arena of European countries throughout the centuries. Top rating.

The Greengage Summer
by Rumer Godden
Puffin, Penguin Books, Ltd., 1986,
206 pages
Jr. High: Average - Advanced
Sr. High: Average
Illustrations: None
Time Period: 1956
Place: France

Themes: Adjustments to a foreign country; Comparison between British and French Towns; Young girl growing into adulthood; Awareness of adult sexuality; Hostility of adult world toward children; Battlefields of France

Description: A thirteen year old British girl, Cecil Grey, on a summer holiday with her family in France, finds herself in charge of her large family of five when her mother and older sister become ill. Into their lives comes a charming but mysterious man and Cecil has to try and understand not only his attraction to their family, but the adult emotions she is experiencing for the first time. The story describes the old town of Vieux-Moutiers, near the Marne, and life in a small French hotel. French

students will enjoy reading the phrases and conversations in French that are sprinkled throughout the book.

"English hospitals are not called the Hotel of God, I said. They don't have nuns with their nurses; they were not built in 1304 by the Queen of Phillip the Beautiful. There has never been a Phillip the Beautiful in England. And the patients don't have wine with their lunch... French hospitals are more interesting and more friendly."

- Cecil Grey

The Horse Goddess
by Morgan Llywelyn
Houghton Mifflin Company, 1982,
417 pages
Sr. High: Advanced
Illustrations: None
Time Period: 700 B.C.
Place: Austria, Russia

Themes: Prehistoric Celtic and Scythian cultures; Close relationship of physical and spiritual world; Belief in ability of a few to be part of both worlds; Importance of gender differences in both cultures; Changes in Celtic culture as they learned to use fast horses

Description: Epona, a "shapemaker" or shaman of her Celtic tribe became a legend after her experience with the Scythians where she learned to train and ride horses. It was with horses that the Celts expanded their culture throughout Europe and the British Isles. In this novel, Epona is a young girl who eagerly anticipates marriage and motherhood. Her unusual "gifts" of hearing the spirits, however, make it important to the tribe for her to

➡

train as a priest and relinquish her private plans. Desperate to avoid this life, she runs away with four Scythians who have come to trade for iron weapons. Her wild ride across the steppes to the grasslands, followed always by the wolf form embodying the Celtic chief spirit determined to bring her back, and her new life as a stranger among the Scythians make this an exciting story. Although not documented historically, the customs and beliefs described here have been authenticated by the author's study of archaeological artifacts and the songs and tales recorded by the Greeks and other cultures influenced by the Celts. Bloody and violent scenes are described as well as explicit sex. For mature readers.

Suggested Uses: Ask student to report on differences in women's status in Celtic and Scythian cultures. How was each affected by Epona's life among them?

"The Scythians had only contempt for docile animals who never showed fight; they spoke of such horses, no matter what their sex, as "she," a point not lost on Epona. The passivity the nomads demanded from their women they found contemptible in their horses."

- Morgan Llywelyn

The Iron Lily
by Barbara Willard
E.P. Dutton, 1974, 175 pages
Jr. High: Average - Advanced
Sr. High: Average
Illustrations: None
Time Period: 1553-1558
Place: England

Themes: Troubled Tudor period, Queen Mary to beginning of Elizabeth's reign; Antagonism between Protestants and Catholics; Restoration of Church of England

Description: Fourth in Mantlemass Series, this is story of Lilias, a fifteen year old girl who flees domestic slavery under her sister-in-law and builds a new life as wife of an Ironmaster. She becomes "Master" of the Ironworks as a widow and economically independent. Her daughter, in turn, rebels against an arranged marriage and also runs away. Detailed description of hard physical labor done by the poor gentry as well as common folk gives a good picture of the daily life of the majority of English people and presents a good contrast to the lives of the royalty. Out of print, but all in this series are excellent and many found in libraries.
 Other titles in Mantlemass series are *A Cold Wind Blowing* (discrimination against nuns in the tumultuous days of the closing of monasteries), *The Lark and the Laurel* (Changing political climate because of Tudor succession and its effect on young lovers), *Harrow and Harvest* (struggle between Parliament and King ca. 1642).

Suggested Uses: Lilias, as a healer as well as an independent business woman, is open to derision and suspicion. She would make a good example for a report on witch-hunts as well as the role of women engaged in "femme sole" enterprises. • All of the Mantelmass stories involve women whose skill in healing endangers them from witch-hunters. Ask students: What Medieval beliefs about the nature of women contributed to this discrimination?

The Mists of Avalon
by Marion Zimmer Bradley
Ballentine, 1984, 876 pages
Sr. High: Advanced
Illustrations: None
Time Period: 700-800
Place: England

Themes: Struggle of Celtic religion and Mother Goddess to retain power; Growth of new Christian church and power of priests; Roman control and inter-tribal conflicts; King Arthur's court; Queen Gwenhwyfar and Lancelot; Roles and work of women

Description: This is the tale of King Arthur and his court told from the viewpoint of the women. The main protagonist is Morgaine, Arthur's half-sister, who is a high priestess in the land of Avalon, where women rule as the creators of life and keepers of knowledge. Morgaine's duty is to maintain

belief in the Goddess worship, which honors women, against the encroachments of Christianity. Book also delineates women's main role as servant of men and producer of heirs. Although the book is long, it has a dedicated following and good students will enjoy it.

Suggested Uses: Compare with *Ariadne* (reviewed here) and the attempt of the Goddess worshipers in Crete to maintain their religion against the growth of the patriarchal religion of the Greek Gods.

"I have no quarrel with the Christ, only with his priests, who call the Great Goddess a demon and deny that she ever held power in this world. At best, they say that her power was of Satan."

- Marion Bradley

The Princesse De Clèves
by Madame De La Lafayette
Penguin Classics, 1982, 198 pages
Sr. High: Advanced
Illustrations: None
Time Period: 1558-1559
Place: France

Themes: Chivalrous and romantic attitudes toward love of the 16th century; Games of love and ambition played at Court of Henry II; Distinction between sexual passion and enduring love based upon trust and respect

Description: This first great short novel in the French language was published anonymously in 1678, but generally was known to be the work of Madame de Lafayette with some assistance from her friends in her salon who at least helped her in the historical research of Henry II's court life. It is considered accurate as historical information with the complicated relationships between

commoners and royalty, the king and his mistress, the mistress and the other courtiers being documented. In essence, the patterns remained the same in Madame de Lafayette's own experience at court one hundred years later. Leonard Tancock has written an Introduction which places Madame de Lafayette in historical context and shows her to be an interesting character worthy of a novel herself. He suggests that the reader not be put off by the long list of characters on the first few pages of the book, that this was a custom of the time, and they can easily be skipped. In any case, there is a Glossary of the historical characters at the end. For good readers who love historical fiction.

Suggested Uses: World Literature classes could study the construction of this novel into the four equal parts, each representing the psychological development which leads inevitably to the conclusion. • Research into the mores of that day relating to the expectations for ladies of the court. Find examples of the famous royal beauties whose love had political as well as personal consequences. • The Introduction provides a guide to the real people who were involved in personal and political intrigues at the court of Louis XIV when this novel was written. Choose one of the women, such as Madame de Sévigné or the King's mistress, Princess Henrietta, as examples of love relationships at the royal French court.

The Road to Damietta
by Scott O'Dell
Houghton Mifflin Company, 1985, 230 pages
Jr. High: Advanced
Sr. High: Average - Advanced
Illustrations: None
Time Period: 1200-1226
Place: Italy, Egypt

⑥

Themes: Profusion of Christian sects; Life of gentry families in Italian communes; Francis Bernardone's (St. Francis) conversion to a pious leader; Teachings of St. Francis; The sisterhood of Poor Clares; Benedictine monasteries and work of the scriptorium; Venice and Assisi; Children's Crusade; Fifth crusade and its effect on Italy; Siege of Damietta, Egypt; Religious debates between Sultan Malik-al-Kamil and St. Francis

Description: The story of St. Francis of Assisi is told through the eyes of Ricca di Montanaro, a young upper-class woman. Helplessly in love with the charismatic Francis Bernardone, she follows him even after he begins his life as a religious. Educated by a Spanish tutor, her work copying scrolls of the early Christians and Arabic scholars is also described. Story is based on the life of Angelica di Rimini and provides wonderful details of 13th century Italy. Top rated.

"It isn't necessary for copyist to believe in what is being copied or to resist the temptation to change an ill-advised word... Early in the Confession, where the saint wrote that he 'should not believe many things concerning himself on the authority of feeble women,' I removed the word 'feeble.'"

- Ricca di Montanaro

The Second Mrs. Giaconda
by E.L. Konigsburg
Atheneum, 1975, 138 pages
Jr. High: Average - Advanced
Illustrations: Paintings; Drawings
Time Period: 1490-1510
Place: Italy

Themes: Leonardo da Vinci's personality and the development of some of his works (Last Supper, horse statue for Milan, portraits) and ideas (war machines, city planning, etc.); Life of da Vinci's apprentices; da Vinci's relationship with his patrons, particularly the Duke of Milan, "El Moro;" Rivalries between Milan, Venice, Florence and France; Clothing, manners and socialization of upper class women

Description: Although the protagonist of this fictionalized account is da Vinci's young apprentice Salai, the story includes a full portrayal of Beatrice d'Este, the Duke of Milan's young wife. In fact Konigsburg uses da Vinci's insight into Beatrice's hidden beauty as a clue to explain why he chose to paint Mona Lisa, the wife of an unimportant Florentine merchant. Readers will learn that among the Italian upper class, a beautiful woman was most prized, yet a "woman of layers," a woman who was clever and imaginative, could also shine.

"This was a woman who knew that she was not pretty and who had learned to live with that knowledge. This was a woman whose acceptance of herself had made her beautiful in a deep and hidden way. A woman whose look told you that you were being sized by a measuring rod in her head."

- Salai

The Sixth Wife
by Jean Plaidy
G.P. Putnam's Sons, 1969, 252 pages
Jr. High: Advanced
Sr. High: Advanced
Illustrations: None
Time Period: 1543-1548
Place: England

Themes: Struggle for power among Henry's Courtiers; Spread of Protestantism at Court; Flirtation between young Princess Elizabeth and Thomas Seymour

Description: This is the story of Henry VIII's sixth wife, Katharine Parr, whose intellect and quick wit saved her from being beheaded for her interest in the "new learning" or Protestantism. Based on historical documentation, the novel describes the court intrigues often made necessary by the changing humors of a brutal king. Especially vulnerable were young women who feared Henry's fancy lest it place them in jeopardy when out of favor. For Katharine, life was precarious as Henry alternately fawned on her, insulted and rejected her, thus giving his advisors opportunity to gain power by accusing her of religious dissent. Out of print, but worth looking for in libraries.

Suggested Uses: Read aloud to class pps. 117-122. This short and dramatic account reveals the real danger to anyone, even the Queen, who dared to believe, think, or speak at variance with this king. Discussion could follow on modern examples of cruel and unusual punishment for unpopular beliefs. Documentation from Amnesty International is available for specific cases of individuals currently being imprisoned, tortured and executed.

The Star in the Forest; A Mystery of the Dark Ages
by Martha Bennett Stiles
Four Winds Press, 1979, 206 pages
Jr. High: Advanced
Sr. High: Average
Illustrations: Map
Time Period: 597-599
Place: France

Themes: 6th Century Gaul divided among quarreling descendents of Clovis; Feudal challenges for power; Women's role as property of men; Role of Roman slaves, better educated than their captors; Outlawed forest people, remnants of Bronze Age inhabitants of Gaul

Description: This novel describes the powerlessness of women of all classes from the nobility to the slaves. Women with any skill as healers are freely accused of witchcraft, and Nuns, who have escaped from intolerable marriages, provide refuge for women fleeing from oppression. Daughter of a Gallic lord, the heroine shows spirit and courage as she defies tribal laws to avenge death of her brother and marry a landless knight of her own choice. A good romance which offers unusual historical period and conditions as a setting. Out of print, but worth looking for in libraries as extra credit reading.

The Wife of Martin Guerre
by Janet Lewis
Ohio University Press, 1967,
109 pages
Jr. High: Advanced
Sr. High: Average
Illustrations: None
Time Period: 1539-1560
Place: France

Themes: Patriarchy; Feudal family customs; Role of women in the family

Description: Based on a true historical incident, this tragic story provides students with a chance for emotional identification with a real medieval heroine who must solve her dilemma according to the constraints of her society. The film, The Return of Martin Guerre, available in video tape, presents a different version of this legend, but also depends upon the character of Bertrande for the final solution.

Suggested Uses: See Unit I, Women Under Feudalism, *In Search of Our Past: Three World History Units*, (reviewed here in Cross-cultural), for classroom activities based on this novel. Two versions adapted for easier reading are included so that the entire class can read the story. Have students list the ways by which Bertrande was socialized to respond to the crisis in her life. What were the advantages of this patriarchal system for her? How would a modern Bertrande react?

To Kill A King
by Madeleine Pollard
Holt, Rinehart & Winston, 1971,
187 pages
Jr. High: Average
Sr. High: Easy
Illustrations: Drawings
Time Period: 1076-1080
Place: Scotland, England

Themes: Saxon unrest following Norman Conquest; Religious fervor of Queen Margaret of Scotland; Role of convents and monasteries as haven for poor and persecuted

Description: Merca, a young teenage Saxon, plots to avenge murder of her parents by killing Malcolm of Scotland although she idolizes his wife, Queen Margaret. This is a good account of feudal relationships as well as a description of the effect of the struggles for power on the citizenry who only want peace and some economic security. A sequel, *The Queen's Blessing*, depicts the resistance of the Saxons to William the Conqueror. Both are good stories for youner readers; Out of print, but found in libraries.

Transport 7-41-R
by T. Degens
The Viking Press, 1974, 171 pages
Jr. High: Average - Advanced
Sr. High: Average - Advanced
Illustrations: None
Time Period: 1946
Place: Germany

Themes: Emotional effect of World War II and its aftermath on the Germans, especially the children; Hardship of life in East Germany; Growing realization of the need of people to help one another

Description: The adventures of the feisty teenager in this story will appeal to students. It is 1946 and a thirteen-year-old German girl is traveling alone on a transport train which is bringing evacuees from the Russian sector of defeated Germany to Cologne. The war years have taught her to believe in nothing but her own resources. Written like a first person account (the heroine is never given a name), this is an important resource for an examination of the plight of Germans at the end and directly after the war. Fast-moving and written in an engaging style. Top rated.

Suggested Uses: Link with other stories of defeated peoples who must use their wits to survive and find the courage to begin to rebuild. One good resource is about a Japanese girl in *So Far from the Bamboo Grove*.

"I had sworn loyalty to Adolph Hitler -loyalty - beyond the grave... Later I had pledged something to the bishop and they made me kiss his ring... Last year I solemnly gave my word to follow Lenin and be a true Pioneer... Now I felt sort of strange. To whom would I have to dedicate my life next? The British, Americans and French must make you pledge yourself to something."

- the heroine

Curriculum

A Doll's House (filmstrip)
by Henrik Ibsen
Films Incorporated
Jr. High: Advanced
Sr. High: Average
Illustrations: Filmstrip
Time Period: 1890
Place: Norway

Themes: Domestic expectations of women; Growth of a woman's consciousness

Description: This is a condensed version of the full length movie, *A Doll's House*, with original British cast: Claire Bloom, Anthony Hopkins, Sir Ralph Richardson. Two parts, each 19 minutes, "So Typical of a Woman" and "Equality in Marriage." A story strip gives the story line so that teacher can explain the plot. It offers suggestions for other films with similar themes and provides questions for stimulating class discussions. Some of these questions put women's struggle into the nineteenth century context. Excellent for illustrating marriage patterns and the efforts of women to overcome the social prejudices against women asserting individual independence. Available from *Encyclopedia Britannica, Educational Corporation*, 425 North Michigan Avenue, Chicago, IL 60611.

Anne Frank
by Lina Tridenti
Silver Burdett, 1985, 62 pages
Jr. High: Easy - Average
Sr. High: Easy
Illustrations: Paintings
Time Period: 1929-1945
Place: Holland

Themes: Holocaust; Invincibility of the human spirit; Role of some citizens in protecting Jews

Description: This fictionalized account of the life of Anne Frank was originally written and published in Italy and is part of a series, *Why They Became Famous*. It is a large size paperback illustrated with colored paintings, easy to read, and has a few excerpts from Anne's diary. A model of the hiding place, an historical chronology, descriptions of the three death camps Anne lived in and a brief bibliography are student aids to further study of this period.

Suggested Uses: Recommended for Junior High and less mature students to introduce the study of Nazi occupation of European countries and the Holocaust. • Use the Historical Chronology Chart and its parallel column for Anne's life as a model for other accounts of the Holocaust written by women survivors and reviewed here: *Elli* by Livia E. Jackson; *Fragments of Isabella* by Isabella Leitner; *The House on Prague Street* by Hana Demetz.

> *"I wonder if it's because I haven't been able to poke my nose outdoors for so long that I've grown so crazy about everything to do with nature?"*
>
> - Anne

Coalmining Women: Victorian Lives and Campaigns
by Angela V. John
Cambridge University Press, 1984, 44 pages
Jr. High: Advanced
Sr. High: Average - Advanced
Illustrations: Photos; Drawings; Charts; Map
Time Period: 1800-1970
Place: England, Scotland, Ireland, Wales

Themes: Women in a nontraditional occupation; Women performing dangerous labor; Physical realities of coalmining vs. Victorian ideals of femininity; Middle class values contrasted with those of lower class in Victorian England

Description: This lively account is based on solid documentary evidence from that period. Among the original and secondary sources described are the census, Parliamentary records, official reports, news reports, and diaries. Of special importance were the diaries of Arthur Joseph Munby, a gentleman lawyer who interested himself in the lives of working women. His accounts provide descriptive details of daily life and personalities of the period. The booklet, designed for use in the classroom, describes the work itself, the type of women who performed this labor, and some of their efforts in the right-to-vote movements in defense of their jobs. This resource is rich with photos, letters, drawings and with explanations of the unusual vocabulary pertinent to this profession. Top rating.

Suggested Uses: Rich source of information and illustration for research and discussion of the Industrial Revolution in Britain. A Chronology table gives Key Dates, the Glossary terms applicable to nineteenth century industrial England. There is a Bibliography and Suggestions for Study. • Using the information about American women in the mines in the 1970s, find magazine or news reports from

Readers' Guide about the first women in U.S. mines. What is their status today?

"Pit mouth's work may not be very pleasant or very seemly for women, but I know nothing as unseemly or so unpleasant for women as an empty stomach and a family of starving children."

- A Member of Parliament

Elizabeth I
by Jackdaw #53
Jackdaw Publications, 1969,
20 pages
Jr. High: Advanced
Sr. High: Average - Advanced
Illustrations: Portraits
Time Period: 1533-1603
Place: England

Themes: Childhood; Girlhood; Reign as Queen; Mary, Queen of Scots

Description: Twenty pieces of classroom material representing original sources are provided for students to compare with secondary sources from books. In her own writing are two letters by Elizabeth, a draft of a speech to Parliament, and her signature on the warrant for the execution of Lord Essex. Six broadsheets give factual summaries of her life and one pamphlet

describes the conspiracies against her life. Available from *Social Studies School Service*, 10,000 Culver Blvd., Dept. Y5, P.O. Box 802, Culver City, CA 90232-0802.

Suggested Uses: Additional research is required for answers to some of the questions provided, but the hands-on material can provide a stimulus for a discussion comparing Elizabeth I and II and Victoria in terms of their education, opportunities for travel and international contact, and their impact as rulers. Also available in Jackdaw Series are *Joan of Arc*, #10; *Mary of Scotland*, #26; *Women in Revolt*, #49; *Elizabeth Fry, Reformer*, #63.

From Workshop to Warfare: The Lives of Medieval Women
by Carol Adams, Paula Bartley, Hilary Bourdillon, & Cathy Loxton
Cambridge University Press, 1983, 39 pages
Jr. High: Average
Sr. High: Easy - Average
Illustrations: Photos; Drawings
Time Period: 1300-1500
Place: England, France, Germany

Themes: Life in Middle Ages: Descriptions of the lady of the manor, nuns in the convent, women and work, and women lawbreakers

Description: This lively booklet was written by London educators for their Middle School students, but it is also appropriate for American junior high students. Numerous attractive illustrations allow students to find answers to questions posed in the captions and provide documentation on which teachers can build their own Inquiry method. Many first person quotes in Medieval English give students a challenge to translate into modern English. Considering the widespread effect of Medieval witch-hunts, it is unfortunate that this book gives only one short section to the subject

and that one under Women Lawbreakers! Unless the teacher places this in an historic context, students may get the impression that there was merit to the claim of the witch-hunters.

Suggested Uses: This book can be used as supplementary reading along with a regular text or with the curriculum unit, Women Under Feudalism, from *In Search of our Past* (reviewed here in Cross-cultural).

"The woe of these women who dwell in hovels is too sad to speak of or to say in rhyme."

-Piers Plowman

Ordinary Lives: A Hundred Years Ago
by Carol Adams
Virago Books, 1982, 222 pages
Jr. High: Average - Advanced
Sr. High: Average
Illustrations: Photos; Charts; Ads
Time Period: 1870-1920
Place: England

Themes: Daily life; Childhood, education, courtship, marriage, work, health and leisure in England during last century; Sex-role socialization; Class and urban-rural differences

Description: A highly readable book that highlights the difference in male/female experiences during the period of great change at the end of the 19th and early 20th centuries. Offers comparison with current attitudes and lifestyles and provides many photos, ads, sayings and excerpts from first person accounts. Discussion and study questions at the end of each chapter.

Soviet Women's World: The United Nations Decade for Women 1976-1985

Novosti Press Agency Publishing House, 1985, 62 pages
Jr. High: Advanced
Sr. High: Average
Illustrations: Photos
Time Period: 1913-1985
Place: U.S.S.R.

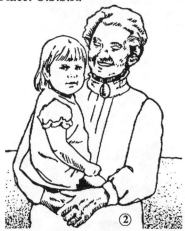

Themes: Brief history of improvements for women following Revolution; Soviet claim that legislation for women is adequate; Women in Parliament; Equal opportunities in employment and promotion; International women scholars in Soviet Union; Women, children, and the State; An ideal Soviet family; Planned improvements for women and children

Description: Published in the U.S.S.R., the following materials are available as part of a curriculum series whose aim is to foster better understanding between the Soviet and American people. Available are *Soviet Women's World, Women in the USSR: Facts and Figures, Remarkable Women of Our Time*. All three booklets are attractive and easy to read, filled with photos and interviews with women from diverse backgrounds who testify that life for women in the U.S.S.R. is an ideal one. They counteract the stereotypical image of overweight unattractive women in shapeless clothes as seen on American TV screens. These women are seen in every profession, skilled and competent, as mothers with small children, as wives on picnics with loving husbands. For a more critical view of women's status in today's Soviet Union, see *Moscow Women* (reviewed here). In addition, two fold-out pictorial posters with pictures and text on both sides are available for classroom display; "May Our Children Never Know the Horrors of War" and "Secondary Schooling for All." Write to: *Ground Zero Pairing Project*, P.O. Box 19329, Portland, OR 97219.

Suggested Uses: Use the fold-out, "May Our Children Never Know the Horrors of War," and compare with pictures of the work of Kathe Kollwitz (*Kathe Kollwitz: Life and Art* by Mina Klein, reviewed here). How can the obsession with peace shown by these women from Russia and Germany be explained?

The World of Anne Frank: Readings, Activities and Resources

by Betty Merti
J. Weston Walch, 1984, 157 pages
Jr. High: Average - Advanced

Sr. High: Average - Advanced
Illustrations: Drawings; Models; Posters; Charts; Photos
Time Period: 1944
Place: Holland

Themes: Hitler's rise to power and Nazi rule; Life of a Jewish girl in hiding; The Frank diaries as testimony against Nazi war criminals

Description: A spiral bound workbook of student readings and activities to be used with *The Diary of Anne Frank*, the most classical literature to come out of the Holocaust experience. Part I consists of readings on historical background of the period; Part II provides activities to increase student writing and research skills. Discussion questions, vocabulary lists, suggestions for research projects and a large bibliography are included. Curriculum available from: *J. West Walch*, Portland, Maine, 04104-0658

Suggested Uses: First read Anne Frank's diary or a dramatized version by Frances Goodrich and Albert Hackett.

Under Control: Life in a Nineteenth-Century Silk Factory

by Carol Adams, Paula Bartley, Judy Lown, & Cathy Loxton
Cambridge University Press, 1983, 44 pages
Jr. High: Average - Advanced
Sr. High: Easy - Average
Illustrations: Photos; Drawings; Maps
Time Period: 1847-1861
Place: England

➡

Themes: Conditions in a textile factory for men and women workers; Living conditions and experiences of working women; Workers' solidarity and resistance; Home factory work

"A poor woman, as soon as she could leave her house after the child was born, usually found some little girl to attend to the child... Sometimes, however, she took the poor baby, on her way to the factory at six o'clock in the morning, to a neighbor's house... With either of these plans, the infants were badly off... Even the mothers themselves gave (the babies) sleeping doses..."

- Mary Merryweather

Description: Developed as curriculum for secondary classes in England, this booklet has many illustrations; photos, drawings and charts which are informative and attractive. Not intended as an in-depth, comprehensive analysis of the conditions of the period, it presents a brief but insightful account of life among nineteenth century women textile workers in one English silk factory. This curriculum is especially valuable because it reveals the impact of the Industrial Revolution on the lives of individual workers who are about the same age as secondary students, and the lessons are ready for instant use in the classroom. Top rating.

Suggested Uses: Several short segments can be used as mini-lessons; case studies of four workers, two women and two men, and the questions on their life. • Compare the duties and job expectations of men and women workers. • Discuss why women were required to live in dormitory conditions. Compare this with the accounts of the mill girls in New England. What were the advantages and disadvantages of life as a textile worker for the average farm girl in either England or New England? What were the advantages of hiring women for the mill owner?

Women in Ancient Greece and Rome
by Marjorie Bingham &
Susan Hill Gross
Glenhurst Publications, Inc., 1983,
117 pages
Jr. High: Average - Advanced
Sr. High: Average
Illustrations: Photos; Drawings; Paintings; Charts
Time Period:2000 B.C.-272 A.D.
Place: Crete, Turkey, Greece, Iraq, Italy, England, Egypt

Themes: Important Goddesses; Theories, evidence and interpretation of data to uncover status of women in classical cultures; Diverse classes of women; Women in Minoan, Ancient Greek and Bronze Ages; Women in the Illiad and Odyssey; Spartan and Ionian women: Women in the Golden Age of Athens; Common experiences of royal Hellenistic women; Constrast between the lives of Etruscan and Roman women; Known Roman women such as Cornelia Gracchus, Livia, Messalina and Agrippina; Byzantine empresses; Queen Boudicca; Women and Imperial Rome in decline

Description: A wealth of information from Minoan women to women rebels against Rome. The "Points to Consider" which follow each short chapter are particularly good. Several activities present data, such as inscriptions, statues, phrases from great male writers and thinkers, laws, etc., to allow students to draw their own conclusions about the lives of women. A sound filmstrip, *Women in Greece and Rome*, is also available. This uses art, architecture and coinage to reveal women's status. The over-reliance on showing artifacts, however, limits its visible impact.

Suggested Uses: Some chapters are more substantive than others. The following would be excellent classroom reading assignments: "The Minoan Age - The Great Goddess and Her Daughter," "The Spartan and Ionian Women," "Women in Athens - A Golden Age?" "Women of Rome," "Women in the Roman Republic," which includes the account of the demonstration by women against the Oppian Law.

"Alexander's mother, Olympias, and sister Cleopatra, seem to be the first Greek women we can trace historically from birth to death. What may this say about Greek historians' attitudes towards women's lives?"

- Bingham and Gross, Points to Consider

Women in the Middle Ages/Renaissance

by Marjorie Bingham &
Susan Hill Gross
Glenhurst, 1983, 182 pages
Jr. High: Average - Advanced
Sr. High: Average
Illustrations: Photos; Drawings;
Maps; Diagrams
Time Period: 500-1650
Place: England, France, Germany,
Italy

Themes: Diverse roles of women
5th - 17th centuries in politics, economics, religion, education, art, and
the social setting; Loss of status of
women during Renaissance

Description: This booklet for the
classroom provides an easy way to
integrate important facts regarding
the role of women into the Middle
Ages and Renaissance periods. Its
thesis that women's status, unlike
men's, was restricted by Renaissance movements helps students
understand the significance of including women in historical study.
Designed by teachers, it is attractive
with two column text, many illustrations and graphs and a Points to
Consider column at the end of each
section. The use of historical
quotes, many of them first person,
makes this a serious and scholarly
student text. It also includes an
eight page glossary of terms, an
extensive bibliography, and a
teacher's handbook. A sound tape
reproducing many of the illustrations in the booklet and introducing
new ones was enthusiastically reviewed by World History teachers
at the 1986 California Council for
Social Studies Conference. Top
rating.

Suggested Uses: This text provides
sufficient material for average students, but can be used as a springboard for advanced students to do
further research based on excellent
bibliography provided. Use to introduce the concept of the uniqueness
of women's history so that subsequent historical periods may be studied for similar contradictions and
surprises.

Women in the U.S.S.R.: The Scythians to the Soviets

by Marjorie W. Bingham &
Susan H. Gross
Glenhurst Publications, Inc., 1980,
142 pages
Jr. High: Average
Sr. High: Easy - Average
Illustrations: Charts; Maps;
Graphs; Photos
Time Period: 700 B.C.-1980 A.D.
Place: Russia, U.S.S.R.

④

Themes: Early history: Scythians,
Kievans, Mongols; Medieval
Russia; Power of Tsaritsas; The
Terem; Peter the Great, Catherine
the Great; Marriage, Education,
Peasant Women, Women Workers,
Women Terrorists, The Woman
Question; Contemporary Soviet
Women and Equality

Description: Part of the series,
Women of the World, this booklet
provides well organized historical
information in chronological order
with scholarly documentation often
from first person accounts. Pages
of two columned text with many
illustrations make this an attractive
class reader. Beginning with the
chapter on 18th century Russian
women rulers, a great deal of biographical detail is presented.
"Russia, the Controlled Society"
focuses on marriage customs and
the status of women from different
classes; peasants, workers, and
nobility. Statistics from charts and
graphs document the unequal status
of the Soviet woman today. The
Glossary makes clear the Russian
terms found in the text.

Suggested Uses: Can be used as a
separate unit or integrated into
history of U.S.S.R., the Soviet
Union today, or a comparative
study of women's status worldwide.
Points to Consider at the end of
each chapter offer questions and
topics for discussion. A filmstrip is
available.

*"My training was such as
would fit me for my destiny--
marriage to a wealthy man, a
life of ease--Good manners,
languages, music, dancing
and embroidery--these were
the requirements of a Russian
lady."*

- Angelica Balabanoff

LATIN AMERICA
INTRODUCTION

The growing concern in the United States about the political tensions in Central America has created an awareness of the need for more information about the history and culture of all Latin America. As a result of this interest, there has been a significant increase in the number of Latin American books and journals available in English translations.

Women authors, as in all cultures, have been marginal figures on the Latin American literary scene, seldom represented in anthologies, and rarely translated for the international market. Now women are being recognized as authentic interpreters of their cultural experience throughout Latin America. In each section of this bibliography the voices of Latin American women can be heard through their novels, short stories and poetry as well as their eye-witness accounts of recent events in Central America. Of special interest for younger students are the stories and poems which feature young girls growing to maturity in the Caribbean Basin.

In the Background/Reference section are works by North American feminist historians and sociologists who have uncovered new evidence that belies the myth of the secluded and inactive woman in Latin American history and culture. Using such sources as ballads, wills, records, parish registers, congressional debates, and newspaper and magazine articles, these social historians bring to light the words of women from every class who were active participants in Latin American history.

In the past, first person accounts by women of lower or middle class origins were recorded by men whose gender, class and racial bias influenced their selection and the context in which they reported. Contemporary researchers are recording the experiences of working class women

directly from the women themselves. These personal stories offer powerful images of lives spent in unending drudgery. They also provide glimpses of the spirit and strength of women trying to keep their families alive and at the same time striving for a better existence. Viewing their struggle for personal liberation not solely within the context of a woman's movement, these women are playing their part in the larger social revolution which aims at basic improvements in the economic and political system.

Four selections of curriculum materials provide rich sources for verifying the claim that the Latin American woman must no longer be characterized as passive and submissive. The traditions of machismo/marianismo are explained in their historical and cultural context and are not allowed to obscure the reality of women's active participation in their own destiny. The curriculum listed here is designed to encourage further study about individual women and the historical events in which they participated.

In our research we were heartened by the amount of respected literary and scholarly material from this region. We limited our selection, however, choosing only those works most relevant to the needs and interests of secondary students in their World History and World Literature classes.

Background/Reference

And Also Teach Them To Read
by Sheryl Hirshon & Judy Butler
Lawrence Hill , 1983, 224 pages
Jr. High: Advanced
Sr. High: Average - Advanced
Illustrations: Photos
Time Period: 1980
Place: Nicaragua

Themes: The nature of the National Literacy Crusade; Life of the Nicaraguan peasant; Unique educational methods employed in Nicaragua

Description: Told from the viewpoint of two North American women who helped train young men and women as teachers, this book provides details about the Literacy Campaign in Nicaragua after the Revolution. It describes the kinds of people who became the Brigadistas, the 60,000 high school and college students and teachers, the techniques and materials used, and the kinds of success they achieved as they went into remote areas to teach the illiterate peasants.

Suggested Uses: Compare with the first-person account of Mónica, a young Brigadista in the Cuban Literacy Campaign, from Oscar Lewis's *Four Women*, pp. 66-77 (reviewed here).

"Any education that merits the name must prepare people for freedom -- to have opinions, to be critical, to transform their world."

- Father Fernando Cardenal

Central American Women Speak for Themselves
Latin American Working Group, 1983, 104 pages
Sr. High: Advanced
Illustrations: Photos; Map; Tables
Time Period: 1975-1982
Place: Nicaragua, El Salvador, Guatemala

Themes: Women's work within their unions, barrio committees, markets, churches; Women in the Committees of the Mothers of political prisoners and those who have disappeared; Women in the guerrilla struggle

Description: Dossier of translations from newspapers, pamphlets, documents and reports focusing on "the participation of women in the popular movements and revolutionary organizations which are so important at this moment in Central American history." Many of these women are indigenous who have overcome tremendous obstacles in order to actively participate in political or economic life. (Reviewed by Heffron and Fenton, *Women in the Third World*). Available from *Latin American Working Group*, P.O. Box 2207, Sta. P, Toronto, Ontario M5S 2T2, Canada.

See also *We Continue Forever: Sorrow and Strength of Guatemalan Women*, Women's International Resource Exchange Service. This collection contains testimonies, poetry, interviews, in-depth analyses of the conditions of Guatemalan women's growing involvement and leadership in the people's movement. Special attention is paid to the key role of the indigenous people in this struggle.

Compañeras: Women, Art, and Social Change in Latin America
by Betty LaDuke
City Lights Books, 1985, 126 pages
Jr. High: Advanced
Sr. High: Average - Advanced

Illustrations: Photos; Paintings
Time Period: 1981-1984
Place: Latin America

Themes: Art as a way of making intense personal/political statements; Art as a precarious way of making a living for many Latin American female artists and crafts persons.

Description: The richness and diversity of art and craft work coming from the smallest backroads villages as well as from sophisticated cities in Latin America are deeply and touchingly enhanced by interviews in this unusual resource. The author not only interviews well-known artists but also seeks out creative expressions in such art forms as birthing dolls of Peru or weavings among the Otomi Indians of Mexico. She finds art which makes political statements, such as embroidered life-and-death scenes by Chileans and drawings by refugee children. Filled with illustrations. Top rating.

Suggested Uses: Most Americans know nothing about the art represented here. Students might try and identify similar art forms from this country. How have many American women throughout this country's history expressed their creativity? Alice Walker's poem, *"In My Mother's Garden,"* illuminates women's "art" and would make an excellent related classroom reading.

"For all Latin America's diversity, there are things that the arts hold in common that are valid regardless of time, place or cultural singularity. One woman's pursuit of a creative vision can make the difference for her own life as well as for her community's."

- Betty LaDuke

Female and Male in Latin America
by Ann Pescatello, ed.
University of Pittsburgh Press,
1973, 290 pages
Sr. High: Advanced
Illustrations: None
Time Period: 1971-1973
Place: Brazil, Argentina, Peru,
Colombia, Dominican Republic,
Cuba

Themes: Female roles in Latin American politics; Historical roles of women; Marianismo/machismo; Women in the media; Female images and realities in writing; Women in politics and professional life

Description: A superb collection of important essays that range from material on women and the novel to the role of the passive female and its effect on social change in Latin America. Some of the writing is dry and should be assigned only to students looking for research material.

Latin American Women: One Myth--Many Realities
by Patricia Flynn, Aracelly Santana, & Helen Shapiro
North American Congress on Latin America, 1980, 35 pages
Sr. High: Advanced
Illustrations: Photos; Cartoon
Time Period: 1978-1980

Place: Mexico, Nicaragua, Caribbean, Peru, Chile, Argentina, Bolivia, Brazil, Colombia, Honduras, El Salvador

Themes: Women's oppression in Latin America; Sexual division of labor; Tenacity of traditional stereotypes of women's "place;" Contemporary women's movement; Changing status of women in Nicaragua

Description: Documented by the research of well-known scholars, the three articles in this small booklet offer important insights into the status of women throughout Latin America. "The Many Realities" claims that stereotyping women -- Latin American style -- is in reality part of the institutionalized sexual inequality that cuts across national and cultural boundaries everywhere in the world. "The 'Maquila' Women" describes the "global assembly line" on the U.S.-Mexican border where women comprise seventy-five percent of the work force. This information is of special significance for American students because of the role played by U.S. firms and U.S. trade policies. Finally, "Women Challenge the Myth," discusses the struggle of women generally in Latin America and specifically in Nicaragua to achieve some degree of equality in social, economic, and political terms. The content is adult in concept and vocabulary; first-person quotes, photos and a cartoon enliven the material. An excellent bibliography provides incentive for further research.

Suggested Uses: Use separate sections as class readings: • "Stereotyping Women Latin American Style" provides information for introducing topic of status of women. • Show cartoon (p. 26) and ask; Would this be true anywhere else in the world? • Read three paragraphs, (p. 17) which describe Nina's situation. Ask; Has Nina gained any greater degree of equality as a woman from her experience as a Maquila worker? • Read first-person account on p. 8 as an example of women's double burden. • Use film, *The Global Assembly Line*, (reviewed here) to personalize this critical situation. Available from *New Day Films*, Wayne, N.J.

"No matter how you look at it, we are in a bind. Either as husbands, lovers or managers, men have power over us."

- Mague, a maquila worker

Nicaraguan Women And The Revolution
Women's International Resource Exchange Service, 1982, 36 pages
Jr. High: Advanced
Sr. High: Average - Advanced
Illustrations: Photos
Time Period: 1977-1982
Place: Nicaragua

Themes: The National Association of Nicaraguan Women; Official Sandinista policy re sexism; Domestic workers; Revolutionary poetry; The legacy of inequality for women

Description: Collected in a folder convenient for classroom use are the following one or two page reprints: a history of the Luisa Amanda Espinoza Nicaraguan Women's Association; "The Struggle for True Equality: The Most

Beautiful of Battles," a speech by Commander Tomás Borge; "Domestic Workers: A Struggle That Is Just Beginning;" and "Battling Sexism Remains a Key Task." Several pages of powerful poetry by three of Nicaragua's finest poets, Gioconda Belli, Olivia Silva, and Claribel Alegría, are also included. These are good resources because they are directly from the people who are involved in the political, economic, and cultural changes currently going on.

Other titles also available from WIRE: *Francisca, Sylvia and Florencia: A Profile of Maquiladora Workers* by María Patricia Fernandez-Kelly, anthropologist and expert on Latina women's work along Mexico's border with U.S.; *Commander/Julia/ Comandante/ Julia* by Claudia Ximena Ruiz, an interview with a woman member of a Colombian guerrilla movement.

Suggested Uses: Use with study of Central American history or current conditions to help clarify Latin American attitudes toward U.S. The poems are evocative and especially appealing to young people.

"I was once a smiling girl who walked with her laughter through a city that was hers.

. . . Now, I am a woman who does not know the land where she lives, without love, nor laughter, nor nicaragua"

- Gioconda Belli

Nicaraguan Women: Unlearning the Alphabet of Submission
Women's International Resource Exchange Service, 1985, 45 pages
Jr. High: Advanced
Sr. High: Average - Advanced
Illustrations: Photos; Charts
Time Period: 1980-1985
Place: Nicaragua

Themes: Determination of Nicaraguan women to forge new roles; Miskito Indians; Anti-sexist education; U.S. feminism and Nicaragua; Family planning; Reeducation of prostitutes; Poems from the Revolution

Description: This packet of materials is updated to include the latest writings about women's concerns in a new society which also is struggling to survive under war conditions. Well known authors who contribute interviews, articles and poetry are Adrienne Rich, Margaret Randall, and Gioconda Belli. Miguel D'Escoto explains Sandinista political philosophy, Dr. Myrna Cunningham testifies about the conditions under which the Miskito Indians live, and an editorial from Barricada reflects on sexism. We hear the voices of women on the front line, fighting for peace, justice, and women's equality.

Nine Mayan Women: A Village Faces Change
by Mary Lindsay Elmendorf
Schenkman, 1976, 155 pages
Jr. High: Advanced
Sr. High: Average - Advanced
Illustrations: Photos
Time Period: 1971-1974
Place: Mexico

Themes: Breakdown in traditional value system resulting from modernization process; Women's response to inevitable change; Quality of life for peasant women in a Mexican village

Description: Using a "creative dialogue" rather than more formal interview techniques, this author displayed fine sensitivity to her women informants and obtained unusually frank information about their attitudes toward themselves as individuals as well as to their husbands and community. Chan Kom, a tiny village in Yucatan, had been studied since 1931 to determine the impact on its cultural traditions as a result of the opening of a new road bringing in tourists from Chichen Itza. The focus on women was an unusual feature providing information about their age of marriage, freedom of marriage choice, property rights, inheritance rights, divorce rights, range of movement from hearth, handling of money/or role as food provider, freedom to be traders and/or business women, and their tribal positions of authority. The informal style and use of direct quotes make this a good classroom resource for important and interesting information about people Americans usually only glimpse at the tourist places of interest. Top rating.

①

Suggested Uses: Assign one student for each of nine women interviewed. Oral comparison of common values and attitudes toward change as represented by the new road. • Introduction contains much information which could be used as class readings: (pp. 1-5) explains global implications of "progress" as it affects traditional

nonindustrialized societies; (pp.5-8) describes anthropologist's method of operation; (pp. 17-20) provides geographical setting for Chan Kom. • Terms in the Glossary should be incorporated into the reports so that class can benefit from this additional information.

"It is my sincerest wish that a better understanding of these women will help us to understand peasant women in other cultures, and to see them as human resources which must be creatively participating if we are to achieve a better life in our rapidly changing world."

- Mary Elmendorf

The Latin American Women's Movement
by Miranda Davies, ed. & trans.
Isis International, Rome, 1986, 70 pages
Sr. High: Average - Advanced
Illustrations: Photos; Graphics; Cartoons
Time Period: 1970-1985
Place: Chile, Guatemala, Argentina, Uruguay, Peru, Mexico, Dominican Republic

Themes: Rise of feminist organizations; Women's cross-cultural issues; Influence of the U.N. Decade of Women on women's consciousness of their problems

Description: This book provides a series of essays which attempts to answer the questions: What does it mean to be a feminist in Latin America? Is there a Latin American women's movement? The essays are very readable and offer a view of women as activists who utilize diverse strategies in their struggle to eliminate discrimination against women. A useful resource to help

confront the stereotype of Latin American women as passive and compliant. Included are extracts from two comic-strip books from the Dominican Republic and Brazil on violence against women and sex education. This resource may be found in women's bookstores or by writing to *Isis International* in Italy.

Suggested Uses: Students read one article from one of the countries represented and then describe feminism as it is defined by the author. Students should be able to describe ways women are overcoming problems in the country they have chosen.

"Feminism is not a recent phenomenon in Latin America, but formal history has always chosen to obscure the presence and achievements of women, both in terms of their specific demands and their participation in the overall political struggle."

- Ana Maria Portugal

The Nicaragua Reader: Documents of a Revolution under Fire
by Peter Roseet & John Vandermeer
Grove Press, 1983, 368 pages
Sr. High: Advanced
Illustrations: None
Time Period: 1979-1981
Place: Nicaragua

Themes: Women's roles and rights in revolutionary Nicaragua

Description: This collection of important documents, articles, essays and speeches related to the revolution in Nicaragua includes

interesting material on women: an interview with Glenda Monterrey from the Women's Association (AMNLAE) on how the revolution changed the lives of women, and a reprint of the 1981 pamphlet by Tomás Borge, "Women and the Nicaraguan Revolution."

⑰

Suggested Uses: Many young women and men participated in the literacy campaign in Nicaragua. Reports of this crusade can be used for classroom reading and discussion about ways the problem of illiteracy might be attacked in America.

"Our armed forces are made up of very young people, many of whom are young women. They are the combatants of our liberation struggle. For that reason our police are very different, our soldiers and our state security people are very different from what those of other countries might think."

- from "Life in the New Nicaragua"

The Rebel Woman in the British West Indies during Slavery
by Lucille Mathurin
Kingston Institute of Jamaica, 1975, 37 pages
Jr. High: Average - Advanced
Sr. High: Easy - Average
Illustrations: Drawings
Time Period: 1655-1844
Place: Jamaica, Barbados, Trinidad, the Leeward Islands, Guyana, Cuba

Themes: Slave heritage of Ashanti leadership qualities; Strength and resiliency of women slaves; Women's defiant behavior and speech; Guerilla women; Nanny, national Jamaican heroine

Description: Mathurin, an historian and Jamaica's representative to the UN, has written a fascinating account of the resistance of women slaves to their British and Spanish masters in the Caribbean Islands. The accounts are based on historical documents mostly from Jamaica. The author traces the fierce resistance of the women to their Ashanti heritage where traditionally the woman as mother is highly regarded. The women were essential to the guerilla forces as providers of food as well as scouts and fighters. This book has double value as a resource: it provides information about an area of the world that is not well known and it shows women as resisters rather than passive victims of the slave system. Top rating. Available from *Caribbean Books*, 25 Kent Street, Hartford, CT 06112.

To update the condition of black women in the Caribbean, see *Women in the Rebel Tradition: The English Speaking Caribbean.* This collection of sixteen articles describes conditions for women in slavery in the Caribbean and the United States, as domestic workers, assembly-line workers, and also as citizens of Grenada before the U.S. invasion. Available from *Women's International Resource Exchange Service.*

Suggested Uses: Have students make a list of unusual terms and expressions used by the slaves. Try to uncover the origin of these terms and the circumstances under which they developed. • Compose an ad for a runaway slave based on a description of themselves. • Compare the role of women in the long march across Jamaica, 1735-1737, with other guerilla actions like Mao's Long March in China or the guerilla movements today in Central America. • Read modern Caribbean literature to understand the lingering effect of slavery; Paule Marshall's story "Merle" from *Reena and Other Stories*, or *Jamaica Woman*, a collection of poetry edited by Mordecai and Morris (reviewed here).

> *"'...in consequence of the delicate appearance of the woman, and her having a young child, their worships sentenced her only to twenty lashes publicly -- then to be discharged.'"*
>
> **- West Indian magistrates' court records**

When Women Rebel: The Rise of Popular Feminism in Peru
by Carol Andreas
Lawrence Hill, 1985, 212 pages
Sr. High: Advanced
Illustrations: Photos
Time Period: 1532-1984
Place: Peru

Themes: Women's history in Peru; Effects of foreign penetration; Work and politics of Andean mountain women; Development of neighborhood organization in cities; Women as entrepreneurs; Guerilla warfare in jungles; Today's issues and prospects

Description: Sociologist Andreas lived and married in Peru and she brings a personal touch to this account of women's roles from the Spanish Conquest until today. Chapter I describes the conquest and the effects that are still operative on the lives of Peruvians. Through photos and personal testimony, Chapter IV provides a picture of women's organizing efforts for survival in present day urban neighborhoods. Other chapters cover the themes listed above. This book has unique value because of its personal and scholarly documentation of a country not often written about. The language is straightforward and not academic. A helpful glossary is included at the beginning.

Suggested Uses: Use first 9 pages as class reading to establish a background of information on women in Peru. Use other chapters as supplemental to Gross/Bingham's two volumes, *Women in Latin America* (reviewed here).

> *"How long will it take you to realize that as women we get twice the trouble this oppressive society has to offer? ... If you can't start changing the way you behave, please don't come around hypocritically offering me gifts on Mother's Day."*
>
> **- Mother of seven from a Lima**
> *barriada*

Women in Cuba: Twenty Years Later

by Margaret Randall
Smyrna Press, 1981, 162 pages
Sr. High: Advanced
Illustrations: Photos
Time Period: 1970-1979
Place: Cuba

Themes: Struggle against sexism; Peasant women in changing society; Childbearing and health; The new family; Women as artists, organizers, and revolutionaries

Description: Randall, an American photo-journalist, has lived in and raised her children in Cuba during the twenty years since the Cuban revolution. Her many books aim to help Americans understand the Cuban philosophy of government and their struggles to make their system work. Interspersed with factual information are interviews and excerpts from magazine and newspaper articles. Chapter 1 provides an historical summary of social and economic progress since 1959 and its impact on women. Of special interest to students are Chapter 2, "Peasant Women," an account of the Literacy Brigade, when 60,000 young people went into the country-side to teach illiterate peasants, and Chapter 5, which identifies women performers and their accomplishments in every field of art.

Suggested Uses: For a description of the Literacy Campaign, use pps. 54-58 as a class reading. Discuss with students possible reasons for its success in such a short time. Are such campaigns to eradicate illiteracy possible in the U.S.?

"If men want us out working they're going to have to get to work in the home!"

- Woman factory worker, Havana

①

Women of the Forest

by Yolanda Murphy &
Robert F. Murphy
Columbia University Press, 1974, 232 pages
Sr. High: Advanced
Illustrations: None
Time Period: 1952-1972
Place: Brazil

Themes: Social and sex roles of women and men; Differences in approach to study by male and female anthropologists; Diet; Effect on social organization of contact with outside commercial world

Description: This classic study of the Munderucu Indian tribespeople of the Amazon River is unusual and important because it was conducted by a woman anthropologist who was able to live alongside her female subjects and win their trust. Male anthropologists can experience difficulties in relating to women who do not trust or understand their questions. In 1952 Murphy explored social and sex roles in a culture which held women subservient even though women held authority over men in day-to-day practical matters. Twenty years later she returned and found that women had pushed for changes because they wanted consumer goods available through commercial contact with the outside world. As a result, communal and sexual division of work and housing was replaced by a nuclear family arrangement which foregoes collective sharing. The book is valuable for its description of a people affected by commercial colonialism only slightly at first, enabling them to keep traditional ways of diet, social organization, food gathering and production. Eventually, however, the three months a year of rubber gathering and contact with traders affected them substantially and altered their way of life. Of special significance is the role the women played in this major change. Top rating.

Suggested Uses: After students read Chapter 1, have them list separately women's daily duties as providers of food and the men's responsibilities. • Discuss the basis for this division of labor. • List the foods eaten. Where did these come from? • Have students list the items which traders brought to them once a year. • Further research for superior readers in Chapter 4, "Women in Myth and Symbol," Chapter 5, "The Woman's World," and Chapter 6, "Women and Married Life."

"Women of the Forest restores something of the balance that has been missing from conventional anthropology---an anthropology largely written by men---in giving this lucid account of the fundamental roles played by women in all societies."

- Ashley Montagu

Anthology

Women Brave in the Face of Danger

by Margaret Randall
Crossing Press, 1985, 150 pages
Jr. High: Advanced
Sr. High: Average - Advanced
Illustrations: Photos
Time Period: 1985-1986
Place: Guatemala, Puerto Rico, El Salvador, Nicaragua, Peru, Bolivia, Cuba, Mexico, United States

Themes: Courage of women in face of psychological and physical danger; Developing awareness as women with political and social rights

Description: This collection of full page photographs and text provides a wide range of women's writings, poetry, diary fragments, and interview responses. Some of the material is very personal, filled with suffering; other entries are political statements of rights and revolution from Central America. Strong language and sophisticated concepts require mature readers.

"The revolution gave their dignity back to human beings; it didn't give it back to man alone because I don't think the word man includes women."

- Haydée Santamaría, leader in the Cuban Revolution

④

Autobiography/Biography

Alicia Alonso: The Story of a Ballerina

by Beatrice Siegel
Frederic Warne, 1979, 170 pages
Jr. High: Average
Sr. High: Easy - Average
Illustrations: Photos
Time Period: 1931-1975
Place: Cuba, United States, U.S.S.R.

Themes: Strength of determination to be a prima ballerina; Breaking upper class traditions; Overcoming visual disability; State of dance in post-revolutionary Cuba

Description: Of interest primarily to students of dance, this is a detailed description of the life of a dancer emphasizing the grueling practice necessary as well as the joy of stage triumphs. There is some information about the efforts of Alonso and the Cuban government to support the dance movement in post-revolutionary Cuba. There is an interesting Glossary of dance terms.

"By staying in Cuba, I gained the love of my people. And who has that is very rich."

- Alicia Alonso

Blaze A Fire: Profiles of Contemporary Caribbean Women

by Nesha Haniff
University of the West Indies, 1987
Jr. High: Advanced
Sr. High: Average - Advanced
Illustrations: Photos
Time Period: 1981-1986
Place: Caribbean Basin

Themes: Contributions of women in Arts, Industry, Agriculture, Education, Politics, Health, Trade - Unions, Domestic Work, Church

Description: To be published soon, this book will present brief biographies of twenty eight women whose lives document the important contributions women have made in all areas of ecomomic and cultural development in the Caribbean Basin. The women described can serve as role-models for young women students of that region so that this curriculum material will help correct the existing bias in the portrayal of women in the text books and reading material now used. Will be available through the *International Women's Tribune Centre*, 305 East 46th Street, Sixth Floor, New York, NY 10017.

Suggested Uses: Useful for secondary and community college level classes in history, sociology, economics, and Women's Studies.

Evita, First Lady

by John Barnes
Random House, 1978, 184 pages
Jr. High: Advanced
Sr. High: Average - Advanced
Illustrations: Photos
Time Period: 1920-1960
Place: Argentina

Themes: Women and politics; The rise of Evita and Juan Perón; Volatile times of the Perón regime

Description: This is a sympathic portrayal of the life and times of Eva Perón. The point is made in various ways that she was deeply aware of how much the people wanted an idol and that she met that need, even as she plundered her country and her people. Material is consistently interesting to read.

Suggested Uses: Compare account of Eva Perón's life in Henderson's *Ten Notable Women of Latin America*. (reviewed here)

I Rigoberta Menchú, An Indian Woman in Guatemala

by Elisabeth Burgos-Debray, ed.
Verso, 1984, 247 pages
Sr. High: Average - Advanced
Illustrations: None
Time Period: 1960-1982
Place: Guatemala

Themes: Effect of colonial domination on the culture of the Guatemalan Indians; Garcia Lucas regime and attempted genocide of Guatemalan Indians; Indian relationship with nature; Indian culture and descriptions of rituals and responsibilities of Indian women; Work on the fincas on the coast and Indian holdings in the Altiplano; Animosity between Ladinos and Indians; Work of women as servants in the cities; Work of organizing peasants and peasant strikes

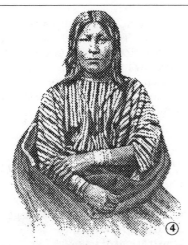

Description: Story of incredible courage and perseverance of personal survival and of an attempt by one women to ensure the survival of her Indian culture. Rigoberta Menchú laboriously taught herself the Spanish language so at the age of twenty-three she could tell others of the oppression her people have been suffering for almost five hundred years. The story told to Burgos-Debray covers her early life with her own people as well as her later years when she moved into the Hispanic culture, worked in the cities and became a political organizer. A powerful book which allows us to hear directly the voice of a woman who deals with the triple oppression of being female, poor, and Indian. Simply written; descriptions of brutality of the army are vivid. Top rating.

"Most of the women who work picking cotton and coffee, or sometimes cane, have nine or ten children with them. Of these, three or four will be more or less healthy, and can survive, but . . . the mother knows that four or five of her children could die. . . it's the mother who has to be with her children during their final moments."

- Rigoberta Menchú

Let Me Speak: Testimony of Domitila, A Woman of the Bolivian Mines
by Domitila Barrios de Chungara with Moema Viezzer
Monthly Review Press, 1978, 235 pages
Sr. High: Advanced
Illustrations: Photos; Map
Time Period: 1937-1978
Place: Bolivia, Brazil, Mexico

Themes: Women's role in overcoming the exploitation of workers in the Bolivian tin mines; History of Siglo XX mine; Life of the miners, most of whom are Indians; Persecution of union leaders; "People's Revolution" of 1950s; Subordinate position of women within the family; Women's International Conference, Mexico, 1975

Description: This oral history tells of the women and men who gradually learned to react against their violent and repressive government. The author's development as a person of social responsibility becomes clear as she details her own life and the lives of her neighbors and friends during a time of political unrest and change. This moving account provides vivid information on the situation of the miners. Domitila de Chungara has become an international spokesperson for the special concerns of exploited working-class women. Top rating. A six-page excerpt, "Let Me Speak!," is available from *Women's International Resource Exchange Service.*

"I saw that those ideas that I'd had were there in those books. And that the exploitation of some people by others could be ended."

- Domitila Barrios de Chungara

Salvador Witness: The Life and Calling of Jean Donovan
by Ana Carrigan
Ballantine, 1984, 305 pages
Sr. High: Advanced
Illustrations: Photos
Time Period: 1980
Place: El Salvador, Nicaragua, United States

Themes: The involvement of the American government and American Catholic church in Central America; Political terrorism

Description: The story of Jean Donovan's life and work furnishes us with an important look at the missionary rescue work going on in Latin American countries. Though much of the book concerns Donovan's personal and political development, it also underlines her understanding of her choices when she volunteered as a missionary worker and her appreciation of the peoples she served. U.S. intervention is seen through the eyes of victims and rescuers. The book contains graphic descriptions and is appropriate only for mature readers.

Ten Notable Women of Latin America

by James D. Henderson &
Linda Roddy Henderson
Nelson-Hall, 1978, 240 pages
Jr. High: Advanced
Sr. High: Advanced
Illustrations: Drawings, Maps
Time Period: 1504-1967
Place: Mexico, Cuba, Peru, Chile, Bolivia, Argentina, Brazil

Themes: Diversity of race, class, and female experience in Latin America

Description: This collection helps break the stereotype held by many North Americans that all Latin Americans are alike. These women, coming from a variety of classes and races, represent the real diversity of people in Central and South America; Indian, pure European, Black, mestizo, slave and aristocrat. Five of the women occasionally appear in secondary textbooks: Malinche, Indian translator and mistress of Cortés; Sor Juana Inés de la Cruz, 17th-century intellectual poetess-nun; Gabriela Mistral, Chilean Nobel Prize poet; Eva Perón, Populist leader of Argentina's working class; Tania, revolutionary comrade of Che Guevara. The others are varied and unique: Mariana Grajales, free black Cuban patriot; Leopoldina, Hapsburg wife of the Emperor of Brazil; The Nun Ensign, 17th century transvestite adventurer; Inés de Suarez, nurse-healer and mistress of the Spanish conqueror of Chile; Policarpa Salavarrieta, Creole heroine of New Granada. Each chapter provides full historical background for the period, place and personality presented. Top rating.

Suggested Uses: Chapter 9, Eva Perón, might be of special interest to students because it describes with objectivity the life and political influence of this controversial woman.

". . . school poetry shouldn't stop being poetry because it's for school use, it should be more so, more delicate than any other, deeper, full of things of the heart: quivering with the breath of the soul."

- Gabriela Mistral

Teresita

by William Curry Holden
Stemmer House, 1978, 232 pages
Jr. High: Advanced
Sr. High: Average - Advanced
Illustrations: Photos
Time Period: 1875-1905
Place: Mexico

Themes: Women with power; Political oppression of women who have power; Regime of Porfirio Díaz

Description: A fascinating biography of Teresa Urrea who came to be known as La Santa de Cabora. Her early years were spent in poverty and relative obscurity, though she was known among the Yaqui Indians as a healer who could perform miracles. Her reputation spread gradually and eventually her followers numbered in the hundreds of thousands. By the late 1800s she had become a threat to the dictator Porfirio Díaz. He had her arrested and deported in order to protect his already shaky control of the people.

Suggested Uses: Students might compare Teresita and Eva Perón. What different paths to power did these women follow? Why are women who receive public acclaim felt to be a threat to the establishment?

Victoria Ocampo: Against the Wind and the Tide

by Doris Meyer
George Braziller, 1979, 284 pages
Sr. High: Advanced
Illustrations: Photos
Time Period: 1890-1978
Place: Argentina

Themes: Women's struggle for intellectual expression; International cultural dialogues between artists and writers; Political opposition to Perón regime

Description: Victoria Ocampo was a lady of letters from both America and Europe and a rebel against traditional Latin American restrictions on women's activities. In addition to the detailed account of her life as a very wealthy intellectual whose friends included all the literary and many of the politically famous people of the world, this book includes fifteen essays she wrote on subjects as varied as Virginia Woolf, to the Redwood trees in Muir Woods, California. This biography makes clear that in cultural and intellectual life several South American nations were far more closely identified with Europe than with North America. Founder and publisher of the literary magazine, *Sur*, she was jailed by Perón as a political subversive.

Suggested Uses: The essay on Garbriela Mistral, Nobel Prize poet of Chile, p. 246-251, is an interesting look at the attitudes of both women toward their native land.
• Maria De Maeztu, subject of an essay, pp. 212-216, was a Spanish educator and feminist, important as an international literary figure and worthy of student research.

First Person Accounts

Child of the Dark: The Diary of Carolina Maria De Jesus

by Carolina Maria De Jesus
The New American Library, 1962,
159 pages
Jr. High: Advanced
Sr. High: Advanced
Illustrations: Photos
Time Period: 1955-1959
Place: Brazil

Themes: Hunger; Life in the favelas (slums) of São Paulo; Resilience and strength of a woman

Description: This classic story of the poor was written as a diary on scraps of paper by Carolina, mother of three illegitimate children. It is ugly with the realities of hunger, squalor and hopelessness, but is also full of humor, hope and the beauty of human kindness. Recommended for mature readers, it is one of the few books written about the very poorest people by one of their own.

Suggested Uses: Use the Translator's Preface as a class reading. This provides historical background of Blacks in Brazil and summarizes Carolina's story. • Choose excerpts from diary as deemed appropriate for class. • Assign research to determine if such favelas still exist today in Brazil's large cities. See article in *NY Times*, February 19, 1987, "One Woman's Mission: To Make Brasília Sensitive." This story and photo of Benedita da Silva, first black woman elected to Brazil's Chamber of Deputies, documents the continued existence of the favelas from which she was elected.

Four Women: Living the Revolution, An Oral History of Contemporary Cuba

by Oscar Lewis, Ruth M. Lewis & Susan M. Rigdon
University of Illinois Press, 1977,
433 pages
Jr. High: Advanced
Sr. High: Advanced
Illustrations: None
Time Period: 1945-1968
Place: Cuba

Themes: Life for women in pre and post-revolutionary Cuba; Literacy Campaign; Political differences among family members; Effect of revolution on middle class

Description: Only Part One is recommended; the oral history of Mónica, a psychologist from a middle-class family. Mónica's account of her childhood, adolescence and student days is engrossing as it describes the division among such families created by the revolutionary experience. Of particular interest is Mónica's participation in the Literacy Campaign which caused great debate within her own family. She describes her teaching experience among rural peasants who also had mixed reactions to the new government.

Suggested Uses: Use excerpts from Chapter Five, "Growing Up," as class readings which describe her participation in Literacy Campaign.

Now We Can Speak: A Journey Through the New Nicaragua

by Frances Moore Lappe & Joseph Collins
Food First Publications, Institute for Food and Development Policy
Development Policy, 1982,
119 pages
Jr. High: Advanced
Sr. High: Average - Advanced
Illustrations: Photos
Time Period: 1979-1982
Place: Nicaragua

Themes: Food, health, and literacy in Nicaragua

Description: Authors Lappe and Collins toured food markets, farms, co-op stores, offices of agrarian reform and research, private homes, offices of the Maryknoll Sisters, speaking to many women (and men) who were just beginning to understand the responsibilities entailed in building a new country. Some of the women interviewed struggled with working and learning to read, as a double burden. Many revealed their freedom and power to explore future possibilities.

Risking a Somersault in the Air: Conversations with Nicaraguan Writers
by Margaret Randall
Solidarity Publications, 1984,
215 pages
Sr. High: Advanced
Illustrations: Photos
Time Period: 1950-1983
Place: Nicaragua

Themes: Poets and revolution; Personal development of a poet; Women as poets

Description: Five women are represented here among the fourteen poets interviewed. They come from varied backgrounds, mostly middle-class families, both supporters and opponents of the Somoza regime. They speak of the importance of religion, family, revolutionary politics, and of the North American literary influence on their development as poets. For students interested in poetry, these short first-person comments are especially interesting, but they also provide a look at a revolution from a unique literary perspective.

Suggested Uses: Use in literature classes as well as in a study of current Latin American history.

Sandino's Daughters: Testimonies of Nicaraguan Women in Struggle
by Margaret Randall
New Star Books, 1981, 220 pages
Sr. High: Advanced
Illustrations: Photos
Time Period: 1979-1980
Place: Nicaragua

Themes: Feelings, ideas and attitudes of Nicaraguan women who fought in the Revolution; Brutality of Somoza regime; Day to day lives of women as mothers, wives and daughters

Description: A series of interviews with Nicaraguan fighting women who consistently combined their personal struggle for personal growth and liberation with political struggles. This book presents women from diverse backgrounds, peasants to professionals, and successfully balances the stereotypical view of Latin woman as always protected and restricted to affairs of the household. For mature readers because it contains some strong material about violence and abuse.

Suggested Uses: Link with other accounts of active women revolutionary fighters such as Chinese women in Jack Belden's *China Shakes the World* or Agnes Smedley's *Portraits of Women in the Chinese Revolution*, or African women in Stephanie Urdang's *Fighting Two Colonialisms*, (All reviewed in this bibliography).

The Diary of "Helena Morley"
by Elizabeth Bishop, trans. & ed.
The Ecco Press, 1977, 281 pages
Jr. High: Average
Sr. High: Easy
Illustrations: None
Time Period: 1893-1895
Place: Brazil

Themes: Growing up female in 19th century rural Brazil; Adolescence in an extended family

Description: Written to amuse her family and friends, this diary of a fifteen-year-old girl has achieved worldwide literary status as a classic. The daily chronicle of events allows an intimate glimpse into this family and the community life of a small and remote mining village where masters and slaves together struggle for survival. Each entry is a complete anecdote. Helena's keen sense of humor and candor about her own behavior make delightful reading. A lengthy introduction provides historical background for the diary, an explanation of Brazilian terms used, and an account of a visit with the author as an elderly woman. Top rating.

Suggested Uses: Use in comparison/contrast with diaries of adolescent girls from other parts of the world. Have students list what these young girls have in common and what cultural or geographic factors determine the differences in attitudes, behavior, and aspirations, e.g. *The Diary of Anne Frank* and *Early Spring* by Tove Ditlevsen (reviewed in the Europe Section).

The Triple Struggle: Latin American Peasant Women
by Audrey Bronstein
South End Press, 1982, 268 pages
Sr. High: Average - Advanced
Illustrations: Photos; Maps; Tables
Time Period: 1980-1982
Place: Guatemala, El Salvador, Ecuador, Peru, Bolivia

Themes: History and treatment of peasants in Latin America; Daily struggle of peasants against poverty; Social differences between women and men; Women's role within the family; Women's organized income-generating activities; Women as leaders; Status of women in each country under discussion

➡

Description: Bronstein looks at the triple suffering of peasant women, as citizens of underdeveloped countries, as peasants, and as women who live in male-dominated societies. The book provides a series of interviews with these "least articulate and heard members of society." We read encouraging words from women who are taking control of their lives as well as discouraging words from women who lack access to birth control, seem cowed by male dominance and live in unmitigating poverty. The author's discussion of her difficulty in achieving authentic interviews is of interest. Each chapter focuses on one country and is introduced with a map and historical information. Top rating.

Suggested Uses: Students might research statistics on the U.S. or on other Latin American countries to match those provided on the countries in this book. Ask these questions: What do these figures tell us about a country? Where do the greatest differences lie? What is the relationship between the Indians and the rest of the rural population?

"The social structure is inhuman. It is important to say this, because, yes, machismo is a real problem, but nothing is ever going to change until we have the basic necessities of life."

- Miriam Galdemez, El Salvador

Women in Latin American History
by June E. Hahner
UCLA Latin American Center Publications, 1984, 186 pages
Jr. High: Advanced
Sr. High: Average - Advanced
Illustrations: None
Time Period: 1556-1972
Place: Mexico, Peru, Argentina, Brazil, Bolivia, Colombia, Puerto Rico, Cuba

Themes: Women's writing as a valuable source for the female past; Myth of the inactive and secluded Latin American woman; Complexity and duality of women's roles

Description: This collection represents the new approach to social history which bases its research on the records, letters, diaries, and wills of the people of a particular period. Its aim is to provide a balanced view by including the role of women in historical accounts, allowing us to hear directly from women in all walks of life about events traditionally associated with men. The first two sections present women from the Colonial Period and from the Nineteenth Century. Twentieth century accounts are divided into Political Activities, Economic and Sexual Roles, and Change and Nonchange. Each of the short selections is interesting, offering personal, sometimes intimate glimpses into daily life. Sor Juana, Eva Perón, and Carrie

Chapman Catt, visiting from the U. S., are some of the better known personalities. Selections #16 and #18, recorded by Oscar Lewis, contain explicit sexual material. Top rating.

Suggested Uses: Use as oral readings in class or as assigned homework reading to personalize traditional textbook accounts. • Use "The Early Feminist Press in Brazil," (#7) to compare with English and American suffragist demands of the late 19th century. • "Anarchists, Labor and Equality for Women in São Paulo," (#14) can be used to compare with the demands of American women workers during the same period.

"We Brazilian, Italian, French, and other women of diverse nationalities do not request the vote under the restrictions currently imposed on Englishwomen, but with the full rights of republican citizens."

-Francisca Senhorinha da Motta Diniz, Brazilian newspaper editor

Women of Cuba
by Inger Holt-Seeland
Lawrence Hill, 1981, 109 pages
Jr. High: Advanced
Sr. High: Average - Advanced
Illustrations: Photos
Time Period: 1962-1977
Place: Cuba

Themes: New roles for women; Effect of the political/social changes in Cuba on the lives of women and children

➡

Description: In simple question-and-answer style, the lives of women are explored. A mixture of political rhetoric and personal soul-searching is interspersed with the daily experiences of women whose lives and responsibilities have been touched by the Cuban Revolution.

Wonderful Adventures of Mrs. Seacole in Many Lands
by Ziggy Alexander &
Audrey Dewjee
Falling Wall Press, 1984,
237 pages
Jr. High: Advanced
Sr. High: Average - Advanced
Illustrations: Photos
Time Period: 1805-1881
Place: Jamaica, England, Turkey, Russia

Themes: Humanitarian and medical services in Crimean War; Adventures in Central America; A successful female entrepreneur; Colonial loyalty to British Empire; Mrs. Seacole's acceptance of racial and class prejudices of British Imperialism

Description: Originally published in 1857, this autobiography of a British Black woman consists of wonderful anecdotes, humorous and poignant, of her unusual adventures crossing the Isthmus of Panama and providing humanitarian and medical services to the British army in the Crimean War. Proud of her Creole ancestry and her British citizenship, Mrs. Seacole was indefatigable in any project she felt important, unconventional though it might be. The book provides the flavor as well as unusual factual material about that period marked by its colonial relationships of master to subject.

Suggested Uses: Recommend teacher read Editor's Introduction first for historical context; choice of appropriate excerpts can depend on requirements of curriculum.
• Suggestions: Mary Seacole's first meeting with Florence Nightingale, pp. 132-137; her work among the wounded on the docks at Balaclava, pp. 141-146; • Use the map on p. 20 to illustrate the position of troops in battle and the hospital in Scutari on other side of Black Sea.
• Chapter 16, pp. 192-196, tells of her nursing under battle conditions. Mrs. Seacole tended to glorify war in spite of her compassion for the wounded British. • What other writers of books and films also make battle an heroic adventure, ignoring the causes and consequences of the conflict or the resultant agony for the noncombatants?

*"Dame Seacole was a kindly old soul,
And a kindly old soul was she;
You might call for your pot, you might call for your pipe,
In her tent on 'the Col' so free."*

- Punch
6 December, 1856

Fiction

Annie John
by Jamaica Kincaid
Farrar, Straus Giroux, 1985,
148 pages
Sr. High: Advanced
Illustrations: None
Time Period: 1960-1967
Place: Antigua

Themes: Mother-daughter relationship; Coming of age

Description: A sophisticated novel by a staff writer for *The New Yorker* which should appeal to young women who are in the throes of pulling away from mother and other eternities of childhood. Told in first person, this has an introspective rather than a fast moving plot, but Annie's ingenuity as a rebel makes for many humorous situations. The Caribbean atmosphere is made evident in descriptions of the food, the relationships with the school teachers, and the British colonialisms still observed. Recommended for World Literature classes to widen student horizons.

Suggested Uses: Compare with other mother/daughter relationships: Paule Marshall's *Brown Girl, Brownstones*; "Mónica" in Oscar Lewis's *Four Women*. • For a powerful portrayal of a West Indian grandmother/granddaughter relationship, use *The Bridge of Beyond* by Simone Schwarz-Bart (all reviewed here).

"My mother and I each soon grew two faces: one for my father and the rest of the world, and one for us when we found ourselves alone with each other."

- Annie John

Beka Lamb
by Zee Edgell
Heinemann, 1983, 171 pages
Jr. High: Average - Advanced
Sr. High: Average
Illustrations: None
Time Period: 1970-1970
Place: Belize

Themes: Adolescence; Belize independence campaign; Colonialism /racism; Family love and solidarity; Matriarchy

②

Description: Through the everyday lives of Beka, a fourteen-year-old Black girl, and her family, we learn about Caribbean/Central American politics and the daily manifestations of colonialism. Beka mourns the death of her dearest friend as she reminisces about her own struggle for scholastic achievement at her convent school. This novel, echoing the rhythm of Caribbean speech, provides a lively, endearing, and believable heroine -- a fine introduction to life in a Latin American country about which Americans know so little. Top rating.

Suggested Uses: For the characterizations and the atmosphere of a Caribbean locale, this would be informative and appealing in World Literature classes.

Crick Crack Monkey
by Merle Hodge
Carna, 1970, 112 pages
Sr. High: Advanced
Illustrations: None
Time Period: 1960-1970
Place: Jamaica

Themes: Class and color differences in Jamaican society; Influence of British institutions on Jamaican education; Life of small landholder; Life of urban middle class

Description: Tee grows up in two worlds - the warm, spontaneous world of "country" aunt Tantie and the pretentious, Creole, middle-class world of Aunt Beatrice. The novel highlights Tee's personal conflicts as well as the political conflicts of Jamaica, whose national identity is confused between its British and its African heritage. A humorous, readable story reminiscent of Toni Morrison's or Maya Angelou's accounts of childhood in the American South. The novel is short, full of descriptions of the social and cultural environment, recommended for sophisticated readers because of use of the Jamaican dialect and its earthy language. Includes a long introduction and a list of study questions.

"Look, my girl, it's not any fault of mine that you are dark; you just have to take one look at me and you will see that!... But the darker you are the harder you have to try."

- Aunt Beatrice

①

Jamaica Woman: An Anthology of Poems

by Pamela Mordecai &
Mervyn Morris, eds.
Heinemann, 1980, 102 pages
Sr. High: Advanced
Illustrations: None
Time Period: 1980-1980
Place: Jamaica

Themes: Caribbean life; Women's vulnerability and strength; Social injustice; Colonialism; Love and death

Description: Fifteen women poets sing their songs in this slim paperback and the reader comes away knowing Jamaican life and people a little better. Not all the poems are in dialect but the rhythm of the verse conveys the musicality of the Jamaican speech. Subject matter is for mature students. Brief notes on the contributors reveal their impressive educational and professional status and the sophisticated quality of their lives.

Suggested Uses: Students choose one of the first lines from the Index of first lines (pp. 107-110), write their own poem, and then compare it with the Jamaican poem. How has the locale affected the poetry? Are these "women's" poems?

My Love, My Love or The Peasant Girl

by Rosa Guy
Holt, Rinehart and Winston, 1985, 119 pages
Jr. High: Advanced
Sr. High: Average - Advanced
Illustrations: None
Time Period: 1980-1980
Place: Caribbean Basin

Themes: Impossible love of a peasant girl for a rich boy; Belief in the gods and their control of peoples' daily lives; Color and class, power and exhausting labor

Description: Using Hans Christian Anderson's fable, "The Little Mermaid," Guy sets this modern fairy story in a lush Caribbean island where color and money are important status symbols. A young orphan girl's love for a man from a different class causes her to leave her home and try to live in his world. The power of the voodoo gods over the lives of the poor creates dramatic tension. This is an evocative story where the lush surroundings and their impact on people are vividly described.

One Day of Life

by Manlio Argueta
Aventura, Vintage Books, Random House, 1983, 215 pages
Jr. High: Advanced
Sr. High: Advanced
Illustrations: None
Time Period: 1980-1980
Place: El Salvador

Themes: Resilient women; Day-to-day struggle of peasants against poverty and the political violence and terror of military rule

Description: Lupe, grandmother of the Guardado family, describes her day of waiting for the arrival of her granddaughter. The young girl is to be interrogated about her political activities by the members of the Civil Guard who also are waiting. Through flashbacks, the tale of harassment and murder of the villagers is told. The role of women, young and old, is described with pride and tenderness by this author, the preeminent male novelist and poet of Central America, who now lives in exile in Costa Rica. Strong language and brutal scenes make this appropriate only for mature students.

"...I caught myself watching them, as if I were saying goodbye, because that's how it is in these times --- every minute you must say goodbye to loved ones in case you never see them again."

- Lupe

Other Fires: Short Fiction by Latin American Women

by Alberto Manguel, ed.
Crown, 1986, 217 pages
Sr. High: Advanced
Illustrations: None
Time Period: 1940-1985
Place: Argentina, Colombia, Cuba, Brazil, Mexico, Uruguay

Themes: Women interpreting, playing and recreating their roles in a male society

Description: Latin American women writers have not generally been included in anthologies or textbooks. This fine collection of short stories, some translated here for the first time, provides an opportunity to read some of the best works from that region. Included are Silvina Ocampo, judged by many to be one of the ten best writers in Spanish today, and Marta Lynch, a best-selling author, and many others. This book has received considerable attention and will undoubtedly become one of the standard collections of women writers.

Suggested Uses: Recommended for advanced readers in World Literature classes.

"Current demands made by women are simply limited to requiring that a man stop thinking of a woman as a colony for him to exploit and that she become instead 'the country in which he lives'."

- Victoria Campo

Reena and Other Stories
by Paule Marshall
The Feminist Press, 1983,
210 pages
Sr. High: Advanced
Illustrations: None
Time Period: 1961-1969
Place: Barbados

Themes: Youth and old age; Relationship of western civilization and the Third World; Ancestor figure; Energy and talent of black women; Effects of Colonialism on modern citizens of Caribbean islands

Description: Three of the stories in this collection are appropriate for students. Each has a female central character whose strength and resiliency enable her to survive difficult situations. The young girl in "Barbados" is ready to flee an unpleasant employer even as she carries out her chores. "Dah-Duh" is actually the ancestral figure of Marshall's own grandmother. In a fictionalized account of her real life experience, Marshall describes the effect of this old woman's powerful personality on a little girl visiting from New York. "Merle" represents the struggle against poverty, racism, and all forms of injustice throughout Latin America. She is a charismatic personality. All three stories provide wonderful atmospheric background as well as historical context of Caribbean life. The beauty of the writing should appeal to serious students of literature. Top rating.

"She (Merle) can be heard condemning all forms of exploitation, injustice and greed...Like Gandhi, she considers poverty the greatest violence that can be done a people."

- Paule Marshall

The Bridge of Beyond
by Simone Schwarz-Bart
Heinemann, 1985, 173 pages
Sr. High: Advanced
Illustrations: None
Time Period: 1948-1968
Place: Guadeloupe

Themes: Image of women as the link with the unseen world and the source of spiritual values; Survival power of women; Special relationship of grandmother and granddaughter; Economic and cultural remnants of French colonial slave system; Celebration of Negritude; Creole cultural values expressed in proverbs

Description: This novel, full of the imagery and rhythm of Caribbean speech, celebrates five generations of strong women who have survived life's harshest experiences and have transmitted to their daughters the skills and moral values of their culture. Telumee is the narrator and central figure of this novel, but these legendary figures of her maternal ancestors are the honored heroines. Telumee takes her place in this dynasty as she is led across the "bridge" and begins to learn the special powers and skills which gives her a unique role in her community. A delightful read for literature classes, this also provides a literary context for Caribbean history. Top rating.

Suggested Uses: A page of Study Questions at the end of the book provide several good teaching possibilities.

"If your mother doesn't nurse you, grandmother will."

- West African proverb

The Defiant Muse: Hispanic Feminist Poems from the Middle Ages to the Present
by Angel & Kate Flores, eds.
The Feminist Press, 1985,
145 pages
Sr. High: Average - Advanced
Illustrations: None
Time Period: 1200-1980
Place: Cuba, Mexico, Nicaragua, Puerto Rico, Uruguay

Themes: Women's roles; Sexual identity; Social and political awareness

LATIN AMERICA:
Fiction

Description: This important collection of poets explores women's lives, relationships, dreams and disappointments. A bilingual edition with notes on the poets, *The Defiant Muse* is one volume in a series of poetry collections from Italy, France, and Germany. Included here is poetry from Sor Juana De La Cruz, a poet whose work is often mentioned but not often quoted. Others represented are Juana De Ibarbourou, Concha Michel, Julia De Burgos, Idea Vilarino, Nancy Morejón, Gioconda Belli and Kyra Galvan. This is a fine source for students of literature. Top rating.

> *"What interest have you,
> world, in persecuting me?
> Wherein did I offend you,
> when all I want
> is to give my beauty to the
> world
> and not my mind to beautiful
> things."*
>
> - Sor Juana Inés De La Cruz

Voices of Women: Poetry By and About Third World Women
Women's International Resource Exchange Service, 1982, 44 pages
Jr. High: Advanced
Sr. High: Average - Advanced
Illustrations: Photos; Graphics
Time Period: 1900-1982
Place: Asia, Africa, Latin America

Themes: Revolutionary women of color; Personal sentiments of love, pain, hope; Women's heroism

Description: This collection of forty-two poems by and about Third World women includes work from anonymous as well as recognized poets who are not frequently included in regular anthologies. "For years now, whenever I lecture about struggle in Latin American and the Caribbean, I take with me the WIRE materials on women in Nicaragua, El Salvador, Guatemala, and especially the all-inclusive *Voices of Women: Poetry By and About Third World Women*. Time after time I have witnessed readers and audiences moved to tears -- and then to action -- by the power of the words of Rigoberta Menchú, Sandra María Esteves, Lolita Lebrón, and Carolyn Forché," says Dr. Gloria F. Waldman, Coordinator, Spanish, Women's Studies, *Latin American and Caribbean Studies Programs*, York College, City University of New York.

Suggested Uses: Use in World Literature classes to document the existence of women as poets, especially women of color. In World History classes, these poems can illustrate the emotions of the participants in the historical events being studied and can explain the attitudes toward foreign invaders.

④

Where the Island Sleeps Like A Wing: Selected Poetry
by Nancy Morejón
The Black Scholar Press, 1985, 89 pages
Jr. High: Advanced
Sr. High: Average - Advanced
Illustrations: None
Time Period: 1440-1978
Place: Cuba

Themes: Slave trade memories; Heroes of Cuban history: Antonio Maceo, general in Cuban Independence War of 1868; Abel Santamaría

Description: These poems depict the rhythms and beauty of Cuba and the poet's personal response to her native country and her family. They are also political and represent the ideals and convictions of the new revolutionary Cuba. Morejón's love of her country and her people are beautifully expressed in these short, evocative verses. Two pages of notes explain the historical and literary allusions. Top rating.

Suggested Uses: Read aloud and have students identify the historical allusions: slave trade, colonial influences of Spain and United States, War for Independence against Spain, Spanish Civil War, Cuban Revolution, Bay of Pigs, War of Guinea-Bisseau for independence from Portugal, Vietnam War. • Discuss why Morejón shows so much interest in the wars in other countries. • Compare with American poets who combine political events with literary expression.

> *"My mother had the
> handkerchief and the song
> to cradle my body's deepest
> faith,
> and hold her head high,
> banished queen -
> She gave us her hands, like
> precious stones,
> before the cold remains of the
> enemy."*
>
> - Nancy Morejón

Curriculum

Mexican Women In Anáhuac and New Spain: Three Study Units
by Doris M. Ladd
Institute of Latin American Studies, 1979, 87 pages
Sr. High: Advanced
Illustrations: None
Time Period: 1529-1695
Place: Mexico

Themes: Involvement of students in learning through primary sources; Classes, deportment, and occupations of Aztec women; Lives of women in Mexico City after Conquest; Life of Sor Juana Inés de la Cruz, Creole poetess and nun

Description: These teaching units, appropriate for advanced students, provide excerpts from many primary sources: The Florentine Codex, a compilation of oral history from Aztec informants by a Spanish priest, 1558-1566; notary records from 16th-century Mexico City; personal papers of Sor Juana. Ladd has edited the texts for brevity and interest, so they are appealing to students. Her suggestions for their use are presented with informality and humor, but she is very serious about the importance of students as active participants in historical research. Definitions of terms and historical comparisons with women's roles in the U.S. are provided. Top rating.

Women in Latin America: From Pre-Columbian Times to the 20th Century, Volume I
by Marjorie Wall Bingham & Susan Hill Gross
Glenhurst Publications, 1985, 159 pages
Jr. High: Average - Advanced
Sr. High: Average
Illustrations: Photos, Graphics
Time Period: 7000 B.C.-1900 A.D.
Place: Latin America

Themes: Differences in status of women among the Mayan, Inca and Aztec cultures; Female gods; Impact of European conquests and settlements on Indians; Hardship and variety of roles of early Spanish settlers; Women's place in the Latin American hierarchy; Machismo/marianismo; Life of female slaves; Occupations of nuns and Sor Juana; The extended family and family honor; Women in the 19th century and women's roles in the Independence movements

Description: A wealth of information and broad view of unusual roles taken on by women. Interesting re-interpretation of pre-Columbian material and activities allows students to act as archaeologists as they analyze data on women. New views of women in Latin America are presented in this unit. It culminates with travelers' accounts of women in different levels of society in the 19th century. The impact of the class system which divided women and sharply delineated their roles is a dominant theme throughout the readings. There are many first person accounts, always appealing to students. Top rating. A sound filmstrip, *Women in Latin America*, is available in English and Spanish. It is very long (134 images). Teacher might select only those images which illustrate the chapters being covered or assign filmstrip from which one or two women could be selected as subjects for research reports.

Suggested Uses: Select sections that fit into the periods under study.

"The role of the moral leader of the family that was an ideal for Latin American women allowed women a certain sense of superiority to men."

- Marianismo Chapter

Women in Latin America: The 20th Century, Volume II

by Susan Hill Gross &
Marjorie Wall Bingham
Glenhurst Publications, 1985,
136 pages
Jr. High: Average
Sr. High: Easy - Average
Illustrations: Photos; Graphs
Time Period: 1900-1983
Place: Latin America

Themes: Influence of time, place, class, and culture on status of women; Diversity of culture; Unique problems of struggle for suffrage; Machismo/marianismo as models for male/female behavior; Importance of Roman Catholic Church; Education for women; Women in military; Eva Perón; Women today: politics, work, Cuba; Importance of older women in Black Carib culture; Uniqueness of each indigenous group

Description: Volume II in this series contains a rich collection of facts, teaching suggestions, a glos-

sary, bibliography and final cognitive test, making possible the inclusion of women in every phase of a study of twentieth-century Latin American history. The book is organized in three sections: Women in the Early 20th Century, Women in Non-Latin America, and Women in Contemporary Latin America. Page one of the Teacher's Guide outlines briefly the unique realities of Latin American culture which have determined women's status. In each section details from a variety of sources make history come alive. Many first person accounts are included which stimulate interest in

further research. Top rating. Use other books reviewed here to complete the story: *Sisterhood is Global*, additional background on each country; *Beka Lamb*, fiction based on the Black Caribs of Belize; *The Global Factory* by Fuentes & Ehrenreich, and the film, *The Global Assembly Line*, for first person accounts of Mexican women maquila workers.

Suggested Uses: Prepare class information sheets, showing the alternative models for studying Latin America. As study proceeds, have class identify the people being studied according to the anthropological division. Are there any predictable behavior patterns dependent on membership in a particular group? Can students recognize any familiar cultural standards among those countries called The Transplanted Peoples? What unique cultural factors have tended to make the role of women in Argentina and Uruguay different from the role of women in Canada and the United States, although all belong to The Transplanted Peoples?

MIDDLE EAST/NORTH AFRICA
INTRODUCTION

The image of women in the Middle East suffers greater distortion from reality than perhaps in any other part of the world. Muslim women in particular are usually seen as passive observers in a male world or as glamorous belly-dancers. Portrayed as the exotic "other", they are most often shown veiled and living in rural settings. Seldom in written text or in illustrations are Muslim women presented in westernized dress as participants in today's urban industrialized society or heard defining their own cultural traditions. In these selections a variety of women speak of their lives, permitting teachers to place Muslim women in a more authentic perspective.

Jewish women in Israel suffer from a different stereotype. Myths of sexual equality in Israel have served to obscure the reality of women's struggle to achieve equal treatment at home, in the work force, and in military service. The entries here, from the pioneer "plough women" in the nineteenth century to the feminists in today's Israel, document this effort to make their dream of equality come true.

Appropriate fiction and biography published in English were difficult to find. For Muslim women, both the fiction and biographical shortcoming are redeemed by the inclusion of a lengthy anthology by Elizabeth Fernea, *Middle Eastern Muslim Women Speak*.

There also is a real need for more curriculum from this area of the world. The section, Background/Reference, however, contains selections adequate to provide students with an historical and contemporary overview. Teachers are encouraged to fill the gaps by watching for the latest developments in current journals and news reports. Fortunately, women in the Middle East are continuing to speak out and are increasingly finding a voice in the English press.

Background/Reference

Aesthetics and Ritual in the United Arab Emirates: The Anthropology of Food and Personal Adornment among Arabian Women
by Aida Sami Kanafani
Syracuse University Press, 1983, 119 pages
Jr. High: Average - Advanced
Sr. High: Average
Illustrations: Photos; Drawings
Time Period: 1980-1983
Place: The United Arab Emirates

Themes: The senses: smell, touch, taste, sight, and sound; Importance of women's food and body rites and rituals

Description: This large picture book illustrates the belief that the senses are symbolic of a value system and cultural pattern which emphasize the ritualization of the experience of the senses. It makes a strong case for the value of inclusion in ethnographic literature of the "lower senses," such as smell, touch, taste, along with sight and hearing. The discussions of perfumed oils, hair care, and bodily adornment with such dyes as indigo and henna, will be particularly fascinating to female students.

Suggested Uses: Experiment in tasting and smelling commonly used spices such as those in sweet and salty dishes, or try these flavorings in ways described in the book, such as flavoring milk with saffron or cardamom. The sections on body rituals invite harmless emulation - particularly the temporary dying of patterns on hands or feet with henna, which is available in the U.S. Study the patterns for their meanings and use. Discuss: Is this the same human need expressed in our own culture in the painting of eyelids and fingernails?

Daughters of Rachel
by Natalie Rein
Penguin, 1980, 177 pages
Sr. High: Advanced
Illustrations: None
Time Period: 1762-1978
Place: Israel, Russia, Palestine

Themes: Exclusion of women from Jewish religious life; Women in the Pale of Settlement; Idealism and radicalism of early pioneer women; Chauvinism to machismo among male Israeli leaders; Growth of feminist movement in Israel

Description: For the mature student this book presents a feminist perspective on the historic struggle for equality by Israeli women. Not until 1971 was a viable Women's Movement established, but the obstacles presented by a male-dominated society make the ultimate outcome unsure. Rein documents the historic reasons for the present second-class status of women and offers many first person accounts which dramatize the fact.

Suggested Uses: For easier reading for the entire class, see *The Plough Woman*, annotated in this section.

"Any Jewish woman who, as far as it depends on her, does not bring into the world at least four healthy children is shirking her duty to the nation, like a soldier who evades military service."

- Ben Gurion

Family in Contemporary Egypt
by Andrea Rugh
Syracuse University Press, 1984, 305 pages
Jr. High: Advanced
Sr. High: Average - Advanced
Illustrations: Photos

Time Period: 1965-1983
Place: Egypt

Themes: Low and middle-class urbanite adjustments to contemporary conditions; Contemporary family patterns; Concepts of family that provide long-term stability

Description: This book is difficult reading with the exceptions of Chapters 2, 4 and portions of 10. Rugh has written well of a society she has carefully and accurately perceived. Chapter 2, "Urban Contexts," contrasts the sphere of women in Bulaq, a populous lower-class quarter of Cairo, with that of Shubra, a typically middle-class area of the same city (Africa's largest). Chapter 4 tells of four families, from the point of reference of the female heads, in each of the two settings described in detail in Chapter 2. Sections of Chapter 10 describe the role of poverty in family life and in relation to male-female roles. These sections of a fascinating, but somewhat difficult work for this level, make a valuable contribution to student understanding of women's experiences today in a densely populated, Third World urban setting.

Patience and Power: Women's Lives in a Moroccan Village
by Susan Schaefer Davis
Schenkman Books, 1986, 198 pages
Jr. High: Advanced
Sr. High: Average
Illustrations: Photos
Time Period: 1970-1972
Place: Morocco

Themes: Roles of men and women within categories used by traditional anthropologists; Comparison of formal and informal roles in the public and private domains

Description: Straight-forward account of life among the women of a Moroccan village by an American anthropologist who not only speaks Moroccan Arabic fluently, but is at home in the culture. Muslim village women show themselves not as subordinate to men, but as having both patience and power. Through photos and text we see veiled and unveiled women busy with domestic tasks, laughing, enjoying friendships, neighborhood gatherings and family celebrations. Susan Davis allows us to see these women go about their lives with active, not passive, patience.

"I often heard women say 'I'll be patient' or 'Women are patient,' but after I became more familiar with the culture I realized that this meant much more than just enduring whatever came their way. They were patient -- until they fully understood a situation and decided which was the best move to make."

- Susan Davis

Reveal and Conceal: Dress in Contemporary Egypt
by Andrea Rugh
Syracuse University Press, 1986, 185 pages
Jr. High: Advanced
Sr. High: Average - Advanced
Illustrations: Photos; Drawings
Time Period: 1976-1986
Place: Egypt

Themes: Clothing as complex cultural expression; Dress patterns as symbolic language

Description: Rugh analyzes contemporary social meanings found in the symbols of dress and shows the way groups and individuals use the symbols as a language to reveal or conceal significant aspects of their personal identities. Over a ten-year period, she traced the patterns of clothing worn by rural migrants in a lower-class quarter of Cairo back to their village origins in Upper and Lower Egypt. Simple dress patterns, embroidery styles and head wraps invite imitation and experimentation. Some discussion of men's dress is included as well.

Suggested Uses: Students with some knowledge of sewing might like to try the included patterns for Bedouin dress (pages 80, 81, 83) or

the Kharga or Dakhla Oases dresses (pages 57, 60, 61). Adapting such patterns will require math skills as measurements in centimeters are transposed and drawn onto paper for creation of working patterns.
• Assign "Personal Status and Generational Differences" (pages 131-140), and "Modesty" (pages 140-148), to raise questions of counterparts and similarities/differences in dress patterns within Western society. Do religious values play a role in influencing dress? How and in what ways does this find expression in the West?

The Arab World: Personal Encounters
by Elizabeth Fernea &
Robert Fernea
Doubleday, 1985, 354 pages
Jr. High: Advanced
Sr. High: Average - Advanced
Illustrations: Photos
Time Period: 1956-1983
Place: Lebanon, Jordan, Libya, Yemen, Morocco, Egypt, Nubia, Saudi Arabia, The West Bank, Iraq

Themes: Transformation of the Arab World in one generation; End of colonialism; Birth of new independent nations; Rise of OPEC; Search for roots; Dispersion of Palestinians; Change as it affects all human beings

Description: Each section or encounter is divided into three parts: a place and its people, a return look, and comments or conclusions. While the "comments" at the end of each section represent collaborative work, the "personal encounters" reported upon after an absence of some years are from a woman's perspective. Elizabeth Fernea went to the region in 1981 under a National Endowment for the Humanities grant to make educational films about social change from the perspective of the women of the region. Her report is a human one giving the reader an

➡

insider's view of life in the Arab World today: literary circles in Beirut, mountain villagers in Yemen, Palestinian refugees in South Lebanon and on the West Bank, Qaddafi's Libya, and more. Most of her observations and reporting are of the lives and circumstances of women, with whom she spent considerable time.

Suggested Uses: Any of these accounts can be used to humanize events. The 9-page chapter on Libya is an excellent opener for a wider discussion of U.S.-Libyan relations. • Chapters 7, 10 and 11 grew from the work that took Elizabeth Fernea to the region. These chapters are therefore worth studying in conjunction with the three resultant films: *The Price of Change, A Veiled Revolution, Women Under Seige* (films reviewed here).

The Art of Arabian Costume
by Heather Colyer Ross
Arabesque, Switzerland, 1981, 188 pages
Jr. High: Average
Sr. High: Easy - Average
Illustrations: Photos; Drawings; Maps
Time Period: 4000 B.C.-1980 A.D.
Place: Bahrain, North Yemen, Oman, Qatar, Saudi Arabia, South Yemen, United Arab Emirates

Themes: Traditional Arabian women's costumes: differences and similarities from region to region within Saudi Arabia; Influence of trade over thousands of years;

Related beauty culture, jewelry, arts and crafts; Family life of women and children

Description: This is an exquisite and impressive "coffee table" book to enthrall the reader with its magnificent photos and art work. Each page reveals a costume unexpected and unlike anything preceding. In addition to the illustrations, the text is fascinating and thorough. The section on Regional Styles reveals the great diversity within the single country of Saudi Arabia. History, background, descriptions of women's lives, and maps combine to make this a very valuable learning tool. Top rating. Available from *Methuen Inc.*, 29 East 35th Street, New York, NY 10001

Suggested Uses: The line drawings of precise patterns invite reproduction. Students will sharpen math skills of algebra and geometry as they transpose these patterns, given their own body length, into garments for themselves. Embroidery patterns may also be imitated. Of special interest are the magnificent tunic costume with leggings, page 108, and the gown on pages 20-21. Students of Art Metal will be interested in the jewelry presented in Heather Colyer Ross's companion volume, *The Art of Bedouin Jewelry* (not reviewed here, but also available from Methuen).

The Jewish Woman
by Elizabeth Koltun, ed.
Schocken Books, 1976, 281 pages
Jr. High: Advanced
Sr. High: Advanced
Illustrations: None
Time Period: 2000 B.C.-1975 A.D.
Place: Palestine, Russia, Germany, Poland, United States, Israel

Themes: Historical status of women in Jewish religion and culture; New approaches to customs and rituals from a feminist perspective; Famous Jewish women in history and literature; Effect of Oriental immigrants on Israeli society

Description: This collection of essays offers historical information, theoretical analysis of Jewish traditions, and some specific suggestions for new versions of rituals for today's Jewish feminist. "Models From Our Past" presents brief accounts of three women who distinguished themselves by their efforts to widen the options for women in the face of traditional male opposition: Sarah Schenierer (Poland), Bertha Pappenheim (Germany), and Henrietta Szold (U.S.). "Flight From Feminism" describes the paradox of the rhetoric of Israeli society which supports women's equity, and the reality of women's exclusion from all areas of responsibility and power.

Suggested Uses: For a dramatic presentation of the struggle of the earliest women pioneers to Palestine: l) Ask one student to prepare as an oral report a chronological outline and an explanation of terms and place names used in "Stages" by Rachel Janait. 2) Ask several students to choose from the many first-person accounts in *The Plough Woman*, reviewed in this bibliography, and to read excerpts aloud from these witnesses of important historical events.

Women and Community in Oman
by Christine Eickelman
New York University Press, 1984, 246 pages
Jr. High: Average
Sr. High: Easy - Average
Illustrations: None
Time Period: 1979-1980
Place: Oman

Themes: Family household organization; Engagement, marriage negotiations and contracts, weddings, polygamy; Women's society of kin, neighbors, community; Women's visitations: Childbirth, Mourning, Quran recitals

Description: This work brings to life a small community in inner Oman, presenting it from the viewpoint of the women of the community. Christine Eickelman speaks Arabic and has had extensive experience in many areas of the Middle East. In a simple and straightforward style she provides a firsthand account of day-to-day life in Oman. Frequent quotations from her journal contribute to the fresh and sympathetic tone. Students who are journal keepers themselves will enjoy Eickelman's sharing of her own entries. She has attempted to present this village society from the Oman women's perspective and not one abstractly derived from the concerns of her own Western culture.

Suggested Uses: Ask students to read Chapter 2, "The Household," making notes regarding the work done by the three women of the house: Badriyya, the grandmother, and Nasra and Salma, the wives of Badriyya's two sons. In the same chapter it is noted that "women of lower social status tend to be more active than those of higher status in moneymaking activities" (page 55). Ask: Why is this so, and in what kinds of moneymaking activities do they engage? • Ask students to note, as they read, what expressions of acceptance and friendship the author encountered during her stay in Hamra. • Conversely, ask students what steps the author took to indicate to the women of Hamra that she wanted their acceptance and friendship?

"Once, when I was discussing marriage with a woman in Hamra, someone interrupted us to ask, 'Why does she want to know this?' The woman with whom I had been conversing answered briefly, 'She is trying to understand.' I wrote this book with a sense of obligation to the women of Hamra, empathy for them as persons, and respect for their trust in me."

- Christine Eickelman

Women in Islam: Tradition and Transition in the Middle East
by Naila Minai
Seaview Books, 1981, 283 pages
Jr. High: Advanced
Sr. High: Average - Advanced
Illustrations: None
Time Period: 600-1979
Place: Middle East, North Africa

Themes: Women in early Islam; Arab Caliphate, Ottoman era; National liberation; Women's liberation; Women's experiences from childhood to old age; Working women; Women and the Islamic revival

Description: Most of these descriptions of women's lives revolve around experiences of women who are personally known to the author. Chapter 6, "Growing Up in a Traditional Society," recounts the author's own experience as a Turkish Muslim woman traveling alone in remote Tunisia and being "adopted" into a traditional family. The excitement and warmth of the story will be appealing to students who themselves are "growing up." Also valuable is Chapter 12, "Women and the Islamic Revival." Both of these chapters are full of instances and examples that invite

comparison and contrast to our own lives. They are short, easy to read and thoroughly enjoyable. Pages 96-99 contain a factual but graphic explanation of female circumcision, more correctly "clitoridectomy." Teachers will want to avoid this section.

Suggested Uses: Chapter 12 would be an excellent prelude to the film, *A Veiled Revolution* (reviewed here). Follow with a discussion of the U.S. feminist movement and its adversaries. In what ways are those experiences the same as Middle Eastern Muslim women? • Discuss: Do the religious agendas of both the Muslim fundamentalist of the Middle East and the Christian fundamentalist movement of the U.S. have similar ideas about women's roles and the family?

Women of 'Amran
by Susan Dorsky
University of Utah Press, 1986, 230 pages
Sr. High: Advanced
Illustrations: Photos; Maps
Time Period: 1978-1979
Place: Yemen Arab Republic

Themes: Changing female strategies in a sexually segregated society; Marriage arrangements, celebration, consumation; Women's feelings and expectations

Description: Susan Dorsky spent 18 months among the women of 'Amran, a small market town in the tribal highlands of North Yemen. Her ethnographic study provides evidence of the great diversity of women's experiences within the Arab and Islamic traditions.

Suggested Uses: Use only the Prologue and Chapter 10, "Women's Perceptions," as these are most valuable and appropriate to student reading and maturity level. • With Chapter 10 ask: "What values and aspirations do the women of 'Amran share with the reader through these tales and stories?"

⑪

Written Out of History: A Hidden Legacy of Jewish Women Revealed Through Their Writings and Letters
by Sondra Henry & Emily Taitz
Bloch Publishing Co., 1978,
283 pages
Jr. High: Advanced
Sr. High: Average - Advanced
Illustrations: Portraits; Letters; Manuscripts
Time Period: 100 B.C.-1925 A.D.
Place: Israel, Palestine, Egypt, Saudi Arabia, Iraq, Yemen, Czechoslovakia, Germany, United States, Russia, England, Italy

Themes: Biblical heroines; Hellenization of Jews; Hasidism; Kahinah (Queen of Maghreb, North Africa); Women in the Talmud (Ima Shalom & Beruriah); Sambathe (Diaspora Community, Alexandria)

Description: This scholarly but readable book is best suited to students interested in Jewish history and culture; many allusions otherwise would be confusing. It provides a glimpse of Jewish life in the Diaspora in the Middle East, Europe, and the United States as well as the Judea of biblical times. Chapter I provides an overview of traditional Jewish attitudes toward women and an explanation of terminology relating to women's concerns. Chapters 2-4 describe the women who are given a place in the religious history in the Old Testament and the Talmud. The footnotes furnish documentation and a bibliography suggests further reading. The pieces are short and the vocabulary is not difficult, but the narrative does not always flow easily.

Suggested Uses: Individuals such as Beruriah, Esther Kiera, Benvenida Abrabane, and Grace Aguilar, to mention only a few, would make fascinating subjects for reports illustrating the extent to which some individual women did exert influence and power even in a culture which officially denigrated women.

"A Look Behind The Veil," Readings in Anthropology
by Elizabeth Fernea &
Robert Fernea
Dushkin Publications Group, 1979,
10 pages
Jr. High: Advanced
Sr. High: Average - Advanced
Illustrations: Photos
Time Period: 1826-1978
Place: The Middle East

Themes: The veil (and its accompanying seclusion and separation) as object, symbol of values, conveyor of messages about men and women, source of fascination and misunderstanding for outside observers

Description: This short piece by persons who know the Middle East intimately is both a complete examination of the subject and a delight to read. The veil and purdah (seclusion) have become a focus of attention for Western writers who equate the modernization of the Middle East with the discarding of the veil. Such concern with the outward manifestations of a cultural pattern deeply rooted in Mediterranean society does little to help an understanding of the Middle Eastern cultures which grew out of the same Judeo-Christian roots as our own. Essential to any discussion or study of Middle Eastern women. Top rating.

Suggested Uses: Ask students: What objects do we notice in societies other than our own? What objects in American society would seem most remarkable or memorable to a foreign visitor? What can we learn from a single object? How can we place a single object within its context? Example: Bring in a MacDonald's "Big Mac" as a cultural object. For the foreigner to understand our culture we must explain the following: fast-foods are needed since both men and women work; mechanized agriculture produces wheat; cheese is processed; beef is favorite meat; marketing techniques make "takeaway" food convenient and popular. None of these concepts are obvious unless explained. • Bring in a veil as an object and ask what it tells us.

⑰

"Arab Women Workers"
MERIP
Middle East Report #50
MERIP Middle East Report,
1976, 13 pages
Sr. High: Advanced
Illustrations: Photos
Time Period: 1800-1976
Place: Egypt, Palestine/Israel

Themes: Egyptian women in the work force: in the past and today, agricultural and non-agricultural, and in the future; Palestinian women: separation of household, subsistence producers from the land, and transformation into wage laborers

Description: Two articles are of particular interest: Judith Tucker's "Egyptian Women in the Work Force" and Amal Samed's "The Proletarianization of Palestinian Women in Israel." The teacher will have to judge the level of student reading competency and comprehension. Suitable for a high school economics course, these short and fascinating pieces provide a balance to the usual textbook portrayal of agriculture in the region as being the domain of men.

"Women and Politics,"
MERIP Middle East Report #138
by Joe Stork, ed.
MERIP, Middle East Report,
1986, 27 pages
Sr. High: Advanced
Illustrations: Photos
Time Period: 1800-1985
Place: Egypt, Iran, Palestine/Israel, Sudan

Themes: Women and politics in the Middle East: 19th-century Egyptian women; Iranian village women; Palestinian women; Sudanese women's emancipation

Description: *MERIP* is a bimonthly magazine specializing in Middle East development. This issue contains five articles by leading scholars on specific topics relating to women's political role in the Middle East: Suad Joseph, "Women and Politics in the Middle East;" Judith Tucker, "Women and State in 19th Century Egypt: Insurrectionary Women;" Mary Hegland, "Political Roles of Iranian Village Women;" and Sondra Hale, "Sudanese Women and the Revolutionary Parties: The Wing of the Patriarch."

"Women often pay a price for their political participation in ways that men do not. They may have to become 'honorary males' to remain honorable and public. . . . They may face negative sexual or political labeling if they raise feminist issues. They may have to drop out of political activism periodically to enjoy female-linked roles or activities."

- Suad Joseph

Anthology

Middle Eastern Women Speak
by Elizabeth Fernea &
Basima Bezirgan
University of Texas Press, 1977,
414 pages
Jr. High: Advanced
Sr. High: Average - Advanced
Illustrations: Photos
Time Period: 600-1975
Place: Middle East, North Africa,
Turkey, Iran, Afghanistan, Spain

Themes: Tradition, transition and
change; Women's conditions, aspi-
rations, struggles and achievements

Description: Important and unique
collection of biographical and auto-
biographical sketches, poems,
lullabies, excerpts from novels and
from the Quran, organized
chronologically in 23 chapters and
spanning 13 centuries. This is the
first work to use a documentary
approach rather than third person
essays and to include materials
currently unavailable in English.
It is an incredible can't-put-down
volume with much to offer the jun-
ior high and senior high student.
The entries are short and the accom-
panying photograph of each woman
draws in the student in a personal
way. Top rating.

Suggested Uses: Use these read-
ings (Chapters 1, 2, 3, 5, 6, 10, 11,
12, 16, 17, 19) as basis for lessons
in group-process and oral presenta-
tion. Introduce the roles of "moder-
ator" and "discussant" by dividing
the class into four groups. Each
group is assigned five women, with
two groups each reading the same
five selections. All students read
Chapter 2, on the Quran. Have
each group present a panel discus-
sion placing the subject geo-
graphically, historically, econom-
ically, etc. Two members act as
discussant and moderator. The dis-
cussant synthesizes the information
and draws conclusions, poses new
questions. Moderator asks of those
who have studied the same women:
"What else could/should be shared
about these persons?" "Did they
leave anything out?" "Of those
who have not studied this group of
women, what else would you like to
know?"

The Tribe of Dina: A Jewish Women's Anthology
by Melanie Kaye/Kantrowitz &
Irena Klepfisz
Sinister Wisdom, 1986, 326 pages
Sr. High: Advanced
Illustrations: Photos
Time Period: 2000 B.C.-1985 A.D.
Place: Argentina; China;
Palestine/Israel; United States

Themes: Growing up in Jewish cul-
ture; Search for Jewish identity;
Feminist Judaism in Israel and
U.S.; Jewish Lesbians; Anti-Semit-
ism and Racism; Radical Jewish
women's history

Description: This collection of
prose and poetry is mainly by and
about American Jewish feminists,
their search for identity as Jews and
for a positive relationship with
Israel in spite of their criticism of
Israeli policies. Section 1, "My
Ancestors Speak," however,
includes a first person account of a
young woman growing up as a
Sephardic Jew in Argentina and an
essay about the Sephardic women
who through the centuries since the
Spanish Inquisition, preserved by
oral transmission the Hebrew heri-
tage in Spanish poetry. Section 5,
"Israeli Women Speak" contains an
interview with a fourth generation
Palestinian Sephardic Jewish wo-
man, a poem, "To Be an Arab Jew,"
and an interview with Galia Golan
who is the Spokesperson for Sha-
lom Akhshav (Peace Now). Each
of these pieces illustrates the diver-
sity of ethnic background among
Jewish Israelis and the struggle of
women to achieve status in their
country. A useful bibliography is
included at the end of this section
for further reading about Israeli
women.

Suggested Uses: Interview with
Galia Golan provides information
regarding the status of women in
Israel today. Students could use
this as an update to the reports
found in Natalie Rein's *Daughters
of Rachel* and Geraldine Stern's
Israeli Women Speak Out (reviewed
here). • Organize a discussion
around these questions: What are
the main issues Israeli women are
concerned about? What govern-
mental agencies exist to take care of
these concerns? What is the status
of abortion? What is the connec-
tion between the women's move-
ment and peace activities? How
has Israeli public attitude changed
since the invasion of Lebanon?
What do Israeli feminists and peace
activists feel that American Jews
should be doing in relationship to
Israel?

*"... one of the main
differences between Israel
and the U.S. is that most
feminists in Israel are
influenced by or accept the
central value of the family in
Israeli society. It is a value
in Judaism and very central
in Israel."*

- Galia Golan

Women and the Family in the Middle East: New Voices of Change
by Elizabeth Fernea, ed.
University of Texas Press, 1985,
350 pages
Sr. High: Average - Advanced
Illustrations: None
Time Period: 1980-1984
Place: Algeria, Egypt, Syria, Lebanon, Iraq, Morocco, Iran, Palestine/Israel, Sudan

Themes: Issues in women's lives in "modern" sector; Women in the workplace; Changes in family life; Political organization

"Equality on the job will remain only an abstraction as long as support sturctures, such as day-care centers and transportation, do not follow."

- Algerian worker

Description: The focus here is less on the family and more on new issues and new voices. This is a rich selection of short stories, interviews, biographies, and easy-to-read studies which present insights from women throughout the region. They cover concerns about problems familiar to American women (the strains of the double shift), as well as dilemmas more specific to Islam (the adjustment a woman must make when a husband takes a second wife). Top rating.

Suggested Uses: The following are most useful for high school reading and discussion: "Algerian Women Discuss the Need for Change," "The Char," "Fatima: A Life History of an Egyptian Woman from Bulaq,""Growing Up Female in Egypt," "The Aunt of Rafiq," "Those Memoiries," "An Islamic Activist: Zaynab all-Ghazali," "The Shoes," "Cairo's Factory Women." • Use with film, *Factories for the Third World* (Icarus Films) about Tunisian women in multinational textile factories. A Mullah criticizes such employment of women because of his fundamentalist interpretation of the Quran.

Autobiography/Biography

A Bridge Through Time, A Memoir
by Laila Said
Summit Books, 1985, 282 pages
Sr. High: Average - Advanced
Illustrations: None
Time Period: 1950-1984
Place: Egypt

Themes: Nasser's revolutions and changes for women; Moslem Brotherhood; 1967 October War and its aftermath; Anwar Sadat years; Reform of the Family Law and Jihan al Sadat's mobilization of women; Open Door policy (infitah); Anti-Chador demonstrations in Iran; Interview with Cessa Nabarawi, leader in pioneering women's movement; Influence of Islamic thought; Sadat's assassination

Description: This candid memoir, set against a wealth of information about the major political events in Egypt from the 1950s until today, reveals Said as a woman who fights and who does not accept her situation. Encouraged to continue her studies, yet finally forced to marry the man arranged for her, Laila found refuge in her work as a teacher and as Egypt's first female director of plays. Increasingly her plays and her video documentaries have centered on the condition of women. She has faced censorship, bureaucratic hassles, and overt hostility which remind us of the struggles of the first feminists in Europe and America. Assign this reading to mature students because there is

a brief description of the filming of the circumcision of a small girl. Top rating.

Suggested Uses: For comparisons with other stories which detail the lives of rebellious women, assign: Munson, *The House of Si Abd Allah*; Kartini, *Letters of a Javanese Princess*; or many others reviewed in this bibliography. • Students can discuss whether it is harder to struggle in the family or in society. Where can change most easily occur first? What are important first steps to the realization of reform for women? Which approaches seem most successful?

"My mother, who embodies all the traditions of our society, did not smile at me. She still does not understand my rebellion and she never will. In her presence, I am always confronted with my society's disapproval."

- Laila Said

A Spy for Freedom: The Story of Sarah Aaronsohn
by Ida Cowan & Irene Gunther
E.P. Dutton, 1984, 158 pages
Jr. High: Average - Advanced
Sr. High: Easy - Average
Illustrations: Photos
Time Period: 1906-1917
Place: Palestine

Themes: Struggle for Palestinian freedom from Turkish rule; Village life in Jewish communities; Relations between Arabs and Jews; Heroism of Palestinian patriots

Description: Sarah Aarohnson is known as the "Joan of Arc" of Israel and is honored by school children as a national heroine. Based on personal interviews, letters, memoirs, and historical data, this is the

story of her short but dramatic life as a spy who worked with the British Intelligence Office during World War I. Although this is fictionalized biography, it is historically accurate and provides a detailed description of the life of the early Jewish settlers in Palestine. Top rating.

Byzantine Empresses: Biographical Portraits of Thirteen Notable Women Who Helped to Shape the Medieval World
by Charles Diehl
Knopf, 1963, 308 pages
Sr. High: Advanced
Illustrations: None
Time Period: 421-1347
Place: Turkey, Greece, Italy, Palestine

Themes: Glories and grandeur of Byzantine rule; Role of women in Byzantine life; Conflict between competing sects of Christianity; Sovereign power enjoyed by Empresses; Diverse backgrounds of the Empresses

Description: This book is included as a reference for excellent readers because it provides a different viewpoint of the Middle Ages and the Crusades and a detailed description of the lives of the women who became Empresses in the Byzantine Empire. Each chapter covers the life of one Empress. The author, an authority on Byzantine history, documents his assessment of each of the Empresses and the special place she holds in history. These princesses led lives of influence, scholarship, and power greater than that enjoyed by most of the queens of Europe of that period. Also described is the influence of Rome in religious affairs and the customs and trappings of an Imperial capitol.

Suggested Uses: Of special interest is Anna Comnena, the first woman historian. Have students compare her characterization of the Crusaders with that given in the textbook. • Read different chapters and compare the women's personalities and contributions to their world.

Golda Meir

by Karen McAuley
Chelsea House Publishers, 1985, 107 pages
Jr. High: Average
Sr. High: Easy
Illustrations: Photos
Time Period: 1902-1978
Place: Russia, Palestine/Israel, United States

Themes: Childhood in Russia; Teen years in U.S.; Married life on a kibbutz; British occupation of Palestine; Jewish refugees from Europe; Israel's "Preventive War;" 1967 War; 1973 Arab-Israeli War; Building Israel; Ambassador to Soviet Union

Description: To read Golda Meir's biography is to learn the history of Israel from its founding almost to the present day. It is an exciting story told in short paragraphs interspersed with many pictures and captions. The news photography gives the account the authenticity of current events and overcomes any feeling of textbook presentation.

"When people ask me if I am afraid that because of Israel's need for defense, the country may become militaristic, I can only answer that I don't want a fine, liberal, anticolonial, antimilitaristic, DEAD Jewish people."

- Golda Meir

In Kindling Flame: The Story of Hannah Senesh

by Linda Atkinson Lothrop
Lee and Shepard Books, 1985, 206 pages
Sr. High: Advanced
Illustrations: Photos; Cartoons
Time Period: 1900-1943
Place: Hungary, Palestine/Israel

Themes: Life of assimilated Jews in Hungary; Anti-Semitism and pre-war tensions in Europe; Kristallnacht; Zionist Movement; British White Paper; Holocaust; The Haganah; Jewish and Yugoslavian resistance and partisan movements

Description: This is the true story of Hannah Senesh who left relative safety in Palestine and died at the age of twenty three attempting to rescue Jews from Hungary. At seventeen, feeling the growing tension toward Jews, she migrated to Palestine, but her mother refused to follow. Forsaking her considerable intellectual prowess for manual labor, she worked in a kibbutz, and then trained in a British partisan outfit for her secret mission to Hungary. Excerpts from her diary and poetry are included, as well as details on the background of the events of the period. Top rating.

"One needs something to believe in, something for which one can have wholehearted enthusiasm."

- Hannah Senesh

My Home, My Prison

by Raymonda Tawil
Zed Press, 1983, 265 pages
Jr. High: Average - Advanced
Sr. High: Easy - Advanced
Illustrations: None
Time Period: 1940-1970
Place: Palestine/Israel, Jordan

Themes: Israeli-Palestinian conflict: 1948, growing up in Israel, exile, occupation; Women's struggle against male-dominated society and Israeli occupation

"Throwing aside conventional thinking, the families gave their full moral support to the young girls in the resistance. Fathers cared more for their daughter's strength of character in facing the ordeals imposed by the occupation authorities than for the old concepts of 'honor' or 'disgrace' Some families, previously unknown, gained honor and respect by virtue of the courage of their daughters."

- Raymonda Tawil

Description: This is the saga of a feminist who struggles to take control of her destiny under circumstances that have worked against her on every level. We are drawn into the development of her identity as a Palestinian nationalist, then back into her past; from her birth in Acre in pre-1948 Palestine to her tour as a lecturer in the U.S. Tawil's home is a political prison for her because Israel has occupied it, and a social prison because of the restrictions Arab society places upon women. A Palestinian nationalist of some importance, Tawil has consistently called for dialogue with Israelis. In fact, the

➠

book was originally written and published in Hebrew and only later translated into English. It has yet to appear in Arabic.

Suggested Uses: Ask students to discuss the phenomenon of the "gilded cage" used by Tawil. Isn't it more characteristic of upper class women's situation even in the U.S., than of rural women who work with men in the fields? Is the author's apparent obsession with appearing, thinking, and talking "Western" another form of the gilded cage? Compare this work with *We Shall Return: Women of Palestine* (reviewed here), which emphasizes the peasant roots of Palestinian society.

⑪

The Road from Home: The Story of an Armenian Girl
by David Kherdian
Greenwillow Books, Wm. Morrow & Co., 1979, 238 pages
Jr. High: Average - Advanced
Sr. High: Average - Advanced
Illustrations: None
Time Period: 1850-1924
Place: Turkey, Syria, Greece

Themes: Dissolution of Ottoman empire; Armenian Revolutionary parties; Persecution of Christian minorities; Young Turks; Balkan War and World War I; Armenian middle-class family life; Massacres of 1895-1909; "Turkey for the Turks" policy and Armenian deportation treks in 1915; Greek/Turkish war over Smyrna; Armenian refugees in Greece

Description: Young Vernon's life is brutally disrupted as her family is deported from Turkey and forced to live in the deserts of Syria. Only Vernon survives the long trek and after a sojourn in an orphanage and an escape from the massacre of Armenians and Greeks in Smyra, she is sent, at age 16, to America as a "mail order" bride. A riveting account of a history unknown to many students. Vernon is the author's mother. Top rating.

Suggested Uses: Story offers ample material for a comparison with Holocaust accounts and a way to discuss the German involvement in this "first" 20th century attempt at genocide.

"We were Christians, and they were Moslem...we did live on the same soil, but I was told that soil could be owned and that the present owner of this soil, which we had always called home, was Turkey."

- Vernon

First Person Accounts

A Street in Marrakech, A Personal Encounter with the Lives of Moroccan Women

by Elizabeth Warnock Fernea
Doubleday and Company, 1975, 377 pages
Jr. High: Advanced
Sr. High: Average - Advanced
Illustrations: Photos; Map
Time Period: 1970-1974
Place: Morocco, Egypt

Themes: Survival strategies of urban poor; Women's economic and spiritual roles; Women's status within the family; Cross-cultural comparisons

Description: Elizabeth Fernea, an American who has just settled into the old town of Marrakech with her husband and her three children, seeks to learn more about her Moroccan female neighbors. The reader is brought along with her as she struggles to find a way into the women's secluded world where one's private life is successfully kept hidden from public exposure. When the breakthrough occurs, Fernea has important glimpses into the female support system, marriage celebrations, spiritual resources. A humorous and entertaining story. Fernea has also written *A View of the Nile*, about her family's residence in Egypt from 1959 to 1965. Less attention here to women, but good portraits of upper class Egyptian and village Nubian women.

Suggested Uses: Students discuss and list on the board characteristics Americans might use to describe Muslim women. Assign the chapter, "Rabia's Wedding." Students discuss where these characteristics hold up and where they do not.

Daughter of the Waves: Memories of Growing Up in Pre-War Palestine

by Ruth Jordan
Taplinger Publishing Co., 1982, 213 pages
Jr. High: Average
Sr. High: Average
Illustrations: Photos
Time Period: 1926-1946
Place: Palestine/Israel

Themes: Growing up in Pre-War Palestine; Uneasy relationship of Jews with Arab population; Ordinary daily life of Jewish community; Yehuda Bourla, Hebrew novelist; British policy refusing sanctuary to Jewish refugees from Hitler

Description: Jordan's memoirs describe the ordinary pleasures of daily life in Palestine against the background of British rule, Arab hostility and Jewish refugees fleeing Hitler's Europe. This is an account of a young Jewish girl's adolescence in the context of historic events which make present Middle East tensions much more understandable. Especially valuable is the portrayal of Jewish and Arab relations among neighbors and schoolmates as well as the vulnerability of this tiny land in relation to the Great Powers who shaped its destiny. Eight pages of photos of Palestine and people add interest.

Guests of the Sheik: An Ethnography of an Iraqi Village

by Elizabeth Fernea
Doubleday, 1969, 337 pages
Jr. High: Advanced

Sr. High: Average
Illustrations: Map
Time Period: 1956-1958
Place: Iraq

Themes: Daily life: costume, food, family; Times of joy and anguish: childbearing, weddings, illness, death; Religious festivals, feasts, and pilgrimages

Description: This is the delightful and informative account of a two-year stay in the Shi'a village of El Nahra in southern Iraq. To be accepted as a respectable woman of the village and to assist her anthropologist husband, Fernea dressed in the all-enveloping black veils of the women of the village and adopted the sheltered life they lead. Hardships were many but the rewards were greater.

Suggested Uses: Chapters 1-4, 13-14, detail the life Fernea shared with the village women. Students who read any or all of this work may want to read the "follow-up," *The Arab World: Personal Encounters*, by Elizabeth and Robert Fernea (reviewed here). Chapter 16 describes the return visits by the authors to the village and a visit to the U.S. by the son of the Sheik.

"I donned my abayah, trying to wrap it around me as the women did, but not succeeding very well. Selma (the Sheik's wife) said kindly: 'Soon you will know how to wear the abayah.' 'Don't they wear the abayah in America?' asked a woman in surprise. 'No no.' said Selma. ... 'Then why does she wear it here?' persisted the woman. 'Because she is polite.' said Selma."

- Elizabeth Fernea

Israeli Women Speak Out

by Geraldine Stern
J.B. Lippincott, 1979, 222 pages
Jr. High: Advanced
Sr. High: Average - Advanced
Illustrations: None
Time Period: 1926-1976
Place: Palestine/Israel

Themes: Holocaust trauma; New Russian immigration; Struggle of Israeli women for civil rights and full equality

Description: Ten Israeli women from diverse backgrounds speak their minds and recount their life stories to an American journalist: Shulamit Aloni (Civil Rights advocate, Knesset member); Marcia Freedman (Founder of feminist movement, member of Knesset); Sylva Zalmonson (Mechanical Engineer, emigre from Soviet Union); Judith Buber Agassi (Political Scientist, Sociologist); Senta Josephthal (Head of Agricultural Enter); Violet Khoury (Mayor of Arab village; Esther Schahamorov Roth (Member of 1972 Olympic Team); Miriam Ben-Porat (Supreme Court justice); Geula Cohen (Guerrilla fighter against British, member of Knesset); Ruth Levin (Artist). Out of print, but available in Jewish and public libraries. Because of the scarcity of first person accounts from Israeli women, it is worth looking for this book.

Suggested Uses: There is a great deal of important and fascinating historical material in these interviews. Students should choose which personality to read about according to their own interests.
• Oral reports on several of these women would be informative and entertaining.

"... isha v'em b'Yisrael... Every woman in Israel is at the same time a mother in Israel. That means that you have to care not only for your family but the family of all Israel at the same time."

- Geula Cohen

The House of Si Abd Allah: The Oral History of a Moroccan Family

by Henry Munson
Yale University Press, 1984, 259 pages
Sr. High: Average - Advanced
Illustrations: Photos
Time Period: 1950-1983
Place: Morocco

Themes: Transformation of highland peasantry into working class in Tangiers; Moroccan independence of 1956; Contemporary "imperialism," Migration to Europe of "guest workers," Women's changing lives and resistance to change

Description: This fascinating history of one extended Moroccan family is told through the words of a "fundamentalist" Moslem and his "westernized" female cousin. These two people offer radically different perceptions of their religion and the major historical processes that have transformed their family over the last half century.

Suggested Uses: Assign the last section: "Al-Hajja Kharddiyi, Daughter of Si Abd Allah." Here Fatima describes her childhood, years in Belgium and America, and life in Morocco where she found herself in limbo between the old world of the Cobblestone Quarter and the Tangiers of the westernized elite.

"Most of the students at Muhammad V University are full of big talk about revolution, but when it comes to the role of women, they still think like their fathers before them."

- Fatima

The Plough Woman: Memoirs of the Pioneer Women of Palestine

by Rachel Katsnelson Shazar, ed.
The Herzl Press, 1975, 268 pages
Jr. High: Average
Sr. High: Easy - Average
Illustrations: Photos
Time Period: 1904-1918
Place: Palestine/Israel

Themes: Eagerness for physical labor felt by many pioneer women; Individual relationship to labor movement; Struggle of woman worker to find recognition in ranks of labor; Hardships facing early settlers; Writings of pioneer women

➡

Description: Originally printed in English in 1932, these memoirs of young women who went to Palestine early in the 20th century provide us with insights into their dreams as well as their struggles to achieve equality in work with their male comrades. Individual short accounts are dramatic and descriptive of the hard life they endured, reclaiming marsh and wasteland, tending tree nurseries, or founding a kibbutz. They give us an historic background to the status of women in Israel today. Also included are some poems written by the young pioneers, a glossary of terms, and biographical sketches of the contributors and some of the personalities mentioned in the memoirs. Top rating. Another memoir of this period is Ada Maimon's autobiography, *Women Build A Land*, Herzl Press, which documents events chronologically from 1904 to 1949. This fascinating book is now out of print but is available in Jewish community libraries.

"The girls who had the opportunity to work in the fields were . . . few and far between, and even within the pioneering, revolutionary labor movement in the Land of Israel women were relgated to their traditional tasks -- housekeeping and particularly kitchen work."

- Ada Maimon

Suggested Uses: Assign " Places and Terms" so that students can refer to the definitions as they read.
• All of the first person accounts make good student reading. They are short enough to be given to each student and used in class. In order to show the variety found in Chavurot (women workers' commune), have the students compare crops grown, problems faced, and successes or failures of the project. For example: "The Women's Farm in Nachlath Jehudah," "The Tobacco Kvutzah," and "Women Build Houses" provide three interesting experiences to compare.
• Make a list of the women's complaints. Were they reasonable ones? What solutions might have been found?

Veiled Sentiments: Honor and Poetry in a Bedouin Society
by Lila Abu-Lughod
University of California Press, 1986, 317 pages
Sr. High: Advanced
Illustrations: Photos; Map
Time Period: 1978-1980
Place: Egypt

Themes: Bedouin moral code; Logic and values expressed through oral poetry; Values of male honor and female modesty; Intimacy and vulnerability in interpersonal relationships

Description: Lila Abu-Lughod describes the "little songs" of the women of a bedouin tribe of Egypt's western desert. Like the Japanese haiku in form, they are charged with an emotion that breaks through Western stereotypes of the Middle Eastern woman. This bedouin women's poetry forms the basis of a fine book by this Western anthropologist who enters the life of a highly organized non-Western society, absorbs its ways with total sympathy, and presents them without domination or complicity.

Suggested Uses: Use Chapter 1, "Guest and Daughter," and Chapter 2, "Identity in Relationship," as these are the most informative. Chapter 7, "Modesty and the Poetry of Love," is certain to appeal to students as it deals with young love.

We Shall Return: Women of Palestine
by Ingela Bendt & James Downing
Zed Press/Lawrence Hill, 1982, 129 pages
Jr. High: Average - Advanced
Sr. High: Easy - Average
Illustrations: Photos
Time Period: 1936-1982
Place: Lebanon

Themes: Palestinian women of the refugee camps: Exodus (1948) or birth in exile; Camp social patterns; Freedom struggle; Military resistance; Transformation from refugees to revolutionaries

Description: This story of the Palestinian women is told by the women of the refugee camps - - women and girls of all ages. It is a short work, easily read and understood. The extensive illustrations, large typeset, clear layout and information in small doses, combine to make it an excellent classroom tool. Top rating.

Suggested Uses: Since these accounts are largely from Rashidiyah Camp, show the film *Women Under Seige* (reviewed here), shot in this camp during the same period, among the same women. Students might like to role play various parts: a journalist interviewing a Palestinian in a camp, a Palestinian child, adolescent, mother, grandmother, etc. What might be the questions asked? The responses? • Have students compose "diary entries" for a youth of their own age in such a camp.

Fiction

Arab Folktales
by Inea Bushnaq
Pantheon, 1986, 383 pages
Jr. High: Average - Advanced
Sr. High: Average
Illustrations: Reproductions
Time Period: 2000 B.C.-1986 A.D.
Place: Middle East, North Africa

Themes: Bedouin tales; Djinn, ghouls and afreets; Magical marriages and mismatches; Animal tales; Famous fools and rascals; Religious tales and moral instruction; Wily women and clever men

Description: Drawing from archival and living sources, the Palestinian author has translated one hundred and thirty stories, giving lyrical voice to the words of women, from the Moroccan woman who worked alongside her husband in the fields, to the Nubian grandmother who first told these tales to archeologists and folklorists. The general introduction and the introductions to each section provide background. Tales in which women are the central figures are found throughout, as in "Atiyah, the Gift of God" or "The Boy in Girl's Dress" from the section on bedouin tales. Many stories are only one page in length, but most are illustrated with details of textile and embroidery patterns. The stories

women tell are compared to the dresses they wear whose embroidered patterns "read" of cultural traditions and history.

Suggested Uses: • Students compare with other folktale traditions. • Students become the storyteller (for the emphasis is on the telling, not the reading). Especially useful would be *The Arab World: Storytelling and Games* (reviewed here). • Stories could be set to puppeteering, or to other Arab culture-appropriate mechanism for their dramatization. Especially useful would be *The Arab World: Storytelling and Games* (reviewed here). • Read several stories aloud. Ask students to brainstorm images and insights and list them on the board. Ask them to use this list in the composition of a poem.

Daughters of Yemen
by Mishael Maswari Caspi, trans.
University of California Press,
1985, 233 pages
Jr. High: Average
Sr. High: Average
Illustrations: None
Time Period: Traditional
Place: Israel

Themes: Young love; Marriage customs; Bride's anguish over separation from mother and region; Older women's feelings

Description: A beautifully printed book of poems in everyday language preserves the culture of Yemenite Jewish women whose lifestyle has now disappeared as a result of their migration to Israel. Sung in an Arabic dialect, they are in the oral tradition of illiterate Jewish and Muslim women, both denied education and participation in the intellectual and religious life of their communities. The poems are organized around the life cycle of a woman: love, marriage, motherhood, and old age. The Introduction provides both historical and

literary context and an explanation of the significance of these songs in a vanishing culture. Students will have no difficulty in understanding the poems as their message is clear. Top rating.

Suggested Uses: Choose two or three poems for class to read. See how many customs and attitudes about women students can list just from reading these. • Why weren't these songs recorded in the same way that the men's poetry was preserved?

"Women's songs . . . arising from an oral tradition... must be recorded before they - - and their singers - - disappear."

- William M. Brinner

Distant View of a Minaret and Other Stories
by Alifa Rifaat
Heinemann Education Books -
African Writers Series, 1985,
116 pages
Jr. High: Advanced
Sr. High: Average - Advanced
Illustrations: None
Time Period: 1980-1983
Place: Egypt

➡

Themes: Women's status within the family; Arranged marriages; Woman's revolt within a religious framework; Women's sexuality

Description: Most of the fifteen stories are five or six pages in length and all are fairly easily read and understood, with notes on unfamiliar words. Their subject is women living and rebelling within a religious patriarchy. Rifaat's point of view is radically different from any postured by Western women's lib, making this collection all the more valuable for its uniqueness and honesty. These short stories are easy to read, but teachers should be the judge of suitability: Story #2 has an oblique reference to clitoridechtomy, and Story #10 presents a sexual fantasy.

Suggested Uses: Use stories #1,3, 4,5, and 13,14,15, for any World Literature course.

God Dies By the Nile
by Nawal El Saadawi
Zed Press, 1985, 138 pages
Sr. High: Average - Advanced
Illustrations: None
Time Period: 1970-1974
Place: Egypt

Themes: Collusion of church and state to control the peasants; Life of peasants; Class differences; Oppression of women

Description: Zakeya, who lives in a village on the banks of the Nile, is an illiterate peasant woman whose family is systematically exploited by the mayor - the religious representative in the village - and other local authorities. This powerful story is unflinching in its portrayal of the brutality of peasant life and the exploitation of the poor. Written by an internationally known physician and author who also wrote *Women at Point Zero*. El Saadawi's works should be read only by sophisticated readers.

Suggested Uses: The teacher might read the story first then excerpt some of the text to describe and read to class • Provides ideal comparisons with women's domination by institutions of family, church and state in other societies such as feudal Europe and China.

Married to a Stranger
by Nahid Rachlin
E.P. Dutton, 1983, 220 pages
Jr. High: Advanced
Sr. High: Average - Advanced
Illustrations: None
Time Period: 1975-1981
Place: Iran

Themes: Young woman growing into adulthood anticipating marriage as an escape; Religious fundamentalism combined with growing resentment of Westernization in pre-revolutionary Iran

Description: Story of a young woman who marries a man of her own choosing and imagines romantic love and personal freedom as synonymous with her pending marriage. We share her struggles with the reality of married life as she and her husband become involved with "revolutionary" trends -- he with the growing criticism of the excesses of the Shah's regime, she with growing feminist expression. Suitable for any World Literature course, although sexual scenes may be too explicit for Junior High students. Nahid Rachlin has also written *Foreigner*, about a woman who returns to Iran after 15 years in America. Her initial alienation to her traditional culture develops into acceptance. Explicit sexual scenes.

Mother Comes of Age
by Driss Chraibi
Three Continents Press, 1984, 121 pages
Sr. High: Average - Advanced
Illustrations: Map
Time Period: 1934-1944
Place: Morocco

Themes: Life of upper class Islamic Moroccans; Effect of introduction of modern conveniences on women's lives; Effect of French Colons on Moroccans; Outbreak of World War II; Conference of Roosevelt, Churchill and De-Gaulle in Casablanca

Description: The story is told through the eyes of two sons who have been educated to fit into the Francophile upper class Moroccan society. Without informing their father, the young men take their mother on secret trips out of her home, where she has lived in seclusion since she entered as a teenage bride. By the novel's end, the mother is seeking knowledge of her own country and actively voicing her opinions of the current World War. This story of liberation is told with humor and warmth.

Sitt Marie Rose
by Etel Adnan
Post-Apollo Press, 1982, 105 pages
Jr. High: Advanced
Sr. High: Average - Advanced
Illustrations: None
Time Period: 1975
Place: Lebanon

Themes: Lebanese Civil War; Christians versus Palestinians and Muslims; Abduction and hostages; Tribal mentality and definition of women's "sins"

Description: This is a fictionalized account of the real-life abduction of Marie-Rose, the headmistress of a school for the deaf in Beirut. Marie-Rose, a well known champion of causes, including women's freedom, dared to cross tribal lines that separated her Christian "tribe" from the Palestinians and from the Muslims. Adnan, a Lebanese poet and artist, wrote this after meeting this modern heroine. Although the reading level is not difficult, comprehension may be. The lyric and abstract quality of Adnan's work may require discussion and explanation. Top rating.

Speak Bird, Speak Again: Palestinian Arab Folktales
by Ibrahim Muhawi & Sharif Kanaana
University of California Press, 1987, 579 pages
Jr. High: Average - Advanced
Sr. High: Easy - Average
Illustrations: None
Time Period: Traditional
Place: Palestine

Themes: Childhood and siblings; Sexual awakening and courtship; Brides and bridegrooms and family life; The influence of society and environment on the individual; Understanding of the universe

Description: The tellers of these tales are women who "do not think of themselves primarily as tellers, nor do they feel they have a special ability. They are all householders, the great majority being housewives who can neither read nor write." These tales were collected from tellers in Nablus, Jaffa, the Galilee and from other cities, towns and villages. Their topics cover the stuff of life and provide a valuable contribution toward rescuing one aspect of a culture under siege. Many appendices, a footnote index and selected bibliography.

Unwinding Threads: Writing by Women in Africa
by Charlotte Bruner, ed.
Heinemann Educational Books, 1983, 207 pages
Jr. High: Advanced
Sr. High: Average - Advanced
Illustrations: None
Time Period: 1891-1980
Place: Algeria, Egypt

Description: Excellent pieces from North Africa. See full annotation in Section on Africa.

Women of the Fertile Crescent: Modern Poetry by Arab Women
by Kamal Boullata, ed.
Three Continents Press, 1978, 206 pages
Jr. High: Advanced
Sr. High: Average - Advanced
Illustrations: Photos
Time Period: 1917-1978
Place: Egypt, Iraq, Lebanon, Syria Palestine/Israel, Saudi Arabia

Themes: Self-identity; War; Pain and love - from the perspective of diverse women

Description: This is a collection of works from thirteen women poets. Introduced with a full-page photograph and biographical notes, each woman carries on a thirteen-hundred-year tradition of self-expression within the male dominated cultures. The reader is drawn into the life of each woman. Through Etel Adnan we experience the Lebanese Civil War; Fadwa Tuqan paints a portrait of dignity under foreign occupation; Fawziyya Abu Khalid shows us a traditional Bedouin family and her mother's legacy of pride and intelligence. Appendices cite ample sources for further study and enjoyment. Top rating.

Suggested Uses: Use in conjunction with any of the three films by Elizabeth Fernea (reviewed here). The Palestinian experience of Fadwan Tuqn, Hanan Mikha'il or Salma al-Khadra' al-Jayyusi, can be found as well in the Tawil autobiography, *My Home, My Prison* (reviewed here).

Curriculum

A Veiled Revolution, (Color film/video)
by Elizabeth Fernea
Icarus Films, 1982, 26 minutes
Jr. High: Advanced
Sr. High: Average - Advanced
Time Period: 1919-1981
Place: Egypt

Themes: Egyptian women spearheading Arab feminist movement begun in the 1920s; Today's young women returning to Islamic or modest dress ("veiling")

Description: Egypt was the first Arab country in which women marched in political demonstrations (1919), the first in which women took off the veil (1923), and the first to offer free public secular education to women (1924). Today the granddaughters of those early Arab feminists are returning to traditional garb, sometimes with full face veil and gloves, which they call Islamic dress. What are the reasons for this new movement? Is it an echo of the Iranian revolution -- a rejection of Western values? What do women themselves say about it? Fernea and director Marilyn Gaunt took an all-women crew (British, American, Arab) to Egypt to find out. Teacher's guide with commentary and eight good questions for discussion is included. It also contains a map, foreword, and a five-page piece on veiling.

Other excellent films by Fernea are: *The Price of Change* (Color film/video, 26 min.) examines the consequences of work outside of home for five women in today's Egypt: a factory worker, a rural village leader, a doctor, a social worker, and a member of Parliament and Speaker for the opposition party. Forty percent of Egyptian women through necessity must work outside the home, once considered a shameful situation.

Factories for the Third World (43 min.) is a case study of young Tunisian women workers, sources of unskilled, cheap labor in factories run by multi-national corporations. Especially good for use with subject of Neo-Colonialism. Top rating for all of these films.

Suggested Uses: *A Veiled Revolution*: Use the commentary in the Teacher's Guide and the short biographical sketches of the women interviewed. Some of these names students can find in a world or international *Who's Who*. *The Price of Change*: List the names of the women on the board so that students can understand their spelling. This helps to humanize the individuals and their region. The lengthy segment on the woman and her family who are involved in a rural family planning program, make this a fine classroom tool for a Social Living course.

The Arab World: Storytelling and Games
by Audrey Shabbas,
Carol El-Shaieb & Ahlam Nabulsi
Arab World Consultants, 1983,
56 pages
Jr. High: Easy - Average
Sr. High: Easy
Illustrations: Drawings; Color slides;
Time Period: 2700 B.C.-1983 A.D.
Place: Middle East, North Africa

Themes: Storytelling and gaming traditions, ancient and modern; Dramatization: readings, theatrics, puppetry; Games: Boardgames and fieldgames

Description: One of six multimedia units from Arab World Consultants, this contains slides, posters, background materials and many student projects to be done individually or in groups. This set contains thirteen slides with full commentary and many student activities. It includes five folktale traditions, with activities involving their translation into creative student projects. Seven games (both boardgames and fieldgames) are explained so that they can be constructed and played. Such uses of leisure time, particularly the storytelling traditions, are the realm of women and their children.

Suggested Uses: The activities are particularly effective with Junior High students. They can be in conjunction with tales found in *Arab Folktales* and in *Speak Bird, Speak Again*. Have students "become" storytellers. • Turn a tale into a dramatized performance, writing dialogue for the characters. • Turn a tale into a puppet performance, using shadow or stick puppets.

Women in Islam: The Ancient Middle East to Modern Times

by Marjorie Bingham &
Susan Hill Gross
GEM Publications, 1980,
129 pages
Jr. High: Average - Advanced
Sr. High: Easy - Average
Illustrations: Photos; Maps;
Drawings
Time Period: 2573 B.C.-1979 A.D.
Place: Middle East, North Africa

Themes: Women in ancient times; Early Islam; Muslim Middle East: marriage, divorce, veiling, seclusion, separation, power, politics; Modern Middle East: Algerian and Iranian revolutions, feminist movements

Description: Chapter 4, "Separate Worlds," and Chapter 6, "Women in the Modern Middle East," are excellent. Other chapters are less useful. The terms, "Islam" and "Middle Eastern," are sometimes confused in describing some aspects of women's lives in the region as being Islamic while in fact they are typical of the region regardless of religion. In place of Chapters 5, "A Diversity of Roles," and Chapter 6, "Four Aspects of the Islamic View of Women," we suggest using Elizabeth and Robert Fernea's article, *"A Look Behind the Veil"* (reviewed here), and Elizabeth Fernea's films, *The Price of Change* and *A Veiled Revolution* (reviewed here).

Suggested Uses: Chapters 4 and 6, used in conjunction with first person readings from *Middle Eastern Muslim Women Speak* (reviewed here).

Women in Israel

by Susan Hill Gross &
Marjorie Wall Bingham
GEM Publications, 1980, 72 pages
Jr. High: Advanced
Sr. High: Average - Advanced
Illustrations: Photos; Maps

Time Period: 1700 B.C.-1978 A.D.
Place: Palestine/Israel

Themes: Biblical women; Plough women, the Pioneer women in Palestine before World War I; Women's suffrage; Brief biographies of Golda Meir, Rachel (first Hebrew poet); Hannah Senesh; Women in the military; Arab women; Women in politics and law; Future possibilities for equal status

Description: This attractive, compact booklet provides basic factual information allowing for the inclusion of women's roles into a curriculum on the Middle East. Short, easily read sections describe the experiences of women in Palestine and Israel from biblical to modern times. For Israeli women today, the primary issue is the difference between the official rhetoric regarding women's equal status and the official policies of restriction and exclusion which confront them. Section D in Chapter V, "The Future - - Towards Fuller Equality," outlines the findings and recommendations of the Committee for the Status of Women established by the Israeli government in 1976 during the International Women's Decade. Under Points to Consider, the authors have provided excellent topics for further research and discussion. Top Rating.

Suggested Uses: The Glossary is excellent and needs to be used in connection with all reading on the Middle East for better comprehension of geographic and cultural terms. • In place of Chapter IV, "Other Women: A Variety of Cultural Traditions," we suggest using Muslim sources, such as *Middle Eastern Muslim Women Speak* by Elizabeth Fernea; *My Home, My Prison* by Ramonda Tawil; and *We Shall Return: Women of Palestine* by Ingela Bendt and James Downing (all reviewed here). For supplemental reading on Jewish women use other books reviewed in this section; *The Plough Woman, Written Out of History*, and *Golda Meir*.

Women Under Siege (Color film/video)

by Elizabeth Fernea
Icarus Films, 1982, 26 minutes
Jr. High: Advanced
Sr. High: Average - Advanced
Time Period: 1981
Place: Lebanon

Themes: Conditions in Palestinian refugee camp; Women's crucial role and concerns

Description: Rashadiyah, a southern Lebanese town six miles north of the Israeli border, was once a peaceful agricultural village, but in 1964 became a refugee camp housing 14,000 Palestinians. Decimated by a 1978 Israeli invasion, the camp regrouped, and in 1981 had a population of 9,000. Women have a crucial role here as mothers, fighters, teachers, political organizers, and farm laborers. Through interviews the film explores the lives of seven women: a member of the central governing people's committee; a mother of five small children; a grandmother; the secretary of the Women's Union; two elderly wives of an aging farmer; and a radical woman commando. In June, 1982, just after completion of the film, Rashadiyah became the first refugee camp overrun by the Israelis during their invasion. An excellent Teacher's Guide accompanies the film.

Suggested Uses: Share with students the background material (5 pages) and Cast of Characters from the Teacher's Guide. • List the names of the seven women interviewed on the board. Use the questions in the Study Guide for classroom discussion. • For further study, use the book, *We Shall Return: Women of Palestine* (reviewed here).

APPENDIX:
Publisher Addresses

ABC-CLIO
2040 Alameda Padre Serra
P.O. Box 4397
Santa Barbara, CA 93140

Academy Chicago Pubs.
425 N. Michigan Avenue
Chicago, IL 60611

Academy Press
Longwood Publishing Group
27 S. Main Street
Wolfeboro, NH 03894

African Studies Program
University of Indiana
Woodburn Hall 221
Bloomington, IN 47405

African-American Institute
833 United Nations Plaza
New York, NY 10017

Africana Publishing Co.
(Division of Holmes &
Meier Publishers, Inc.)
30 Irving Place
New York, NY 10003

AFS International
Intercultural Programs
313 East 43rd Street
New York, NY 10017

Alfred A. Knopf
(See Knopf)

American Friends
Service Committee
1501 Cherry Street
Philadelphia, PA 19102

American Heritage Publishing Co.
Harper & Row
60 Fifth Avenue
New York, NY 10003

American Museum of
Natural History
Central Park West & 79th Street
New York, NY 10020

Amnesty International, U.S.A.
15 Rutherford Place
New York, NY 10003

Anchor Press
(See Doubleday & Co., Inc.)

Arab World Consultants
2137 Rose Street
Berkeley, CA 94709

Asia Society
727 Park Avenue
New York, NY 10021

Asia Society, Inc.
(Distrib.: Charles E.L. Tuttle, Co.)
P.O. Box 410
28 S. Main Street
Rutland, VT 05701

Assoc. of American Geographers
1710 Sixteenth Street
Washington, DC 20008

Atheneum
115 Fifth Avenue
New York, NY 10003

Australian Information Service
636 Fifth Avenue
New York, NY 10111

Aventura, Vintage Books
(See Random House)

Avon Books
1790 Broadway
New York, NY 10019

B.T. Batsford Ltd., London
4 Fitzhardinge Street
Portman Square
London WH, England OAH

Ballantine Books
(See Random House)

Bantam Books, G. P. Putnam
666 Fifth Avenue
New York, NY 10019

Barnes & Noble Books
(See Harper & Row)

Beacon Press
25 Beacon Street
Boston, MA 02108

Bellerophon Books
36 Anacapa Street
Santa Barbara, CA 93101

Black Scholar Press
485 65th Street
Oakland, CA 95609

Bloch Publishing Co.
19 W. 21st Street
New York, NY 10010

Bookwright Press
387 Park Avenue South
New York, NY 10016

Boydell Press
(See Academy Chicago)

APPENDIX:
Publisher Addresses

Bradbury Press: Macmillan, Inc.
866 Third Avenue
New York, NY 10022

Braziller
1 Park Avenue
New York, NY 10016

Cambridge Book Co.
New York Times Media
888 Seventh Avenue
New York, NY 10106

Cambridge University Press
32 E. 57th Street
New York, NY 10022

Carna Resources
24 Kent Street
Hartford, CT 06112

Celestial Arts: Ten Speed Press
Box 7327
Berkeley, CA 94707

Center for Global Perspectives
(Global Perspectives In Education)
218 East 18th Street
New York, NY 10003

Center of Concern
3700 13th Street, N.E.
Washington, DC 20017

Chelsea House Publishers
5014 West Chester Pike
Edgemont, PA 19028

China Books & Periodicals, Inc.
2929 24th Street
San Francisco, CA 94110

Cite Book
(Center for International
Training and Education)
777 United Nations Plaza
New York, NY 10017

City Lights Books
261 Columbus Avenue
San Francisco, CA 94133

Columbia University Press
526 W. 113 Street
New York, NY 10025

Continuum
(Distrib. : Harper & Row)
Keystone Industrial Park
Scranton, PA 18512

Cornell University
East Asia Papers
140 Uris Hall
Ithaca, NY 14853

Coward, McCann &
Geoghegan, Inc.
200 Madison Avenue
New York, NY 10016

Crossing Press
Box 640
Trumansburg, NY 14886

Crown
225 Park Avenue South
New York, NY 14886

Cultural Survival Quarterly
11 Divinity Avenue
Cambridge, MA 02138

Cumberland Press
136 Main Street
Freeport, ME 04032

David McKay Company, Inc.
O'Neill Highway
Dunmore, PA 18512

David R. Godine
(See Godine)

Dell
1 Dag Hammarskjold Plaza
245 E. 14th Street
New York, NY 10017

Dial Press
(See Doubleday)

Diemer, Smith Publishing
Company, Inc.
Suite 322
3377 Solano Avenue
Napa, CA 94558

Dodd, Mead & Co.
79 Madison Avenue
New York, NY 10016

Doubleday & Company, Inc.
(Anchor, Dolphin, Dial, Virago)
245 Park Avenue
New York, NY 10167

Dushkin Publications Group, Inc.
Gilford, CT 06437

E.P. Dutton
(Lodestar, Hawthorn)
2 Park Avenue
New York, NY 10016

East African Publishing House:
(See Heinemann
Educational Books)

East Asian Institute
Columbia University
420 West
New York, NY 10027

East Asian Outreach Program
Yale University
Box 13A Yale
New Haven, CT 06520

Ecco Press
18 West 30th Street
New York, NY 10001

Education Development Center
55 Chapel Street
Newton, MA 02160

Educational Resources Center
c/o State Education Department
Room 9B52
Albany, NY

Falling Wall Press:
Flatiron Book Distributor, Inc.
Suite 807
1170 Broadway
New York, NY 10001

Farrar, Straus & Giroux
19 Union Square, West
New York, NY 10003

Fawcett Books:
(See Random House)

Feminist Press at the
University of New York
311 East 94th Street
New York, NY 10128

Films Incorporated
Encyclopaedia Britannica
Educational Corp.
425 N. Michigan Avenue
Chicago, IL 60611

Food First Publications
Institute for Food and
Development Policy
1885 Mission Street
San Francisco, CA 94103

Foreign Policy Association
(Headline Series #248)
250 Lexington Avenue
New York, NY 10016

Four Winds Press
730 Broadway
New York, NY 10003

Franklin Watts
387 Park Avenue, South
New York, NY 10016

Frederick Warne and Co., Ltd.
(See Viking Penguin)

Frederick A Praeger:
Greenwood Press, Inc.
521 Fifth Avenue
New York, NY 10175

Freer Gallery of Art
12th & Jefferson Drive, SW
Washington, DC 20560

Friendship Press
Church World Service
Rm. 772
475 Riverside Drive
New York, NY 10027

GEM Publications
(See Glenhurst Publications Inc.)

Glenhurst Publications, Inc.
Central Community Center
6300 Walker Street
St. Louis Park, MO 55416

Godine
Horticultural Hall
300 Massachusettes Avenue
Boston, MA 02115

Greenwillow Books
Wm. Morrow & Co.
105 Madison Avenue
New York, NY 10016

Greenwood Press
(Division of Congressional
Information Services)
Box 5007
88 Post Road, W.
Westport, CT 06881

Grosset & Dunlap
51 Madison Avenue
New York, NY 10010

Grove Press
920 Broadway
New York, NY 10010

Harcourt, Brace, & World
1250 Sixth Avenue
San Diego, CA 92101

Harper & Row
(Colophon Books, Torchbooks,
J.B. Lippincott, Kodansha, John
Day, Thomas Crowell, University
of Illinois Press, Women's Press)
10 East 53rd Street
New York, NY 10022

Hastings House
260 Fifth Avenue
New York, NY 10016

Heinemann Education Books
(African Writers &
Asian Writers Series)
70 Court Street
Portsmouth, NH 03801

Herzl Press
515 Park Avenue
New York, NY 10022

Holt, Rinehart & Winston
(CBS Education Professional
Publication)
521 Fifth Avenue
New York, NY 10175

Houghton Mifflin Company
1 Beacon Street
Boston, MA 02108

Icarus Films
Suite 1319
200 Park Avenue
New York, NY 10003

Ide House
4631 Harvey Drive
Mesquite, TX 75150

Immaculate Heart College Center
Suite 2021
10951 W. Pico Blvd.
Los Angeles, CA 90064

Indiana University Press
10th & Morton Street
Bloomington, IN 47405

Institute for Policy Studies
1901 Q Street, NW
Washington, DC 20009

Institute of Latin American Studies
University of Texas
Sid Richardson Hall
Austin, TX 78712

International Defense and
Aid Fund for Southern Africa
P.O. Box 17
Cambridge, MA 02138

International Women's
Tribune Centre
777 United Nations Plaza
New York, NY 10017

Iowa State University Press
2121 South State Avenue
Ames, IA 50010

Isis International, Rome
Via Santa Marie dell'Anima
Rome, Italy 00186

J. Weston Walch
P.O. Box 658
Portland, ME 04104

J.B. Lippincott
(Harper & Row)
E. Washington Square
Philadelphia, PA 19105

Jackdaw Publications
(Distributed by Social Studies
School Service)
P.O. Box 802
10200 Jefferson Blvd.
Culver City, CA 90232

Jewish Publication Society of
America
1930 Chestnut Street
Philadelphia, PA 19103

John Daniel
Box 21922
Santa Barbara, CA 93103

John Day Company
(See Harper & Row)

Johns Hopkins University Press
Suite 275
701 W. 40th Street
Baltimore, MD 21211

Julian Messner
1230 Avenue of the Americas
New York, NY 10020

Kingston Institute of Jamaica
(Kingston Publications, Ltd.)
1A Norwood Avenue
Kingston, Jamaica 5

Knopf
201 E. 50 Street
New York, NY 10022

Kodansha International
(See Harper & Row Publishers,
Inc.)

Latin American Working Group
P.O. Box 2207, Station P
Toronto, Ontario
Canada M5S 2T2

Lawrence Hill & Co.
520 Riverside Avenue
Westport, CT 06880

Lee and Shepard Books
(See Lothrop, Lee & Shepard)

Lerner Publications Co.
241 First Avenue, North
Minneapolis, MN 55401

Little, Brown & Co.
200 West Street
Waltham, MA 02254

Lodestar Books, E.P. Dutton
2 Park Avenue
New York, NY 55401

Longman Group Ltd.
45 Church Street
White Plains, NY 10601

Lothrop, Lee & Shepard Books
(Div. of Wm. Morrow & Co.)
Wilmore Warehouse
6 Henderson Drive
West Caldwell, NJ 07006

Lynne Rienner Publisher
948 North Street, No. 8
Boulder, CO 80302

Macmillan Publishing Co.
(Acorn, Alladin, Collier)
Front & Brown Street
Riverside, NJ 08370

McGraw-Hill
8171 Redwood Highway
Novato, CA 94947

MERIP, Middle East Report
(Research and Information Project)
475 Riverside Drive
New York, NY 10115

Methuen Inc.
(Subsidiary of Assoc. Book
Publishers Ltd.)
29 W. 35th Street
New York, NY 10001

Metropolitan Museum of Art
Fifth Avenue & Second Street
New York, NY 10028

Monthly Review Press
155 West 23rd Street
New York, NY 10011

Mountaineers Books
306 Second Avenue, West
Seattle, WA 98119

Ms. Magazine
119 West 40th Street
New York, NY 10018

Multi-Media Productions
P.O. Box 5097
Stanford, CA 94305

Nationwide Women's Program of
the AFSC
1501 Cherry Street
Philadelphia, PA 19102

Nelson-Hall Publishers
111 North Canal Street
Chicago, IL 60606

New American Library
P.O. Box 999
120 Woodbine Street
Bergenfield, NJ 07621

New Direction Books
(New Direction Publishing Corp.)
80 Eighth Avenue
New York, NY 10011

New Society Publishers
4772 Baltimore Avenue
Philadelphia, PA 19143

New Star Books, Ltd.
2504 York Avenue
Vancouver, B.C., Canada
V6K1E3

New York University Press
70 Washington Square, South
New York, NY 10012

North American Congress on
Latin America
151 West 19th Street
New York, NY 10011

North Carolina State University
Curriculum Publs.
School Of Education
P.O. Box 5096
Poe Hall
Raleigh, NC 27650

North Point Press
850 Talbot Avenue
Berkeley, CA 94706

Ohio University Press
(Ravan Press)
Scott Quadrangle
Athens, OH 45701

Orbis Books and Zed Press
The Maryknoll Fathers
Maryknoll, NY 10545

Oxfam America
115 Broadway
Boston, MA 02116

Oxford University Press
16-00 Politt Drive
Fair Lawn, NJ 07410

Pandora Press
(See Routledge & Kegan Paul)

Pantheon
201 East 50th Street
New York, NY 10022

Pantheon Books
(See Random House)

Pathfinder Press
4120 West Street
New York, NY 10014

Penguin Books, Inc.
(Puffin, Peacock, Peregrine)
40 West 23rd Street
New York, NY 10010

Peoples Translation Service
4228 Telegraph Avenue
Oakland, CA 94609

Philippine Resource Center
P.O. Box 40090
Berkeley, CA 94704

Population Reference Bureau
777 14th Street, NW
Washington, DC 20003

Post-Apollo Press
35 Marie Street
Sausalito, CA 94965

Praeger Publishers
(Div. of Greenwood Press)
P.O. Box 5007
Westport, CT 06881

Presidio Press
31 Pamaron Way
Novato, CA 94947

Putnam's Sons
(Seaview, Grosett & Dunlop, Inc.)
200 Madison Avenue
New York, NY 10016

R.R. Donnelley & Sons Co.
2223 Martin Luther King Dr.
Chicago, IL 60616

Random House
(Vintage, Stanyan, Times Books,
Ballantine, Pantheon,
Fawcett Books)
400 Hahn Road
Westminister, MO 21157

Rizzoli International
Publications, Inc.
597 5th Avenue
New York, NY 10017

Routledge & Kegan Paul
(Pandora, Oriel Press)
9 Park Street
Boston, MA 02108

Schenkman Books
P.O. Box 1570
Cambridge, MA 02138

Schenkman Publishing Co., Inc.
190 Concord Avenue
Cambridge, MA 02138

Schocken Books (Verso)
62 Cooper Square
New York, NY 10003

Seabury Press
815 Second Avenue
New York, NY 10017

Seal Press
312 S. Washington
Seattle, WA 98104

Seaview Books
(See Putnam's Sons)

Sheba Feminist Publishers
488 Kingsland Road
London, England E8

Silver Burdett
(See Simon & Schuster)

Simon & Schuster
(Silver Burdett, Touchstone Books,
Summit Books)
1230 Avenue of the Americas
New York, NY 10020

Sinister Wisdom
P.O. Box 1308
Montpelier, VT 05602

Smyrna Press
P.O. Box 1803, G.P.O.
Brooklyn, NY 11202

Solidarity Publications
Box 40874
San Franciso, CA 94140

South End Press
300 Raritan Parkway
Edison, NJ 08818

Southeast Asian Chronicle
Southeast Asian Resource Center
P.O. Box 4000 D
Berkeley, CA 94704

SPICE
(Stanford Program on International
& Cross-cultural Education)
Rm. 200
Lou Henry Hoover Bldg.
Stanford, CA 94305

Spinsters Ink
803 DeHaro Street
San Francisco, CA 94107

St. Martin's Press
(Subs. of Macmillan Press)
175 Fifth Avenue
New York, NY 10010

Stanford University Press
Stanford University
Stanford, CA 94305

Stemmer House Publications Inc
2627 Canes Road
Owings Mills, MD 21117

Summit Books
(See Simon & Schuster)

Syracuse University Press
1600 Jamesville Avenue
Syracuse, NY 13244

Taplinger Publishing Co.
132 West 22nd Street
New York, NY 10011

Temple University Press
Broad & Oxford Street
Philadelphia, PA 19122

Thelphini Press
1218 Forest Road
New Haven, CT 06515

Third World Women's Project of
the Institute for Policy Studies
1901 Q. Street, N.W.
Washington, DC 20009

Thomas Nelson, Inc.
P.O. Box 141000
Nelson Place of Elm Hill Pike
Nashville, TN 37214

Thomas Y. Crowell
(See Harper & Row)

Three Continents Press
Suite 501
1636 Connecticut Avenue, NW
Washington, DC 20009

Touchstone Books
(See Simon & Schuster)

Two Continents Publishing Group
30 E. 42nd Street
New York, NY 10017

UCLA Latin American Center
Publications
405 Hilgard Avenue
Los Angeles, CA 90024

UNICEF NEWS, UNICEF
1 Children's Blvd.
Ridgeley, MD 21680

United Synagogue of America
(United Synagogue Book Service)
155 Fifth Avenue
New York, NY 10010

Universal Library, Grosset &
Dunlap
(See Putnam)

University of California Press
2120 Berkeley Way
Berkeley, CA 94720

University of Chicago Press
(Metropolitan Museum of Art)
3rd Floor
5801 Ellis Avenue
South Chicago, IL 60637

University of Illinois Press
(See Harper & Row)

University of North Carolina Press
P.O. Box 2288
Chapel Hill, NC 27514

University of Pittsburgh Press
127 N. Bellefield Avenue
Pittsburgh, PA 15260

University of Texas Press
Box 7819
Austin, TX 78713

University of the West Indies
Extra-Mural Department
Pinelands, St. Michael, Barbados

Vanguard Press
424 Madison Avenue
New York, NY 10017

Verso
(See Schocken Books)

Viking Press
(Viking-Penguin)
(Order from Vikeship)
299 Murray Hill Parkway
East Rutherford, NJ 07073

Viking Press and Metropolitan
Museum of Art
(Order from either publishing
house)

Vintage-Random House
(See Random House)

Virago Press, CVBC Services, Ltd.
9 Bow Street
London, England WC2EL

W. W. Norton & Company
(New American Library)
500 Fifth Avenue
New York, NY 10110

Wayland Publishers, Ltd.
61 Western Road
Hove, East Sussex
England BN3 ID

Wayne State University Press
Leonard Simmons Bldg.
5959 Woodward Ave.
Detroit, MI 48202

Wesleyan University Press
110 Mt. Vernon Street
Middletown, CT 06457

Westview Press
5500 Central Avenue
Boulder, CO 80301

William Morrow & Company
(Greenwillow Books)
Wilmor Warehouse
6 Henderson Drive
West Caldwell, NJ 07006

Women in the World
Curriculum Resource Project
1030 Spruce Street
Berkeley, CA 94707

Women's International League for
Peace & Freedom
1213 Race Street
Philadelphia, PA 19107

Women's International Resource
Exchange Service
Room 7
2700 Broadway
New York, NY 10025

Women's Press, Ltd.
(See Harper & Row)

World Watch Institute
1776 Mass. Avenue, NW
Washington, DC 200036

Yale University Press
302 Temple Street
New Haven, CT 06520

Zed Books Ltd.
(Biblio Inc.)
81 Adams Drive
Totowa, NJ 07512

Zed Press/Lawerence Hill
520 Riverside Avenue
Westport, CT 06880

Title	Section	Category	Page
The Diary of Nina Kosterina	Europe	First Person Accounts	124
Distant View of a Minaret and Other Stories	Middle East North Africa	Fiction	182
The Doctor's Wife	Asia	Fiction	49
A Doll's House (filmstrip)	Europe	Curriculum	140
The Dream of the Red Chamber	Asia	Fiction	49
Early Spring	Europe	Autobiography Biography	102
Eighteen Songs of a Nomad Flute: The Story of Lady Wen-Chi	Asia	Fiction	44
Eighth Moon	Asia	Autobiography Biography	34
The Eighth Wife	Africa	Fiction	19
Eleanor the Queen	Europe	Fiction	129
Eleni	Europe	Autobiography Biography	103
Elizabeth I	Europe	Autobiography Biography	103
Elizabeth I	Europe	Curriculum	141
Elizabeth Tudor: Portrait of a Queen	Europe	Autobiography Biography	103
Elli	Europe	First Person Accounts	120
Eminent Victorian Women	Europe	Autobiography Biography	104
"End of the UN Decade: Advances for Africa Women?" Africa Report 30:4(March-April)	Africa	Background Reference	8
The Endless Steppe: Growing Up in Siberia	Europe	First Person Accounts	124
European Women: A Documentary History	Europe	Background Reference	85

Title	Section	Category	Page
Women, the Family, and Freedom: The Debate in Documents Volume One, 1750-1880 & Volume Two, 1880-1950	Europe	Anthology	99
Women Impressionists	Europe	Background Reference	95
"Women In A Changing World," Cultural Survival Quarterly	Cross-cultural	Background Reference	70
Women in a Hungry World	Cross-cultural	Curriculum	80
Women in Africa of the Sub-Sahara, Vol. I: From Ancient Times to the 20th Century	Africa	Curriculum	23
Women in Ancient Greece and Rome	Europe	Curriculum	143
Women in China	Asia	Background Reference	31
Women in Cuba: Twenty Years Later	Latin America	Background Reference	152
Women in Development; A Resource Guide for Organization and Action	Cross-cultural	Background Reference	66
Women in Islam: The Ancient Middle East to Modern Times	Middle East North Africa	Curriculum	186
Women in Islam: Tradition and Transition in the Middle East	Middle East North Africa	Background Reference	171
Women in Israel	Middle East North Africa	Curriculum	186
Women in Japan	Asia	Curriculum	55
Women in Latin America: From Pre-Columbian Times to the 20th Century, Volume I	Latin America	Curriculum	165
Women in Latin America: The 20th Century, Volume II	Latin America	Curriculum	166
Women in Latin American History	Latin America	First Person Accounts	159
Women in Modern China: Transition, Revolution and Contemporary Times	Asia	Curriculum	56
Women in Music: An Anthology of Source Readings from the Middle Ages to the Present	Europe	Anthology	99

Title	Section	Category	Page
Women in the Global Factory	Cross-cultural	Background Reference	66
Women in the Middle Ages	Europe	Background Reference	95
Women in the Middle Ages/Renaissance	Europe	Curriculum	144
Women in the Third World: A Directory of Resources	Cross-cultural	Background Reference	66
Women in the U.S.S.R.: The Scythians to the Soviets	Europe	Curriculum	144
Women in the World: An International Atlas	Cross-cultural	Background Reference	67
Women in the World: 1975-1985, The Women's Decade	Cross-cultural	Background Reference	67
Women in Traditional China	Asia	Curriculum	56
Women in War	Cross-cultural	First Person Accounts	75
Women In Western Civilization	Europe	Background Reference	95
Women Leaders in African History	Africa	Autobiography Biography	12
Women of Action in Tudor England	Europe	Autobiography Biography	117
Women of Africa of the Sub-Sahara, Vol. II: The 20th Century	Africa	Curriculum	24
Women of 'Amran	Middle East North Africa	Background Reference	171
Women of Asia: Patterns of Civilization	Asia	Curriculum	56
"Women of China"	Asia	Background Reference	31
Women of Cuba	Latin America	First Person Accounts	159
The Women of Suye Mura	Asia	Background Reference	30